*Faith, Art, and Politics
at Saint-Riquier*

University of Pennsylvania Press
MIDDLE AGES SERIES
Edited by
Edward Peters
Henry Charles Lea Professor
of Medieval History
University of Pennsylvania

A listing of the available books
in the series appears at the
back of this volume

Faith, Art, and Politics at Saint-Riquier

The Symbolic Vision of Angilbert

Susan A. Rabe

University of Pennsylvania Press

Philadelphia

Library of Congress Cataloging-in-Publication Data
Rabe, Susan A.
 Faith, art, and politics at Saint-Riquier : the symbolic vision of
Angilbert / Susan A. Rabe.
 p. cm — (Middle Ages series)
 Includes bibliographical references and index.
 ISBN 0-8122-3208-9
 1. Saint-Riquier (Monastery : Saint-Riquier, France)
2. Angilbert, Abbot of Saint-Riquier, ca. 745–814. 3. Christian art
and symbolism — France — Saint-Riquier. 4. Theology — History — Middle
Ages, 600–1500. 5. Catholic Church — France — Liturgy — History.
6. Saint-Riquier (France) — Church history. I. Title. II. Series.
BX2615.S285R33 1994
271'.104426 — dc20 94-32913
 CIP

To My Parents

Contents

Illustrations

Acknowledgments

A study such as this naturally incurs many debts of gratitude for the help and insight so many have generously offered. This book began in a graduate seminar on Carolingian monasticism conducted by Barbara Rosenwein at Loyola University of Chicago. My first debt of gratitude is owed to her. It was she who inspired my love for the Early Middle Ages, and her insight and support have been unfailing. She has always challenged me to look further. I must also thank the late Thomas Hogan, S.J., Mary Lawton, and Michael Masi for their guidance as this study initially took shape.

A scholarship from the Newberry Library enabled me to benefit from paleographical and codicological training at the Ecole des Chartes in Paris. I wish especially to thank Robert-Henri Bautier, Emmanuel Poulle, and Marie-Clothilde Hubert, as well as Jean-Loup LeMaitre of the École des Hautes Études, Section IV. I owe special thanks to Jean Vezin of the École des Hautes Études, Section IV, for his continued generous guidance on codicological concerns, and to Reginald Foster, of the Pontifical Gregorian University, for his rigorous and enthusiastic Latin training.

I wish to thank the library staffs of Loyola University of Chicago, Loyola Marymount University, and UCLA, Mme. Agache and the staff of the Bibliothèque Municipale d'Abbeville, the Pontifical Gregorian University, the Bibliothèque Nationale, and the Vatican Library. A grant from Loyola Marymount University aided the publication of this book, for which I must thank Joseph Jabbra and Mary Milligan. For the technical preparation of this manuscript in its many metamorphoses I thank Margaret Edwards, whose untiring good humor, sharp eye, and excellent judgment were invaluable, and Jerome Singerman and Alison Anderson of the University of Pennsylvania Press.

My deepest gratitude I owe to my family. They created the environment in which my interests grew. Their valuing of education, their respect for the integrity of all things, their fairness and sensitivity have inspired me. Their support in every way has made this work possible. This book is dedicated to them.

Abbreviations

AASS, OSB	*Acta Sanctorum, Ordinis Sancti Benedicti* Jean Mabillon, editor		
CCCM	*Corpus Christianorum, Continuatio Medievalis*		
CCM	*Corpus Consuetudinum Monasticarum*, Volume 1: *Initia Consuetudinis Benedictae* Kassius Hallinger, editor		
CCSL	*Corpus Christianorum, Series Latina*		
CSM	*Corpus Scriptorum Muzarabicorum* Juan Gil, editor		
DACL	*Dictionnaire d'Archéologie Chrétienne et de Liturgie*		
DHGE	*Dictionnaire d'Histoire Ecclésiastique et de Géographie*		
Mansi	*Sacrorum Conciliorum Nova et Amplissima Collectio*		
MGH	*Monumenta Germaniae Historica*		
MGH AA	*Auctores Antiquissimi*, Volume 15		
MGH Epp		*Epistolae*	
MGH LL 1,	*Leg. Nat. Germ.*	*Leges*, sectio 1,	*Leges Nationum Germanicarum*
MGH LL 2,	*Capitularia*	*Leges*, sectio 2,	*Capitularia*
MGH LL 2,	*Concilia Aevi Carolini*	*Leges*, sectio 2,	*Concilia Aevi Carolini*
MGH LL 3,	*CC*	*Leges*, sectio 3	*Conciliarum*
MGH PL		*Poetae Latini*	
MGH SS		*Scriptores*	

MGH SSRM	*Scriptores Rerum Merovingicarum*
PL	*Patrologia cursus completus, Series Latina* Jacques-Paul Migne, editor

Introduction

Sometime around 789, Charlemagne appointed Angilbert, one of his foremost friends and court officials, to be abbot of the royal monastery of Saint-Riquier in the Ponthieu. Angilbert immediately razed the original abbey and, with a great deal of moral and material support from the king, built a new and spectacular complex with, he tells us, three churches, three hundred monks who sang the office in three choirs, relics and liturgical furniture arranged in groups of three, and the structural proportions of the main basilica based on the number three. In 800, the new monastery was dedicated in the presence of twelve bishops. Charlemagne came at Easter with his entourage, which included the great secular and ecclesiastical officials of the realm. Alcuin, the spiritual father of Angilbert, was also in the group, and wrote for the occasion a new vita of the abbey's heavenly patron, Saint Richarius.

Why such interest in a small monastery at the northern edge of the realm, dedicated to an obscure seventh-century Frankish hermit? Angilbert revealed his concern in his own account of the project:

> So that, therefore, all the people of the faithful should confess, venerate, worship with the heart and firmly believe in the most holy and undivided Trinity, we, with God cooperating and my aforementioned august lord helping, have been zealous to found in this holy place three principal churches with the members belonging to them, according to the program of that faith in the name of almighty God.[1]

Angilbert went on to say that "the program of that faith" would be expressed not only "in marble buildings and in other decorations . . . but also in the praises of God, in various teachings and in spiritual songs."[2]

These seemingly simple words in fact were highly charged. They articulated a cultural vision, the unity of politics, aesthetics and theology in the world of Charlemagne. It was a unity at once centered, achieved and perfected in liturgy, expressed in word and sacred space and act. The world of Charlemagne was a world that placed a premium on gesture.[3]

How are we to assess this monumental program? Scholars from a

variety of fields have been attracted to Saint-Riquier, including historians of monasticism, architectural historians, and liturgists. This is because the extant sources are relatively rich for the period, and provide insights into the ritual life and physical structure of the monastery from a variety of viewpoints. The sources include detailed writings which scholars have traditionally interpreted to come from Angilbert himself, as well as an eleventh-century drawing of the Carolingian buildings.[4]

Until recently, the students of Saint-Riquier have been most interested in the monastery as a precursor of later developments, whether of Romanesque architecture and liturgy or of the problems of lay proprietorship of ecclesiastical properties. The abbey has been treated as a classic example of various aspects of the Carolingian period — yet of that period not necessarily assessed in its own right, but as an age of transition. Moreover, two broad tendencies have characterized the historiography of Saint-Riquier. First, scholars have analyzed the evidence in broad institutional terms rather than for the peculiar information it provided about the life of this particular monastery at the turn of the eighth century. Second, students from different fields have rarely consulted each other's work, seeing Saint-Riquier from the perspective of strict disciplinary boundaries. Beyond that, they have largely ignored Angilbert himself, widely acknowledged as one of the most important members of Charlemagne's entourage. Thus few students have looked at the genesis of Saint-Riquier's program, so provocatively suggested in the sources.

What we know about Angilbert and his work at Saint-Riquier provides a unique opportunity for an integrative and specific approach. He was a prominent member of court, the intimate of Charlemagne and friend of such scholars as Alcuin, Theodulf, Paulinus of Aquileia, and Paul the Deacon. He was an admired poet — nicknamed Homer — whose work is still extant. He was the head of the palatine chapel of Pepin, King of Italy, the young son of Charlemagne. He served as the negotiator between Charlemagne and the Pope on critical theological issues throughout the 790s. At the same time, he built the unusual complex at Saint-Riquier and wrote its *ordo* with Charlemagne's patronage and encouragement.

Thus consideration of the work of Angilbert himself can provide insight into many aspects of Carolingian culture and concern. The pieces are in place to examine the substance and vision of his work. The growing interest in the meaning of liturgy as a creator of political power and perceptions of community for the Carolingians is an area in which the liturgical program of Angilbert can be both illuminated and illuminating.[5]

Furthermore, there has been a burgeoning interest in the character and membership of Charlemagne's court, reflected not least in many new editions of their writings. Editions have been, or are being prepared on Alcuin,[6] on Theodulf,[7] and on Paulinus of Aquileia, whose complete works are now being edited by the *Corpus christianorum*.[8] Peter Godman's studies of Carolingian poetry have also stimulated a rethinking of the nature and intellectual activity of the court in general, and of the relationships between members of the court and Charlemagne.[9] It is time to redress the balance for Angilbert. Hence the value of rethinking Saint-Riquier and examining the genesis of its program.

At Saint-Riquier we can see a culture in formation. Here, through the eyes of a pivotal figure, we can see with unusual clarity the interpenetration of politics, religion, and art in the age of Charlemagne. This study will argue that the spirituality of Saint-Riquier, as expressed in its monastic buildings and life, grew out of dominant political, aesthetic, and especially theological concerns of the Carolingian court of the 790s. Angilbert built Saint-Riquier as a *signum* (to use his own word) of the Trinity, the expression of the faith in stone and prayer.

Saint-Riquier was Angilbert's creation, and we can understand its meaning from the rest of Angilbert's activities. Here I follow the lead of Josef Fleckenstein, for Fleckenstein understood the role of royal abbeys such as Saint-Riquier as *herrscherliche Gottesdienst*, one of the means of extending, through the invocation of the holy, Charlemagne's royal authority.[10] It is within this matrix that we can integrate the various aspects of Angilbert's life and royal service. Thus my methodology has been interdisciplinary and my focus synthetic. My focus is also, however, intentionally narrow. To understand Angilbert's program we must look closely at it. While I will draw some comparisons with other monasteries, it is my intention to use a different approach than the traditional methodology of broad chronological and material comparison.

Let us establish the contours of this study. At the very time that Angilbert was rebuilding Saint-Riquier, he was also involved in the theological controversies that concerned Charlemagne and his court in the 790s: Adoptionism and the struggle with Byzantium that produced the *Libri Carolini*. It is this involvement that explains Angilbert's desire to build a monastery through which "all the people of the faithful might confess, venerate, worship with the heart and firmly believe in the most holy and undivided Trinity."

Chapter 1 examines the background of studies of Saint-Riquier in

order to understand both the ways in which this monastery and the broader development of Carolingian religion have been assessed, and the need for a fresh look.

Chapter 2 examines the theological issues, the official Carolingian responses, and Angilbert's involvement with them. The two clusters of problems emerged in the Frankish realm at about the same time, but almost always have been considered separately and with little reference to each other by historians. Yet those fighting on behalf of the tradition of the faith as the Franks knew it saw connections between them that became a basis of their argumentation. From at least 789 onward, the defense of the faith became a primary concern for Charlemagne and his court. Angilbert played a direct part, particularly with regard to Adoptionism. Any understanding of the way that he encoded belief in the Trinity at Saint-Riquier must begin here.

Chapter 3 looks in detail at Angilbert, his life and writings. In particular, an examination of his poetry reveals that from very early in his public career he was concerned with the spread of the faith and with liturgy as the transmitter of that faith. The poem *De conversione Saxonum,* the subject of recent controversy over authorship, bears reconsideration as a poem of Angilbert. Taken together with a later poem written as the dedication of a manuscript of Augustine's *De doctrina christiana,* it reveals a great deal about Angilbert's conviction that the Trinity is revealed to the faithful through earthly signs in a Creation ordered by God in "number, measure, and weight." Hence the Augustinian sources of Angilbert's interest in aesthetic symbolism as a source of faith and his assessment of the importance of kingship in the propagation of the true faith. He dedicated his book to the young Louis the Pious because the first function and the justification of kingship was to understand the faith rightly and thereby to pray properly and effectively for his own well-being and that of his realm. Right worship was the key to both earthly prosperity and eternal bliss.

How Angilbert actually understood his trinitarian *signa* at Saint-Riquier to function is the subject of Chapter 4. Angilbert used Augustine's *De doctrina christiana* and *De Trinitate* as the taproot of his own spirituality. In the *De doctrina christiana* he came to understand the role of signs as the most important and effective means of teaching dogmatic truths. He found a description of the internal moral development that a believer underwent through a desire to come closer to the source of those signified truths. And he found that the result of that development was the vision of the Trinity, the Godhead itself. Peculiar to Angilbert's own understanding of Augustine, as revealed in his dedicatory poem, was the conviction that number

was the key symbol through which the believer could intuit the Trinity. How this happened Angilbert learned from the *De Trinitate,* in which he found the claim that the Trinity was implicit in Creation. The beauties of this world were themselves trinities that enabled the observer to intuit the Trinity at their source. Most important among these was the tripartite mind of the believer, the intellect, memory, and will, which in their operations enabled the viewer of the symbol to be assimilated to the reality beyond. That is, recognition or intuition of the Trinity from the partial clues in the world stimulated love for the Trinity and the ability to become like the Trinity through holy actions. Here we can see the correlation between the individual and society so important to Charlemagne's program of reform: the holy actions of an individual, springing from a pristine faith in the Trinity (particularly as mediated through Christ), contributed to the regeneration of a holy society. Thus a trinitarian *signum* at Saint-Riquier in which threes were visible everywhere, and in which specific christological doctrines were also made concrete, would bring about this belief, love, and action.

Chapter 5 considers in detail the architectural and liturgical program at Saint-Riquier through a close reading of Angilbert's texts. Symbolism based on the number three was present everywhere: in the number of churches, in the number of monks, in the arrangement of the choirs, the relics, the liturgical furniture, in the structural proportions of the buildings. Angilbert's westwork, the first structure on so monumental a scale, was a church within a church, the site of festival liturgies as well as the daily office. The direct correspondence between the liturgical setting and the liturgy itself, both in the main basilica and in the Mary chapel, underscored particular doctrines at issue in the 790s.

Finally the Conclusion again places Angilbert in perspective and assesses the uniqueness of his program through a comparison with others. Here the work of Benedict at the monastery of Aniane will be most illuminating. Like Angilbert, he was intimately and actively involved in the prosecution of Adoptionism and the controversy with Byzantium. And like Angilbert, he built a church that concretely expressed his theological visions. Much attention has been paid to Benedict's later monastic structures at Inde (Cornelimünster), so aggressively a part of Louis the Pious's monastic reform effort and overshadowing his earlier monastery at Aniane. A brief examination of the sources for Aniane, however, reveals a striking relationship to Angilbert's work at Saint-Riquier.

Thus Saint-Riquier yields insight into many Carolingian concerns. Let us begin, then, with a consideration of what scholars have seen in Saint-Riquier.

1. The Problem of Saint-Riquier

Recent years have seen a revolution in thinking about what religion in general and monasticism in particular meant in the Carolingian world. Indeed, to speak of monasticism is itself to misapprehend the reality because it has become clear that individual monasteries and their specific programs were an essential part of the Carolingian cultural debate. Rather than the uniformity that has traditionally been understood to characterize Carolingian monasticism, scholars now discern variety. In the hands of the great ecclesiastical lords of the court, churches and monasteries expressed unique and often competing cultural visions. It is in this context of cultural debate that Angilbert's Saint-Riquier must be assessed.

This is a context new to Saint-Riquier. The work of Angilbert has never been systematically studied, for reasons that are illuminating. Those who have studied his program for the monastery have fallen largely into three groups: architectural historians, historians of monasticism, and liturgists.[1] Until fairly recently the work of students of Saint-Riquier has been characterized by two rather broad tendencies: isolationism, and breadth rather than depth of focus. By isolationism I mean that, until the ground-breaking work of Jean Hubert, those studying Saint-Riquier have approached the monastery from within strict disciplinary boundaries.[2] Historians, monastic scholars, art historians, and liturgists have long written methodologically classic studies. But they have rarely consulted each other's work. By breadth I mean that scholars have paid little attention to the genesis of Angilbert's program and to his quite specific, clearly articulated interests. Rather they have tended to view Saint-Riquier from the perspective of long-term, general developments to the neglect of Angilbert's concerns.

The Traditional Approaches

By far, it has been historians of architecture who have shown the greatest interest in Saint-Riquier. Two reasons account for this. First, there is a

variety of documentation ranging from descriptive texts written by An-
gilbert himself to modern archeological excavations.[3] Second, architectural
historians have almost unanimously seen in Angilbert's buildings an impor-
tant transition from Early Medieval to Romanesque architecture. In partic-
ular, they have cited Angilbert's development of the monumental west end
(westwork) of the main basilica at Saint-Riquier as the progenitor not only
of subsequent Carolingian westwork churches, but also of the monumental
façades of Romanesque churches. Thus Saint-Riquier quickly gained an
undisputed position of importance in their assessments.

Of these studies, the *locus classicus* was Wilhelm Effmann's *Centula-
Saint-Riquier,* which carefully reconstructed and analyzed the appearance
of the main basilica of Angilbert's abbey according to the textual evidence
and the evidence of later architectural development.[4] A model of balanced
and careful analysis, Effmann's work was not superseded until 1965 when
excavations of the monastery by Honoré Bernard shed new light on Angil-
bert's structure.[5] His study had two major historiographical consequences.
First, although Saint-Riquier was a three-church complex, Effmann saw
only one church as important: the basilica with its westwork. Second, he
judged Saint-Riquier by its relationship to Romanesque art. There was little
awareness as yet of Carolingian architecture in its own right or of the
reasons for which Angilbert built this complex structure. For Effmann and
his followers, Saint-Riquier was important as the first example of a type, the
westwork church.

Implicit in Effmann's analysis was the question of interpretation of
forms. What was the meaning of this new monumentality of the western
end of the main basilica? The question was implicit in Effmann's work
because although he essayed an interpretation, his fundamental concern,
and that of most architectural historians until Richard Krautheimer and
André Grabar, was formalistic: to trace the development of specific archi-
tectural forms or elements over time.[6] The question of function and sym-
bolic meaning was secondary. Nevertheless, because of the striking and
apparently sudden appearance of westworks in the Carolingian period, a
debate did emerge over function. Westworks contained two storeys, the
upper of which was a gallery or large niche. In Effmann's view, these held
the throne of the bishop when he came to render judgment in local cases,
thus symbolizing ecclesiastical jurisdiction.[7] Others, however, saw a more
political content, juxtaposing the essentially religious functions of the east-
ern apsidal end with royal symbolism in the western end, the area where the
king's throne would be placed when he visited the abbey.[8] This political

interpretation became particularly important in the 1950s with the painful awareness of the Fascist use and abuse of religio-political symbolism. Besides Krautheimer's call for the study of architectural iconography, of seminal importance in stimulating these studies was Ernst Kantorowicz's *Laudes Regiae,* which analyzed the manipulation of religious images in the creation of a new identity for Carolingian kings, as well as the subsequent work of Percy Ernst Schramm tracing the development of the liturgical symbolism of royal accoutrements vesting the ruler with quasi-sacramental status.[9] This interest in iconography had a critical impact on methodology as well, for it demanded the integration of textual evidence, both literary and liturgical, in ways not previously used. Thus the way was laid for using specific contemporary sources rather than analyzing Saint-Riquier solely by its technical relationship to other buildings both before and after it.

If the formalistic tendency in scholarship on Saint-Riquier was addressed by these studies, it was another article by Richard Krautheimer that began to shift focus away from the main basilica of Angilbert's complex to the other churches in the monastic complex. Krautheimer studied the Mary church at Saint-Riquier as part of an ongoing examination of Mary churches in the Carolingian period.[10] Krautheimer saw the Mary chapel as one of many round or polygonal churches dedicated to the Virgin in the Carolingian period and modeled on the Roman Pantheon, which had been rededicated as *Sancta Maria ad martyres* early in the seventh century. The formal prototype for all such churches was, in his view, the round tomb of the Virgin in Jerusalem from which, it was believed, Mary was assumed into Heaven. Thus the subsequent iconography of round Mary churches, including Angilbert's, symbolized this heavenly assumption of the Virgin. This was represented in the fact that all such churches were dedicated in some way to the concept of Mary leading the Church to Christ.[11] Krautheimer both broadened and deepened the study of Saint-Riquier to comprise more of Angilbert's cloister and to understand more fully what Angilbert meant by his work. Moreover, he asserted an essentially religious focus for Angilbert's spirituality.

It was only, however, with the groundbreaking study of the great French archeologist and architectural historian Jean Hubert that an integrated iconographical interpretation of Saint-Riquier that drew substantially on Angilbert's own texts appeared. In a paper delivered at Spoleto in 1957, Hubert argued for a new methodology specifically for the study of this monastery.[12] He called for the consideration of all available evidence from Angilbert's monastic program; his was the first analysis to discuss

Angilbert's program from Angilbert's point of view. Hubert's methodology was interdisciplinary, combining the perspectives of history, architectural history, liturgy, and archeology in an attempt to understand the forces that shaped Saint-Riquier's spirituality. But he also assumed that Saint-Riquier was a Benedictine monastery, and this requires some explanation. Let us first consider Hubert's findings.

Like so many others, Hubert saw Saint-Riquier as a pivotal institution and described it as the herald of the future. When he examined Angilbert's *ordo* he found a minutely detailed and highly controlled set of liturgical prescriptions that organized the liturgical lives not only of the monks but of the entire local populace. He described the monastery as the nucleus of a "holy city" organized on a feudal basis. His evidence was Hariulf's (false) claim that Angilbert was the Count of Ponthieu and therefore responsible for the military support and political control of the entire province on Charlemagne's behalf. Hence Saint-Riquier still represented essentially imperial political concerns.

Hubert also noticed important numerical symbolism in Angilbert's liturgy, involving most notably the numbers three and seven. He was particularly interested in the sevens as the key to Saint-Riquier's spirituality, citing the seven towers of the monastery complex and a peculiar Rogations liturgy in which monks and townspeople marched in ranks of seven to the seven neighboring towns in the area. This was, he said, an evocation of the seven regions of the city of Rome; therefore, Rome was the ultimate source of custom and spirituality at Saint-Riquier.

For Hubert as for the other architectural historians writing in the fifties, Saint-Riquier was essentially a political entity whose importance lay in the carrying out of imperial policy. But Hubert's was also a thesis about Carolingian monasticism. In his view, Benedictinism was the key to subsequent local political and social stability. Saint-Riquier, as the center of a holy city and, by extension, of a holy province which radiated from it, provided the order, the organization, and the discipline that underpinned local Carolingian life. Benedictinism as lived at Saint-Riquier became the local foundation of feudalism in its highly organized social, political, economic, and even liturgical order.

Hubert's perspective drew Saint-Riquier into the realm of monastic historiography because he rightly understood that this monastery could not properly be assessed without a consideration of its relationship to Carolingian monastic concerns. Angilbert's relationship to Charlemagne, his prominence at court, and Charlemagne's patronage of the abbey argued for

an integral connection between the abbot's program at Saint-Riquier and official Carolingian interests. But Hubert was the first to examine Saint-Riquier in this way. Indeed, traditionally, historians of monasticism came at Saint-Riquier strictly from the broad perspective. This is not to say that significant studies of individual monasteries were not done. But the tradition within which Saint-Riquier was analyzed was a broad institutional and spiritual tradition that aimed at defining the character of Carolingian monasticism as a whole. Its characteristics, such as the assumed pervasiveness of the Benedictine Rule, also tended to characterize the more specific studies. They generally took two different approaches, one focusing essentially on the institutional elements of monasticism and the external political and social relationships of monasteries, the other focusing on what we might call the internal elements of monastic spirituality. Both viewed early medieval monasticism as Benedictine, assuming that the Benedictine Rule was the basis of the monastic life in all houses. Both drew from the same sources: charters and royal decrees, chronicles, and the Rule of Saint Benedict. They read the Benedictine Rule as if it applied everywhere.

The consequence of this perspective was to create a paradigm of Carolingian monasticism that focused essentially on the work of Benedict of Aniane as the central figure in the monastic life of the Carolingian period. The scholarly debate that emerged was about the work and role of Benedict, and it was only as a consequence of this that scholars became aware of other alternative programs and monastic spiritualities such as Angilbert's.

The basic scenarios are well known. The political and institutional approach to Carolingian monasticism is perhaps best represented by Emile Lesne's *Histoire de la propriété ecclésiastique en France,* which examined the increasing politicization and laicization of the Church under the Carolingians, focusing especially on the alienation of Church lands into the private hands of local lords.[13] Lesne's study, like most of this group, was an indictment of secular interference in the Church. It was in this context that he assessed Saint-Riquier, citing Angilbert as the last ecclesiastical abbot of the monastery who laid the foundations of Saint-Riquier's cultural greatness by establishing the school, the library, and the economic organization that made of the abbey a great social benefactor. For Lesne, Saint-Riquier was distinctive because it exemplified ecclesiastical temporal power and the development of monastic institutions.[14] Thus Saint-Riquier, like other Carolingian monasteries, was assessed strictly from the perspective of its relationship to secular political power and institutional interests. The ecclesiastical and especially the monastic history of the late eighth and ninth

centuries was a history of pernicious secularization and corruption of spiritual offices and the need for systemic reform.

The internalist or spiritual school of Carolingian monasticism presented an equally influential scenario, one that hinged on the supposed centrality of Benedictinism in Western monastic life. In this view, Benedictinism became the civilizer of barbarian Europe. This school characterized the Rule established by Benedict of Nursia as balanced and ordered, founded on the two commandments to pray and work, *ora et labora*. The Rule was able thereby to harness the dedicated and disparate ascetics of the West to a new Christian culture and society put to the use of the Church. (This was the perspective from which Hubert's comments on the organizational role of Saint-Riquier emerged.) Such was the excellence of Benedict's Rule that Gregory the Great chose Benedictines to establish Christianity in England, a pivotal point from which Benedictinism, through Anglo-Saxon monk-missionaries, conquered for Christianity the vast pagan territories of Frisia and Germany and reconquered lax Christianity in Gaul. The Carolingian kings supported their work; the monks in turn provided the educational tools for Charlemagne's great renaissance and for the establishment of schools throughout his realm.[15] Under Louis the Pious and his Benedictine counsellor Benedict of Aniane, however, a reform of Benedictinism took place that changed its spirit. The second Benedict established a rigid standard by which all houses were to follow the Benedictine Rule to the letter, taking the monks out of worldly activity and devoting them entirely to the life of prayer. This destroyed the equilibrium of the Rule and paved the way for the so-called abuses of Cluny in which the monks did no manual labor but spent their days "multiplying offices" and living luxuriously with nothing else to do. Within this approach, Saint-Riquier did not fare well. Either it was dismissed generically as a Benedictine monastery or its elaborate liturgy became an example of spiritual corruption and the need for monastic reform, the kind of corruption that culminated later in Cluny.

It was only gradually that traditional views began to change, as scholars came to question whether pre-Carolingian and early Carolingian monasticism were as monolithically Benedictine as once thought. Increasingly, scholars spoke of competing monastic forms and an era of "Mixed Rule," when Benedictinism spread in combination with other monastic practices.[16] From a different point of view, when research conducted for a new edition of the Benedictine Rule between 1933 and 1937 brought to light the importance of the *Regula Magistri* as the source of Benedict's Rule, scholars

began to search for its spiritual roots.[17] Thus the way was opened to examine the particularist character of pre-Anianian monasticism. Again, while this perception only slowly gained ground, it heralded a major shift in attitudes toward the sources and created a climate in which the unique character of Angilbert's program at Saint-Riquier could be better appreciated.[18]

This perception of the important diversity of Carolingian and pre-Carolingian custom culminated in the systematic study and publication of monastic texts, the *Corpus consuetudinum monasticarum*.[19] The aim of this project was to produce new critical editions of monastic customaries from the eighth to the fourteenth centuries. Among these would be Angilbert's *ordo* for Saint-Riquier, as well as resources and a stimulus for examining in detail a wealth of specific materials. This resource has been of inestimable value; through it, scholars have understood monasticism in the Carolingian period with much greater subtlety and openness to the sources and to the unique spiritualities and monastic functions within the Carolingian realm. Scholarship leading up to the publication of the *Corpus consuetudinum monasticarum,* and the new editions themselves, have suggested that monasteries were founded, patronized, and popular for different and distinct reasons, and that each had a spiritual program or role to fulfill within broader Carolingian concerns. The work of Benedict of Aniane, the effects of Anianian spirituality, and the broad monastic policies of both Charlemagne and Louis the Pious have been brought into much clearer perspective.[20] Perhaps most important has been the stimulus for much fuller, more integrative interdisciplinary study of monasteries and of monastic spirituality. This stimulus is evident in a variety of ways, as we shall see momentarily. First, however, let us briefly consider the third group of scholars of Saint-Riquier.

This group, the liturgists, are few in number but their insights have been important. They have long understood what it has taken historians of architecture and monasticism decades to discover: the importance of recognizing diversity in Carolingian custom and the importance of Angilbert's liturgical complex at Saint-Riquier. In 1918 the great liturgist Edmund Bishop published an edition of Angilbert's *ordo*. He was primarily interested in Angilbert's text as an interesting source. Though he provided little analysis of its content, he did bring it to light by publishing its text.[21] Bishop's work gave him an early awareness of the richness and diversity of the Carolingian period liturgically; his examinations of the work of Benedict of Aniane also revealed ways in which Benedict had added what Bishop called "devotional accretions" to the monastic liturgy by including the daily

recitation of the office of the dead as a "supplement" to the regular office of the Psalms.[22] Dom Philibert Schmitz took this thesis a step further, saying that Benedict of Aniane was responsible for ceremonializing Benedictinism by making the liturgy the entire focus of the monastic life and defining the Carolingian reforms as a ritualizing movement in monasticism.[23] It was this perspective that gradually came to inform the awareness of ritualization that we have seen among the scholars of monastic spirituality above. Angilbert's Saint-Riquier, with its complex liturgical and processional formulae, thus exemplified the movement toward this ritualization. More recently, and in this same vein, Carl Gindele examined Saint-Riquier's liturgy as an early example of *laus perennis,* or perpetual prayer cloisters, through his close examination of Angilbert's ritual order.[24]

Monasteries and the Carolingian Cultural Debate

Since the publication of the *CCM* the stimulus for integrative and interdisciplinary study of monasteries and monastic spirituality in the Carolingian period is evident in a variety of ways. Sociological perspectives, for example, particularly with the aid of computers, have brought new insights on the social and regional relationships, influence, and importance of monasteries.[25] Monastic historians have achieved a much greater precision of understanding and of differentiation between the monastic concerns of Charlemagne and those of Louis the Pious, and much greater clarity on the work of Benedict of Aniane and its influence. The extent to which Benedict's program at Inde was part of a much larger and more comprehensive reform movement in which monasteries were at the center of Carolingian cultural debate has become increasingly clear. Josef Semmler's edition and study of the Aachen reform legislation of 816/817 first brought to light a bitter conflict over the nature and role of monastic life in the Empire.[26] There is increasing evidence to show that monastic *ordines* and the physical complexes which housed them, in the hands of the great ecclesiastical lords of the realm, expressed competing or complementary visions of Carolingian culture. It is within this larger movement that Angilbert's work, in all of its complexity, must be assessed.

The dimensions of the monastic debate first became clear with the publication of Walter Horn and Ernest Born's monumental study of Saint Gall.[27] Horn and Born assessed the manuscript Plan of Saint Gall as a paradigmatic Carolingian monastery, but acknowledged widespread op-

position to this model within the Empire. In their view, Saint Gall was the ideal plan of a monastery representing the Anianian program, with its stress on uniformity and normativity. The Plan of Saint Gall was a prototypical master plan for a monastic settlement, an ideal schematization. Produced sometime around 820, it clearly expressed the monastic reform program of the imperial legislation of 816–817. In Horn's words, it was "an architectural program whose conception depended on policy decisions of major magnitude."[28] Thus it was the triumph — at least on paper — of the Anianian program, the constriction and spiritualization of monastic life and its clear and radical separation from the laity and public involvement. The Plan revealed a fully self-sufficient monastery withdrawn from outside contact, with a cloister church clearly intended for the monks and monastic liturgy alone.

Besides the integral self-sufficiency and exclusivity of Saint Gall, one of the most striking and noteworthy elements of its plan was the consistent use of sacred numbers in the very structure of the buildings and site. Here was a physical plan resonant at least in part with Saint-Riquier. According to Horn, the predominant numbers used were three, four, seven, ten, twelve, and forty. These numbers were built into the physical structure of the monastery in a variety of ways. Seven, for example, was incorporated in obvious elements: seven buildings in the cloister, seven steps by which the presbytery was raised above the crossing, seven desks for the scribes in the scriptorium, seven tables in the refectory, seven beds in the abbot's dormitory and seventy-seven beds in the dormitory of the monks. Similarly, the number three determined the basic division of sites: the monastic grounds were divided into three tracts, of which the central and northern tracts were further divided into three sites.[29]

More significant, however, was the fact that the architectural space at Saint Gall was organized around the principle of numerical modularity, or to use Horn's term, square schematization. In fact, according to Horn, the Plan represented the purest Carolingian form of square schematization. This meant that the spaces that constituted the church and grounds were calculated as multiples of a fundamental spatial unit, the crossing square. Thus the square grid became "an active principle of architectural composition."[30]

According to this plan, squares of forty by forty feet made up the church and the cloister at Saint Gall. The church was three forty-foot units wide by nine forty-foot units long. The cloister was a grid of three by six forty-foot squares. Over all, the dimensions of the Plan were in the propor-

tion of three by four, arranged within a grid of 160-foot squares. Both the importance of numbers in general in the Plan and the organization of buildings according to modularity closely relate Saint Gall to Saint-Riquier, which Horn cited as the first of the Carolingian basilican-design churches to employ square schematization.[31]

The symbolic meaning of these numbers and modular usage, however, Horn examined only in generic rather than specific terms. He related the number four, for example, to the basic divisions of time, matter, and space in pagan and Christian thought. Seven was related to Augustine's description of this number as "the wholeness or completeness of everything" and to the ordering of human life. The meaning of forty, the basis of the square grid, again was drawn from Augustine's claim that Christ stayed on earth forty days after the Resurrection, as well as from the biblical tradition of periods of penance and anticipation.[32] Any specific allusion to numerical symbolism or practice in the life or liturgy of Saint Gall, however, Horn did not make.

As the epitome of official Carolingian policy under Louis the Pious, the Plan of Saint Gall represented the culmination of the monastic reform of Benedict of Aniane. Yet that reform program was far from unchallenged in the early years of the ninth century, and careful examination has revealed a spectrum of visions of monastic life. The figure most noted for his opposition to this program was Adalhard, whose monastery at Corbie, a close neighbor of Saint-Riquier and a center of the *regula mixta* Adalhard so ardently defended at the Synod of 802, represented a countermovement to Benedict of Aniane. Corbie's credentials were sterling, with a royal immunity and close family ties to the king (Adalhard was the cousin of Charlemagne). Corbie's active scriptorium made it a center of study, and in the later eighth and ninth centuries a center of Classical humanism.[33] David Ganz, the most recent student of the abbey, described the cultural function of Corbie as a "medieval 'textual community'" shaped by — and critically reflecting on — imperial policy: "Corbie was concerned to expand the frontiers of the Christian world. . . . Both the needs of the mission, inspired by imperial policies, and the tradition of independent thought about all of these needs shaped the abbey's intellectual stance."[34] If the Carolingian *renovatio* centered on written culture and the dissemination of authoritative texts, then the role of Corbie was paramount in the promotion of cultural ideals, or as Ganz has described it, the transformation of written culture, by mining ancient texts to speak to new issues and by carefully copying and correcting important manuscripts. In this context, the development of the

Carolingian minuscule at Corbie reflected the scriptorium's creative re-
sponse to the intellectual problems caused by the wide variety of minuscule
scripts used in Merovingian Gaul. The development and propagation of the
distinctive Carolingian minuscule meant the critical clarification of the
transmission of ideas in the realm.[35] Most striking about the impressive
library and intellectual culture at Corbie was its critical stance and tolera-
tion—even promotion—of diversity, in tension with the official view.[36]

Yet a third example that reveals the creative cultural debate was Theo-
dulf of Orléans's small church at Germigny-des-Prés. Placed within the
larger context of the *Libri Carolini,* Theodulf's program is well known,
thanks to the insights of Ann Freeman.[37] The church at Germigny, which
seems to have been the chapel attached to Theodulf's villa, was substantially
destroyed, and the current edifice is not a faithful reconstruction of the
original.[38] Only the apsidal area and the mosaic remain from Theodulf's
original church; these can, however, reveal a great deal about Theodulf's
interests. The apse was decorated only with borders of stucco surmounted
by the famous mosaic of the Ark of the Covenant held by two angels and
two cherubim. While a number of interpretations of the subject and sources
of this mosaic have been advanced, the weight of opinion has rested on the
centrality of Carolingian theological concerns.[39]

The subject of the mosaics was unique in Western iconography, ap-
pearing directly over the altar; traditionally, the Ark would have been borne
by Levites in the normal narrative sequence at the base of the apse usually
associated with the subject.[40] This placement and iconography stressed the
dogmatic and symbolic rather than the narrative character of the subject.[41]
Furthermore, the parallels between the stuccos and mosaic on the one
hand, and the illuminations of Theodulfian Bibles on the other, stressed the
aesthetic principles that Theodulf upheld against the Nicene Council of 787
in the *Libri Carolini.* That is, they upheld what has been called an essential
iconoclasm in religious art.[42] The decorative program of Germigny was
austere, even severe. Moreover, it underscored, through the image of the
Ark of the Covenant, the centrality of Word over Image, a principal theme
in Theodulfian spirituality and discourse.[43]

There was, then, a clear and important example of the application of
the theological debate of the 790s to religious architecture, and in particular
of the expression of a key position within those debates in concrete terms.
Theodulf was a connoisseur, his excellent taste and love of good art are well
known. But the point he made at Germigny was quite specific: religious art
and the ability of material objects to portray or in any way express spiritual

realities must be understood consistently within the theological framework established by the *Libri*.

At Saint-Riquier, Angilbert took the opposite position on symbolic meaning. This is a context, however, in which the agenda of this monastery has never been placed. The greatest contemporary student of Angilbert's program, Carol Heitz, has reoriented the study of Saint-Riquier after the political historiography of the 1950s that viewed Saint-Riquier strictly as an expression of imperial power.[44] Heitz's first contribution was to insist upon the essentially religious and liturgical character of the complex at Saint-Riquier and of Carolingian church architecture in general. His second contribution was to insist on the importance of contemporary sources for understanding Carolingian religious architecture, rather than assessing it more generally as a precursor of the Romanesque style. Heitz believed that the particular architectural and liturgical elements characteristic of Carolingian churches were importations and interpretations of the stational buildings and liturgy of Jerusalem, and reflected not only a christocentric liturgy appealing to the Carolingian kings but also the growth of a piety based upon the Apocalypse. The essential impulse, then, for Saint-Riquier as for other great Carolingian churches and monasteries was foreign, and the importance of Angilbert's work there was as a representative of the first great example of these usages.

Heitz's work, following Hubert, marked a turning point both in understanding Saint-Riquier. Nevertheless, given the insights achieved on the cultural significance of other churches, much remains to be done. The sources for both Angilbert and his program are relatively rich for the period. In recent years, however, their authenticity has been challenged. There is much that can and should be said on behalf of the Carolingian documentation for Saint-Riquier. Let us turn to the sources and their critics.

The Sources

Four types of sources provide evidence for the appearance and the liturgy of Angilbert's Saint-Riquier. The earliest and most important are the *Libellus,* a document traditionally attributed to Angilbert himself, which described the various elements of the buildings and their treasures and which we may also refer to as *De perfectione Centulensis ecclesiae,* and the monastic liturgy, also called the *Institutio.* The *Libellus* is extant in only one manuscript,

Vatican Codex Reginensis 235, a mutilated text dating from the twelfth century. A second source, Hariulf's *Chronicon Centulense,* which dates from the late eleventh century and included Angilbert's texts, was lost in a fire at the library of Saint-Riquier in 1719. Lot and Bishop believed that both the Vatican Codex and Hariulf's version were taken from a common manuscript from Gorze, now lost, which Hariulf believed was Angilbert's original text. The special value of Hariulf's manuscript was that it contained a drawing of the monastery, probably in Hariulf's own hand, which he made because the old Carolingian buildings, now unsound, were being razed in his own day.[45] Two seventeenth-century reproductions of this drawing exist. One, copied from the original, was made by Paul Petau in 1611. The other, by Mabillon, was taken from a printed tertiary source.[46] (See Figure 1.)

The third source of information on Saint-Riquier is provided by modern art historians who have suggested various reconstructions of the buildings. They have traditionally based their work upon the copies of Hariulf's drawing and to some extent upon Angilbert's text. In addition, they have added the perspective of formalistic comparison with other contemporary and subsequent buildings. Four studies have been most important. Durand's *Saint-Riquier,* the first such study, suggested floorplans of the main basilica and its interior organization. Effmann's *Centula-Saint-Riquier* was the most daring and the most influential on subsequent thinking, attempting not only a floorplan of the basilica and the disposition of its altars and sculptures, but also various sectional views and an important projected reconstruction of the west facade of the basilica. Kenneth Conant, discussing Saint-Riquier as "the most characteristically northern and most energetic of the church designs" in *Carolingian and Romanesque Architecture,* provided a reconstructed view as seen from the northeast.[47] Edgar Lehmann suggested a reconstruction of the interior arrangement of the church to correct the suggestions of Durand and Effmann.[48]

Finally, the fourth and most recent source of information is the evidence unearthed from archeological excavations undertaken by Honoré Bernard, a Belgian archeologist, between 1959 and 1989. Bernard's work gives a much fuller and clearer idea of Angilbert's program because it corrects misunderstandings generated by Hariulf and perpetuated in modern reconstructions. It is worth noting at this point that the differences between Hariulf and the physical evidence of the excavations corroborate Angilbert's trinitarian theme.[49]

The most substantial critique of the documentary evidence for Saint-

Riquier has been undertaken by David Parsons, who in an article published in 1977 claimed that there was little that could be said about the monastery's Carolingian phase.[50] Citing the fact that the only surviving manuscript of what scholars have always interpreted as Angilbert's program dates from the twelfth century (Vatican Reginensis 235) and differs in some elements from Hariulf, Parsons made three broad conclusions: first, that the manuscript evidence was problematic and subject to considerable contamination; second, that the available material for Saint-Riquier was consequently evidence only of its appearance and liturgy in the eleventh century; and third, that recent archeological excavations did not support the textual claims. As a consequence, Parsons viewed most traditional analyses of Saint-Riquier as making claims for the monastery which could not be substantiated. The matter, however, is not quite so simple. Let us examine Parsons's critique and the extant sources for Saint-Riquier in greater detail.

A point of style and substance must first be noted. Parsons often presented his argument in absolute dichotomies that were tendentious. Two examples will illustrate the point. First, in the introduction to his article Parsons took issue with a statement found in the liturgical prescriptions for Rogations processions. The text says that the monks and lay participants from the seven neighboring villages marched seven by seven, and that if they were arranged by twos or threes the procession would stretch almost for a mile: *si bini vel terni incederent, unum vix miliarium caperet.*[51] Parsons asserted that this claim must be taken either as literal truth, which could not possibly have been the case, or as deliberate gross exaggeration that "brings the text as it stands into disrepute." But as read in the context of the passage, the statement expresses wonder. It may well be an exaggeration expressing admiration for the majesty and importance of the monastery. It is certainly not one that implies more, or which must be taken so forcibly as to debunk the validity of the text.

In a second example, Parsons discussed the relics contained in the altars of the Mary Church, describing them as reading "like the names of virgins from a standard list." Again, his conclusion presented the logical extremes: "since such a collection of relics is unlikely to have come together in a random manner, one has to believe either that someone went around systematically collecting them, list in hand and ticking them off as he went; or that the relics did not exist in the altars as claimed and that the list which appears in Chapter 4 is a fictitious one based on such a standard list." Parsons speculated that this list was in fact based on a litany.[52] It is true that the relic list contains natural pairings of Roman saints, such as Gervasius

and Protasius or Linus and Cletus, and it was precisely this that troubled Parsons. However, Angilbert was a well-known relic collector, as we know from Alcuin's request that he bring back some Roman relics for him from one of Angilbert's trips to Italy.[53] Furthermore, Patrick Geary and Leo Mikoletsky have both shown the strong interest of the Carolingian kings in disseminating specifically Roman relics as a means of centralizing royal power.[54] This point will be discussed in greater detail below; here let it suffice to show that there are other explanations for Angilbert's relic list than the logical extremes of Parsons's analysis.

This taken into account, what can be said about the Carolingian evidence for Saint-Riquier? Parsons's analysis proceeded from three broad points. First, he noted the seeming difference in the character and origin of the two main texts traditionally associated with Angilbert: the *Institutio* and the *De perfectione*. Traditionally, scholars have assumed that the two texts were a single work from the beginning. Parsons took issue with this on two counts. He noted that the extant text of the *Institutio* is very fragmentary, whereas the text of the *De perfectione* is relatively complete and seems to come from a clean model. Bishop and Lot believed that there was a single source manuscript that deteriorated, leaving the first portion, the *Institutio* in fragments and the *De perfectione* relatively untouched.[55] However, the difference in the quality of the texts led Parsons to believe that the *Institutio* and the *De perfectione* came from separate sources that were brought together only by the scribe of Vatican Reginensis 235, where they first appeared in association. To support this, he cited the fact that Hariulf did not incorporate the *Institutio* as defined by the rubrics of the Vatican manuscript and stated that he would omit most of the liturgical material since it was no longer used. This implies, however, that what Hariulf did include — the daily rather than the festival liturgy — was still consistently in practice at the monastery and therefore valid evidence.

Parsons's second objection to these documents was the fact that, according to Mabillon, almost the whole of Chapter 7, containing the liturgical text, was in a different hand than the rest and also reproduced a miscellany of material seemingly unrelated to Angilbert. From this, Parsons concluded that the whole of this liturgical section — and consequently, the whole of Hariulf's version of the *Institutio* — is completely untrustworthy and must have come from a source entirely independent from the *De perfectione*. Ironically, however, it is this interpolation that argues for the Carolingian authenticity of the liturgical text that Hariulf reproduced and supports the view that the *Institutio* and the *De perfectione* were associated

from the beginning. Parsons himself noted that the style and content of Hariulf's liturgical passage is consistent with the *Institutio* as reproduced in Vatican Reginensis 235. Moreover, the miscellaneous material that concludes the interpolation was not random. It consisted of several sections. The first was the liturgical passage, which included several prayers for "my august lord Charles and the stability of his realm" as well as for the royal family and for Pope Hadrian, providing internal support for Angilbert's authorship. This was followed by Charlemagne's letter to Alcuin, some epitaphs, a note of the obituary of Alcuin, and information about Adelhard of Corbie. These references are chronologically confined and refer consistently to high members of Charlemagne's entourage who were also close friends of Angilbert. They infer that the source from which the interpolator drew his information—even if a "mixed bag"—was a Carolingian source related to Angilbert of Saint-Riquier. They argue in fact for the Carolingian authenticity of Hariulf's liturgical text.[56]

Parsons's second broad objection to the written documentation was lack of direct proof that Angilbert was the author. Here he cited the difference in style between the *Institutio* and the *De perfectione* and a lack of homogeneity in the text of the *De perfectione* itself as evidenced by the problem of the relic list mentioned above.[57] Both texts were written as first person narratives, which Parsons cited as indirect evidence for Angilbert's authorship. The *Institutio* was written in spare prose, with directions for the liturgy given in the third person subjunctive. The *De perfectione* was written consistently in the first person and with the use of compound verbs such as *reaedificare studuimus*. Parsons accepted the authenticity of the *De perfectione* on Hariulf's conviction that Angilbert wrote it, corroborated by explicit references to Charlemagne within the text. Interestingly, Parsons ignored the same references to Charlemagne and to Pope Hadrian in Hariulf's text of the *Institutio,* even while using those in the *De perfectione* to fix the date of the text between 801 and 814. There is also a compound verb in the *Institutio, statuere curavimus,* consistent with those in the *De perfectione.* Moreover, the difference in style between the two texts stems from their differing purposes. The *De perfectione* was Angilbert's narrative account of his personal rebuilding of the abbey, naturally using more developed prose and first person verbs. The *Institutio,* on the other hand, was a series of liturgical directions prescribing what the monks were to do. Its style would naturally be more spare, and its verbs—describing the actions of the monastic community—would logically be in the third person subjunctive, "let them. . . ." Such differences in style, then, are organically related to the function of the

text, and the internal references to Charlemagne and Hadrian underscore the organic relationship of the *Institutio* and the *De perfectione.*

Parsons also discussed the fact that the inventory of the library produced in 831 for Louis the Pious did not list any writings by Angilbert. It is worth noting in this regard that the library of Corbie, an even greater library than that of Saint-Riquier, contained no writings of its own prolific abbot, Hrabanus Maurus, neither his commentaries, his *De universo,* nor his *De institutione clericorum.*[58]

Let us return to the question of the relic list. Parsons was troubled by two elements that in his view indicated textual inconsistency. First, both Chapter 8 and Chapter 9 of Book 2 contain lists of the relics at Saint-Riquier, but the list of relics in the Mary Church in Chapter 8 includes twelve names more than that in Chapter 9. Second, in Parsons's view the list of saints in Chapter 8 has an artificial character that suggests it was actually a reworked litany.[59] A careful comparison of the two lists, however, reveals that the vast majority of saints are included in both lists, and that characteristic turns of phrase describing some of them appear in both lists, providing internal consistency. Moreover, two of the names Parsons did not find in Chapter 9, Linus and Cletus, actually are there.

Ten names are unaccounted for. Again, however, the lists must be put in context. The first, in Chapter 8, describes the relics that were contained in each altar. The second, in Chapter 9, is organized in a sacred hierarchy by the type of saint: relics of Christ, Mary, apostles and evangelists, martyrs, confessors, and virgins. The descriptive passage in Chapter 9 is ambiguous. It makes collective references, for example, to *sanguine aliorum multorum* and includes a passage stating that relics certainly identified were included among the martyrs and confessors, but that there were other names among both groups whose relics had not certainly been identified, of which little would be written.[60] Lot noted that in Mabillon's edition this passage was found after the list of relics of the virgins, where the divergence with the list in Chapter 8 occurs. This may suggest that the list was updated and scaled down; it does not *per force* invalidate either list, particularly given the overwhelming similarity between them. It should also be noted in this context that there are internal references in both Chapter 8 and Chapter 9 to Charlemagne and Pope Hadrian — evidence that Parsons accepts elsewhere for authenticating and dating the *De perfectione,* and that again illustrates internal consistency between the texts.

As for Parsons's litany, there is no need to posit such a source for the relic lists, although, as Jean-Loup Lemaitre has pointed out, the monks of

this period were so steeped in the litany that such an arrangement would not have been at all unusual.[61] Parsons questioned the fact that so many of the saints were Roman and arranged strictly in twos along with the relics of the saint to whom each altar was dedicated. However, we need only look at other ninth-century sources on relics to see the broader similarity with what was going on at Saint-Riquier. Einhard recorded the translation of Saints Marcellinus and Peter and of Saint Tiburtius to Saint Medard under Abbot Hilduin. Saints Januarius and his companions and Fortunata and hers were translated to Reichenau. Saints Chrysanthus and Daria were brought to the north by the Abbot Macuardus of Prüm; the relics of Pope Saint Alexander and the priest Justin arrived in 834. The most eloquent source, however, was the monk Rudolf, writing about the miracles of the saints at Fulda in the 830s, who listed the following saints in Francia: Sebastian at Saint Medard in Soissons; Einhard's Marcellinus and Peter, Protus and Hyacinth, and Hermes at Seligenstadt; Alexander, Fabian, and other saints in a variety of locations and at Fulda the following: Pope Alexander and the deacon Felicissimus; Concordia, Fabian, and Urban; Castulus and Sebastian, Pamphilus, Papias, Maurus and Victor, Felicity, Emmerentiana and Basilla. Rudolf went on to describe the arrival in Francia of a Roman layman named Sabbatinus bearing numerous relics of the following saints: Quirinus, Romanus, Cornelius and Calixtus, Nereus and Achilleus, Turturinus, and Stracteus; and the Italian journey of Abbot Addo, who brought back the body of Venantius. These were listed, when applicable, in their natural pairings, which should not seem odd. They were, after all, memorialized in this way in Rome itself, and their relics were and are still commemorated together.[62]

Parsons's third broad objection regarded the archeological information provided in the texts. He focused on the size and character of the Mary Church. In his view, the archeological remains unearthed by Honoré Bernard called into question two elements of the evidence: the claim that the Mary Church housed thirteen altars which themselves housed the relics cited in the problematic list, and the claim that the church was the site of liturgical celebrations on Christmas and Easter. Specifically, Parsons questioned whether the chapel dedicated to the Virgin was large enough to house so many altars and such a liturgy for three hundred monks. Bernard's excavations have corroborated the information given in Hariulf's engraving: a hexagonal structure surrounded by a dodecagonal ambulatory and an annex to the west. As we shall see, such polygonal or circular churches were associated with the Virgin in this period and the structure at Saint-Riquier

seems to be very similar to the Church of Saint Michael at Fulda, both in form and dimensions (about twenty meters in diameter). Although Bernard was unable to determine the length of the western annex, the width was about nine meters. This implies a substantial structure, and since Hariulf's picture indicates that the annex was nave-like, the structure itself was very likely sizeable, as Parsons himself admitted. Since the excavations corroborate Hariulf's rendering in other ways, it is reasonable that in this detail the eleventh-century picture was accurate as well, given the physical evidence. As we have seen, the relic lists of the altars in this church make sense within a ninth-century context and lend weight as well to the architectural information provided in the texts.

Finally, we must consider a point of interpretation on which Parsons has criticized Carol Heitz, the foremost contemporary student of Saint-Riquier. At issue is a passage from the *Institutio* on the liturgy for Easter, which I shall quote here in its original Latin:

> In die autem sanctissimo Paschae tam de processione et reliquo officio quam et de missa, ita ut in Nativitate Domini omnia peragantur. Ordinavi enim ut in die sanctissimo Paschae et in Nativitate Domini, fratres et ceteri omnes qui in aecclesia Sancti Salvatoris ad missam audiendam steterint in eadem aecclesia communionem percipiant.[63]

The instructions go on to say that the celebrant should communicate the "other clergy" while two further priests simultaneously administered the sacrament to men and women in the Holy Savior:

> Dum vero fratres vel reliqui clerici ab illo sacerdote, qui ipsa in die missam cantaverit, communicantur, sint duo sacerdotes alii cum duobus diaconibus atque subdiaconibus, quorum unus viros, alter in eadem aecclesia communicet mulieres, ut clerus et populus simul communicati benedictionem sive completionem missae pariter possint audire. Qua finita laudantes deum et benedicentes dominum simul egrediantur.

Heitz interpreted this text to mean that on Easter, as on Christmas day, the Mass was celebrated in the westwork church of the Holy Savior in the presence of monks and laity. According to Parsons, however, this was a misreading of the evidence, which in his view stated that the monks were at the altar of Saint Richarius and only the laity were hearing Mass in the Church of the Holy Savior. Parsons underscored his point by saying that the meaning would be clear if the words *fratres vel reliqui clerici* were transposed to read *fratres reliqui vel clerici*. This is not, however, what the

text says. It states that the brothers and all others who are in the church of the Holy Savior to hear the Mass shall receive communion in that same church—*eadem aecclesia*. The distinction in the order of communion is clearly between the clergy on the one hand—*fratres vel reliqui clerici,* who are to receive communion from the celebrant himself—and the laity, who are to receive communion from two other priests with deacons and subdeacons, one group to communicate men and the other women. The purpose of this arrangement is that all may hear the end of Mass and exit together according to the prescriptions of the *Admonitio generalis,* Chapters 6 and 71. Parsons claims that the phrase *ad missam audiendam* would not apply to the brothers, but in fact the brothers would *not* be celebrating Mass. This is particularly clear given the distinction in the text between *fratres* and *reliqui clerici*. In this instance, then, Parsons's suggested change in the text is not warranted, and Heitz's reading is correct.

In summary, then, with regard both to historiographical issues and to the sources, the key to assessing Saint-Riquier is sensitivity to the nuances of context. This means that Angilbert's work at Saint-Riquier must be compared with his other activities at court, and especially to his work in the years in which he was rebuilding Saint-Riquier: his involvement in the theological issues of the 790s. With this perspective on Saint-Riquier and its sources in place, let us turn to what the Carolingians knew about the Trinity

2. *Cultores Fidei*: The Theological Issues of the 790s

During the years in which Angilbert was rebuilding Saint-Riquier, the Carolingian court was embroiled continuously in theological controversy. The issues were three: Adoptionism, the procession of the Holy Spirit, and the veneration of images. The first, an internal problem within the Frankish realm, was christological. The second and third, challenges raised by the Byzantine Council of 787 at Nicaea, were trinitarian issues. Ultimately, however, Carolingian theologians came to see them as integrally related — indeed, inseparable — and defined them as a threat to the integrity of the whole tradition of belief. Each issue had crucial implications for the others.

Moreover, this challenge to belief was also a challenge to the cultural identity of the Franks and especially to the identity of Carolingian kingship. The Carolingians saw themselves as tribal defenders of the faith virtually by divine appointment. They were *cultores fidei*, the successors of the Fathers at Nicaea.[1] Right faith, whatever that meant, was not only theological and devotional; it was a political and cultural program. As these issues were the framework for Angilbert's work at Saint-Riquier, any consideration of his program must begin here. This chapter will examine the theological controversies in which Angilbert was involved.

To aid him in his teaching capacity Charlemagne began in the 780s to gather around himself a group of scholars and theological *doctores*.[2] Most noted among the company was the great Anglo-Saxon *magister* Alcuin, who came from York to the itinerant Frankish court at the king's invitation in 782. Alcuin brought with him considerable erudition and a strong background in Scripture and patristic tradition, resources which would serve both him and Charlemagne well. His work until 790, when he returned to England for a three-year visit, was teaching, and there is little information on him before the late 780s. It was only after his return to Francia at the king's request in 793 that he seems to have become involved in theological issues.

A number of prominent intellectuals were already at court upon his arrival. Arn, a native Bavarian and a deacon at Freising, had come to Charlemagne before 780, and by 782 had been appointed as abbot of Saint Amand. In 784 he went to Salzburg as Archbishop to replace Vergil, the Irish scholar who had been an advisor and teacher to King Pepin. As Archbishop Arn was responsible for the Church in the Eastern March and led the effort to evangelize the pagan Avars as part of Charlemagne's policy of eastern conquest. By 790 he was joined in this effort by the cleric Leidrad. Both Arn and Leidrad were by that time close friends of Alcuin as the Anglo-Saxon's letters imply.

Paulinus, a Lombard of great intellectual sophistication and the most prolific of Charlemagne's theologians, joined the court sometime after 776 as a teacher of grammar. His reputation as a teacher must already have been great, as the king in the same year had given him property confiscated in a revolt of Lombard magnates. He was appointed as Patriarch (Bishop) of Aquileia either in 781 or 787, but his prominent participation in the theological controversies of the 790s brought him often to court.

By the end of the 780s two other influential scholars were at court as well. The first was Angilbert, one of Charlemagne's most prominent courtiers and a member of the Palatine chapel.[3] Probably the scion of a great Frankish family, Angilbert had been raised at the court of Pepin and Charlemagne. During the 780s he had served as advisor to King Pepin of Italy, whence he seems to have returned probably by 787 or 788. He quickly became Alcuin's most intimate friend at court; he worked with Theodulf and Paulinus, and he corresponded with Arn.[4]

Probably the last of the scholars to come to Charlemagne's court was Theodulf, a Visigoth from northern Spain or Septimania, who arrived sometime before 789. We know little of his early life and nothing of his reasons for coming to Francia, though it is possible that he left Spain in the wake of Charlemagne's disastrous military expedition of 778. A poem of his describes his arrival after *immensis casibus,* "terrible disasters," seemingly a reference to the attempts of the Arab ruler, Abd-al-Rahman I, to destroy Carolingian sympathizers in his territory.[5] He lived continuously with the court after that time, and his prolific poetry offers us many glimpses into royal life. A gifted theologian of considerable erudition, he too contributed substantially to the doctrinal debates of the 790s. Charlemagne appointed him as bishop of the ancient and important see of Orléans, possibly around 797 or 798.

These were Charlemagne's companions along the *via regia,* and they helped to define and implement his cultural program. That program was epitomized in the governmental charge set out in 789 in the greatest of the Carolingian capitularies, the *Admonitio generalis.* The capitulary described an ecclesiological society in which the expressed intent of human institutions was the salvation of God's — and Charlemagne's — holy people.[6] In it, Charlemagne was presented as the "new Josiah" who was eager "to call back to the worship of the true God the kingdom given to him by God, by going around, by correcting, and by admonishing."[7] Like his biblical forebear, Charlemagne was to reestablish the good law found in the Temple, and to that end he mandated the reform of both the institution and the belief of the Church, the latter for the good understanding of the laity as well as of the clergy. The capitulary envisioned a holy people called to understand and witness to the faith, and regularized the status and duties of the clergy as administrators of the cult.

Corrupted institutions were not the only concern to which Charlemagne was responding. Chapter 82 of the capitulary protested "*pseudodoctores* coming in the most recent times," and the opening paragraphs forbade *nova,* new teachings and practices that perverted the faith. So that the Christian truth might triumph Charlemagne prescribed that all Christians preach "first of all things the faith of the holy Trinity and the Incarnation of Christ, his Passion, Resurrection, and Ascension."[8] Purity of belief informed the prescribed rules of ritual and canonical behavior; belief and action must conform perfectly to bring about salvation.

These warnings against the innovations of false teachers reflected serious royal concern over the recent penetration of heresy into the Frankish realm. The threat was not idle; *nova fidei pseudodoctorum* were to challenge the Carolingian understanding of the tradition of belief and to force Carolingian intellectuals to reassess and reassert that tradition throughout the following decade. It was against these specific issues that Angilbert would build Saint-Riquier. These theological problems have never been viewed together as they arose for the Carolingians and as their claims impinged upon each other.[9] Yet it was precisely because they did impinge and did come to be related quite directly in the Carolingian mind that they became such an obsession at court. The symbolism at Saint-Riquier addressed each of these issues directly, and related them closely in the interpenetration of sacred space and gesture. They need to be examined in this light.

Galatae Forte Rebelles: The Theological Issues

The theological concerns to which Angilbert addressed himself were two clusters of issues which arose almost simultaneously in the late 780s: Spanish Adoptionism and the Image Controversy and attendant problems in Byzantium. Although it now seems clear that both controversies occurred because of Carolingian misunderstandings of what their perceived opponents were saying, taken together they seemed to challenge the most fundamental beliefs of the faith.[10] Carolingian texts described Adoptionism as a christological problem that claimed that Jesus was the true Son of God in his divine nature only and adopted as Son of God in his humanity. Within the tradition of the faith, this seemed to divide the person of Christ into two. The conflict with Byzantium, which arose in the wake of the Second Council of Nicaea in 787, is murky at best, but seems to have issued from a Carolingian misunderstanding of the Greek position on the veneration of images. Receiving a mistranslated document from the Roman Curia which they took to have arrived directly from Constantinople, Charlemagne and his theologians understood the Greek position to support the worship of icons. Coupled with suspicion over a statement of faith promulgated by the Council, the Carolingian court circle saw the entire problem as a deep error in trinitarian belief. Thus from 789 onward the traditional faith seemed everywhere denied: the christological tradition by the Adoptionists and the broader trinitarian faith by the Greeks. There was a sense of urgency in the Carolingian response, culminating but not ending with the Frankfurt Council of 794. Let us establish a working chronology of events to see the interpenetration of events. We will then be in a position to analyze the specific theological issues involved.[11]

789/790 Adoptionism penetrates from Spain into Septimania where the noted theologian Felix of Urgel becomes its champion.
Charlemagne receives the decrees of II Nicaea. In formal consultation with his theologians errors are identified and an official refutation, the *Libri Carolini,* begun.[12]

791 Felix of Urgel appeals to Charlemagne, sending an Adoptionist tract to court. He is summoned to an official investigation of his theology.

792 Felix is examined at Regensburg by Paulinus of Aquileia, and his Adoptionism condemned. He is taken to Rome for formal recantation before the Pope by Angilbert of Saint-Riquier. Angilbert also delivers

the outline of the *Libri Carolini* to the Pope, and a copy of the acts of II Nicaea is sent to Britain.

793 After his release, Felix flees to Spain where, under the protection of Archbishop Elipandus of Toledo, he again takes up Adoptionism. The bishops of Spain write letters to Charlemagne and to the bishops of Aquitaine, Gaul, and Austrasia defending Adoptionism. Charlemagne calls Alcuin back to Francia from England to help the anti-Adoptionist cause.

Pope Hadrian's response to the arguments of the *Libri Carolini* arrive from Rome. In the wake of the papal rejection of those arguments formal work on the *Libri* is brought to an end. Charlemagne convokes an ecumenical council to meet at Frankfurt in 794 to settle both of these theological crises.

794 The Council of Frankfurt condemns Adoptionism. Two synodal letters, the *Libellus sacrosyllabus* of the Italian bishops and the *Epistola synodica* of the bishops of Gaul, Aquitaine, and Germany present the scriptural and patristic refutations, and an anti-Adoptionist letter from Pope Hadrian is included.

The Council then takes up the question of image worship. The apparent claim that images should be worshipped just as the Trinity is anathematized. The *Libri Carolini* are not officially promulgated due to the papal reservations, but are deposited in the royal archives for future reference.

796 / 797 In spite of Carolingian attempts at reconciliation, Felix of Urgel and Spanish clerics continue to propagate Adoptionist teachings. Paulinus of Aquileia convokes a synod of clergy under his jurisdiction at Friuli to clarify trinitarian dogma. With Alcuin, he promotes the Creed as the most effective tool for teaching the faith, which becomes a permanent fixture in the Mass by 798. Alcuin begins a florilegium of anti-Adoptionist patristic texts; he also writes conciliatory letters to Felix and Elipandus.

798 In reply to Alcuin's letter, Felix sends a new tract to Charlemagne attacking the Anglo-Saxon and pushing the Adoptionist argument to its furthest development. Pope Leo III, Alcuin, Paulinus, Theodulf, and Richbod of Trier are asked to respond; Alcuin writes the *Adversus Felicem libri VII* in preparation for a debate with Felix at Aachen in 799, and Paulinus writes the *Contra Felicem libri III,* the most fully developed anti-Adoptionist argument.

799 Alcuin and Felix debate Adoptionism before Charlemagne and his full court, and Felix is condemned. He is held in house arrest at Lyons until his death; after the death of Elipandus, Adoptionism declines in Spain.

Adoptionism seems to have arisen in Spain sometime around 782 under Elipandus, Archbishop of Toledo, and to have come to Charlemagne's attention in the late 780s when Felix, Bishop of Urgel in the Spanish March, territory under Frankish jurisdiction, began to propagate the teaching.[13] As John Cavadini has convincingly argued, Adoptionism was not a heretical novelty, as portrayed by Alcuin and Paulinus of Aquileia, but an ancient and native Western christology unrelated to the Chalcedonian tradition championed by the Carolingians. This meant that the anti-Adoptionists argued from within the christological perspective governed by the debates of the fifth-century East, delimited by Nestorianism on the one hand and Monophysitism on the other. Because the works of Felix of Urgel survive only in the refutations of Alcuin and Paulinus, and the writings of Elipandus are viewed through their lenses, Adoptionism has been understood as a "new Nestorianism," a heresy that divided the person of Christ into the human and the divine. In reality, it was a perfectly legitimate and organic Western theological formulation, with roots in the christological reflections of Augustine, Leo the Great, and Hilary. It was as a result of the controversy with the Carolingians, then, that the last of the indigenous Western christologies was eliminated, and the range of christological debate narrowed to the possibilities of the Chalcedonian formulation.

Adoptionism as first elaborated by Elipandus was essentially a theological reflection upon the meaning of the self-emptying of Christ described in Philippians 2: 7, where Christ, though the same as God, "emptied himself and took the form of a slave."[14] Adoption of sonship from the womb of the Virgin was integral to this full self-emptying and the salvation which it accomplished; without it, the self-emptying that achieved salvation could not be complete. That the adoptive subject — the human Jesus — was fully continuous with the pre-adoptive subject in the form of God is evident from Elipandus's explanatory letter to the bishops of Francia: "Why is there any hesitation to say that the Son of God, according to the form of a slave, emptied of his Godhead, corporeal and visible and palpable, is adoptive?"[15] It was the paradoxical character of this divinity and slavery that was important to Elipandus, since the Son of God became human so that he could become a son not only by nature but also by grace, as was the human

condition. As John Cavadini has put it, "the self-emptying of the Word has permitted this unique relation to be exhibited in the terms which respect the limitations of another nature. That is why this self-emptying is salvific."[16] This established a familial relationship, in that Christ in his adopted humanity became the first-born whose brothers and sisters in grace would also become children of God. Adoptionism stressed this relational role of Christ as elder brother in contradistinction to the unique and mediatorial role emphasized in the Chalcedonian (and Carolingian) formulation.

The first association of this teaching with Nestorianism was made by Pope Hadrian in a letter to the bishops of Spain in 785, and developed in a second such letter probably dated about 793.[17] In Hadrian's perception, Elipandus's terminology of adoption meant that Jesus was merely a human being, alienated from the Father and separate from the eternal Son. He was deeply opposed to the image of slavery, even given its biblical origin, because he felt it to imply such degradation of the Son that his role as liberator of humanity from sin would in actuality mean nothing. Hadrian would admit only a mystical use of the word slave, as in the prophets.[18] Thus the Pope evidenced no awareness of the exegetical tradition of self-emptying from Philippians 2: 7 which stemmed from Leo and Augustine, or of its meaning as a starting point for christological reflection.

At about the same time that Adoptionism came to the attention of Charlemagne, a different challenge arose from another quarter. It was probably in 789 that the report of an ecumenical council held in Byzantium on the issue of Iconoclasm reached the Frankish court from Rome. Iconoclasm was a policy established in the early eighth century which rejected the veneration of icons or images. The policy claimed that an icon, a material image, could in no way resemble its prototype which was a spiritual reality. Icons were destroyed, and *proskynesis,* or venerating and performing acts of devotion toward icons, was forbidden. The policy spawned tremendous conflict and controversy in Byzantium, and shortly after the Empress Irene came to power, she called an ecumenical council at Nicaea in 787 to reestablish icon veneration.

The decrees of the council, including a statement of faith, were sent to Rome, where they were translated and disseminated to the North. According to the later testimony of Anastasius Bibliothecarius, the Latin translation was so poor that it grossly misrepresented the Greek position. The greatest casualty was the translation of the Greek *proskynesis,* "bending the knee" or veneration, as *adoratio,* "adoration" or "worship."[19] Charlemagne seems to have believed that the conciliar decrees came to him directly from

Constantinople, not from Rome. When the decrees were read at court, he was outraged. In formal consultation with his theologians, significant errors were identified throughout the text, and the king commissioned a strong defense of the faith, the famous *Libri Carolini*. The objections were recorded in a series of *reprehensia* or official objections, which were the outline or chapter headings of the treatise. Let us consider the arguments in some detail.

The basic argument of the *Libri* was drawn from a discussion of "image," "likeness," and "equality" in the *De diversis quaestionibus* of Augustine.[20] There was, according to these texts, an essential difference between an image and the prototype to which it referred. The image was a *similitudo* or likeness of the transcendant spiritual reality, but was not in itself and could never be that reality. Just as the soul was different from the body, so was the material image unlike its spiritual prototype. The unconsecrated art, made of material substances and qualitatively different from the persons or events portrayed, could have likeness only to other material substances. In the strict definition of the *Libri,* a true image had to issue from its prototype or have contact with it in some specific sense.

Furthermore, the *Libri* distinguished between the types of perception with which the viewer/believer comprehended reality. Bodily sight enabled the viewer to create a spiritual vision, an imaginative memory or mental copy of the material image. These images were memories of corporeal objects. Bodily and spiritual sight existed together and inseparably as the way of perceiving the material world. Spiritual realities, however, which were abstractions such as God, love, and justice, could be perceived and comprehended only with a different type of sight, which was intellectual sight. This intellectual truth was entirely separate from bodily and spiritual vision, and could in no way be stimulated by them. In other words, the mind could not move from the physical to the abstract world through material representations.[21]

The *Libri* did, however, distinguish certain types of sacred art that, because consecrated, were of a different character and effect. These were *res sacratae*: the Eucharist, liturgical vessels, the Cross, Scripture, and the Ark of the Covenant. Because these objects were blessed by God they had direct contact with the holy. They received the operation of divine grace and either mediated that grace to humans, as in the Eucharist and the liturgy, or reminded believers of spiritual mysteries and truths, as in the Cross, Scripture, and the relics of the saints. These, then, were extraordinary not

because of their material character but because of their graciousness. As we shall see, this doctrine of *res sacratae* would become important to Angilbert in his liturgical program at Saint-Riquier.[22]

These aesthetic arguments stemmed from a central theological tenet. The *Libri Carolini* rooted aesthetic theory and political legitimacy in correct belief in the Trinity. The Byzantines had never spoken of Iconoclasm as a trinitarian issue. This was a connection made by the *Libri*. Here we enter the heart of Carolingian conviction, because here we can discern the clear linkage of theology, art, and political life. The *Libri* argued that the Byzantines did not believe rightly on art and did not exercise authoritative political power to make these conciliar pronouncements because they were fundamentally in error. The objections were three. First, the Byzantines misunderstood both the Son and the Holy Spirit in the Trinity because they denied a doctrine traditional in Western trinitarian thought and credal formulation: the simultaneous procession of the Holy Spirit from the Father and the Son.[23] This was expressed in the version of the Creed used by the Franks in the famous *filioque* interpolation, and the absence of this usage in the Byzantine credal statement accompanying the conciliar decrees thus became a fundamental issue.[24] Second, the Byzantines worshiped art because they already misunderstood what God was. Since in Latin theological eyes the denial of the procession of the Holy Spirit from the Son was a confusion over the nature of the divine, it was only natural that this confusion lead ultimately to idolatry, worship of things that were not divine. Third, the Byzantine emperor did not retain legitimate authority as ruler. In the decrees, Irene and Constantine had described themselves as God's co-rulers on earth, a claim to divinity as Charlemagne saw it. They could perpetrate this sacrilege, again, because they were already sacrilegious in their misunderstanding of the Trinity.[25]

Thus every question of legitimacy was rooted in the soil of impeccable belief. Indeed, the importance of this trinitarian grounding was evident even in the structure of the *Libri*. In the initial *reprehensia* sent to the Pope, these doctrinal issues were raised first, as the context in which the rest would be argued. In the final version of the *Libri*, however, they appeared as the third book. Theodulf made it clear that this was not a demotion but a promotion in status and a matter of strategy. Having already debunked the Byzantine arguments of the first two books, the treatise could now get to the true matter, the trinitarian faith. The arrangement was itself a symbol, since three signified the Trinity:

> In these two books, resisting (the heretics') most foolish carpings, through the salutary arms of the two Testaments, let us approach the third book, in the beginning of which will be the foundation of our faith, so that just as the confession of the one and only Trinity will be contained in it, so too the number of the third book be kept and adorned with the most sacred number, which is to be adorned with the mystery of the holy faith, establishing all hope of our disputation and of our other actions not in the argumentative allegations of worldly arts, but in him who said through the bodily presence: "It is not you who speak, but the Spirit of your Father who speaks in you."[26]

The *filioque* clause thus became the touchstone by which the right faith of the Byzantines was judged. Although Paulinus of Aquileia later would point out at the Synod of Friuli in 796 that the clause was not part of the original Nicene Creed (as many seem to have believed), nonetheless the usage was understood to be essential to the right expression of the faith.[27] It appeared this early as a critical component of the Carolingian argument in the *Libri*.

In the midst of the work on the *Libri,* an Adoptionist tract arrived at court from Felix, Bishop of Urgel. We have no independent witness of Felix's teaching. Alcuin and Paulinus presented his later teachings as a claim that the person of Christ was divided into two distinct and separable parts: the divine Word and the human Jesus. The man Jesus was in no way, except by the honor of adoption, to be considered the Son of God; he was merely called "God" as an honorific title. In other words, Sonship was in no way integral to his person, but implied a verbal exchange of titles only.[28] As Carolingian treatises presented it, this also affected the theological understanding of Mary. Theological tradition called Mary "Mother of God," a title attributed to her at the Council of Ephesus in 431 to refute the Nestorian separation of Jesus into two persons, the God and the Man. In the anti-Nestorian paradigm, if Mary was nothing more than the mother of the man Jesus then Christ the Word did not assume the flesh in an active and fully integrated sense, but the flesh was adopted passively. Thus Jesus suffered in the flesh by necessity, not by voluntary choice; suffering was the demand of his human nature. This seemed to make the Son inferior to the Father by dividing the Son into two separate natures, not necessarily related to each other except by the Father's gracious grant.[29]

Charlemagne sent the tract of Felix to Pope Hadrian for his examination. The king then summoned Felix to explain his views to the synod of bishops to be held at Regensburg in August, 792. Little record of the synod remains, but Paulinus of Aquileia argued against Felix's case.[30] His Adop-

tionism was condemned, and abbot Angilbert of Saint-Riquier was commissioned to take him to Rome for a formal recantation of his theology before Pope Hadrian. As he would present the Carolingian case, it is probable that Angilbert was present at the synod himself. Angilbert also carried with him the *reprehensia* to plead the case of the *Libri Carolini* to the Pope. Additionally, a copy of the acts of the Byzantine council were sent to Britain to garner support for the Carolingian cause.[31]

Felix recanted his Adoptionism, but after his release the prelate fled to Spain where he put himself under the protection of Elipandus, Archbishop of Toledo. He renewed his Adoptionism which now gained the wide support of the Spanish bishops. Numerous references in the Carolingian sources testify to the impressive, erudite, and charismatic character of Felix as a partial explanation of Adoptionism's success. But the appeal in Spain of such a native theology undoubtedly also was a central factor. The bishops wrote to Charlemagne, and secondly to the Bishops of Gaul, Aquitaine, and Francia, to protest the condemnation of 792. With the dissemination of the Spanish bishops' letter in 793, the situation became threatening, and Charlemagne determined to call a general council at Frankfurt in 794. The *Libri* were now ready for presentation for theological debate; the person of Christ, images, and the *filioque* would now be considered together and determined by the authority of the council.

In the meantime, however, the papal response to the *Libri* arrived from Rome and presented Charlemagne with a complete rejection of the *Libri's* arguments. Hadrian held fast to the Greek decisions which he had (unbeknownst to Charlemagne) originally supported, and he argued that the *Libri* misrepresented the Byzantine view. On the matter of images he set the veneration of icons squarely within patristic tradition. Interestingly, he never questioned the use of the term *adorare* to mean veneration, but explained that what was meant was not worship in the cultic sense but respect. Veneration of images as channels of grace under divine inspiration Hadrian saw as a good and salvific work.[32] On the *filioque* the Pope was adamant. He noted that the Fathers had spoken at times of the procession of the Spirit through the Son without denying the consubstantiality of either Son or Spirit with the Father. Thus the general usage of the Western Church — the usage followed by the Carolingians — he would not endorse.[33]

In the wake of Hadrian's letter, formal work on the *Libri* came to an end. Although the question of image worship was taken up at the council, and the claim that images should be worshiped "just as the Trinity" was anathematized, the *Libri* were not promulgated. Instead, they were depos-

ited in the royal archives for future reference, where they would be examined much later by Hincmar, who again took up the image question later in the ninth century.[34]

On the Adoptionist controversy the council made a strong and comprehensive series of statements intended in particular to refute the writings of Elipandus, since it was with the archbishop's writings that they had direct familiarity.[35] Present were the bishops of the whole Empire and northern Italy, and also papal legates carrying the anti-Adoptionist letter from Hadrian to the Spanish bishops. Besides its influence in interpreting the meaning of Adoptionism, this letter was also the first to make an explicit connection between the procession of the Holy Spirit and the true Sonship of Jesus. Thus, perhaps ironically, the Pope upheld the theology of the simultaneous procession at the very time he rejected the interpolation of the *filioque* formally into the Creed. Hadrian's letter linked the two doctrines in a formulation which would, again, be developed more fully by Alcuin after Frankfurt and Paulinus of Aquileia in 796. As Hadrian saw it,

> Over whom do you judge that the Holy Spirit descended in the form of a dove, over God or over man, or, on account of the one person of Christ, over the Son of God and of Man? For the Holy Spirit, since it is inseparably of both, namely of the Father and of the Son, and proceeds essentially from the Father and the Son (*ex patre filioque*), by what means can it be believed to have descended over God, from whom he had never withdrawn and from whom he proceeds always ineffably? For the Son of God, according to that which is God, because the Father was never withdrawing from him, sent the Holy Spirit in an unspeakable way; and according to that which is man, received the one coming over him.[36]

Here the oneness of the person of Christ required that the Holy Spirit be related integrally to both of his natures. The affirmation of the two natures required an explicit distinction between those relationships; Hadrian applied the distinction to the procession of the Holy Spirit.

Two synodal letters were produced refuting both Felix and the Spanish bishops. The first, the *Libellus sacrosyllabus*, written by Paulinus of Aquileia, was an argument from Scripture which represented the position of the Italian bishops.[37] Paulinus employed two arguments. The first was summarized in the great confession of Peter: "You are the Christ, Son of the living God." This was, Paulinus pointed out, a confession of sonship in the absolute sense, not relatively as through adoption. The proof of this lay in other scriptural events, and Paulinus's choice of text became a standard corpus against the heresy: the Baptism of Christ, the Ascension, the Annun-

ciation texts heralding the Incarnation of Jesus.[38] The second argument, one addressing the issue of salvation, followed from 1 Timothy 2: 5: "'Mediator,' says the Apostle, 'of God and men, the man Christ Jesus.'" If "the man Christ Jesus" was not himself the true Son of God, how could the Adoptionists understand the Passion and Resurrection, except by the heretical separation of the man and the Word into two persons?[39] Here again the differing approaches of Adoptionism and the mainstream tradition appeared: the emphasis on the mediatorial role of Christ in the Carolingian position was a point that they saw lacking in the relational, familial view of salvation posited by the Adoptionists in which the Word, having adopted flesh, became the brother of humankind, which shared in Christ's resurrection.

The other document, the *Epistola episcoporum Franciae,* was written by Alcuin.[40] This letter represented the opinion of the bishops of Gaul, Aquitaine, and Germany, according to the argument of patristic tradition. The piece was essentially a line by line refutation of the letter of the Spanish bishops, attacking that document for its many misinterpretations, misquotes, and misattributions, and especially for the points at which, Alcuin claimed, interpolations were made in texts to prove the Adoptionist point. Indeed, Alcuin went so far as to ridicule even the acceptable Spanish Fathers cited by Adoptionist bishops: "And if your Hildefonsus called Christ adopted in his prayers, indeed our Gregory, Pope of the See of Rome and the most enlightened teacher in the entire world in his prayers always did not hesitate to call him only-begotten."[41] In the weight of authority, the Spanish Hildefonsus could not meet the powerful witness of both a pope and so influentially pristine a theologian. Here we can see with particular clarity the thrust of Alcuin's argument from authority, and the strong impulse for the correct and authoritative text so fundamental to Carolingian educational interests; Alcuin's sarcasm expressed a much deeper concern than merely to best his opponent.[42] The Adoptionists' case was problematic precisely because they could cite so many authorities in their favor. In Alcuin's view the Adoptionists carried their arguments to a conclusion those authorities would never have countenanced. Alcuin's response, both here and later in the final refutation of Adoptionism, was to muster a stronger, more powerful arsenal of authorities in the service of the faith.

The council added to these two episcopal responses the letter from Pope Hadrian refuting the Spanish bishops.[43] Hadrian's decision was unequivocal: "The catholic Church has never believed, never taught this, never proffered assent to those believing wrongly."[44] That Jesus was the

true, and not adoptive, Son of God, he said, was the very foundation of the faith of the Church, and unshakeable.

The theological decisions at Frankfurt were a strong trinitarian and christological statement that clearly understood the Chalcedonian—and Roman—model of theological interpretation to be the sole valid model. Nevertheless, the council favored moderation and reconciliation with repentant heretics. Felix, despite his condemnation and his previous backsliding, was allowed to return to his see in Urgel after his new recantation. Most likely Charlemagne, who had had trouble with the Muslims in the Spanish March, feared religio-political revolt among Felix's followers.[45] Indeed, the letters of Alcuin throughout 795 and 796 and the preoccupation of the court with other issues indicate the extent to which Adoptionism had ceased to be an issue.

It was also shortly after the council that Alcuin wrote the first full treatise on the *filioque,* the *De processione Sancti Spiritus.*[46] The tract was essentially a list of scriptural and patristic quotes implicitly or explicitly affirming the simultaneous procession, and revealing the extent to which the issue was still raw for the Carolingians. All of the texts referred to Jesus' breathing of the Holy Spirit on the disciples. From this act, in Alcuin's commentary, followed two critical points. First, it was the man Jesus who was transmitting the Holy Spirit. Hence, the man Jesus was God. Second, the man-God Jesus was equal to the Father because he equally transmitted the divine power of God to the disciples. The key text cited here and discussed on this issue by the Fathers was John 20: 21–23. Alcuin quoted it: "When he had said this, he breathed on them and said, 'Receive the Holy Spirit; those whose sins you remit, it will be remitted to them, and those whose sins you retain, they will be retained.'"[47] Alcuin located the meaning of the passage in the word *insufflare,* "to breathe into," which implied possession by the Son and, therefore, origin from him. It was, after all, his very breath. "By breathing out, he signified that the Holy Spirit was not of the Father alone, but his own," as Alcuin quoted of Saint Augustine.[48] Here again, Alcuin made an explicit christological point in his examination of the *filioque* issue. The ability of Jesus to "breathe the Holy Spirit into" the disciples was explicit proof of his full divinity and equality with the Father. Thus, though Alcuin made no overt reference to Adoptionism here, the connection between the simultaneous procession and orthodox Christology was clear.

Despite the apparent settlement of the Adoptionist controversy, however, it proved impossible to hold Felix to his new recantation. By 796 or shortly thereafter, word arrived in Francia of the bishop's new backsliding.

On his return to Urgel he seems to have fled into Muslim Spain beyond the reach of Charlemagne and again took up his Adoptionist teaching. The Carolingian anti-Adoptionist arsenal was again hauled out with immediate and unqualified response.

Felix's apparent recalcitrance motivated Alcuin to undertake a reading of the Fathers and of a new manuscript of the canons of (significantly) the Council of Ephesus available to him at Tours. He intended to make a new collection of excerpts with which to refute the heresy definitively. The canons in particular seem to have informed Alcuin's christological understanding, specifically in regard to the implications of Nestorian dualism and the role of Mary, as Mother of God, in salvation history. This florilegium would eventually provide the authoritative basis for a specifically anti-Adoptionist treatise, the *Liber contra haeresim Felicis.*[49]

Paulinus of Aquileia convoked a synod at Friuli in 796 to "explain more clearly about the mystery of the holy and unspeakable Trinity."[50] Here the link between anti-Adoptionism and the *filioque,* first made by Hadrian in 794, was made explicit. Paulinus focused the synodal discussion on the Creed as the most important vehicle of teaching and propagating doctrine, the "plumbline" (*linea, perpendiculum*) of the Christian life.[51] He first defined the doctrine of the Holy Spirit as the critical component in trinitarian belief. To declare belief in the Holy Spirit, just as in the Father and the Son, was to declare belief in the Trinity. For Paulinus this demanded belief in the *filioque.* He justified this not only by scriptural testimony, but by arguing that the very oneness of the Trinity demanded the simultaneous procession to affirm the equality of Father and Son.

With the *filioque* of the Creed as his basis, Paulinus now turned against the Adoptionists. The very unity of the divine essence, the consubstantiality that he used to prove the simultaneous procession, now would prove the true Sonship of Christ as well. Basic to his argument was the Augustinian dictum that the entire Trinity often operated in the presence of one of the persons. He cited Matthew 28: 19 as his scriptural basis:

> How rightly, therefore, the Lord, in his high and ineffable wisdom, (blessed) "in the name of the Father, of the Son, and of the Holy Spirit," so that he might reveal *personally* the mystery of the Trinity and so that he might demonstrate *essentially* the inseparable unity of the undivided Godhead, he put forth "in the name." For he does not say "in the names," as if in many, but "in the name," because God is three and one. For he did not describe (his own) nature, but the *person.* How felicitously indeed the Apostles too taught us to understand the entire holy and ineffable Trinity in the name of Jesus, that is, of the Savior.[52]

To underscore the union of divine and human in Jesus, Paulinus made a change in the formula used in anterior versions of the Nicene Creed to describe the incarnation: the term *humanatus est* became *et homo factus est.*[53] The *humanatus* formula had become a mainstay of the Adoptionist argument; Christ was *Deus humanatus,* "God humaned." Paulinus set a distinct counterpoint, describing Christ as "made man." The meaning of the words was, in effect, the same. But the formula *humanatus est,* tainted by its association with the Adoptionists, was no longer acceptable to the orthodox teacher intent upon using the Creed as an anti-Adoptionist weapon.[54]

It was also at this time that Paulinus write the poem *Regula fidei metrico promulgata stili mulcrone.* It has traditionally been assigned to Paulinus for two reasons. First, in the most important manuscripts of the *Contra Felicem libri III,* the poem immediately follows the treatise and, as Dag Norberg has pointed out, summarizes in poetic form the arguments made formally in the prior text. Second, the style of the poem is consistent with the other poetry of Paulinus.[55] We know that it was written before 798. The poem responds directly to the issues raised in the theological debates, and it is worth examining for that reason. It reveals the variety of ways, including artistic forms, in which responses were made to these critical Carolingian concerns. Let us examine the most important sections of the poem here.[56]

The *Regula fidei* is an explicitly anti-Adoptionist poem, which presents its "arguments" in four parts. The first, lines 1–50, is a summation of beliefs held against the Adoptionist position. It begins with an affirmation of faith in the Trinity and the mystery of three persons in one God:

6	In te credo patrem, cum quo deus unica proles	I believe in you, Father, with whom God as unique offspring
	regnat, et omnipotens cum quo deus aureus ignis.	reigns, and with whom reigns almighty God as golden fire
	Non tres ergo deos, absit, sed sanctius unum	Not three Gods then—may it be far removed—but I believe
	corde deum credo, labiis non cesso fateri,	with my heart, with my lips I do not cease to confess one God, more holy.
10	qui semper summus, perfectus semper et altus,	You who are always highest, perfect always and above,
	solus, et ipse potens, trinus persistis et unus.	You yourself, alone powerful, remain constant, triune and one.
	Personas numero distinguo denique trino,	I distinguish the persons by the threefold number,
13	naturam nullo patior dividere pacto.	the nature I tolerate in no way to divide.

It then emphasizes the importance of the Virgin birth, Christ's baptism in the Jordan, and, as a proof of Christ's divinity, the Transfiguration in which Peter affirms the divinity of Christ (lines 49–50) *non homines aequare deo, dominoque clyentos*:

30 Hunc pater omnipotens tinctum Iordanis in unda,

This one—wet in the waves of the Jordan,

protinus ex alto sanctus cum spiritus albae

by the great servant Baptist John

caelitus in specie discendit namque columbae,

while at once indeed the heavenly Holy Spirit

baptista sibimet magno famulante Iohannae,

in white dove's form came down to him from on high—

dilectum propriumque, pium dulcemque tonantem

him the almighty Father discerned with his holy mouth

35 esse suum genitum sancto discrevit ab ore. . . .

to be his beloved and own, mild and righteous Thunderer. . . .

39 unicus altithroni caelorum gloria Iesus,

Jesus, unique, glory of the high-enthroned of heaven

ut solis radius facies plus pulchra refulget,

shines, a face more lovely than a ray of sun,

candor ut alba nivis vestis radiabat, et ecce

the luster of his garment gleams white as snow, and behold

intonuit vox alta dei de nube serena,

the great voice of God intones from the bright cloud,

aera per vacuum, teneras transfusa per auras.

through the empty ether, poured forth through soft airs.

Talia mellifluis depromit gaudia dictis:

It produces such joy with mellifluous words:

45 "Hic meus est" inquit dilectus filius unus,

"This is my beloved only Son," he says,

"hunc audite." Datum hoc est mirabile signum,

"listen to him." This is the wondrous sign given,

quod deus atque homo Christus sit verus et altus.

that Christ be God and man, true and lofty.

Filius ille dei sancta de virgine natus

That Son of God, born of a holy virgin

arguitur hinc: forte Petrus hac voce docetus

was proven thus: Peter taught by this strong voice

50 non homines aequare deo, dominoque clyentos.

that mankind is not equal to God, and mankind is the servant of God.

The second part of the poem, lines 51–79, reveals the fruits of right belief: the vision of heaven. Here Paulinus describes a pastoral scene of great tranquility and beauty awaiting those who are faithful to Christ.

62 Illic picta rubent croceo de flore virecta,	For him the glades blush, painted with saffron flower,
candidulo rident pulchre de germine cincta,	they laugh, beautifully girded with dazzling buds,
frigore quae numquam radio nec solis arescunt,	which never become dry with the cold nor with the sun's ray,
65 marcescunt numquam gelidis infecta pruinis.	never droop corrupted with icy rimes.
Nec pluviis perfusa quidem madefacta tabescunt	Nor indeed do they, injured, melt away, poured over with rains,
Sed semper, paradise, tuos redolentia flagrant	But always, O Paradise, mingled with perfumed oil,
messis aromaticae permixto chrismate odores.	redolences burn your sweet smells of aromatic harvest.

The third section, however, addresses nine heresiarchs and anathematizes all heretics, who shall never taste the waters of life because they are, in the words of Paul, *Galatae forte rebelles* (lines 80–117). Among the great heretics he includes Arius, Eutyches, Nestorius (so important in the Adoptionist struggle), and Mani among others. At the end of this section, however, he returns to the true faith of the Church, held without blemish since the time of the Apostles and presaged by the Prophets (lines 115–118).

Arrius in foveam, fodiit quam perfidus ipse,	Arius sinks down in the pit which he himself, treacherous one, dug,
95 corruit, aeterna damnatus nocte tabescit.	damned, he wastes away in eternal night.
Eunomius laequeo sese suspendit in alto,	Eunomius hangs himself on high with a noose,
per medium crepuit, picei petit ima profundi.	he rattles through the middle, he makes for the shores of deep pitch.
Perfidiae iaculo propria se perculit ulna	Insane Nestorius beats himself down with the javelin of perfidy
Nestorius demens, Stigias descendit ad umbras.	with his own arm, he descends into the Stygian shadows.
100 Canceris ut pestis Macedonia dogmata serpent,	The Macedonian dogmas creep along just as the plague of cancer,
pro quibus ambusta Macedonius ardet in olla.	for which Macedonius burns in boiling oil.
Eutices infelix, ex omni parte nefandus,	Unhappy Eutyches, abominable from every side,
trita venena bibit, sibimet quae miscuit ipse.	drinks ground drugs, which he mixed for himself.
Pestifer ille Manis, totum quem possidet error,	That plague-ridden Mani, whom error possesses entire,

105 sulphorae fumos conflat sine
 fine gehennae.
Haud secus horrisono
 spurcoque Savellius ore
blasphemus ignivoma Cociti
 gemet justus ab unda.

blows up without ceasing the fumes of
 sulphurous Gehenna.
Just so Sabellius, with defiled and
 dreadful-sounding mouth
groans burnt and blasphemous from the
 fire-spewing waves of Cocytus.

In the final section of the poem, lines 118–151, Paulinus lauds the faith of the three hundred eighteen Fathers at the Council of Nicaea, professes his adherence to their Creed, and confesses once again his belief in the mystery of the Trinity.

Catholicos sanctosque viros
 patresque beatos
120 trecentos octoque decem
 cunctosque perennis
iudicis aequisonae cultores
 nempe fidei
amplector placidis strictim
 feliciter ulnis. . . .
141 Summe tibi, genitor, referam,
 deus alta potestas,
et tibi, nate dei, lati spes unica
 mundi,
spiritus alme, tibi, metuende,
 tremenda maiestas,
fons caritatis, amor dulcis super
 omnia mella,
145 lux et origo boni, casti spirator
 amoris,
qui quo vadis et unde venis
 nesciris, et orbem
terrarum reples et ubivis
 perpete spiras.
Auditur vox ecce tua, clamore
 silenti
cordis in aure sonat, nullo
 quatiente fragore.

The three hundred eighteen catholic and
 holy men
and blessed fathers, and all truly
 worshippers
of the equitable faith of the everlasting
 judge
I tightly embrace happily with gentle
 arms. . . .
To you, highest father — I shall repeat —
 God, highest power,
and to you, Born of God, only hope of
 the wide world,
kind Spirit, to you, by fearing,
 tremendous majesty,
fount of charity, gentle love over all sweet
 things,
light and source of good, breather of
 chaste love,
who, whence you go and where you come
 from you do not know,
you fill the orb of the earth, and wherever
 you like, you breathe.
Behold, your voice is heard — by no
 shaking crash —
by the silent clamor of the heart it sounds
 in the ear.

In these poetic images Paulinus was concerned to underscore the truths of the faith revealed in the great biblical mysteries of incarnation, baptism, and transfiguration, revealed in the utterances of the Prophets and Apostles and in the conviction of the Fathers at Nicaea. The anti-Adoptionist pan-

oply was fully laid out. The *Regula fidei* reveals the variety of ways, including artistic forms, in which responses were made to critical Carolingian concerns.

In early 797 Alcuin wrote a highly conciliatory letter to Felix exhorting him to renounce once again his errors and join the catholic fold.

> May you beware conscientiously, O brother worthy to be venerated, lest this house of yours be built upon the sand, and your labor be in a strange house: Arise, brother, arise and return to your father and into the lap of holy Mother Church. Faithful is Mother: recollect yourself and congregate your flock with you in the sheep pen of Christ, which that very one commended, because of the glory of his three-fold confession, to blessed Peter, prince of the Apostles, for feeding his sheep.

Here Alcuin emphasized the force of the tradition of consensus and adherence to the teaching of Peter. Alcuin seems to have been convinced until quite late in the controversy that Felix was a reasonable man who would return to the truth with reasonable persuasion. Up to this point, Alcuin had contact only with the texts of Elipandus, from which he most likely extrapolated Felix's position, again revealing the lack of nuanced awareness of the actual issues being argued.[57]

With the same tone and the same intention Alcuin wrote to Elipandus, "the most sacred light of Spain," in late 797 or early 798.[58] To this point, Alcuin's contribution had been the development of the argument from authority. Now, however, Alcuin moved beyond authority to a central liturgical argument against Adoptionism. Right understanding of the sonship of Christ, he said, was crucially linked to right understanding of baptism. He articulated the theological issues first in these terms:

> And so our Lord Jesus Christ alone was able to be born thus, so that he was not in want of the second regeneration; likewise in the baptism of John he wanted to be baptized with the sure act of mercy of the dispensation, because in the baptism of John there was not regeneration, but a certain precursory sign of the baptism of Christ. In his baptism alone through the Holy Spirit is there the remission of sins for believers, so that in his spirit we are born, in whom he was born from the Virgin Mary. For he wanted to be baptized in water by John, not so that any iniquity of his be washed away, but so that his great humility might be commended. For in him there was no baptism which washed, just as there was no death which punished; he came so that the devil might be conquered by the truth of Justice, not crushed down by the violence of power. Whence he undertook both baptism and death not by necessity needing to be pitied but rather by compassionate choice.[59]

Here Alcuin made a clear distinction between Redeemer and redeemed, which he saw to be a vexing issue in Adoptionism. And since baptism was the believer's entry into the life of salvation, it was of critical importance to Alcuin.

At about the same time, in 798, he expanded on the significance of baptism in the anti-Adoptionist struggle in a letter to the monks of Septimania, to whom he had already sent a copy of his treatise. This time he focused on liturgical differences with Adoptionism.

> And indeed, a third question from Spain — which was once the mother of tyrants, but now of schismatics — has been brought down to us against the universal custom of the holy Church on baptism. For they say that one immersion must be performed under the invocation of the holy Trinity. The Apostle, however, seems to be against this observation in that place where he said: "For you are buried together with Christ through baptism." For we know that Christ . . . was in the tomb for three days and three nights. . . . Three immersions can symbolize the three days and three nights. . . . For it seems to us . . . that just as the interior man must be reformed in the faith of the holy Trinity into its image, so the exterior man must be washed by the third immersion, so that that which the Spirit works invisibly in the soul the priest should visibly imitate in the water.[60]

Alcuin's opinion was unequivocal. The symbolic action of the liturgy effected a change in the recipient of the sacrament, and that symbolic action grew from or concretized the *fides recta* of the believer. In his view, belief, liturgy, and salvific change were intertwined. One could not be altered or manipulated without destroying the other two. Thus the effect of the perverted dogma of Adoptionism extended to the very moral condition of each Adoptionist, who could not be washed clean of sin in baptism because he neither believed nor prayed correctly.[61] The great irony of this interpretation was that the Spanish Church had itself practiced baptism in both single and triple immersions, the single immersion associated with the Hispano-Roman churches and triple immersion brought with the Visigoths from the East. The single immersion had run the risk of a Sabellian interpretation (symbolically confusing the three persons in the single deity), whereas triple immersion was associated with Arianism (and hence an "over-distinction" of the three persons and a denial of the deity of the Son and Holy Spirit). While the ultimate decision of the councils of Toledo was to stress single immersion as the preferable, anti-Arian alternative, there is no evidence whatsoever that Visigothic or Adoptionist baptismal practice was heterodox.

Hopes for reconciliation were not to be realized, however. In 798 a new treatise from Felix arrived at court, the bishop's caustic response to Alcuin's conciliatory letter. While it seems that up to this point Alcuin had had direct contact only with the writings of Elipandus and had hoped that Felix would see the truth of Alcuin's argument, now he discovered the bitter truth that Felix was deeply committed to his Adoptionism. What disturbed Alcuin now was his perception that Felix had sharpened the Adoptionist argument with a new usage, calling the man Jesus *Deus nuncupativus,* "God by appellation only." Similarly, Mary was *nuncupativa genetrix,* or "Mother of God by appellation only."[62] Alcuin was shocked: here even more clearly loomed the Nestorian dualism. He greeted the treatise with alarm: "If nothing else be found against the catholic faith, that (*nuncupativus*) alone suffices him for his perdition."[63] It was determined that Alcuin himself would dispute directly with Felix at Aachen in April 799. Claiming, however, that he alone was not equal to the task of refuting this heresy once and for all, he asked Charlemagne to solicit individual responses from Pope Leo III, new successor of Hadrian I, Paulinus of Aquileia, Richbod of Trier, and Theodolf of Orléans.[64] In late summer, Leidrad, as Bishop of Lyons, served as royal *missus* in Septimania, going to Urgel to summon Felix to the disputation. It is possible that Theodulf accompanied him.[65]

Alcuin honed his arguments in a new treatise, now the *Adversus Felicem libri VII.*[66] Again, the argument was traditional: Felix's great error was his willingness to stray from the way of patristic consensus.

> It is great foolishness for a man to have confidence in his own opinion, and spurn the catholic understandings of the holy Fathers and the whole Church. Wasn't this the cause of perdition to all heretics, that they wanted more to be lovers of their own opinion than of the truth? . . . And it is a wonder that such *doctores* do not fear to introduce beliefs new and unknown to ancient ages, while the most excellent teacher of the nations firmly prohibited in every way that all novelties of speech and newly discovered sects be taken up by any catholic whomsoever.[67]

Always paramount for Alcuin, the true son of England, was the one unanimous authority of the apostolic Church. As Cavadini has pointed out, tradition was so critical to Alcuin because he was aware of the great distance that separated his own age from that of the Apostles, and believed that it was only by consistency with tradition that the faithful of his own day would have the same accessibility to Jesus as contemporaries of Jesus did. Thus Alcuin saw the Adoptionist controversy as the "struggle of an ec-

umenical and traditional way of thinking against a dangerous parochial innovation."[68]

Paulinus also produced a treatise, now the *Contra Felicem Urgellitanum libri III,* which remains the most mature statement of the anti-Adoptionist position.[69] If Alcuin's strategy turned on the power of authority and the transformative power of liturgy, Paulinus's developed three principal theological arguments against the Adoptionists. They provide us with a final summary of the theological problems which concerned Angilbert at Saint-Riquier.

Paulinus's first strategy was a traditional anti-Nestorian stance. Felix's views, he said, implied not only a division of the person of Christ, but also a confusion of his natures. Just because Christians spoke of God and man in Christ, and because God was one thing and man another, did not mean that there was more than one Christ. Instead, the Word took flesh without change and without confusion with the man. This was proven in Mary, whose role as Mother of God Paulinus upheld, "not *nuncupativa genetrix* of a *nuncupativus* God." From the moment of conception in the womb of Mary, full divinity and full humanity were joined in Jesus. The Psalms and the Prophets had never spoken of a true and a putative God. The Passion and the Resurrection did not reveal a true and a putative God. Jesus suffered by choice, not necessity, and because of this God justified him as Savior in the bodily Resurrection.[70]

Paulinus then addressed the issue of salvation. For Felix to use the term "adopted" of Christ was to confuse his role as Savior. It was to make of him the redeemed rather than the redeemer, the saved rather than the Savior; it was to confuse his role as adopter of fallen humanity with ours as adopted sons of God. It was to make of him an advocate rather than a mediator, and therefore to deny his essential role in salvation. This ultimately denied the peculiar roles of each person of the Trinity in the world. "Though he was in the form of God, Paulinus quoted from Philippians, "Jesus did not deem equality with God something to be grasped at, but emptied himself and took the form of a slave, being born in the likeness of men."[71] Nonetheless, Paulinus did not interpret this critical passage in a way hospitable to the Adoptionist treatment, nor did Alcuin. In these works, this passage was explicated in a way consistent with the Carolingian starting points. The Adoptionists stressed that the slavery of Christ was the end result of the self-emptying of the Word, and therefore the point at which grace could accomplish salvation. Paulinus (and Alcuin) saw the "form of a slave" as another way of describing the human nature taken up by the Word, in

which they understood this as the beginning of a process of assumption, rather than the end of the process of self-emptying. Thus the man Jesus was actively assumed by the Word at the moment of incarnation and freely chose to be obedient to death on the Cross, again as active and freely willing subject rather than (as they saw it) passive adoption.[72]

The final tactic argued from the Trinity itself, using Augustinian formulations. The Trinity was one and inseparable. Hence the entire Godhead must be present in the works and events of the life of Christ.

> And because the works of the Trinity are always inseparable, just as in the womb of the Virgin the entire Trinity effected the man, so the entire Trinity cannot be denied to have raised him from the dead. . . . But there is not one Son who raised, and another who was raised; although there be the one and the other, that is, the divine and the human, nevertheless the Son is one, raising and raised.[73]

It was to this end that Paulinus offered the formula *homo factus est* to describe the Incarnation in the Nicene Creed. This fully and starkly designated the personhood of Christ. Better than the traditional *humanatus est*, better even than the beautiful and mystical *Verbum caro factus est* of the Gospel of John, this phrase radically identified the man Jesus with the eternal Word.[74]

Thus the doctrinal disputes of the 790s, with regard both to Adoptionism and to the *filioque*, reflected the strong concern of Charlemagne and his court theologians to foster correct trinitarian and christological belief. The theological result was a closer and fuller relating of christology and pneumatology to belief in the Trinity as a whole. In this phase of the debate the work of Paulinus of Aquileia most clearly articulated the integral character of the relationship between the true humanity and true divinity of the Son, the procession of the Holy Spirit, and the description of the immanent Trinity for the post-Augustinian West. Alcuin supported these theological principles with the argument from authority and made an important doctrinal tie with liturgy, the liturgy of baptism in its trinitarian and christological symbolism. There was one other element of the debate which was significant as well, and that was the use of Scripture in the anti-Adoptionist position.

De Culmine Fonte: The Use of Scripture in the Treatises

I have argued that the theological controversies of the 790s provided the lens through which Angilbert's program at Saint-Riquier must be viewed.

Angilbert's involvement in the conflicts, both in supervising Felix's recantation in Rome and in presenting the *reprehensia* of the *Libri Carolini* to the Pope, meant that he had intimate familiarity with the theological debate and the Carolingian response. In effect, he stood as the official representative of Charlemagne's position in Rome.

It is worth noting that the arguments set forth by Hadrian, and especially Paulinus and Alcuin, consistently cited key events in the life of Christ as the scriptural basis for the orthodox position.[75] Six events from the Gospels were, in fact, the starting points from which they argued against the three heresies: the Annunciation, Jesus' Baptism in the Jordan, Peter's Confession of faith, the Crucifixion, the Resurrection, and the Ascension.[76] They used associated texts from the Epistles and the Psalms to explain or clarify those events. However, these events appeared not only in theological treatises; used in the same context against the same heresies, they appeared in pictorial and liturgical form at Saint-Riquier, as we shall see. They deserve to be examined, therefore, in some detail for their meaning within these debates.

Paulinus, Alcuin, and Hadrian cited these passages for two reasons. First, they proved that Jesus, the Redeemer, was true God and true man, the divine Word coequal, coeternal, and cooperative with the Father, made flesh in the man Jesus. Second, they emphasized the unity of the Trinity by proving that the work of Father, Son, and Holy Spirit was inseparable. In other words, these texts showed that the entire Trinity operated in the works of each Person. More important, they showed that the entire Trinity was present in these moments of the life of Christ.

The first group of texts were those associated with the Annunciation, Luke 1: 26–38, and the Nativity. Thus they described the moment of Incarnation of the second Person of the Trinity. They revealed that Jesus was both God and man, fully and integrally, from the moment of conception, receiving his divine nature from the Holy Spirit ("The Holy Spirit will come upon you, and the power of the Most High will cover you with its shadow") and his humanity from his mother Mary.[77] Paulinus supported this text with John 1: 14: *Verbum caro factum est,* "The Word became flesh." Saint Paul's Letter to the Galatians 4: 4–5 was also to the point: "But when the appointed time came, God sent his Son, born of a woman, born a subject of the Law, to redeem the subjects of the Law and to enable us to be adopted as sons."[78] Here Saint Paul provided the explanation, as it were, of Luke's text. He emphasized that the Son of Man was born of a woman (*factum ex muliere* in the Carolingian version), and born under the Law (*factum sub lege*) for the sake of redeeming humans who were under the

Law, lost through the sin of Adam. The Incarnation of the Word through the womb of Mary was what enabled the redemption of lost men to take place. The Annunciation and the divine motherhood of Mary set the entire order of salvation. It was effected in the Son through the Holy Spirit as the will of the Father. While these texts were important throughout the anti-Adoptionist treatises, and were developed speculatively by Paulinus, it was Alcuin who relied on them most heavily in the advancement of his argument by authority. Indeed, a substantial portion of his argument in the *Adversus Felicem libri VII* was devoted to the meaning of the Incarnation and the importance of Mary in giving the Word flesh; he also returned to this theme repeatedly in the *Adversus Elipandum libri IV.* For Alcuin, the master and friend of Angilbert, the anti-Nestorian argument and the centrality of Mary in the economy of salvation were the key element of faith in the Incarnation.

The second event was the Baptism of Jesus described in Matthew 3: 13–17, the moment of revelation of Jesus' messianic status at the beginning of his public ministry.

> Then Jesus appeared: he came from Galilee to the Jordan to be baptized by John. John tried to dissuade him. "It is I who need baptism from you," he said, "and yet you come to me." But Jesus replied, "Leave it like this for the time being; it is fitting that we should, in this way, do all that righteousness demands." At this, John gave in to him.

> As soon as Jesus was baptized he came up from the water, and suddenly the heavens opened and he saw the Spirit of God descending like a dove and coming down on him. And a voice spoke from heaven, "This is my Son, the Beloved; my favor rests on him."[79]

Here the voice of the Father, saying "This is my beloved Son," identified the man Jesus as the Christ while the Holy Spirit descended from Heaven in the form of a dove. Again, the entire Trinity was manifested in this work of the second Person.[80] Matthew 16: 16–18 recounted the Confession of Peter, in which Peter himself called Jesus "the Christ, Son of the living God," and hence, the Messiah. This was the third event. Following patristic tradition, this confession of faith was the rock of the Church as the fundamental truth upon which Christianity rested. It inseparably linked the man Jesus with the divine Christ, the promised Messiah.[81]

The Crucifixion, the fourth event, "made all especially clear."[82] This was a text cited by Pope Hadrian in his anti-Adoptionist letter to the Council of Frankfurt. In Hadrian's interpretation, the words *consummatum*

est, "it is accomplished," of John 19: 30, acknowledged the fulfillment of the prophetic witness of the Old Testament and the achievement of redemption. With these words, Jesus in his own body and his own suffering inaugurated the Church, which was the Body of Christ and the witness of the faith.[83]

The fifth event was the Resurrection account detailing the meeting of Jesus with Mary Magdalene in the Garden on Easter morning, John 20: 17. This was one of several crucial texts that delineated Christ as "the first fruits of redemption."

> Jesus said to her, "Do not cling to me, because I have not yet ascended to the Father. But go and find the brothers, and tell them: I am ascending to my Father and your Father, to my God and your God."

This text underscored Jesus' unity with the Father while clearly separating him even in his humanity from the rest of sinful humankind. Especially important here was the distinction between "my Father and your Father." The fact that Jesus would specify "my" and "your" in this way, as Hadrian said, was proof that Jesus was not "mere man," but was of unique and perfect status as Redeemer of mere men.[84] The sixth event, the Ascension, as described in Acts 1 and as alluded to in John 20: 17 clarified the same point.[85] This delineation expressed the character of salvation: the Father was "mine" for Jesus according to nature, and "yours" for the disciples and the rest of humankind according to grace. The texts of John 5: 17, "My Father goes on working and so do I," and John 17: 1, "Father, the hour has come: glorify your Son so that your Son may glorify you," were used in the same way.

These texts emphasized the difference between Jesus and other human beings. But others, all from the Gospel of John, proved the likeness of the Father and the Son. John 10: 29 said, "The Father who gave them to me is greater than anyone, and no one can steal from the Father. The Father and I are one." John 14: 9–10 said, "To have seen me is to have seen the Father, so how can you say 'Let us see the Father'? Do you not believe that I am in the Father and the Father is in me?" Similarly, in John 17: 6 Jesus said, "I have manifested my Father's name." Clearly, this Gospel provided the most important scriptural testimony on the mystery of the Trinity and the consubstantiality, coequality, and coeternity of the three Persons of the Godhead.

Two other texts described the relationship of the Son to the Holy Spirit. They affirmed the equality of the Son with the Father and the unity of the Trinity as a whole.[86] John 20: 21–22 said, " 'As the Father sent me, so I

am sending you.' After saying this he breathed on them and said, 'Receive the Holy Spirit.'" Similarly, I John 3: 24 said, "Whoever keeps his commandments lives in God and God lives in him. We know that he lives in us by the Spirit that he has given us."

One final text above all described both the unity and the redemptive activity of the Trinity, Matthew 28: 18–19.

> Jesus came up and spoke to them. He said, "All authority in heaven and on earth has been given to me. Go therefore, make disciples of all the nations; baptize them in the name of the Father and of the Son and of the Holy Spirit, and teach them to observe all the commands I gave you."

In this passage, baptism in the name of the Trinity, the redemptive work of the Trinity, expressed the oneness of Father, Son, and Holy Spirit. This was the epitome of all of the passages we have seen. That Jesus specified baptism in the name of each and all of the three members of the Godhead was the ultimate proof of unity in Trinity. The identification here of christology with trinitarian theology in Carolingian scriptural usage is striking. The character and meaning of the person of Christ were located in his relationship to the Father and the Holy Spirit.

Conclusions

Let us pause to consider the result of this battle of Charlemagne's theologians, the Adoptionists, and the Byzantines. It has been my intention to present the conflict in some detail both to show the interpretation of issues and to indicate the variety of ways, both theological and liturgical, in which the responses were made. We have seen a focus on three key issues. Of central importance was the christological debate over the relationship of the human and divine in Christ. Against the Adoptionists, who were defined as new Nestorians dividing the person of Christ through the claim that Jesus was only adopted as the Son of God in his baptism, Alcuin, Paulinus, and Hadrian asserted the oneness of the person of Christ, the integral union of his human and divine natures through his incarnation in the womb of Mary. The importance of Mary as the true Mother of God was a critical component in asserting this unity. It was Paulinus who began to focus, at least in a rudimentary way, on the importance of Mary in salvation history. Although Spanish theologians, most notable among them Hildefonsus and Julian of Toledo, had written treatises on her in the seventh century, their

influence was confined to Spain and their reputations tarnished by frequent Adoptionist citations from their works. Paulinus made Mary important for the Franks and for Western theology on more than a devotional or liturgical level. Christ's assumption of humanity from his mother became the main defense both in the anti-Adoptionist argument and in the *filioque,* since both depended upon the unity of the two natures in the one person of Christ.

The second issue was the proper understanding of the procession of the Holy Spirit, which the Carolingians defined in the *filioque* clause of the Creed. To the Byzantine claim that the Spirit proceeded from the Father through the Son the *Libri Carolini* and later the synodal decrees of Paulinus at Friuli responded with the doctrine of the simultaneous procession of the Spirit from the Father and the Son, *ex patre filioque,* as the interpolated Creed stated. This emphasis on the simultaneous procession, as we have seen, was not only in support of the true trinitarian faith, but also buttressed the right understanding of Christ as fully divine and fully human. In this instance, the work of Paulinus, especially at Friuli, and building upon the foundations laid by Hadrian and by Alcuin, was a major contribution to clarifying the Western understanding of the Trinity, and relating christology and pneumatology more fully and directly to belief in the Trinity as a whole. It was here that the integral relationship between the true humanity and divinity of the Son, the procession of the Holy Spirit, and the description of the immanent Trinity was most clearly articulated in post-Augustinian theology. And it was here that the Creed was set forth as the keystone of right belief, to be included as a regular part of the Mass.

The third issue was the role of images or art in transmitting spiritual truth or meaning, and, as we have seen, the result was more ambiguous. The veneration of icons in Byzantium was sharply rejected by Charlemagne in the *Libri Carolini,* but never formally promulgated as policy due to the objections of Pope Hadrian. Nevertheless, two points mut be noted. First, the Carolingian rejection of icon veneration was not simply a matter of the mistranslation of conciliar decrees from Constantinople. If the *Libri* saw such veneration as idolatry, this was because of profound errors of trinitarian faith in Byzantium. As the third book of the *Libri* asserted, the outrageous claims of Irene and Constantine to co-rulership with Christ and the failure of the Byzantines to accept the simultaneous procession of the Holy Spirit were the real sources of their error on images. Thus it was a deeper issue of trinitarian and christological theology that was at stake. This leads to the second point. The *Libri Carolini* rooted art in proper theologi-

cal understanding, that is, in right faith in the Trinity and in Christ. The third book of the *Libri* (remembering Theodulf's own symbolic understanding of this book) was of utmost importance in the total argument. Although rejecting the view that art could express spiritual truths, Theodulf placed aesthetic theory within the matrix of proper trinitarian and christological understanding.

Charlemagne's interest in these issues went beyond "mere" theology. Along with the *Libri Carolini,* the king sponsored the work of Angilbert at Saint-Riquier. The timing is significant. Angilbert began his project at about the time that the *Libri Carolini* were begun, or at the latest when he returned from having taken Felix and the *reprehensia* to Rome. He argued at the Curia—unsuccessfully, from the papal viewpoint—the aesthetic and theological program of the *Libri*. He delivered for condemnation the errant Adoptionist Felix. He was, in all of this, not only intimately involved himself but also in constant contact with Alcuin as his disciple and friend, as the letters of Alcuin so clearly witness. He also razed the old buildings and began to construct on a new and massive scale a monastery which would, as he said, inspire "the entire people of the faithful to confess, venerate, worship with the heart, and firmly believe in the most holy and undivided Trinity." Supported by Charlemagne, he addressed in a new and striking way the defense of the true faith *quapropter ob veneratione sanctae Trinitatis,* "on behalf of the veneration of the Holy Trinity"[87]

The focus and the nature of Angilbert's project were also significant. At least in part, this was the one type of art—liturgy—the *Libri* extolled as leading the mind to God. Certainly in response to both the Greek rejection of the *filioque* and the christological challenge of Felix, Angilbert presented a concrete liturgical program of Carolingian doctrinal and aesthetic principles. However, while it is true that the liturgical program of Saint-Riquier was the liturgical program of the *Libri* applied to the dogmatic issues that the Carolingians faced, Angilbert went much further. Whereas the *Libri* explicitly and unqualifiedly rejected physical images as revealing spiritual truths, Angilbert created an architectural and artistic structure which quite squarely expressed the theological positions that Charlemagne was so anxious to promote. As we shall see, based on texts of Saint Augustine, Saint-Riquier provided what we might call an alternative spirituality or aesthetic understanding to that of the *Libri*. It was a monastic *ordo* of the living and symbolic presence of the Trinity in prayer and sacred space.

This artistic and liturgical program, as a monumental symbol of the Trinity, was fully consistent with the wider theological and liturgical inter-

ests of Charlemagne. It gives us insight into yet another facet of the Carolingian preoccupation with liturgy, one intimately bound to aesthetic concerns. It extended that vision to the realm of aesthetics. Indeed, as we shall see, it asserted the integral importance of art and liturgy to Carolingian life as a whole, through the importance of the symbol to the lives of the faithful here and now, and salvation hereafter. This is the topic of Chapters 4 and 5. First, however, let us consider Angilbert's life and work and his own interest in trinitarian and christological symbols, because though Charlemagne was a supporter of this work, Angilbert was its creator.

3. *Dogmatibus Clarus, Principibus Sotius*: Angilbert of Saint-Riquier

A pivotal member of the group who worked on the trinitarian theological positions was Angilbert, courtier, poet, *primicerius* of King Pepin in Italy, and abbot of the monastery of Saint-Riquier. He was, as his epitaph says, *dogmatibus clarus, principibus sotius,* "preeminent in dogma, the companion of princes."[1] Around him much of the practical success or failure of the Carolingian program turned, because it was he who argued the *reprehensia* at the Lateran Court, he who accompanied Felix to Rome and presented him for judgment to Pope Hadrian. He is a pivotal figure in another sense as well, for he gives us the fullest insight into the cultural expression of the theological debates. His new monastery of Saint-Riquier embodied an aesthetic sensibility based on symbols of the Trinity and of Christ. His poetry presented an ideal of kingship that sustained and actively encouraged those symbols. This chapter will consider Angilbert, his work, and his personal understanding of the right faith.

Many letters exchanged between members of the court circle give us the measure of Angilbert as a man well loved and highly regarded by his companions. From them we can glean an overview of his life.[2]

760s Angilbert receives traditional aristocratic training at the court of Pepin and in the entourage of Charlemagne.

777 or later Angilbert writes the poem *De conversione Saxonum* commemorating Charlemagne's victory over the Saxons in the previous year.

781 Angilbert goes to Pavia as *primicerius* or leader of the palace chapel of King Pepin of Italy, Charlemagne's infant son; resident at the court at Pavia.

late 780s Angilbert's friendship with Alcuin; *friedelehe* with Charlemagne's daughter Bertha.

c.789 Angilbert appointed, again by Charlemagne, as abbot of the monastery of Saint-Riquier, near Amiens. Although an absentee abbot, he undertakes the rebuilding of the seventh-century structure.

792 Charlemagne commissions Angilbert to conduct Felix of Urgel from the Synod of Regensburg to Rome; he also carries with him the outline of the *Libri Carolini* to present Charlemagne's case to Pope Hadrian.

794 Angilbert probably present at the Council of Frankfurt; according to the *Annales Laurissenses,* he returned to Rome with the results of the Council.

796 Angilbert carries part of the Avar treasure, along with Charlemagne's exhortations, from Paderborn to the new Pope, Leo III, in Rome.
Writes the laudatory poem *Ad Pippinum regem.*
Probably also writes the dedicatory poem of a manuscript of the *De doctrina christiana* for King Louis of Aquitaine.

late 790s Angilbert probably resident at the new court at Aachen, with visits to Saint-Riquier's work-in-progress.
Writing of the inscriptions and saints' epitaphs for the monastery

800 Dedication at Easter of the new abbey of Saint-Riquier in the presence of Charlemagne, Alcuin, and the great lay and ecclesiastical magnates of the realm.
Angilbert accompanies Charlemagne to Rome where the king is crowned emperor on Christmas Day.

811 Angilbert is present at the witnessing of Charlemagne's will at Aachen.

814 Angilbert dies on February 18, twenty-two days after the death of Charlemagne.

Of Angilbert's background and early life we know very little. He seems to have been a younger contemporary of Charlemagne, who even much later affectionately referred to him as *puer,* "child."[3] A letter of Pope Hadrian to Charlemagne described Angilbert as having been "brought up almost from the very beginnings of infancy in your palace."[4] Nithard, in his *Historia,* spoke of his father Angilbert as being of a family "in no way unknown" (*haud ignotae familiae*), of the lineage of Madelgaud and Richard. These two were not identified, although a Madelgaud was the imperial *missus* sent to the territory of Le Mans in 802 along with Bishop Magenard of Rouen, and several Counts by the name of Richard were mentioned in the anonymous *Vita Hludovici* as *ostiarii,* overseers of royal villas, one of the highest positions at court.[5] Given that background and his leadership of the palace chapel in Italy by 781, we may speculate that he was born sometime in the mid- or late 750s to one of the great families of the Frankish aristocracy, and that he received at the court of Pepin, and then of Charle-

magne, the usual training for royal service given to noble children sent to the court.[6]

The phrase *pene ab ipsis infantiae rudimentis,* "from the very beginnings of infancy," is unusual in that noble children were usually brought to court at adolescence — *roborata aetate* "at a strengthened age" — after having received their first education at home.[7] Angilbert's father may have already been resident at court in an official capacity. He would thereby have been exposed in his earliest years to the cultural renewal taking place under Pepin.[8] He knew Ovid and Virgil well. He drew on Ovid's *Amores, Ars Amatoria,* and *Metamorphoses,* on Virgil's *Eclogues,* and especially on the *Aeneid* for the imagery in his poetry.[9] Angilbert's poetic efforts later earned him the nickname "Homer" as a poet of the Palatine Court, a name given him by Alcuin and used affectionately by Charlemagne and the rest of the court circle as well.[10] Beyond that, he seems to have had a fairly extensive training in theology. Much later, in the 790s, Angilbert more than once stood as the official representative of the Carolingian position on difficult theological controversies in Rome, for which he would have needed a good knowledge of the complex doctrinal and philosophical issues involved. Our best guess is that Angilbert was in orders of some sort and served as a cleric.[11]

De conversione Saxonum

It is in one of his poems that the earliest glimpse of Angilbert appears. In 777 or shortly thereafter he wrote a laudatory poem in honor of Charlemagne's conquest of the Saxons the year before. As the attribution of this poem to Angilbert has been controversial, let us first examine the technical issues and then the circumstances and content of the poem itself.

The earliest extant version of this poem is in a mid-ninth century Regensburg codex copied under Liutprand of Salzburg, and accompanied by a number of poems by Alcuin, Angilbert's "Eclogue," and the *Conflictus veris et hiemis.* Another later version, dating from 1494, is in the Pommersfeld Codex, Graf Schonborn MS 2883, included with the work of Hroswitha of Gandersheim. Froben, who published the first edition of the text, attributed it to Alcuin, but Dümmler, in the edition that became normative, claimed authorship for Angilbert.[12] Until recently, this attribution has been widely held.[13] However, recent scholarship has called Angilbert's authorship into question.[14] Most important in this critique has

been the work of Karl Hauck, who linked the poem to the dedication of the great baptismal church at Paderborn and attributed its authorship to Lull, the Anglo-Saxon disciple of Saint Boniface and later Bishop of Paderborn. This was due largely to Hauck's determination that the literary influences, claimed by Dümmler to be Virgilian, were instead from Aldhelm of Malmesbury, a source that Lull would have known from the manuscript collection of Boniface.[15] The early date of the poem (probably 777–778 in Hauck's view) also argued against Angilbert's authorship, since Charlemagne seems not to have begun to form his court of scholars before about 781.[16] Let us reconsider the evidence.

Several elements were determinative in Hauck's analysis. First, the *De conversione Saxonum* placed a great emphasis on Charlemagne's baptism of the Saxons, the primary focus of the poem, as we shall see. Hauck noted the author's use of the word *aula* (*progeniemque novam Christi perduxit in aulam,* line 62 below) which, combined with the baptismal subject matter, in his view linked the composition of the poem to the consecration of the great baptismal *Salvatorkirche,* the first Carolingian *aula Christi,* in Paderborn/Karlsburg in 777. This was, then, a poem written to honor Charlemagne at the celebration of this dedication, which Hauck closely linked to Carolingian interests as *herrscherliche Gottesdienst.* Most important, however, was the consistent borrowing of imagery from the poetry of Aldhelm. The latter point led Hauck to posit an Anglo-Saxon author very familiar with the poetry of Aldhelm, as Lull would have been at least through the manuscript collection of Boniface. Hauck viewed as the key piece of Aldhelmian evidence a laudatory poem celebrating the dedication of the basilica of Saints Peter and Paul in Malmesbury, which would have set the theme and the tone of the 777 hexameter.

The imagery from Aldhelm which appears in the *De conversione Saxonum,* however, is not taken from this poem but from Aldhelm's *De virginitate,* a long hexameter poem written for the nuns at Barking.[17] *De virginitate* is a poem that praises the monastic life by recounting the heroic achievements (and often the deaths) of men and women virgins from the Old and New Testaments and the age of the martyrs, up to Aldhelm's own day. Nothing from the *De conversione Saxonum* comes from this dedicatory poem cited by Hauck. We know, however, that the library inventory of 831 from Saint-Riquier contained a volume from Aldhelm, cited as *Metrum cujusdam de veteri et novo testamento, cum vita Cosmae et Damiani metrica.*[18] While there is no such title in Aldhelm's corpus per se, the description matches, albeit selectively, the content of the *De virginitate.* Moreover, we know that

one of the two earliest manuscripts of the *De virginitate* (now Petro-politanus F.XIV.1), dating from the eighth century, was at Saint-Riquier.[19] I am arguing, therefore, that the manuscript referred to in Saint-Riquier's library was Aldhelm's *De virginitate,* and that it was this text Angilbert knew. Angilbert was fond of Anglo-Saxon sources: he cited Bede in another of his poems.[20] We may accept the rest of Hauck's cogent argument: that this panegyric was written for the dedication of the Paderborn church and in the wake of the Saxon conquest, that it bears all of the relationships to that church and to the rest of Charlemagne's missionary activity in the Saxon territory, and that the poem dates from 777–778. Given the fact that Angilbert was in Charlemagne's entourage *pene ab ipsis infantiae rudimentis* and was long one of the king's closest confidantes, his presence at Pader-born with the king is to be expected. And even though Charlemagne had not yet formed his court circle of scholars in a formal sense, royal patronage would certainly have rewarded so glowing a panegyric of royal and re-ligious power. If Hauck saw Lull's subsequent ecclesiastical advancement in the years after 777 as evidence of Charlemagne's favor for this poetic glorification, we may also cite on Angilbert's behalf the fact that it was very few years later that he went at Charlemagne's behest to Italy to head the palatine chapel of the infant king Pepin, a position of great honor and responsibility. His integral involvement with the king in the exercise of *herrscherliche Gottesdienst* in whatever forms it took, was already well estab-lished by the early 780s.[21]

More recently, Dieter Schaller has suggested that the *De conversione* was written by Paulinus of Aquileia.[22] His argument is based upon a close comparison of this poem with the meter and characteristic phrases of Paulinus's *Regula fidei metrico* written during the doctrinal controversies, in which he finds clear parallels. Although Schaller acknowledged borrowings in the *De conversione Saxonum* from Aldhelm, he saw as far more significant the similarities of the *De conversione Saxonum* with the *Regula fidei metrico,* as well as Paulinus's general abilities with the hexameter. As a consequence, he posited that it was far more likely that Paulinus was the author of the *De conversione Saxonum* than an Anglo-Saxon familiar with Aldhelm, and in-deed, his analysis of the borrowings from the *De virginitate* draws little from that text.

We have already seen that a manuscript of Aldhelm's poem was at the library of Saint-Riquier, and that Angilbert himself used another Anglo-Saxon author, Bede, in his poetry. Schaller also notes that another promi-nent Carolingian poet, Theodulf, drew frequently upon Aldhelm's imagery

as well. This suggests that Aldhelm's work was more widely known and may have served both as an aesthetic and spiritual source for the intellectual circle of which Angilbert, Paulinus, and Theodulf were a part.[23] It is significant that, despite a relatively large poetic corpus (at least for his day), Paulinus seems to have borrowed from Aldhelm primarily in two contexts only: his *Regula fidei metrico* and his *Contra Felicem Urgellitanum,* both much later than the *De conversione Saxonum.* Both of these writings were directed explicitly at the doctrinal controversies in which Paulinus was involved, and perhaps this indicates the nature — or the limits — of Aldhelm's meaning for him as a source of defense of right belief (and by implication the willingness to die for that belief).

The extent to which the *De conversione Saxonum* was dependent upon Aldhelm per se is evident in its imagery and content, as well as in the obvious form of its meter. One of the most striking elements of the *De conversione Saxonum* is its extended description of dates, best illustrated in lines 23 through 26, announcing the year 777:

> Iam septingentos finitos circiter annos
> Et septem decies, ni fallor, supra relicti,
> Ut tradit, septem, priscorum calculus index,
> Adsunt praesentis defluxu temporis anni.

This directly parallels Aldhelm's usage in lines 509 and 510 of *De virginitate:*

> Quatuor et decies cum septem degeret annos
> Progeniem domini narrans ab origine prima.

Aldhelm's words *ab origine prima,* in fact, directly echo those of another date, in line 1 in *De conversione Saxonum: Quintus erat mundi tristis ab origine limes;* and the term *calculus index* above echoes Aldhelm's *calculus index* in line 855. Many other images show direct parallels:

De conversione Saxonum		De virginitate	
49	Raucisonos tinctos furve nigredine corvos/Vertit in albifluas subito iamiamque columbas	Qui plerumque tetros furva nigredine corvos/Vertit in albentes glauco sine felle columbas	491
60	Chrismatibus sacro inunxit baptismate lotos	Hunc pater omnipotens nondum baptismate lotum/Nec balsamorum sacris chrismatibus unctum	679

47	Traxit silviculas ad caeli regna phalanges	Plures perducens ad caeli regna falanges 676
62	Progeniemque novam Christi perduxit in aulam	Donec aetheream miles migraret in aulam 708
71	Princeps interea clemens pro munere tanto	Princeps interea, mundi qui sceptra regebat 1095
20	Sic quoque fellivomi praedam de fauce celydri / Abstulit et cociti calidas spoliavit arenas	Faucibus invidiae sic gloria carpitur atris / Et laus almorum mulcatur fraude malorum 1647
35	Barbarica rabie fluxas grassante medullas	Fluctibus et rabies pulsat per saecula salsis 1737

These are but a few of the phrases and terms that show the parallelism between the poems. Even the content of the *De conversione Saxonum* mirrors elements of Aldhelm. Both are poems about the *missionary* triumph of the true faith in Christ and its effects. Although Aldhelm's poem is about early Christian martyrs, whereas the *De conversione Saxonum* discusses the much later conversion of the Saxons, both exploit the contrast between the bestial savagery of paganism, usually represented in animal imagery (especially wolves, ravenous hounds, and snakes), and pastoral images of Christian gentleness and salvation. Any parallelism between Paulinus's *Regula fidei metrico* and the *De conversione Saxonum* can be attributable to the pervasive and independent use of Aldhelm in both poems, as Theodulf also drew upon Aldhelmian imagery. Access to a manuscript or manuscripts of the *De virginitate* was the key, and here we have the direct proof of a manuscript of Aldhelm in the library at Saint-Riquier.

There are also, however, two other links with Angilbert that find no parallels in the *Regula fidei* of Paulinus. The first is the evidence of poetic structure. There is no evidence in the *Regula fidei* of the type of symbolic structure that organizes the *De conversione Saxonum*. Paulinus's poem seems to lack any conscious structure beyond its meter (hexameter). The *De conversione Saxonum,* however, is tightly structured around the same kind of numerical symbolism that is integral to Saint-Riquier, as we shall see below. It is a striking physical parallelism that cuts across media and indicates a grasp of symbolic meaning that is an overarching conceptualization.

The second is the absolute character of the *De conversione Saxonum*. Paulinus's borrowings from Aldhelm are strictly within a religious and dogmatic context. However, as has often been pointed out by scholars, the *De conversione Saxonum,* with all of its missionary intent, is a deeply secular discussion of royal power closely paralleling Virgil's fourth *Eclogue*. The fourth *Eclogue* was a profoundly political poem lauding in panegyric and

even messianic terms the coming of the prince of peace sent from heaven to accomplish the divinely appointed mission of peace-bringing. The same description of historical time according to the cycle of ages and the heralding of the coming age of glory found in the *De conversione Saxonum* are also characteristic of the fourth *Eclogue*. In this sense, the overarching character of the *De conversione Saxonum* is much closer to Virgil's poem than to Aldhelm's — or Paulinus's. Here again there is a direct link to Angilbert, since the library list of Saint-Riquier includes a copy of Virgil's *Eclogues*. Angilbert had access to this literary resource as well as to Aldhelm. The political character of the *De conversione Saxonum,* then, presents a very different picture of the use of Aldhelm and Virgil than the strictly religious resonances with Aldhelm in the *Regula fidei.*

Let us now turn our attention to the poem itself and the circumstances it describes. As is well known, the Saxon conquest had seemed to resolve a long-standing and intractable problem for the Frankish kings, at whose borders the Saxons stood. First taken over as a tributary state by the Merovingians in the sixth century, Saxony had resisted Frankish military and economic hegemony. Charles Martel had reconquered the Saxons in the early eighth century; Pepin III again fought them and forced them to receive Christian missionaries. He sent Anglo-Saxons, led by Saint Boniface, to do the work. They were willing evangelizers; from the earliest years of Anglo-Saxon missions on the Continent the great hope had been to bring Christianity to the pagan brother Saxons living in the original homeland. Indeed, it was a major motivation for their Continental evangelization in the first place, a matter both of fraternal duty and longing.[24] Thus the urge to evangelize the brethren combined with the aggressive Carolingian interests and provided a new thrust for Frankish hegemony in Saxony, even while it built upon the ancient Frankish warrior culture of raid and plunder that always underlay Frankish territorial expansion.[25]

The pagan Saxons, however, were not eager to be "reunited" with their Anglo-Saxon brethren, nor to endure Frankish domination of any sort. They continually resisted Frankish demands for submission and tribute. Charlemagne led a military raid against them in 772 to assert his own control and gain plunder. He captured their greatest fortress and destroyed their most important religious object, the Irminsul, despoiling its temple of its gold and silver treasure. In 774 the Saxons retaliated by devastating the Frankish borderlands; a small and highly successful Frankish contingent sent by Charlemagne defeated the Saxons, wasted their territories, and carried away much plunder. Finally, in 775, Charlemagne determined that

the Saxons would submit totally to him and to Christianity or be extermi-nated.[26] After an extensive campaign, he conquered in 776 when three Saxon tribes at last submitted to baptism.

The description of that conquest from the *Royal Frankish Annals* — the official court account — is worth examining in detail as a context for An-gilbert's own description in the *De conversione Saxonum*. It is the most valuable chronicle account, because as the official history produced at court, it unabashedly presented the Carolingian point of view and can be expected to have described the Saxon war with high praise. While it is a chronicle entry, very different from poetry, it provides one of the few glimpses into attitudes toward Charlemagne's actions.

> Then a messenger came with the news that the Saxons had rebelled, deserted all their hostages, broken their oaths, and by tricks and false treaties prevailed on the Franks to give up the castle of the Eresburg. With Eresburg thus deserted by the Franks, the Saxons demolished the buildings and walls. Passing on from Eresburg they wished to do the same thing to the castle of Syburg but made no headway since the Franks with the help of God put up a manly resistance. When they failed to talk the guards into surrender, as they had those in the other castle, they began to set up war machines to storm the castle. Since God willed it, the catapults which they had prepared did more damage to them than to those inside. When the Saxons saw their constructions were useless to them, they prepared faggots to capture the fortress in one charge. But God's power, as is only just, overcame theirs. One day, while they prepared for battle against the Christians in the castle, God's glory was made manifest over the castle church in the sight of a great number outside as well as inside, many of whom are still with us. They reportedly saw the likeness of two shields red with flame wheeling over the church. When the heathens outside saw this miracle, they were at once thrown into confusion and started fleeing to their camp in terror. Since all of them were panic-stricken, one man stampeded the rest and was killed in return, because those who looked back out of fear impaled themselves on the lances carried on the shoulders of those who had fled before them. Some dealt each other aimless blows and thus suffered divine retribu-tion. How much the power of God worked against them for the salvation of the Christians, nobody can tell. But the more the Saxons were stricken by fear, the more the Christians were comforted and praised the almighty God who deigned to reveal his power over his servants. When the Saxons took to flight, the Franks followed on their heels as far as the River Lippe, slaughtering them. Once the castle was safe, the Franks returned home victorious.

When the Lord Charles came to Worms and heard what had happened he called an assembly there. He held his general assembly, and after deliber-ation, suddenly broke through the fortifications of the Saxons with God's

help. In great terror all the Saxons came to the source of the River Lippe; converging there from every point they surrendered their land to the Franks, put up security, promised to become Christians, and submitted to the rule of the Lord King Charles and the Franks.

> The Lord King Charles with the Franks rebuilt the castle of Eresburg and another castle on the River Lippe. The Saxons came there with wives and children, a countless number, and were baptized and gave as many hostages as the Lord King demanded. When the above castles had been completed, and Frankish garrisons installed to guard them, the Lord King Charles returned to Francia.[27]

Two points stand out. First, the overwhelming emphasis of the passage was on the power and victory of God. It was he who controlled and conquered; Charlemagne and his Franks were in total dependency to him. It was God who acted when Charlemagne suddenly overcame the Saxon fortifications. The defeat was divine retribution. The victory was comfort and escape for the Christians. The supernatural character of the conquest was emphasized by the miracle story, in which "God's glory was made manifest." Interestingly, although conversion to Christianity was one result of the defeat, (and the only aspect on which Angilbert chose to focus) according to this annalist paganism was not the Saxon problem. God's retribution was sent because of their perfidy against the Christian Franks, because they rebelled, abandoned hostages, broke oaths, and attacked Frankish forts. Of course it was clear that God supported the Franks because they were Christians. But virtually nothing was said here of Saxon paganism, and baptism into Christianity was presented very much within the context of political submission to "the Lord King Charles and the Franks." The whole question of religious belief or adherence to a form of worship, then, was political. It was the following of the tribal, Frankish, god who brought victory and prosperity.

Second, and perhaps more striking, was the tribal emphasis of the author. Surrender and submission were not just to Charles, but to Charles and the Franks. Similarly, it was as a group that the Franks completed the rebuilding of the devastated territory. Most significant was the fact that it was after the deliberation of the Frankish assembly — and not on the initiative and action of Charles alone — that the king "suddenly broke through the fortifications of the Saxons with God's help." Here the tribe was all important, and defined the power and majesty of the king.

Only one other contemporary source sheds light on attitudes toward

the Saxon conquest of 777. That is a letter from Pope Hadrian to Charlemagne congratulating him on the victory. The tone of this letter was very similar to that of the *Annals* with regard to the power of God and the meaning of the victory, although there was no tribal emphasis.

> When we had heard this, our soul, rejoicing in the Lord, was lifted up with the joy of powerful exaltation; and thereupon with palms stretched to the heavens, we repeated sumptuous praises to the King of kings and Lord of lords, beseeching more earnestly his ineffable divine clemency, so that he might grant you both safety of body and salvation of soul and might grant tremendous victories over enemies, and put all barbarous nations under your feet . . . From that day on which you set out in those parts from this Roman city, daily at spontaneous moments and even for unremitting hours all our priests, and even religious servants of God, monks, through all our monasteries at the same time, and the rest of the people both through titular priests and deacons, with voices raised do not cease to proclaim to our God three hundred Kyrie eleisons on your behalf, and on bent knees to beseech the same most merciful Lord our God that he grant you greatly both pardon of sins and the greatest joy of happiness, and beyond, plentiful victories from heaven.[28]

Again the emphasis was on God's work and God's victory. In the papal view Charles was totally dependent upon God for success. And, as in the *Annals,* the critical issue here was the conquest of barbarians, rather than the conversion of pagans. That the conversion was not even mentioned in this letter from the Vicar of Peter is remarkable. As remarkable was the chanting of the kyrie, the penitential prayer for mercy, three hundred times, since 300 was the symbol of the heavenly kingdom, perfection in the Trinity. As we shall see below, it was a most important symbol to the Franks, the product of 100, the symbol of perfection, times 3, the symbol of the Trinity.[29]

Let us now consider Angilbert's poem within this context of thought about the Saxon war. The tone of Angilbert's work was quite different, a virtual panegyric on that triumph, written in the vein of the old exhortatory papal letters sent to Pepin III and Charlemagne calling them to holy war as kings of a Chosen People.[30] In fact, the very focus of his work was different: not the conquest, but the *conversion* of the Saxons. Here follows Angilbert's text.[31]

I

Quintus erat mundi tristis ab origine limes Expletus, morbo nimium tabefactus acerbo	The fifth course from the beginning of the sad world had been completed, Made to waste away too much with a harsh disease

Quatuor horribilis metas dum
 torqueret orbis,
Dumque diurna rotans
 redeuntia saecla redirent,
5 Quae patribus promissa darent
 fulgentia regna.
Post cepit sextus felix se volvere
 cardo,
Qui meruit tandem praedictum
 germinis alti
Adventum, antiquis multisque
 capessere saeclis.
Qui genitor solio clemens
 prospexit ab alto
10 Pompiferum mundum, dura
 sub morte iacentem,
Et genus humanum, ex limo
 quod finxerat olim,
In baratri cernens foveam
 mersisse profundam.
Tunc pater omnipotens, rerum
 gratissimus auctor,
Ille pius sator, superam qui
 temperat axem,
15 Progeniem sanctam praecelsa
 mitis ab arce
Misit, et extemplo cinxit lux
 aurea mundum,
Horrida probosae dempsit qui
 crimina mortis,
Et facinus mundi Iordanis lavit
 in undis,
Signavitque pios pretiosi
 sanguinis ostro.
20 Sic quoque fellivomi praedam
 de fauce celydri
Abstulit et cociti calidas
 spoliavit arenas,
Victor ovans rediit, patriam
 remeavit ad arcem.

Until the horrible limit had twisted the
 four poles of the earth,
Rotating daily, until the returning ages
 should come back
Which might give the shining kingdoms
 promised to the Fathers.
Next the sixth happy hinge began to turn
 itself,
Which finally was worthy to grasp the
 coming
Of the noble offshoot prophesied in many
 and ancient ages.
The clement Father surveyed from the
 exalted throne
The pomp-bearing world, prostrate under
 harsh death,
And seeing that humankind, which he had
 once formed from the dirt
Had sunk into the deep abyss of the lower
 world.
Then the almighty Father, most gracious
 author of things
That devoted begetter who controls the
 sky above,
Gentle one, sent a holy progeny from the
 lofty citadel—
And immediately a golden light girded
 the world—
A progeny who took away the horrid
 accusations of infamous death,
And washed away the crime of the world
 in the waves of the Jordan,
And marked the pious with the purple
 dye of precious blood.
And thus he snatched the plunder from
 the jaws of vile-spewing Celydrus
And despoiled the hot sands of Cocytus;

The victor rejoicing came back, he
 returned to the paternal citadel.

2

Iam septingentos finitos circiter
 annos
Et septem decies, ni fallor,
 supra relicti,

Now about seven hundred completed
 years
And seven times ten, unless I err, besides
 seven left over,

25 Ut tradit, septem, priscorum calculus index,	As the calculator index of the ancients hands down,
Adsunt praesentis defluxu temporis anni,	Are present by the flowing away of the time of the present year,
Quo Carolus nono regnat feliciter anno,	And in that year Charles is reigning happily for his ninth,
in quo Saxonum pravo de sanguine creta	In which the nation of the Saxons, sprung from depraved blood,
Gens meruit regem summum cognoscere caeli,	Merited to know the highest king of heaven;
30 Sordida pollutis quae pridem dona sacellis	A nation which long ago was placing filthy gifts at polluted temples
Ponebat rapidis bustim depasta caminis,	Consumed with quick flames, pyre-like;
Rite cruentatas tauros mactabat ad aras.	Duly was slaughtering bulls at bloodied altars.
Et demonum cultus colla inflectendo nefandos,	And, by suppliantly bending necks, venerating the abominable cults
Suppliciter venerans proceresque, deosque, penates,	Of demons, and princes, gods, penates;
35 Barbarica rabie fluxas grassante medullas,	While barbaric rage was attacking flowing marrows,
Pro rerum fortuna plebs miseranda rogabat.	The people needing to be pitied was praying for the good fortune of life.
Hoc genus indocile Christo famularier alto	This nation, not knowing how to serve the exalted Christ,
Ignorans, dominum nam corde credere nolens	For not wanting to believe in their hearts that the Lord
Ob causam nostrae in mundum venisse salutis	Had come into the world for the sake of our salvation,
40 Hanc Carolus princeps gentem fulgentibus armis	This nation Charles the prince, bravely girded
Fortiter adcinctus, galeis cristatus acutis,	With shining arms, crested with pointed helmets,
Arbitris aeterni mira virtute iuvatus,	Helped by the wonderful strength of the eternal judge,
Per varios casus domuit, per mille triumphos,	He tamed through different destructions, through a thousand triumphs;
Perque cruoriferos umbos, per tela duelli,	And through blood-bearing shields, through spears of war,
45 Per vim virtutum, per spicula lita cruore	Through the strength of virtues, through javelins smeared with gore
Contrivit, sibimet gladio vibrante subegit:	He crushed down and subjected it to himself with a shimmering sword.
Traxit silvicolas ad caeli regna phalanges,	He dragged the forest-worshipping legions into the kingdoms of heaven

Moxque lupos saevos teneros
 mutavit in agnos;
Raucisonos tinctos furva
 nigredine corvos

And thereupon changed savage wolves
 into tender sheep;
Raucous ravens dyed with inky blackness

50 Vertit in albifluas subito
 iamiamque columbas,
Alipedes griphes subito
 arpeiasque volucres

He turned suddenly and immediately into
 snow-white doves,
Wing-footed griffins and flying harpies

In placidas convertit aves,
 dirosque molossos
Transtulit in molli tectas
 lanugine dammas,
Saltigerosque tygres, fulva
 cervice leones

He converted into placid birds, and
 frightful hounds
He transferred into gentle gazelles
 covered in soft down,
And pouncing tigers and tawny-necked
 lions

55 Haud secus ut pecual proprio
 reclausit ovili.
Postque salutiferi perfusos rore
 lavacri,
Sub patris et geniti, sancti sub
 flaminis almi
Nomine, que nostrae constat
 spes unica vitae,
Christicolasque rudes ad caeli
 sidera misit,

Hardly different from a herdsman he
 contained in his own sheepfold.
And afterwards poured over with the dew
 of salvation-bearing baptism,
Under the name of the Father and the
 Son and the dear Holy Breath,
By which the only hope of our life stands
 firm,
The Christ-worshipping rude ones he sent
 to the stars of heaven,

60 Chrismatibus sacro inunxit
 baptismate lotos,
Quo iam fumiferas valeant
 transcendere flammas,
Progeniemque novam Christi
 perduxit in aulam.

He anointed with chrisms those washed
 by holy baptism,
So that they might already by able to rise
 above the smoky flames,
And he led the new progeny of Christ
 into the great hall.

3

Porro celsithronus iudex cum
 factor Olimpi
Venerit, ultricibus mundum
 damnare favillis,

Again when the heaven-enthroned judge,
 maker of the heavens,
Shall have come to condemn the world
 with avenging ashes,

65 Et vas pestiferum caelesti
 fulmine fractum
Ad Stigias raptim vinctum
 retruserit umbras,
Pulvereoque globo versutum
 coxerit anguem,
Quo sine fine dolens picea
 marciscat in olla,
Cunctorum meritum trilibri
 tunc lance librando,

And the vessel of pestilence shattered by
 celestial thunder
Shall have pushed the bound one back
 violently to the Stygian shadows,
And he shall have cooked the crafty snake
 on the dusty world,
So that grieving without end it might
 waste away in a pitch pot,
Then by weighing the merit of all on a
 three-pound scale,

70 Lactea dona bonis, seu tristia iungit amaris,	He joins milk-white gifts to the good, and sad gifts to the bitter;
Princeps interea clemens pro munere tanto	Meanwhile may he grant that the clement prince, for so great a reward,
Praestet, ut astrigeri potiatur praemia regni;	may take possession of the prizes of the star-bearing kingdom,
Dulcia mellifluae degustet pascua vitae:	May he taste the sweet pastures of honey- flowing life:
Pascua, quae noster iamdudum iure redemptor	Pastures which our redeemer already long since
71 Caelicolisque dare proprio promisit ab ore.	Promised by right with his own mouth to give to heaven-dwellers.

The poem has seventy-five lines.[32] It contains three major sections divided in terms of time and protagonist. There is one continuous theme throughout: salvation. Three characters—God the Father, God the Son, and Charlemagne—perform. More than half of the poem, forty-two lines, is devoted to Charlemagne; thirty-three lines are given to the Father and the Son.

The first section, comprising lines 1 through 22, opens with a prologue that sets the conditions of time and circumstance. This is the sixth age of the world after five ruinous ages have passed: *post coepit sextus felix se volvere cardo* (line 6). These ages were so devastating that the earth itself has rotted and its very poles have been twisted out of shape. Physical decay and chaos mirror the moral condition of the world: *et genus humanum ex limo quod fecerat olim, in baratri cernens foveam mersisse profundam* (lines 11–12). But the endless cycle of days promise hope of better things, the "shining kingdoms promised to the ancients," *redeuntia saecla redirent, quae patribus promissa darent fulgentia regna* (lines 4–5), because with the advent of the sixth age comes the hope of redemption. God the Father and Creator has surveyed the world as a cosmic emperor from his heavenly throne and has sent his "holy progeny" (*progeniem sanctam*, line 15) from the heavenly citadel who will save humankind. In baptism this savior has purified the world of crime (*Et facinus mundi Iordanis lavit in undis*, line 18), and then, as a glorious young warrior, he has despoiled Hell of its treasure, condemned men: *sic quoque fellivomi praedam de fauce celydri abstulit et cociti calidas spoliavit arenas* (lines 20–21).

That Angilbert's computation of time has a deliberate theological and messianic intent we can see from recent studies of early medieval chronography.[33] The theory of six ages, long and widely combined since the Early Christian period with the calculation of six millennia until the Second

Coming, implies a deliberate apocalyptic intent. The ancient Hippolytan calculation that the world would end and the Apocalypse would arrive in the year 6000, despite theological prohibitions on predicting the Second Coming and attempts to dislodge such calculation, seems to have had such popular currency that the switch to chronography *anno domini* and the rejection of the genre of universal history in the Carolingian period did not fully solve the problem. That Angilbert would have used such a calculation to introduce his poem indicates not only the persistence of the tradition, but also the clear intent of the poem: to glorify Charlemagne as a messianic figure in the current age. Indeed, the identification of Charlemagne with Christ is pervasive. Their work takes place in the same age, the age of salvation, the establishment and propagation of the Church in an ongoing and uninterrupted progress. Charlemagne completes the work that Christ began. Angilbert here makes no reference to the progressive development of the arts of civilization and society throughout those ages; in his poem the ages preceding the Incarnation were unregenerate, bad, chaotic. Hence the redemptive work that occurs here truly appears as the only hope of mankind in salvation from the chaos that would otherwise continue.

Angilbert's action and characters in this section are strictly Biblical, focusing on the redemptive acts of Christ and the Father. But within that Biblical picture he paints many of the details in Classical or Germanic colors. Hell, for example, is called "the hot sands of Cocytus" (one of the tributaries of Acheron, the river of Hell) and "the vile-spewing jaws of Celydrus" (the most deadly of poisonous snakes, which in the Carolingian period was a metaphor for the Devil). Both these images are taken from the *Aeneid*. His description of Christ, however, stands squarely within the Frankish warrior tradition. Christ's victory is portrayed as the seizing of human plunder which he carries back in glory to the fortress of heaven. Two words in particular underscore the image: Christ has snatched away "plunder" (*praedam*) and "has despoiled" the hot sands (*spoliavit*, lines 20–21). Salvation here is purification and battle with the forces of Hell, whose treasure horde the victor has brought to his father's high palace.[34]

Angilbert carries on and expands the symbolism of salvific battle in the second section of the poem (lines 23–62). The transition, an extended time description playing with the number seven—seven hundreds plus seven times ten plus seven years—is minimal: *iam septingentos finitos circiter annos et septem decies, ni fallor, supra relicti, ut tradit, septem, priscorum calculus index, adsunt praesentis defluxu temporis anni* (lines 23–25). Angilbert's reference to the calculator index of the ancients and his use of the image of the

flowing out of present time add gravity to the description, which provides the context for this special year of Charlemagne's reign. The short transition juxtaposes the great victor Christ quite radically with Charlemagne, the victor and protagonist of this section. That juxtaposition casts Charlemagne himself in a salvific role toward the Saxons. Here we may detect echoes of the *laudes regiae,* with their similar associations of the king and Christ.[35] Lines 27 and 40 (*quo Carolus nono regnat feliciter anno . . . hanc Carolus princeps gentem fulgentibus armis*) whose subject is Charlemagne, function almost parenthetically to enclose the barbarians in their false worship and focus them on his coming action. The Saxon rites are demonic, inspired by Hell (*et demonum cultus colla inflectendo nefandos,* line 33), and carried out with slaughter on impure altars (*sordida pollutis quae pridem dona sacellis,* line 30, and *rite cruentatas tauros mactabat ad aras,* line 32). And because they worship devils and idols they are virtually possessed with uncontrollable rage in the very marrow of their bones: *barbarica rabie fluxas grassante medullas* (line 35). This echoes the savagery of the original condition of humans described in the first section, humans prior to the effects of civilization and redemption, prior to the possibility of peace.

Here, however, the remedy is immediate. Charlemagne, glittering with warrior splendor (*fulgentibus armis adcinctus,* lines 40–41), strengthened by virtues, and helped with amazing power from God (*arbitris aeterni mira virtute iuvatus,* line 42 and *per vim virtutum,* line 45), ends that possession through conquest and subjection of the Saxons to himself (lines 41–45). His very person shimmers with divine favor; the sword, normally the instrument of death, becomes in his inspired hand the transmitter of life, soaked with sacred power: (*sibimet gladio vibrante subegit,* line 46). It is so for one reason: Charlemagne by it has "dragged the forest-worshipping legions into the kingdom of heaven" (*traxit silvicolas ad caeli regna phalanges,* line 47) and thereby initiated a profound transformation in the Saxons. Their demons flee and they become peaceful. Lines 47 through 55 concentrate in striking metaphors the full meaning of conquest as a movement from the demonic and devilish to the pure and benign, from aggression to peace. Screeching black ravens become gentle white doves, vicious wolves lambs, and snarling dogs soft gazelles (*moxque lupos saevos teneros mutavit in agnos; raucisonos tinctos furva nigredine corvos vertit in albifluas subito iamiamque columbas; dirosque molossos transtulit in molli tectas lanugine dammas,* lines 48–49, 52–53). The sword brings form out of chaos and life out of death.

Charlemagne's victory is a cosmogony. It brings resolution out of

conflict by virtually replicating the original divine work of creation and most especially the divine work of redemption. The images of beastly chaos echo the horrible condition of the world before the coming of the holy progeny in the first section; here the effects of salvation are made explicit. Critical is the form that lies at the heart of that new world, the Trinity. The sacrament, the "dew of salvation-bearing baptism" (*salutiferi . . . rore lavacri,* line 56), becomes a hierophany, the manifestation of the Holy Trinity "under the name of the Father and the Son and the dear Holy Breath" (*sub patris et geniti, sancti sub flaminis almi nomine,* lines 57–58). The Trinity is the center, the fixed orientation, the reference point of this world "by which the only hope of our life stands firm" (*que nostrae constat spes unica vitae,* line 58), and in which the true power and source of all life and fecundity lie. The invasion of the Trinity through the invasion of the Franks has brought the Saxons into the *aula,* the "great hall" of sacred space of the Trinity-worshippers.

It is significant, however, that the real focus and determining factor here are not the actual sacrament of baptism. Although important, it is subordinate to the conquest. Rather, that which transforms is the sword. It is the sword that in the potent hand of Charlemagne becomes a virtual liturgical, almost sacramental instrument that mediates between heaven and earth. It is a physical channel of grace in its power to subject. It is the shimmering sword of Charlemagne that has overcome demonic powers; it is his sword that has brought about the great transformation of the barbarians into a people and enabled them to live a human life, indeed to receive the baptism that has saved them in an ultimate sense. Most important is that it is Charlemagne's sword, for it is the piety of his heart that yields the power of his hand.

His triumph is single-handed. No army backs him up, no mention of troops, no deliberations of Franks. Only his charismatic person makes war here to complete the cosmic battle for salvation. This is a power very different from that described in the *Annals* or the papal letter, for even such phrases as "helped by the wonderful strength of the eternal judge" seem to disappear under the force of the actions ascribed to Charlemagne. He has tamed (*subegit,* line 46), converted (*convertit,* line 52), sent to heaven (*ad caeli sidera misit,* line 59), and led the progeny of Christ into the great hall (*progeniemque novam Christi perduxit in aulam,* line 63). These verbs assert virtually salvific action. Charlemagne has saved the Saxons by conquering them and bringing them peace in the name of the Trinity. He has carried out in microcosm the salvific work that the great warrior Christ has carried out

cosmically. He is successful because he is the warrior of the Eternal Judge. Whether that judge is the Father or the Son Angilbert does not make clear. Interestingly, his ambiguity here mirrors the unity of the persons of the Trinity which characterized the Western Augustinian theological tradition. What was predicated of one person was predicated of all. Here we might say there is even a confusion of persons.

The third and final section of the poem speaks of the Final Coming, the end time of the world when the Last Judgment will reduce the world and bring the faithful to their eternal reward. This section is very short, comprising lines 65 through 75. The first six lines again provided the transition and set the context; the last five prayed for the just reward due to the king, to "take possession of the prizes of the star-bearing kingdom" (*ut astrigeri potiatur praemia regni*), and "taste the sweet pastures of honey-flowing life" (*dulcia mellifluae degustet pascua vitae*). Again the main actor was the terrible and just judge (ambiguous as to whether the Father or the Son); nevertheless, the focus was still on Charlemagne, who was now shown worthy to receive the prize of eternal life.

The effect of the second section and its powerful images of Charlemagne remained, particularly since this closing section was so short. Charlemagne, even as one needing to be saved, seemed to have superhuman status. He was more than a man; he was a mediator between man and God. Indeed, that was one of the great innovations of this poem, particularly in comparison with the far more modest claims of the *Royal Frankish Annals* and the letter of Hadrian regarding the conquest of the Saxons. Those texts continually emphasized the power of God as the determining force in the victory. It was God's victory, to which Charlemagne happened to be privy. But here the active force was Charlemagne himself, and his status was very much magnified. It was *his* status that dominated, it was he who acted, and he who conquered. He was in this poem the third member of a trinity of actors: the Father ruled from the high citadel, the Son justified the world through blood sacrifice, and Charlemagne continued that redemptive process through the imposition and extension of right worship. He shared center stage, dominating alone fully half of the poem, while Father and Son shared the other half. It is true that the subject of the poem was the work of Charlemagne with the Saxons; but its setting in this overall context of cosmic redemption and the work of the Father and the Son was more than suggestive. Whether he intended to or not, Angilbert here took a great ideological step in the magnification of the figure of the ruler.

Angilbert's poetic technique reinforced the trinitarian theme that the developed in the poem, because it implied a numerological structure based

on the numbers three and seven. The work was divided into three major parts. There were three characters who acted, Father, Son, and Charlemagne. The two sections that referred to the Father and the Son and the cosmic redemption comprised thirty-three lines. The year of Charlemagne's triumph chosen by Angilbert was 777 — "seven hundreds plus seven times ten plus seven left over" — even though the actual battle and conquest took place in 776. For the Carolingians, as we shall see, three symbolized the Trinity quite directly. Seven was both a trinitarian number referring to the ongoing salvific work of the Holy Spirit in the world, and an apocalyptic number signifying the End Time of justification of the righteous and condemnation of the wicked. Even the coincidence of this year with the ninth of Charlemagne's reign was suggestive, since nine, or three times three, was also a trinitarian symbol.[36] The symbolic structure of the poem, then, evoked the very truths that Angilbert wanted to convey.

What was important for Angilbert in the *De conversione Saxonum,* thus, was the focus of the whole poem upon the phenomenon from a religious — or, better, perhaps — a politico-religious point of view. The various chronicles and Pope Hadrian's letter spoke in prosaic terms about conquest. But for Angilbert, what was significant was that conquest brought about salvation. This was the life-giving battle waged by the unique king. Through it the Trinity was made manifest as the center of the sacred world that Charlemagne ruled. It was the truth exposed and made available to all who were subject to him, for their peace right now and their eternal salvation.

In 781 Charlemagne appointed Angilbert as *primicerius* of the palace chapel of his three-year-old son Pepin when he made Pepin King of Italy. Angilbert was resident at Pepin's court at Pavia. We have little knowledge of what that title meant in substance; the use of the term for Angilbert appears only in a letter of Alcuin dated probably before 792.[37] The letter asked Angilbert to obtain King Pepin's aid for a pilgrim on his way to Rome and requested him to send relics to Alcuin in Francia:

> Mindful of the mutual friendship between us, I have presumed to direct these letters to you, beseeching you kindly to deign to receive the bearer of these letters, and intercede with the king, Lord Pepin, to assist the ways of his pilgrimage. . . . I beg you most devotedly besides, dearest brother, to take care also to send me the gifts sweetest and most necessary to me, that is, the relics of the saints, or some relics.

Originally the term *primicerius palatii* referred to the first among the palace chaplains (the more common usage being *capellanus* or *archicapellanus*) charged with caring for the cape (*cappa*) of Saint Martin and the

other relics of the royal palace, and with carrying those relics into battle.[38] The *primicerius* seems to have been primarily a religious official and advisor; Fleckenstein understood by this title that Angilbert was the head of the royal chapel at Pavia.[39] Given the great desirability of Italian relics to the Carolingians — and especially relics of the martyrs — Angilbert's role as procurer of relics would have been extremely important.[40]

It is from later letters, dating from the 790s and referring to Angilbert's work back again at the court of Charlemagne, that we can infer more of what he did. Another letter from Alcuin, dated between 792 and 796 (when Alcuin was travelling between Rome and Charlemagne's court on diplomatic missions) asks Bishop Agino of Constance to send him relics through Angilbert.[41] At the same time, Pope Hadrian's letter to Charlemagne on the image controversy, cited above, refers to Angilbert as *ministrum capellae,* minister of the royal chapel, and in 796 a letter from Charlemagne to Pope Leo III introduces him as *manualem nostrae familiaritatis auricularium.* "the secret counsellor and secretary of our intimacy."[42] Taken together, these references suggest that he served Pepin in an ecclesiastical and advisory capacity, since the *primicerius* was a royal advisor and Angilbert had been educated for royal service. The later references to *manualis* and *auricularius,* both important and confidential posts at the court of Charlemagne, imply some of the work that Angilbert probably did for Pepin in Pavia, since they refer to a confidential secretary entrusted with the secrets of state and probably the king's private life.

As *primicerius,* Angilbert was a key figure in the administration of these territories throughout the 780s, although in all of these matters the main actor and most important figure was Charlemagne, since the subkings really functioned only as auxiliaries to him. It is significant, for example, that none of the papal letters in the *Codex Carolinus* from this period mentions Angilbert. All of those letters, even those on relatively minor matters, were exchanged directly between the pope and Charlemagne, and through other specifically appointed legates. On the other hand, Angilbert is always mentioned as legate for issues in which he was involved in the letters of the 790s. Thus we can surmise that Angilbert's concerns were primarily the local ones of administering the Lombard territory and church, whereas major questions of direct dealings with Rome and the initiation of military campaigns were still in Charlemagne's hands.

Angilbert also traveled back and forth between Pavia and Charlemagne's itinerant court where, after 782, he met Alcuin newly arrived from York. The two formed a long and extremely close friendship, as witnessed in

the intimate language with which Alcuin addressed Angilbert in his letters. By 794 he was calling him "the most elect envoy of my lord king, indeed my dearest son."[43] The Anglo-Saxon master took a paternal attitude toward Angilbert, mentioning him often in letters, asking and returning favors, and rebuking him on his love of public games. Alcuin was as devoted as a father to many of the members of the court circle, often referring to Paulinus, Arn, and others as his "dearest sons." But the extent of his love for Angilbert is revealed in a letter written in 796 asking Angilbert to intercede on his behalf with Pope Leo III for special forgiveness of a sin that troubled him deeply:

> You being gone, I have often tried to come to the port of stability. But the rector of things and the dispenser of souls has not yet conceded that I am able to desire what I once did. The wind of temptations still flails the young branches of reflection being born from the depths of the heart, so that the flowers of consolation and the fruits of rest cannot be nourished. . . . But if I might return to the point again with a creased brow, indeed demanding that you, as a friend of like mind, begging that you, as the caretaker of a soul, intercede for the counsel of our souls from God, with the approval of the holy apostles. For the chain of necessity constrains us both, as I recognize, and does not allow us to enter the forts of the will with a free course.[44]

This passage has been interpreted as evidence of a homosexual relationship between Angilbert and Alcuin.[45] This view is based upon the phrase "the chain of necessity (*catena necessitatis*) constrains us both," interpreting the chain of necessity to be a mutual sin. Although this is possible, the language Alcuin uses is not in itself evidence of such. To a great degree it follows medieval convention, and it reflects a certain emotional character evident in many of Alcuin's letters. His references to Arn and Paulinus have already been cited, and in general it is clear that he means these affectionate titles and remarks in a spiritual sense. Alcuin's letters in the years between 793 and 796 reveal a real turning inward and an increasing concern with the approach of death, which may account for the intensity of his reaction in this letter toward whatever chain of necessity he and Angilbert knew.[46]

Whatever Angilbert's bond with Alcuin, it was also during these years that Angilbert began a marital relationship with Bertha, the daughter of Charlemagne. Two sons, Nithard, who later became abbot of Saint-Riquier, and Hartnid were born of the relationship. Angilbert described his boys playing in the garden of their home in the *Ecloga ad Carolum regem* a poetic account of the court of Charlemagne written sometime during the 790s.[47] The relationship was most likely *Friedelehe*, an ancient Germanic

custom of marriage by mutual consent, usually between partners of unequal status, in which the woman remained under the power of her own kin. It was essentially a romantic match. If Angilbert was a cleric, the marriage is an indication that conditions at court were quite fluid, despite the evidence of the capitularies that Charlemagne was eager to regularize and reform the clerical status.[48]

Ex filio pater

Sometime around the year 789, Charlemagne appointed Angilbert abbot of the monastery of Saint-Riquier. In a letter dated 790, Alcuin addressed Angilbert as *filium, nunc vero ex filio patrem,* "my son, but now from my son to my father," which seems to refer to the new dignity.[49] Saint-Riquier had first become prominent under Pepin, Charlemagne's father, who had given it to Widmar, one of his chancery secretaries. Pepin characteristically awarded abbacies for service in the royal chancery, as he also did, for example, with the abbey of Saint-Denis to his chaplain Fulrad, and of Marmoutier to Badillo.[50] Charlemagne continued the practice, a further indication of Angilbert's work and worth in Italy and at court. The tradition may explain why it was that Angilbert was given this particular abbey.

Angilbert was an absentee abbot, at least during the years of the reconstruction, probably living at court as part of Charlemagne's entourage. From 791 through 796 he was intimately involved in the theological controversies as Charlemagne's papal envoy, completely conversant with the issues continually being discussed at court. He was *ministrum capellae,* as a letter from Pope Hadrian to Charlemagne called him in 791, therefore a member of Charlemagne's palace chapel. And as *missus* to the Pope, he was entrusted with the most delicate theological negotiations with Rome. Angilbert's high position at court during those years and the extent of Charlemagne's trust in his friend are evident in a letter of presentation with which Charlemagne introduced Angilbert to Pope Leo III in 796. He called him *manualem nostrae familiaritatis auricolarium,* "the secret counsellor and secretary of our intimacy."[51] He was confidential secretary and counsellor, privy to the king's public and private wishes. His poem of the 790s, the *Ecloga ad Carolum regem,* described in intimate detail the life and people at court, and as we have noted above, spoke of Angilbert's boys, Nithard and Hartnid, playing in the garden of their home nearby. A letter from Alcuin to Charlemagne in 799 spoke of Angilbert as a friend of Peter of Pisa,

then teaching grammar at Aachen, and as privy in the palace to Peter's concerns.[52]

In 792 Charlemagne commissioned Angilbert to conduct Felix of Urgel to his recantation and to carry the *reprehensia* of the *Libri Carolini* to Pope Hadrian in Rome. His task was a difficult and sensitive one, as it was he who had to argue the Carolingian position not only on Adoptionism, but also on Iconoclasm and the Trinity, with a Pope who was essentially favorable to the Byzantines. Hence he needed an integral knowledge of the theological argument and its early development among the scholars who served as theologians. And he needed consummate diplomatic skill to convince Hadrian of the official Carolingian position. Although Hadrian would not budge on the *filioque* issue or on images, he responded fully to Charlemagne's concerns and sent back a detailed and comprehensive critique of the *Libri,* as we have seen.[53]

It was probably also at this time, around 790, that Angilbert began the work for which he is most famous, the razing and rebuilding of the monastery of which he was abbot. He undertook the task with both the encouragement and the open patronage of Charlemagne, who commissioned the most precious building materials from throughout the world, and with the largesse of the Frankish nobles. He began to rebuild the simple seventh-century monastery on a much larger and more opulent scale, dedicating it as a symbol of the "veneration of the holy Trinity."[54] Given his involvement in the negotiations of the theological issues, it will become clear that Angilbert undertook the rebuilding at Charlemagne's behest in order to put into concrete terms and to develop (and assert) the Carolingian position more fully. With Hadrian's rejection of the arguments of the *Libri,* Angilbert's architectural and liturgical creation at Saint-Riquier became even more forcefully an alternative understanding of art and symbol.

In 796 Angilbert went to Rome yet again, this time from the court at Paderborn, where Charlemagne was again fighting the Saxons. His work this time was to create a liaison between Charlemagne and the new Pope, Leo III. He carried with him not only the congratulations of the king and exhortations explaining the proper respective roles of Leo and Charlemagne, but also a portion of the Avar treasure just captured by King Pepin as a gift for the Pope.[55]

It was probably in connection with this journey to Rome that Angilbert wrote his poem in honor of King Pepin, *Ad Pippinum regem,* in which he described Charlemagne, Louis, and the sisters of Pepin lamenting the young king's absence from the family and longing to see him coming

over the Alps. The *Royal Frankish Annals* for this year also record that Charlemagne "in the palace at Aachen was happy to see his son Pepin returning home from Pannonia bringing along the treasure."[56]

Another poem to Louis the Pious, King of Aquitaine, was probably written at the same time. This was a dedicatory poem for a manuscript of the *De doctrina christiana* which Angilbert had copied and sent to Louis. His choice of text and his description of it in the poem are significant because they reveal Saint Augustine as a major source of Angilbert's thought and give important insight into Angilbert's understanding of symbols. For Angilbert the most important aspect of the *De doctrina christiana* was its treatment of the things of this world as symbols of the kingdom of heaven, the transcendant realm where truth resides.

Angilbert's poem not only summarized the meaning of Augustine's symbols, but showed that it was a critically important duty of kings to understand those Christian symbols as well. The text is as follows:

I

Hic Augustini Aurelii pia dogmata fulgent,	Here glow the reverent dogmas of Augustinus Aurelius,
Quae de doctrina aedidit almifica	Which he set forth on teaching that nourishes.
Haec tibi multa docent, lector, quod quaeris honeste,	These teach you many things, reader, because you seek virtuously,
Si replicare cupis scripta sacrata libri.	If you desire to unfold the sacred writings of the book.
5 Huius enim corpus, parvum quod cernitur esse,	For the body of this book, which seems to be small,
Continet insertos quattuor ecce libros.	Contains — behold — four books mingled within.
Primus enim narrat Christi praecepta tenere,	For the first explains how to keep the teachings of Christ,
Quae servare deus iussit in orbe pius:	Which God, the Righteous One commanded us to observe on earth:
Rebus uti saecli insinuans praesentibus apte	Suggesting how to use the present goods of the world well,
10 Aeternisque frui rite docet nimium.	It also rightly teaches how to enjoy the eternal goods to the utmost.
Edocet ex signis variis rebusque secundus,	The second instructs by different signs and objects
Qualiter aut quomodo noscere signa queant.	How and in what way signs can be known.
Tertius ex hisdem signis verbisque nitescit:	The third glitters with these same signs and words:

Quid sint, quid valeant
 quaeque vitanda, canit.

15 Tunc promit quartus librorum
 dicta priorum:

Quid res, quid signa, quid pia
 verba docent,

Qualiter et possint cuncta
 intellecta referre,

Magno sermone intonat ipse
 liber.

Summisse, pariter moderate,
 granditer atque,

20 Lector, perlecta dic: Miserere
 deus.

Hunc abbas humilis iussit
 fabricare libellum,

Angilbertus enim vilis et
 exiguus,

Quem daret ille pio caelesti
 numine fulto

Hlodoico regi, qui est pius
 atque humilis,

25 Qui sanctae sophiae certat
 rimare secreta

Nobilis ingenio nocte dieque
 simul,

Quique etiam domini ac fratris
 praeclarus amator

Ingenti dictu permanet ore pio.

Quem deus omnipotens multos
 feliciter annos

30 Glorificet servet diligat ornet
 amet.

It sings about what they are, what their
 power is, and which must be avoided.

Then the fourth sends forth the teachings
 of the prior books:

That very book intones with a great
 expression

What objects, what signs, what pious
 words teach,

And how they can refer to all intellectual
 things.

Humbly, moderately and even grandly,
 reader,

After reading through the words, say:
 "Lord, have mercy."

For a humble abbot commanded that this
 book be made,

Angilbert, worthless and puny,

Which he, who is reverent and humble,
 might give

To the pious King Louis, borne by
 heavenly divine power,

Who strives to comprehend the secrets of
 holy wisdom,

Noble in character by day and night alike,

And who moreover remains a lover of his
 lord and his brother,

Outstanding by a great command in a
 righteous mouth.

May almighty God glorify, preserve,
 cherish, adorn, love

Him happily for many years.

2

Haec perlecta pii, lector,
 doctrina patroni,

In primis domino, totum qui
 condidit orbem,

Devote laudes iugiter perfunde
 benignas,

Qui mare fundavit, caelum
 terramque creavit,

5 Omnia qui numero, mensura
 ac pondere clausit,

Continually and devotedly pour out as
 kind praises, reader,

These teachings of the pious patron,
 thoroughly grasped,

To the Lord who in the beginning
 founded the whole earth,

Who poured the sea, who created heaven
 and earth,

Who enclosed everything by number,
 measure, and weight,

Per quem cuncta manent vel per quem cuncta manebunt,	Through whom all things remain, and through whom all will remain,
Quae sunt, quae fuerant, fuerint vel quaeque futura.	Which are, which were, which shall have been and which will be.
Ipso iterum magnas domino perfundito grates	Again you shall pour out great thanks to that same Lord
Pro tali ac tanto, casto doctoque magistro,	For such a chaste and learned teacher, so great,
10 Ordine sub digno scripsit qui talia nobis.	Who wrote such things for us in worthy style.
Cholduici regis precibus memorare benignis,	Be mindful of King Louis with generous prayers,
Nomine qui est dignus, divino ac munere fretus,	Who is worthy in name, and borne by divine grace,
Laudibus almificis, ingenti et mole coruscans.	And glittering in immense strength with fruitful praises.
Cui deus omnipotens multos feliciter annos	May almighty God grant that he faithfully keep
15 Hic pie concedat felicia regna tenere;	Bounteous kingdoms happily for many years;
Cum quo coniugium, prolem cunctosque fideles	May the rector of the heavens deign from on high that
Dignetur regere caelorum rector ab axe.	The offspring of his wives may rule all the faithful with him.
Et post hunc cursum caelestia scandere regna	And after this course, may the Lord, kind founder of all things,
His tribuat dominus, cunctorum conditor almus.	Grant that they mount the celestial kingdoms.
20 His ita perlectis curvatis undique membris,	And so, reader, for these readings, thoroughly grasped and everywhere moved,
Lector, dignanter haec verba micantia prome:	Worthily proclaim these glittering words:
Gloria sit patri, solio qui fulget in alto,	"Glory be to the Father, who shines forth on high,
Filius aeternus cum quo est et spiritus almus,	With whom is the eternal Son and the nourishing Spirit too,
Nomine qui trino regnans super omnia solus.[57]	Reigning alone over all things in the three-fold name."

The poem did three things. First, it described the treatise of Augustine by summarizing briefly the contents of its four books. Second, it praised Louis as a pious ruler, and exhorted him to the virtue and blessings proper to kings, to be achieved by approaching the world as Augustine prescribed. Third, it exhorted the reader to praise the triune God who created that world, and in filial piety, to pray for Louis and his kingdom.

In Angilbert's eyes, Augustine's work was important because it taught men how to understand the world as symbol. The four books elaborated progressively on that theme. Book 1 distinguished between present conditions and the eternal and transcendent truth behind them: *rebus uti saecli insinuans praesentibus apte aeternisque frui rite docet nimium* (lines 9–10). The present world was to be used for attaining the eternal in which its whole value resided. The here and now were means to a greater end, and only the eternal was to be sought and enjoyed since it was the source of truth. According to Angilbert, the second book explained how the signs of the eternal might be known, *qualiter aut quomodo noscere signa queant* (line 12). Book 3 discussed the power of signs, and what signs thereby must be avoided as evil: *quid sint, quid valeant quaeque vitanda, canit* (line 14). The fourth spoke of the eternal world behind the signs, what the signs themselves referred to, "all intellectual things," *qualiter et possint cuncta intellecta referre* (line 17). Angilbert then spoke briefly of himself to explain why he had the book copied: it was for King Louis, who always sought knowledge of sacred things, and who was notable for his piety and faithfulness to his lord and father, Charlemagne, and his brother Pepin. Thereby he was worthy of honor in God's eyes, and Angilbert ended this part of the poem with a prayer that God would favor him with a long and happy reign: *quem deus omnipotens multos feliciter annos glorificet servet diligat ornet amet* (lines 29–30).

The second section of the poem presents two key pieces of aesthetic philosophy. First, as Part 1 teaches that truth was to be found in forms abstracted from concrete things, so Part 2 teaches that the abstraction is objectively possible because the essence of the created world, the structure that underlies everything, is number. The key is line 5: *omnia qui numero, mensura ac pondere clausit,* "who enclosed everything by number, measure, and weight." Angilbert quotes these words from the Bible, Wisdom 11: 21. The Biblical text is worth quoting, because the line occurs in the context of beastly chaos and demonic worship, using vocabulary strikingly similar to that which Angilbert had used in the *De conversione Saxonum*. Augustine did not quote this text in his *De doctrina christiana*.[58] Angilbert, quoting it in the context of commentary on the treatise of the master, seems to have used the Biblical passage itself because it so closely described the world he saw around him.[59]

> As their foolish and wicked notions led them astray
> into worshipping mindless reptiles and contemptible beasts,
> you sent hordes of mindless creatures to punish them
> and teach them that the instruments of sin are instruments of punishment.

And indeed your all-powerful hand did not lack means
— the hand that from formless matter created the world —
to unleash a horde of bears or savage lions on them
or unknown beasts, newly created, full of rage,
exhaling fiery breath,
ejecting swirls of stinking smoke
or flashing fearful sparks from their eyes,
beasts not only able to crush them with a blow,
but also to destroy them by their terrifying appearance.
But even without these, they could have dropped dead at a single breath,
 pursued by your justice,
whirled away by the breath of your power.
But no, you ordered all things by measure, number, and weight.

These words, and those of Angilbert in the poem, expressed the fundamental conviction that Creation could have been chaotic, but indeed was orderly — ordered by arithmetical truths. That order was divine. It was the intellectual and intuited truth available both to sense and reason. And so it lifted the believer into the realm of the abstract: "what things, what signs, what pious words teach, and how they can refer to all intellectual things," as lines 16 and 17 of Part 1 of Angilbert's poem put it: *quid res, quid signa, quid pia verba docent, qualiter et possint cuncta intellecta referre.* By feeling the proportionate harmonies and striving to comprehend the internal structures of things, the mind moved toward the truth of right belief in the eternal, unchanging Form that was God. Even more striking was the fact that Angilbert's God — as Augustine's — was expressed as a number — "He who is reigning in the threefold name, alone above all things," *nomine qui trino regnans super omnia solus,* as the last line of the poem said. God was Three-in-One, the essence of both unity and multiplicity. He was the numerical form that gave and guaranteed form in numbers to all things "which are, have been, will have been, and will be" (Part 2, line 7): *quae sunt, quae fuerant, fuerint vel quaeque futura.*

 Thus signs and the very order of the universe pointed to the Creator behind them and both gave birth to and fed correct and salvific faith. In Augustine's treatise, that faith was the inseparable bond between right belief and moral behavior. Understanding the Christian truth and the way it permeated the whole world resulted in good action. This was related to Augustine's famous *uti-frui* distinction (Part 1, lines 9 and 10). And in Part 2 the reader was shown again the moral fruits of that understanding. He was to praise the Trinity and he was to pray for and be faithful to Louis and his family, who could not reign rightly without this desire to grasp the truth. As in the *De conversione Saxonum,* the Trinity was the source of reality.

At Easter of 800 Angilbert's greatest work was at last unveiled: the new monastery complex of Saint-Riquier. Charlemagne, Alcuin, and the greatest bishops and dignitaries of the realm attended the dedication. What they found was a *signum* that brought together and expressed in stone and prayer the ideas that had occupied Angilbert from the time he had written the *De conversione Saxonum*. It was the culmination of his work.

Saint-Riquier

Shortly after the dedication Angilbert wrote a little book in two parts, the *Libellus,* which explained his program and his intentions. The first section, the *De perfectione et dedicatione Centulensis ecclesiae,* described the buildings, their dedication, and the physical arrangement of the cloister as well as its altars, relics, and treasures. The second, the *Institutio de diversitate officiorum,* recorded the order of offices that Angilbert prescribed for the cloister for both its daily routine and its special festival celebrations.[60]

The *Libellus* described a little monastic city organized "on account of the veneration of the Holy Trinity," *quapropter ob veneratione sanctae Trinitatis.*[61] This image of the Trinity was quite literally the structural integrator of Angilbert's program, the image into which both the physical house and the liturgy were built. There were, for example, three churches in a triangular cloister. There were three main altars covered by three liturgical canopies; three times ten priests said three times ten masses daily at the three times ten altars of the complex. Three hundred monks divided into three choirs sang antiphonally the office and prayers for the salvation and prosperous reign of Charlemagne. Even the many relics in the churches were arranged under the altars three by three.[62]

This small glimpse alone is enough to reveal a liturgified, symbolic articulation of the theological concerns that had dominated the 790s in which Angilbert had played so prominent a role. The abbey of Saint-Riquier thereby gives us a clear view into Angilbert's contribution to those debates. Here he applied an artistic program in an architectural and liturgical complex that stood as a great symbol of the Trinity and, as we shall see, included and emphasized the doctrinal issues that had been so great a problem in the 790s, while the monastery was being built. Chapters 4 and 5 will discuss the aesthetic sources and the program of the monastery in detail, but first let us consider the character of Angilbert's thought as drawn from his writings.

Above all Angilbert was concerned with the *signum*. Whether he was

talking about a program of political expansion and conversion as in the *De conversione Saxonum,* a program for kings as in the *De doctrina christiana,* or an artistic and liturgical creation that drew participants into a particular aesthetic sensibility, he conveyed his meaning through symbols. His *signa* came from one great source: the Trinity. For him the triune God stamped form and order on the world, and was reality itself.

Our picture of Angilbert's trinitarian thought is filled in by layers, though his themes are constant. The earliest evidence, the *De conversione Saxonum,* reveals the fundamental assumption that adherence to Christianity, belief in the Trinity, created the moral order. It brought peace. To be outside the sacred company of the new Chosen People headed by the most pious Christian, King Charlemagne, was to be in the no-man's-land of demonic possession and raging chaos. It was to be insane with aggression and the lust for blood sacrifice and the desperate search for luck. To be within the sacred company was to find peace, prosperity, and salvation.

Angilbert used liturgical images to describe the transformation. Righteous battle became sacramental, the weapons of Charlemagne channels of grace. Christian belief was in itself described in liturgical terms. It was the *act* of baptism and that alone, without any overt reference to the internal state of belief or to the instruction of neophytes. The Power of the *name* of the Trinity transformed.

Already we see the aesthetic concern for symbolic structure, though it was rudimentary in this early poem. The evocation of threes and sevens, the setting of the Saxon conquest in the context of the cosmic redemption, and the transforming, sacramental action of a trinity of performers were early examples of the symbolic mentality that would come full flower at Saint-Riquier. Angilbert's spirituality was aesthetic.

In the poem *De doctrina christiana* Angilbert elucidated further the moral character stamped by the name of the Trinity (conversion brings peacefulness). Now it was linked overtly with the interior life of intuition and understanding. Here the only source of that understanding was symbolism. The world itself became the channel of grace and the communication between heaven and earth. Moral righteousness was contingent on the proper understanding of the world as such, as no more than a symbol of the greater spiritual truth at its source. The things of this world were to be used for the enjoyment of the eternal goods.

As in the *De conversione Saxonum,* kingship was intimately bound to a Christian ideal. There the king was pious by the sword as he fought for Christ. Here he was made pious in word and understanding as he sought to

know and love the eternal truths hidden in the world. Without this he could not reign, since it was righteousness that made him worthy of the love and honor of God. Furthermore, the pious reader who understood the Christian order would act righteously as well, as he prayed for the well-being of Louis and his kingdom.

Most important here was the link between the beauties of this earth, the triune God who stood behind them, and the virtue that was required of Christians. Augustine's treatise and Angilbert's poem asserted the unity of knowledge, love, and action. God had ordered the world by number. Therefore, the believer could strive to comprehend that order and thereby could come to know more of the God behind it. The world brought the Christian to knowledge and love of the eternal source, the Trinity, and inspired in him praise and fidelity to all that expressed God's will or presence.

That conviction of the threefold unity of knowledge, love, and action and of the mediatory role of the symbol in that unity was embodied in Angilbert's monastery of Saint-Riquier. Here was a liturgical complex meant to house the perpetual prayer and praise of the Trinity. Its physical structure replicated the divine form in "number, measure, and weight." The abbey stood as the witness of the transcendant truth with all the clarity of the true symbol: it referred at once to itself, rooting participants in the physical aesthetic soil of visual and aural beauty, architectural harmony, and ritual splendor; and beyond to the Trinity who was the end and source of that rich expression. Reality was its template.

Angilbert himself described his aim in these terms:

> So that, therefore, all the people of the faithful should confess, venerate, worship with the heart and firmly believe in the most holy and undivided Trinity, we, with God cooperating and my aforementioned august lord helping, have been zealous to found in this holy place three principal churches with the members belonging to them, according to the program of that faith in the name of almighty God.[63]

This was a tight mesh of practice and belief that ensured the right and salvific ongoing worship of the Trinity. For as Charlemagne said, "Without right belief it is impossible to please God."[64] Angilbert understood this as collective as well as personal salvation, since the monks, echoing the charges of the *De doctrina christiana* poem (1.19–30, 2.11–19) daily prayed and said Mass for the well-being of Charlemagne and the realm. Throughout Angilbert's works the figures of Charlemagne and his heirs stood as the

earthly authority that guaranteed the moral order and made it available to humans. The Carolingian kings embodied Christian well-being and validity on earth. By their work on behalf of the Christian order they tied the individual believer to the polity and defined his Christian identity.

Hence this monastery of the Trinity was meant to embody the truest worship that concentrated and carried out the metaphysical and practical concerns so pressing in the 790s. It located in miniature the conjoined mirror orders of heaven and earth. It was the point of passage between the natural and supernatural worlds. The transcendent reality of the divine Form became apprehensible in number, measure, and weight. The immanent power of kings was justified and focused as they intuited the spiritual truth seized in those places; it became greater in the invocation of God's favor upon them. Liturgy was the hinge between heaven and earth.

Angilbert's contribution to the debates of the 790s was a program that rooted theological and philosophical assertions in culture. Angilbert tapped the thought-world of symbols and thereby revealed not only the integral importance of symbols to the Carolingian cultural experience, but also the practical and full-bodied application of the aesthetics of symbolism. He articulated the essential conviction that belief and action were united. That symbolic mentality was the intellectual taproot of the Carolingian world. Let us now consider the sources of Angilbert's symbolic understanding.

4. *Ordo et Mimesis*: Angilbert's Symbolic Understanding

Angilbert presented his rationale for the building of Saint-Riquier in a key text which we have already seen.[1] This rationale, tied to the buildings at Saint-Riquier, enable us to discern his spirituality and aesthetic understanding. Angilbert's focus was important: his foundation of three churches was a catalyst for "confessing, venerating, worshiping with the heart, and firmly believing in" the Trinity. His program at Saint-Riquier was thus a response to Carolingian concerns in the 790s on two levels. It addressed the immediate dogmatic concerns about the Trinity in which Angilbert was so closely involved. And, by its concern in the belief of "all the people of the faithful," it expressed in a new way the cultural vision of the Carolingian Chosen People: in Angilbert's monastery at Saint-Riquier, the political and theological concerns of the Carolingian passion for the correct faith were presented in concrete iconography.

We have already discussed the character of Angilbert's early thought in the *De conversione Saxonum* of 777.[2] We have seen Angilbert's concern with conversion to right faith and his conviction that that faith was critical to worthwhile life. In his terms, the conversion of the Saxons to Christianity was a virtual cosmogony or recreation of the people, which he described in animal metaphors. Christianity quite literally meant the transformation of the people from savage bestiality to sublime peacefulness.

We have also seen that Angilbert implicitly expressed the truths in which he believed in numerical symbols evoking the Trinity. These were intuited symbols, structural rather than imagistic. He ordered his poem around three actors: God the Father, Christ, and Charlemagne. And he ordered it in three parts, representing the three ages he saw as the history of salvation: Creation, Redemption, and Conversion.

Angilbert from the very beginning showed a great sensitivity to symbolism as the expression or locus of religious belief. Symbols, especially numbers and metaphor, were vehicles of understanding and information on the trinitarian faith which was the key to all life and salvation.

The *Libri Carolini*

Angilbert came into contact with the *Libri Carolini* about twelve years after writing the *De conversione Saxonum*. He encountered an aesthetic philosophy with ambivalent meaning for him. On the one hand, as we have seen, the *Libri* utterly rejected the contemplative and grace-filled character of images, saying that material objects of art could not lead a viewer to spiritual knowledge or truth. On the other hand, however, the *Libri* did find great value in liturgical expression, which did become the focus of symbolic meaning. As the *Libri* put it,

> The Church sets forth through the parts of three-fold prayer the mystery (*mysterium*) of the holy Trinity, while her words must be grasped by the ears of the divine majesty, that is, she prays the melody of psalmody, which she displays without ceasing, and she also prays out with a devoted heart the acclamation which must be understood, that is, the love of the heart, which is received wonderfully not with fleshly ears, but with the ineffable hearing of divine majesty; and she entreats that the voice of her prayer be stretched forth so that she might declare, namely, that this is perfect prayer which inflames the love of a burning heart. And although she intermingles our senses with words changed metaphorically, nevertheless she believes that the divine nature does not separate the things that are to be separated with the parts of its members, but goes through all things with one power, who hears all things that are seen by us and sees into that which we have thought and are going to think; nor is anything able to hide from this ineffable light. For indeed, to grasp words, to understand the sound, to strain toward the voice of prayer although they be brought forth again and again under a variety of words through that type of speech which is called *metabole* by the rhetoricians, nevertheless the threefold repetition signifies one and the same thing. Even while she says in the invocation of both the King and the Lord God: "Because I will cry to you O Lord my King and my God," she demonstrates that she believes in and confesses three persons and one substance in divinity, because she interposes to the invocation of three names not plural, but singular words.[3]

In the opening lines of the *Libri* was a statement that argued the integral relationship of faith and liturgy, especially the role of the Church's liturgical ritual in expressing the trinitarian faith. That role was "to set forth the mystery (*mysterium*) of the holy Trinity through the parts of threefold prayer," (*per partes trinae orationis mysterium sanctae Trinitatis exponit*). The *significatio* of the threefold perfect prayer was quite direct. The repetition three times of the same prayer confessed the Trinity, *tres personas et unam substantiam in divinitate*, "three persons and one substance in divinity." Even prayers directed to God under three different names, such as the

psalmist's "O Lord, my King and my God," signified that same "divine secret" or *mysterium* of the Trinity, since it directed three singular names to the one God.[4]

Threefold prayer was, in effect, the Church's liturgy. It was prayer offered *metaforicos*, metaphorically or symbolically, in which the Church "intermingles our senses" with the same prayer expressed in many ways. It was visual in gesture, vestment, candlelight, procession, mosaic or sculpture. It was verbal in the words of the Mass and prayers; aural in the chanting of the psalms and sequences. It was sensual in the incense that purified the participants and rose to heaven as proferred prayer.[5]

The intermingling of the senses through liturgical symbol drew the whole person into the *mysterium sanctae Trinitatis* without confusion or error. It was the action of God that drew the sensual clues together and gave them meaning, not "separating the things that are to be separated with the parts of its members, but going through all things with one power" (*divinam tamen naturam credit non partibus membrorum discernenda discernere, sed una virtute cuncta peragere*). All of the sensual expressions and manifold metaphors were in fact one through the power of the God who was their referent.

Liturgy had a double purpose and effect. It was to "seize the ears of the divine majesty" (*auribus divinae maiestatis percipienda*), God himself. And it was to "inflame the love of a burning heart," (*mentis affectus ardentis inflammat*) as the inspiration and expression of the believer. In this way the threefold prayer, which the *Libri* defined as the heart of the liturgy, created a real bond between God and the believer. As *oratio perfecta* it assured a hearing from God, and it inspired desire for God in the heart of the believer. It was indeed perfect prayer, complete prayer, sung as psalmody *sine intermissione,* "without ceasing."[6]

Thus there was a deeper level of expression and meaning underneath the sensate effect. This was the level of intention and desire that was not "apparent" but pervasive: "the acclamation which must be understood, that is, the love of the heart, which is received wonderfully not with fleshly ears, but with the ineffable hearing of divine majesty" (*clamorem intelligendum, id est cordis affectum, qui non auribus carnalibus, sed ineffabilibus divinae maiestatis auditibus mirabiliter excipitur*). That love of the heart was the internal commitment of the one who prayed.

In the affirmation of the truly symbolic character of *res sacratae* (as opposed to religious images), the *Libri* drew on a critical text from Augustine's *De diversis quaestionibus* to explain the nature of that particular

physical bridge to the divine: "But all things which live and do not know participate less in likeness. . . . That which participates in knowledge both lives and is."[7] In Augustine's treatise this was an epistemological point: knowing something brought about likeness to it, which was continuity with it. In the optic of the *Libri* this meant that consecrated objects possessed characteristics that were identical to their spiritual prototypes and were "like" them insofar as those characteristics were concerned. The liturgical piece thus could engage the intellect, which in turn could engage the entire person who would respond to and conform with the spiritual truths portrayed. Liturgy, ordained by God, could render contact with God.

There was one aspect of the *Libri*'s discussion on religious images that influenced Angilbert's program in another way. The *Libri,* while they denied the mystical content of pictorial images, nonetheless recognized their mundane capacity. That is, images that represented events in the earthly life of Christ or of the saints served to remind believers of those concrete historical events. While an image of Christ could not lead the viewer to contemplation of the glorified Christ now, or union with him, it could stimulate memory and recognition of an event in Jesus's earthly life as recorded in the Bible. In the problematic theological context of Adoptionist and *filioque* christology, this human memory was important. Art could serve to underscore and affirm the biblical and historical truths of faith in the incarnate Christ. Thus it could be a visual counterpart to the scriptural texts cited in Carolingian treatises — and Angilbert used them in this way, as we shall see below.[8]

Thus the *Libri* both confirmed Angilbert's understanding of the importance of liturgy and developed it far beyond what he had expressed in the *De conversione Saxonum*. These books asserted the critical importance of liturgical symbols for the growth of the internal conviction of faith. In the theory of the *Libri,* the litugical gesture, as a reminder of the reality beyond, allowed one to participate at least in part in that reality.

Let us return once more to the opening paragraphs of the *Libri* to consider the context of their statement on threefold prayer as a trinitarian symbol. Critical to this argument was what we might call the ecclesiological dimension. It was in and through the Church, and specifically through the sensual symbols of the liturgy, that the mystery of the Trinity was revealed. This revelation was in fact the Church's function: *quae incessanter per partes trinae orationis mysterium sanctae Trinitatis exponit,* "she reveals unceasingly through the parts of threefold prayer the mystery of the holy Trinity." We can perhaps see in this the rationale behind Angilbert's creation of a com-

plex of churches and liturgical celebrations as his *signum* of the Trinity. For it was in the structure of the physical house of Saint-Riquier and in the chanting of the psalms that the sign was contained:

> Since our churches have been elegantly ordered and ornamented by these and other of the diverse and aforementioned relics of the saints mentioned above, as we were able to do, Lord granting, we have begun with diligence of heart to treat how, Lord granting, we were able to persist, so that, just as in marble buildings and the rest of the decorations churches shine forth for human eyes, so also they grow more clearly in the praises of God, in various doctrines and in spiritual songs, in our own and future times, in the strengthening increase of faith, God helping, today and unto eternal salvation.[9]

As eyes were illumined, so hearts were enkindled *in augmento fidei roborante*.

Let us take stock of our evidence. As we can see from Angilbert's own words, his creation of a trinitarian iconographical program in a monastery was no accident. It did not merely result from the fact that he was appointed as abbot of Saint-Riquier in 789–790. That appointment was contemporary with the writing of the *capitula* of the *Libri* (which he took to Rome), and Angilbert's rebuilding of the monastery began at the same time that the *Libri* themselves were being written. This is not to say that Angilbert was appointed to the monastery specifically for the purpose of creating an aesthetic program there. It is to say that there was a serious concern about art, its role, and its explicitly doctrinal content that Angilbert understood very well and that informed his "ecclesiological" *signum*. He disagreed with Theodulf's overall formulation, and given his contact with Hadrian on precisely this issue, it may well be that his own program was stimulated by the papal response to the *reprehensia*. What is clear is that he was not following the official position as expressed in the *Libri*, but was creating instead an alternative spirituality. His program has a consistency, a coherency, and a monumentality that make its expressed intent strikingly clear when compared with other contemporary religious buildings.[10] Of particular interest in this light is the work of Angilbert's contemporary, Benedict, who was also actively involved in the prosecution of Adoptionism, and whose first monastery at Aniane bears both some significant similarities and differences with Saint-Riquier.

I have spoken above of an "ecclesiological" *signum*. By ecclesiological I mean that Angilbert understood the very nature and function of the Church to be the symbolic revelation of the Trinity. The symbolism was liturgical. Given the definition of liturgy in the passage from the *Libri Carolini* that

we examined at the beginning of this chapter, I would argue that in general, the Carolingians understood liturgy comprehensively. It comprised both prayer and the sacred space in which it was performed. Angilbert's statement made no distinction in the way in which the mystery of the Trinity was revealed: *sicut in aedificiis marmoreis et in ceteris ornamentis . . . ita etiam in laudibus Dei, in doctrinis diversis et canticis spiritualibus.*

But Angilbert's program at Saint-Riquier was more than ecclesiological: it was monastic. In the monastery the life of prayer was perpetual; no matter what other work monks did in Carolingian cloisters, the foundation of their life was contemplative. Hence the monastery was the natural setting for *oratio perfecta,* for setting forth *incessanter per partes trinae orationis mysterium sanctae Trinitatis,* as the *Libri* prescribed. One view of the special meaning of monastic prayer, and its link with Carolingian kings, had already been expressed many years earlier in a charter of Pepin to the family monastery of Prüm.

> Therefore it is well known to foreign peoples as well as to our neighbors that we and our wife Bertrada, in love of the holy Savior, as well as of Mary, Mother of God, and of the blessed princes of the Apostles, Peter and Paul, and of Saint John the Baptist and the holy martyrs Stephen, Denis, and Maurice, and of the confessors Saints Martin, Vedast, and Germanus, are building on our property a monastery . . . in the church of which we have been seen to bury relics of our Lord Jesus Christ as well as of Mary his mother and of the other saints of whom we made mention above, and in the same place we have established monks who should carry on entirely under the rule of holy behavior and according to the doctrine of the Fathers going before us, to the end that they who are called solitary monks should be able to exult through time and, living under the holy rule and following the life of the blessed Fathers, to entreat more fully the mercy of the Lord, with Christ leading, on behalf of the condition of the Church and the longevity of our kingdom, as well as of our wife and children and the catholic people. And so it must be provided that . . . the priests and monks who are present serving in that place . . . may return praises to almighty God day and night.[11]

This was a monastic life dedicated entirely to prayer *die noctuque* through *perfecta quiete,* "perfect quietude," and adherence to *sanctae conversationis norma,* the ancient way of the Fathers who had already achieved the life of sanctification. It was a life lived in purity of faith and practice so that the monks might more effectively and completely intercede on behalf of the king, his family, and the Franks for prosperity here and for salvation hereafter. This text cast the monks in a mediatory role that oriented earth to heaven.

What is significant is the lifestyle that the monastery demanded. The permanence, stability, and quietude of the monastic life, its capacity for regular behavior in the truest sense — that is, in conformity with norm of purity — made it uniquely hospitable to the prayer that channeled petition and grace.

Thus we may view the monastic setting of Angilbert's program in the light of both the ecclesiological argument of the *Libri* and in the more specialized meaning of the cloister. The monastery of Saint-Riquier functioned on at least two different levels. On one hand, it served as a physical representation of the Trinity for "all the people of the faithful," through its outward, physical appearance and performance.[12] On the other hand, the internal life of the monastery, the lifestyle of prayer, which was the defining characteristic of its spirituality, functioned in a mediatory and intercessory capacity for the Frankish king and people. That this was Angilbert's intention is clear in the prayers that were said at the monastery daily:

> Indeed, by all means let all with one voice continually set forth with devotion the sacrifice of praise to the almighty Lord for the salvation of my glorious august lord Charles and for the continuing stability of his kingdom. . . . We order moreover that that be observed with special devotion, so that no day pass without the singing of sacred masses . . . which in the morning and at noon are celebrated most solemnly, in which daily the memory of the most holy Pope Hadrian and of my glorious august lord Charles and of his wife and children is kept: just as according to the word of the apostle, "we have been constituted on behalf of the king and of all who are in sublimity," let us continually carry out prayers to God our Savior and the thanks of prayers.[13]

These words of intercession on behalf of the King and his family, and for King and Pope, were generally incorporated into the monastic office during the Carolingian period. The association of prince and Pope is also reminiscent of the *laudes regiae*. Charlemagne held these prayers in greatest esteem as a crucial element in the stability of his realm, both in times of crisis and in important deliberations. Indeed, he viewed them as acts of loyalty to the monarch, as Michael McCormick has shown.[14] At Saint-Riquier the monks were dedicated to prayer *iugiter*, "continually," according to the *sacrae conversationis norma* of the Apostle.

This was Angilbert's conception of the monastic life of perpetual prayer when he began his work at Saint-Riquier. We may now turn to another piece written by Angilbert during the years in which he was building Saint-Riquier: the dedicatory poem of the *De doctrina christiana*, Augustine's great work on symbols, which Angilbert wrote to Louis the

Pious sometime around 796. What we can see here, in schematic form, is both the Augustinian basis of his thought and the particular aspects of the *De doctrina christiana* that he deemed important. We have discussed the text of the poem above, in Chapter 3.[15] Let us now consider the aesthetic content of the *De doctrina christiana* both in terms of what Augustine actually said and how Angilbert interpreted it.[16]

De doctrina christiana

Augustine wrote his treatise in order to lay out an educational program for understanding and interpreting Scripture. He set the context in the opening lines of Book 1. "The entire treatment of the Scriptures is based upon two factors: the method of discovering what we are to understand and the method of teaching what has been understood."[17] Christian teaching was scriptural revelation. Thus Augustine started with the assumption that the Christian somehow had unique access to truth because he had access to God's Word in the Bible. But to understand that Word was *magnum onus et arduum,* as Augustine said, because the Bible was full of signs that were often obscure or impenetrable.

Because of this difficulty, Augustine's underlying premise was that the intellectual disciplines of this world aided in understanding the revelation of the eternal and transcendant divine world. The hand of the Creator could be seen in Creation, and so the things of this world, properly understood, could lead men beyond to the divine source. Profane intellectual knowledge added to or unfolded the meanings of Biblical revelation. Christians were to "plunder the Egyptians," to take from the world of profane observation and discourse anything that would profitably help them.

Creation, then, was a great sign or *signum,* symbolizing divine truth. "All teaching is either of things or of signs, but things are taught through signs."[18] The transitory goods within the human purview pointed to the God behind them who was true happiness. For the Christian this was the objective experience of Creation. But inseparable from this was the subjective experience, one's attitude toward the world and its Creator. This was the moral dimension of Creation. Humans could either enjoy the world in and of itself, or they could use the world as a guide and vehicle to the true and eternal happiness beyond. To enjoy (*frui*) the things of this world in themselves was to turn away from the truth: "The proper object of our enjoyment, therefore, is the Father, Son, and Holy Ghost, the Same who

are the Trinity."[19] The world was something, rather, to be used (*uti*) for knowledge of one's true source, end, and happiness, God.

Augustine defined a sign, or *signum,* as "a thing which, apart from the impression that it presents to the senses, causes of itself some other thing to enter our thoughts."[20] It was a concrete or sensible object that referred to something else that was qualitatively different. Some signs were natural, indicative of something else by their very nature, such as smoke inferring fire, or a footprint indicating that an animal had passed by. These *signa* had no meaning by their own nature. They intrinsically and through our progressive experience of them pointed to another phenomenon.

But there were also signs that were accepted by human convention as a revelation of something else. These were intended to express "either the operations of (human) minds or anything perceived by sense or intellect" so that ideas could be transferred or conveyed to others. These signs were contained either in sensible gesture such as a nod or a movement, a banner or a sound, or in words, which were by far the most common way of articulating thoughts.[21]

Augustine saw signs as working on one or both of two levels (and here we see the basis for the interpretation of symbols advanced by the *Libri Carolini* as well as by the normal exegetical practice of the day). They could be literal, expressing the intended image or thing. For example, the word "ox" signified a particular animal.[22] But words, even the same words, could also be figurative, "when the very things which we signify by the literal term are applied to some other meaning." In this sense the word "ox" could mean Luke the Evangelist. This figure was understood as such through Scripture, as the Apocalypse spoke of the four winged creatures surrounding the throne of God to indicate the four Evangelists. Augustine himself cited the words of Paul as his source of interpretation.[23] In other words, the Bible itself was to provide much of the interpretation of figurative signs.

These *signa* led at least to partial knowledge of God. But the coming to knowledge had a critical moral effect. Augustine saw it as a progression of the soul to purity. This was important for Angilbert because the result of that progression was the vision of the Trinity. According to Augustine, the believer began in the fear of God which created humility of heart by reminding him of his mortality and his absolute dependence upon Christ for redemption. Through this he came to piety, which fostered gentleness. Augustine seems to have used the word "piety," *pietas,* in its classical context to mean filial respect and reverence. Piety humbled the mind into accepting Scripture as the ultimate wisdom, better than any of one's own thoughts

and opinions even when it was obscure or harsh in its admonitions. Only then could one be open to the knowledge of the divine truth of the Scriptures.[24]

This knowledge, however, placed upon the recipient a crushing burden. It revealed to him the extent of his unworthiness and involvement with the evils of the world. His only hope was to beg God's help through prayer, which brought the soul to the fourth level, fortitude. Fortitude was "the hunger and thirst for justice," the complete rejection of the transitory and temporary "deadly pleasures" of the world. This was the moment of truth for the soul, because in turning aside from the world it turned "toward the love of eternal things, namely, the unchangeable Trinity in Unity.[25]

At that point, the Christian began to achieve his goal, the "counsel of mercy" in which the desire for God led to love of neighbor. The vision of the Trinity appeared as a blinding light unbearable to the still imperfect soul. (*Incommutabilem scilicet unitatem eandemque trinitatem . . . quam ubi aspexerit, quantum potest, in longinqua radiantem, suique aspectus infirmitate sustinere se illam lucem non posse persenserit.*) The craving for that light led the believer to cleanse and perfect his soul through zealous charity. When he achieved even love of his enemy, he achieved both spiritual vigor and the virtue of hope, the two steps by which he could climb to the sixth level, the vision of God. He could see "in proportion to the extent that (he) dies to this world" (*quantum potest ab eis, qui huic saeculi moriuntur, quantum possunt*). This was the ultimate proof of faith, because it was still, in the "exile" of this life, vision "through a glass darkly" (*in aenigmate et per speculum*).[26]

He who so loved the truth and perfected faith so that he could never be turned away or discouraged from this still obscure vision, even by the charitable desire not to cause confusion or consternation in others, achieved the seventh and final step, Wisdom, which he "fully enjoys with perfect calm and serenity." This was the culmination and revealed consequence of the first step, fear. "For 'the fear of the Lord is the beginning of Wisdom.' From that fear until we arrive even at Wisdom, it is through these steps that we make our way."[27] Hence the initial act of submission to the signs of God's presence was the most critical.

It was to that moral end that Augustine wanted to urge men through the understanding of the Bible. The rest of his treatise was taken up with a discussion of the intellectual training that could benefit the Christian, as well as those subjects that must be avoided as harmful to Christian virtue. Although this bears little direct relationship to Angilbert's work, in the final

section, Book 4, Augustine discussed the nature of teaching those truths, and from here we can draw principles that relate to Angilbert's purpose at Saint-Riquier. Both Angilbert and Augustine were concerned with the art of persuasion.

Augustine said that signs were the most efficacious way of transmitting knowledge. Humans, he said, learned better and more felicitously by a few well-chosen and striking signs than by intellectual discourse or exegesis, no matter how straightforward and simple it be.

> Why is it, then, I ask, that, when anyone asserts these facts, he affords less charm to his listener than when he explains with the same interpretation that text from the Canticle of Canticles where the Church is alluded to as a beautiful woman who is being praised: "Thy teeth are as flocks of sheep that are shorn, which come up from the washing, all with twins, and there is none barren among them?" Does one learn anything more than when he hears that same thought phrased in the simplest words, without the aid of this simile? But, somehow or other, I find more delight in considering the saints when I regard them as the teeth of the Church. They bite off men from their heresies and carry them over to the body of the Church, when their hardness of heart has been softened as if by being bitten off and chewed. . . . But it is hard to explain why I experience more pleasure in this reflection than if no such comparison were derived from the Sacred Books, even though the matter and the knowledge are the same.[28]

The power of the image, here expressed *metaforicos* (to use the term of the *Libri Carolini*), lay in its ability to attract and afford pleasure. Rational exposition, while putting across simply and effectively the same material, was not as powerful as metaphor. The metaphor, or the *signum,* more immediately attracted attention and pleased, and therefore sustained interest. But the *signum* was not to obscure the point. The first criterion of good teaching was that it be understandable, since its purpose was to instruct. Then the format had to be pleasing. Finally, the style must be both appropriate to the dignity of the subject and compelling in its images, so that it might convince.

Augustine did not, however, attribute persuasion ultimately to human genius. For when one spoke truly about God and his Word it was not by his own power, but was the Holy Spirit speaking through him. This was accomplished, Augustine said, "more through the piety of prayers than the power of oratory," since it was in the medium of prayer that the Holy Spirit operated most freely.[29] In this way also the uprightness of the teacher's life spoke most eloquently, since it revealed both total commitment to God and

the "doing" of one's belief. "Let his beauty of life be, as it were, a powerful sermon."[30] The righteous and prayerful life of the teacher became in itself a *signum* of the truth.

So said Augustine. We may begin our consideration of the importance of the *De doctrina christiana* for Angilbert here. In his discussion of teaching, Augustine's theory meshed with Angilbert's purpose. Angilbert's monks were dedicated to persuasion. They taught by their very life, which was lived in witness "so that all the people of the faithful should confess, venerate, worship with the heart and firmly believe in the most holy and undivided Trinity." Teaching the right faith was the *raison d'être* of the *ordo* as Angilbert himself described it, but this was not teaching in the academic sense. The eloquence of the monks was in the *signum* of their lifestyle.

This was, furthermore, a lifestyle lived through "the piety of prayers." Saint-Riquier was a *laus perennis* cloister, a cloister in which the real work of the monks was not only the chanting of the office at the regular times of the day, but the continual singing of psalms throughout the entire day. We have already seen the highly charged meaning of prayer *die noctuque* for Carolingian kings in the charter of Pepin to Prüm.[31] The purity of the monastic lifestyle and the continuity of prayer for Pepin was a channel of supplication and grace between the Frankish king and people on the one hand, and God on the other. But here we see another dimension of meaning in Angilbert's *laus perennis*, for in the terms of the *De doctrina christiana* this became the persuasive eloquence of the Holy Spirit itself, teaching "more through the piety of prayer than the power of oratory." Thus it was of the utmost importance that Angilbert's *signum* of the Trinity be expressed in a monastic setting. The contemplative *ordo* of the monastery became the "understandable, pleasing, and persuasive" message of the trinitarian truth. The monks themselves, as well as the sacred space in which they dwelt, were the teachers.

We see in Angilbert's treatment of the *De doctrina christiana* his focus on the broad context of the work. Angilbert was concerned with *signa,* and he schematized Augustine's treatise as the revelation of *res aeternae: quid res, quid signa, quid pia verba docent, qualiter et possint cuncta intellecta referre.* Let us look again at his description of the treatise.

> Primus enim narrat Christi praecepta tenere,
> Quae servare Deus iussit in orbe pius:
> Rebus uti saecli insinuans praesentibus apte
> Aeternisque frui rite docet nimium.

Edocet ex signis variis rebusque secundus,
> Qualiter aut quomodo noscere signa queant.
Tertius ex hisdem signis verbisque nitescit:
> Quid sint, quid valeant quaeque vitanda, canit.
Tunc promit quartus librorum dicta priorum:
> Quid res, quid signa, quid pia verba docent,
Qualiter et possint cuncta intellecta referre,
> Magno sermone intonat ipse liber.

We see in these lines no reference even to the ostensible purpose of Augustine's work, the analysis of Scripture. Angilbert has abstracted from these books only one thing: *cuncta intellecta,* "all intellectual things" which are present in the *signa* on earth. Angilbert has deemed important the moral dimension of the work, presenting it rightly, as the content of Book 1, the *praecepta Christi tenere.* He also interpreted Book 2 in Augustine's original format, since it was here that Augustine discussed the figurative and literal types of signs and their importance. Book 3, however, Angilbert changed. He presented it in the lines quoted above as the revelation of signs, their power, and their danger. *Hisdem signis verbisque* referred to "these same signs and words" discussed in the second book, that is, the figurative and literal signs. *Quid sint, quid valeant quaeque vitanda, canit* referred to the exposition of those signs and words themselves: what they were and what they were able to do. But Augustine had in fact devoted the third book to a technical discussion of the disciplines that were helpful and unhelpful to the Christian for interpreting Scripture. In other words, it was the heart of his work on the formal education of the Christian exegete.

Similarly, Angilbert changed the meaning of the original Book 4. Augustine had included here his formal discussion of the techniques of good teaching. There was almost no mention of signs per se. He had spoken of effective types of discourse, the criteria for persuasion, style, and the nature of eloquence. He had spoken, too, of the work of the Holy Spirit as the true speaker in oration, and of the importance of the righteous lifestyle of the teacher. Angilbert, however, saw something entirely different. He presented the fourth book as the epitome, or summary, of the first three. According to him it was the symbols themselves that taught, by leading the mind to "all intellectual things": *quid res, quid signa, quid pia verba docent, qualiter et possint cuncta intellecta referre.* There was no mention here of eloquence and rhetorical style. Angilbert's only interest was the symbol and the intuited truth to which it referred.

Again in the second part of the poem Angilbert returned to the same theme.

Haec perlecta pii, lector doctrina patroni,
In primis domino, totum qui condidit orbem,
Devote laudes iugiter perfunde benignas,
Qui mare fundavit, caelum terramque creavit,
Omnia qui numero, mensura ac pondere clausit,
Per quem cuncta manent vel per quem cuncta menabunt,
Quae sunt, quae fuerant, fuerint vel quaeque futura.

His concern was to identify God as the creative source and aim of earthly *signa*. Creation itself was the great symbol because it was structured according to "number, measure, and weight." Here Angilbert developed an aesthetic theory of number symbolism that Augustine had never considered. The *De doctrina christiana* had discussed the study of numbers as essential for Christian education, since the Scriptures were full of numbers that had a mystical significance in need of interpretation.[32] But in this treatise there was no mention of number or measure as the basis of Creation or as especially evocative of the work of God. Augustine had simply said that number was not a human invention, but a discovery of that which was of divine creation.

Angilbert took this imagery from Wisdom 11.21, in which the arithmetical order of Creation was contrasted with the chaos that God could have created had he so wanted.[33] The scene in the Book of Wisdom had been described in animal symbolism strikingly similar to that which Angilbert had used in the *De conversione Saxonum* to describe the life of the Saxons before their conversion. In the Book of Wisdom, attacks by horrible and unimaginable beasts represented cosmic chaos. Similarly, Angilbert described the terrible and demonic existence of the pagan Saxons in bestial terms, by referring to the Saxons as beasts themselves. But in Angilbert's poem Christianity was literally the restoration of God's created order.

Angilbert's quoting of Wisdom described the world as ordered in its essence by arithmetical truths: *omnia qui numero, mensura ac pondere clausit*. "Number, measure, and weight" were the very nature of physical creation. They were the hallmark of God's artisanship. Number, then, was the key to knowledge about God. It was the foundation of Wisdom. It enclosed (*clausit*) sacred secrets.

In Angilbert's interpretation of Augustine's treatise, therefore, there was a direct correlation between symbolism, belief, and proper worship.

Especially charged was the number symbolism that conveyed both in concrete structure and in abstract relationship the transcendant and eternal spiritual truth. The *De doctrina christiana* and its affirmation of the critical importance of symbolism to the understanding of and relationship to God was developed in Angilbert's dedicatory poem to focus especially upon the relationship between numerical structure and the intuition of God.

Angilbert's interpretation of the *De doctrina christiana* thus went in a much different direction than the aesthetic vision of the *Libri Carolini*. Indeed, Angilbert's reliance on Augustine carried the understanding of symbolism beyond liturgy and art, beyond allegory and figure and its expression of spiritual truths, into the area of moral activity and development and the meaning of Creation itself.

That others at court, intimately involved with Angilbert, also understood liturgy, dogma, and moral activity to be integrally connected is evident from several letters of Alcuin written in the heat of the Adoptionist controversy. We have already seen these letters as an element of the anti-Adoptionist polemic.[34] In fact, these letters assert the importance of liturgy as an expression and reflection of belief, and as a catalyst for true belief and righteousness in the fullest and most active sense.

As we have seen, Alcuin made a direct connection between Adoptionist heresy and incorrect liturgical practice in baptism in a letter written to the monks of Septimania (the "mission territory" of Felix of Urgel) in 798. Let us examine his text again.

> And indeed, a third question from Spain—which was once the mother of tyrants, but now of schismatics—has been brought down to us against the universal custom of the holy Church on baptism. For they say that one immersion must be performed under the invocation of the holy Trinity. The Apostle, however, seems to be against this observation in that place where he said: "For you are buried together with Christ through baptism." For we know that Christ . . . was in the tomb for three days and three nights. . . . Three immersions can symbolize the three days and three nights. . . . For it seems to us . . . that just as the interior man must be reformed in the faith of the holy Trinity into its image, so the exterior man must be washed by the third immersion, so that, that which the Spirit works invisibly in the soul the priest should visibly imitate in the water.[35]

Alcuin's opinion was unequivocal. It focused on the symbolic significance of the act, a physical representation that effected an interior change of a particular sort. Liturgy, belief, and salvific change were inseparable in the words of this text. Because the symbolic action of the liturgy induced a

profound change in the recipient of the sacrament, and that symbolic action originated in and concretized the *fides recta* of the believer, one could not be changed without destroying the other two.

This was an allegorical explanation of the triple immersion of the traditional baptismal liturgy. The immersions and elevations referred to the specific and descriptive scriptural event of the burial and resurrection of Christ. But Alcuin went on to develop his own view of the symbolism through a consideration of its interior, spiritually catalytic effect.

> To us, however, according to the meagerness of our paltry talent, it seems that, just as the interior man must be reformed into the image of his Creator in the faith of the holy Trinity, so the exterior man must be washed with the three-fold immersion, so that, that which the Spirit invisibly effects in the soul, the priest visibly imitates in the water. For original sin is worked in three ways: by desire, consent, and act. And so, because all sin is accomplished either by desire, or consent, or doing, so the three-fold ablution seems to accord with the triple nature of sins. . . . And rightly is the man, who was created in the image of the holy Trinity, renewed into that same image through the invoca-tion of the holy Trinity: and he who fell into death by the third degree of sin, that is, by the work, lifted from death rises into life through grace.[36]

Baptism by triple immersion, invoking individually the Father, Son, and Holy Spirit, was literally the washing of the soul. Each immersion cleansed away one of the elements of sin. There was no formalism in this explanation of Alcuin's, that is, adherence to a ritual without conviction or understanding of its content. There was no blind reliance on mere authority or custom.[37] Alcuin's concern was the regenerative or recreative potency of the symbol of baptism and Trinity-invoking triple immersion.

This power was what the single immersion baptism of the Adoption-ists lacked, and rightly so, in Alcuin's view. In Carolingian eyes the Adop-tionists could not be true trinitarians because of their faulty christology. For them the effect of this perverted dogma extended to the moral condition of each Adoptionist, who could not be washed clean of his sin in baptism without correct belief or prayer. What hope, then, did he have of salvation? In the symbolic spirituality of Alcuin, every physical act performed liturgi-cally had an interior, spiritual, God-binding consequence.

That the physical act had to be related to an internal condition Alcuin reaffirmed in 798, in a letter to Arn of Salzburg. Alcuin, writing about the evangelization of the Huns that Arn was about to undertake in the eastern March territory, urged his student to look after the interior conversion of

these pagans before considering any baptism. Professed faith, Alcuin said, was imperative for the act to be sacramental.

The Carolingians had learned hard lessons about forcible conversion after the conquest of the Saxons (which Angilbert had lauded so highly in the *De conversione Saxonum*). The Saxons had been baptized en masse and without prior evangelization in the territory. They knew virtually nothing of the faith they were taking on. It had served for them as nothing more than an ignominious mark of submission to a hated conqueror, and more than once they had apostasized in bloody revolt. Alcuin reminded Arn of this precedent in his discussion of baptism among the Huns.

> Without faith, what does baptism profit? . . . For that reason the wretched nation of the Saxons so many times lost the sacrament of baptism because they never had the foundation of faith in their hearts. . . . For that which the priest visibly works in the body through water, the Holy Spirit works in the soul through faith. There are three visible elements in the sacrament of baptism, and three invisible. The visible are the priest, the body, and the water. But the invisible are the Spirit, the soul, and the faith. Those three visible elements profit nothing outside, if these three do not work inside. . . . "For we are cooperators with God."[38]

The sacrament was not magic. It was a gesture that united the soul of the participant with the great spiritual reality beyond and above. Without true faith there was no union, no sacrament, and no true liturgy. To be a "cooperator with God" was to teach the faith, to prepare the soul of the recipient to receive the sacrament.

De Trinitate

The full meaning of Angilbert's symbolic spirituality and its relationship to the trinitarian symbolism of Saint-Riquier unfolds in the light of one other source that he knew, the great *De Trinitate* of Augustine. There is significant manuscript evidence for the *De Trinitate* at Saint-Riquier. Seven manuscripts of the text which date from the late eighth or early ninth centuries are extant. Most of them come from monasteries with close ties to the Carolingian court.[39] They are as follows: Cambrai, Bibliothèque Municipale MS 300, dating from about 780, seemingly written at the same scriptorium as the Gellone Sacramentary; Codex Vaticanus Palatinus Latinus 202, late eighth or early ninth century, probably from Lorsch; Laon, Biblio-

thèque Municipale MS 130, early ninth century; Paris, Bibliothèque Nationale Nouvelle Aquisition Latine 1445, from the early ninth century; Paris, Bibliothèque Nationale Latin 9538, an eighth-century codex probably from Echternach.

Two manuscripts have a history that makes them likely candidates for Angilbert's manuscript. Oxford Bodleian Laud. Misc. 126, dating from the mid-eighth century, contains in part a peculiar and immediately recognizable uncial script called the N-uncial, which E. A. Lowe attributed to the convent of Chelles. The decoration, in Lowe's view, suggested the school of Corbie, the near neighbor of Saint-Riquier whose abbot, Adalhard, was an intimate friend of Angilbert. Both the scriptorium of Corbie and that of Chelles had close ties to the royal court. The Oxford *De Trinitate* itself seems to have had quite direct ties to Charlemagne. Folio 1 contains in Anglo-Saxon script of the eighth or ninth century a letter to Abbot Baugulf of Fulda relating to Charlemagne's educational reforms. According to Lowe, this manuscript belonged to Saint Kilian's of Würzburg by the ninth century. Both its peculiar script and its decoration connect this manuscript with the famous Gelasian Sacramentary, Vatican Reginensis 316. The Gelasian manuscript, interestingly, has the same later provenance as the Reginensis manuscript of Angilbert's *De perfectione:* the collections of Christina of Sweden and then of Alexander Perau. This particular manuscript contains an added interlinear Latin text of the Creed and the *Pater noster.* The Gelasian Sacramentary seems an odd text to have for one so close to court developments as Angilbert, since at this time the Hadrianum of Alcuin was preferred for liturgical usage. However, the 831 inventory of Saint-Riquier's library mentions among its *libri sacrarii Missales Gregoriani tres, Missalis Gregorianus, et Gelasianus modernis temporibus ab Albino ordinatus.*

The other, Monte Cassino Archivio della Badia MS 19, dating from the late eighth or early ninth century and written in Visigothic miniscule, was produced in Spain. It is closely related to Monte Cassino MS 4, a copy of Ambrose's *De fide, De Spiritu Sancto,* and other texts. The marginalia of both manuscripts, in Arabic and Visigothic cursive contemporary with the original script, contain the name of Ibinhamdon, who seems to have been an opponent of Elipandus of Toledo. Lowe believed that the history of migration of these two manuscripts was the same, and that they came to Monte Cassino toward the end of the eleventh century.

The *De Trinitate* presented its trinitarian argument in two stages. The first stage, which we have already seen developed and used so fully in

Carolingian anti-Adoptionist and *filioque* argumentation, set out the dogmatic principles of trinitarian theology. The second stage elaborated a psychological and aesthetic argument in order to show that the ability to understand and relate to the Trinity was innate in Creation and especially in the very structure of human thought. "Traces of the Trinity" were stamped in the physical world and in the human mind.[40]

Augustine had hoped to prove that the eternal archetype of the Trinity was available to human understanding by way of analogy with the things of this world. This was a fuller development of his exposition of the *signum* in the *De doctrina christiana*. To say that there were traces of the Trinity in the structure of Creation and in human intuition was to provide an important psychological link between the eternal archetype and the temporal world. It was also to say that the world could in some senses lead humanity to a greater knowledge or understanding of God. More important, the human mind itself was created in God's image and reflected the divine reality in one local and specific instance. Thus believers' minds could conform them to the eternal and salvific archetype of the Trinity.[41] Therefore, through analogy between the trinities present here, especially the threefold mind, and the eternal archetype that was their source, one could come to the truth of the Trinity itself and could conform oneself more and more to it.

Three-part structures were ubiquitous and visible. Being, knowing, and loving made up one soul. One animal was composed of unity, species, and order. One love was made up of lover, love, and beloved. Most important were the three parts or three functions that composed the mind: the intellect or understanding, the memory, and the will.[42] They were most important because the mind conformed the human to the Trinity.

Let us now consider Augustine's aesthetic analysis of the mind. By intellect Augustine meant understanding, the rational capacity to grasp and comprehend both sensory experience and noncorporeal principles. Memory was the faculty that retained and reconceived bodies or sensory experiences currently absent. It enabled a person to see again and again an image or concept that had once been impressed upon it and see it now with the inner vision, the "mind's eye," as Augustine called it. Will was that faculty of passion or desire that conformed the senses or the inner vision to the object perceived or remembered. It was the act of attention that "moved the eye to be informed" and then to be attached to its object. The greatest desire and constant quest of these faculties was to contemplate God, the truth. When it did so, it achieved wholeness; and Augustine defined that part of the mind that consulted the truth as the image of God in man.[43]

Fundamental to Augustine's theory of knowledge was the principle of analogy. It was only by knowing what was palpably observable in himself that one could come to an understanding of the other.

> For we recognize the movements of bodies also from their resemblance to ourselves, and from this fact we perceive that others live besides ourselves, since we also move our body in living as we observe these bodies to be moved. For even when a living body is moved, there is no way opened for our eyes to see the soul, a thing that cannot be seen with the eyes; but we notice that something is present within that mass such as is present in us, so that we are able to move our mass in a similar way, and this is the life and the soul. . . . Therefore we know the soul of anyone at all from our own, and from our own we believe of him whom we do not know. For we are not only conscious of our soul, but we also know what a soul is by studying our own, for we have a soul.[44]

Analogy, then, both operated out of similarity and made the observer aware of his similarity with others.

The mind moved between the two poles of the observer and the observed object in order to come to understanding. Hence there was always a three-part functioning of the mind: the observer, the object, and the will that mediated between them. The action could be current and immediate, linking an external object with the sensory faculties to form a sensory image. Or it could draw upon the inner storehouse of images, the memory, and interior vision, to create mental images.

This dynamic operation of the will between two poles to create a third entity was itself a trinitarian analogy. Augustine described it as "procession," analogous to the procession of the Holy Spirit out of the dynamic love between the "poles" of the Father and the Son. Augustine completed the analogy by likening the three faculties of thought to the three persons of the Trinity. The memory was as the Father. The understanding, "formed from the memory by the attention of thought, where that which is known is spoken," was as the Son. The love "which proceeds from knowledge and combines the memory and the understanding" was likened to the Holy Spirit.[45]

The creative mediation of the will (or love) between the poles of memory and rational understanding was movement toward wholeness or fruition.[46] This meant that the actions of the mind ultimately were inseparable, as all of the persons of the Trinity were present in the works of one. Any thinking involved the act of attention or desire that bound together the carnal image with perceptive understanding. Understanding of necessity

involved the relation of the sensory image to memory in which experience was filed. The act of attention or desirous perception of an object grew from and fed back into the inner vision. Relationship was formed through understanding. One could not love something unknown; similarly one could not understand something without the act of attention that held perception to the object.

> For the gaze of thought does not return to anything except by remembering, and does not care to return except by loving; thus love, which unites as a parent with its offspring the vision brought about in the memory with the vision formed from it in thought, would not know what it should rightly love if it did not have the knowledge of desiring, which cannot be there without memory and understanding.[47]

The action of the mind of necessity had a moral dimension, in Augustine's view, since it required the orientation of love. Hence the critical importance of knowing and seeking the truth. Knowledge kindled desire for the object known; desire kindled the search to know more about it. More importantly, it was from that inner commitment that one's outer actions grew:

> Thus there is nothing that we do through the members of our body, in our words and actions, by which the conduct of humans is approved or disapproved, that is not preceded by the word that has been brought forth within us. For no one willingly does anything that one has not spoken previously in one's heart.[48]

In this way, love assimilated a person to the object of one's love, because it determined the nature and end of one's actions. And since the eternal archetype was the source and fulfillment of one's own inner (and thus outer) life, the mind, the image of God, was driven by desire for creative likeness to God. That is, it was driven by the desire for wholeness.[49]

Christ was the turning point in the assimilation of the human to God. As the Word of God Christ was the eternal archetype of creative action, one's fruitful life in the world. As the spoken Word Christ revealed what was in the heart of God, and was the mirror of the eternal archetype. He was the most direct means of knowing, and therefore of loving God. Conformity to his actions meant conformity to God. Such knowledge and action went beyond this world into eternal wisdom.

> For (humans) could not be one in themselves, since they were separated from one another by conflicting inclinations, desires, and uncleannesses of sin. They

are, therefore, purified through the Mediator, in order that they may be one in him, and indeed not only through the same nature in which all mortal men become equal to the angels, but also by the same will working together most harmoniously toward the same blessedness and fused together in some way by the fire of charity into one spirit. . . . Then he reveals this truth itself, that he is the Mediator through whom we are reconciled to God in the following words: "I in them, and Thou in me, that they may be perfected in unity.[50]

Thus love made humans like the Trinity. Love of God was the only true love; anything else was desire. Even love of the things of this earth or of other humans could be love in God, "that while holding fast to the truth we may love justly, and, therefore, despise everything mortal for the sake of the love of humans, whereby we wish them to live justly."[51] Thus all things might become referents to that eternal truth, or means of contemplation of the eternal through Christ. Indeed, the corporeal "traces of the Trinity" were of great importance as referents to the Trinity because they provided some hint of the eternal archetype. "No one can in any way love a thing that is wholly unknown," as Augustine said.[52] The things of this world, even the great revelation of Christ himself, enabled one to see beyond this world only "as through a glass darkly." But without them the opacity of the eternal would be impenetrable.

Earthly signs not only gave partial illumination, they also kindled desire for greater illumination. They referred one to God and thereby inflamed love for God. The partial inflamed desire for the whole.

And yet, unless some slight knowledge of a doctrine were impressed upon our mind, we would in no way be enkindled with the desire of learning it. . . . So, too, if anyone hears an unknown sign, for example, the sound of a word whose meaning one does not know, one desires to know what it is, and what idea that sound is intended to convey to one's mind. . . . Suppose someone hears the word *temetum* and in one's ignorance asks what it means. One must, therefore, already know that it is a sign, namely, that it is not a mere word, but that it signifies something. This word of three syllables is in other respects already known and has impressed its articulated species on one's mind through the sense of hearing. What more can be required for one's greater knowledge, if all the letters and all the spaces of sound are already known, unless it shall have been known to one at the same time that it is a sign, and shall have moved one with the desire of knowing the thing of which it is the sign?[53]

This yearning for greater knowledge was especially true of beauties of which one became aware. For beauty and virtue one had a particular yearning and responded with full inner approval that aroused genuine love

because those things participated in and expressed truth itself. The mere rumor of a beauty or a virtue even unseen was enough to enkindle the love because its truthfulness was known generically as a good.

Thus the trinities of this world, especially the beauties that were trinities, were stepping stones to the eternal Trinity. The partial knowledge of the temporal led both to analogical understanding of and love for the archetypal source. That love led also to action by which the knower/lover conformed more and more to that eternal Trinity. Christ was important as mediator, as the most direct revelation and channel of the trinitarian mystery and of loving human response. The integral relationship between knowing, loving, and doing, between memory, understanding, and will, emphasized the importance of right belief, right understanding of the Trinity. As a source of Carolingian intellectual life the *De Trinitate* thus boldly underscored the obsession with correct dogma. According to the Augustinian context, truly it was not possible *sine fide* to please God.

These, then, were the intellectual and theological presuppositions of Angilbert's aesthetic theory. From the earliest evidence we have of Angilbert's thought, we have seen his concern with liturgy and symbolism. The *De conversione Saxonum* emphasized external gesture as expressive of internal state. Indeed, Angilbert developed the meaning of his poem entirely through actions and behavior. Conversion was virtually imposed from without by Charlemagne who was victorious in battle against the Saxons. The fruits of that conversion, *sub patris et geniti, sancti sub flaminas almi nomine,* were manifested as peacefulness and liberation from the kingdom of the demons. But never was internal conviction mentioned.

Angilbert's poetic technique employed symbolism of number, and especially of metaphor, to evoke the theme of conversion. The Saxons were described as vicious beasts in their pagan state, and as gentle and beautiful animals when they became Christians. The context of the poem was the physical power of the Trinity and the power of Charlemagne as its agent.

About twelve years later Angilbert came into close contact with the aesthetic theory of the *Libri Carolini.* The *Libri* echoed his understanding of liturgy, and further, predicated an intimate relationship between liturgy and the true faith. The *Libri* were written as a defense of the Trinity against the bad theology of the Byzantines. Within that context the *Libri* asserted that the function of the Church was "to set forth through the threefold prayer the mystery of the holy Trinity." Liturgy was the essential revelation of the Trinity through the symbolism of ritual gesture. Prayer was offered *metaforicos,* "metaphorically," in manifold ways that had one meaning only. That

meaning was discerned by the divine nature. A further, tacit level of meaning, the level of intention or the love of the heart that prompted prayer, supported the gestures and attracted the attention of the "ineffable hearing of divine majesty." Thus liturgy created a channel of communication between the participant and God.

Because of the revelatory function of the Church and liturgy, the *Libri* contained an ecclesiological dimension that was of utmost importance in understanding the monastic context of Angilbert's program. It was in the stone and prayer of churches that the mystery of the Trinity was contained and made available to the faithful. The life of the monk was devoted to prayer *die noctuque,* as the charter of Pepin to the monastery of Prüm said, and was circumscribed by the *norma patrum praecedentium*. This was a life of particular dedication and sanctification that was a continual channel of petition from below and grace from above for the Frankish king and people.

The *De doctrina christiana,* about which Angilbert wrote a poem in 796, provided both the aesthetic theory of *signa* and the analysis of the moral effect of those *signa* that were the basis of Angilbert's program at Saint-Riquier. In Augustine's view, everything in the world was a *signum* of God. What was critical was the Christian understanding that revealed this greatest of truths and informed one's attitude toward the world. One could either enjoy (*frui*) the world or use (*uti*) it. Enjoyment meant to appreciate something as an end in and of itself, whereas use meant to refer something to the ultimate cause, God. Hence, one could only truly and properly enjoy God himself, the source of all happiness.

It was the function of signs to refer one to God; without signs God could not be accessible. The partial knowledge that signs gave enkindled the desire to know more. This created in the heart and mind of the seeker an attitude of humility, in which he was willing to submit to the truth and to moral purification in order to come closer to God himself. This was a process of sanctification.

Augustine affirmed that men learned best through signs. They were far more effective, he said, in putting across theological truths than was intellectual discourse. For Angilbert, anxious to forward particular trinitarian doctrines, this teaching methodology was crucial. *Signa* were to be his strategy in the defense of the faith. And they were to be the vehicle for the interior purification and sanctification of the faithful.

In Augustine's view, the most compelling *signum* of all was the righteousness of the *magister* himself. The purity of one's life was the purest

witness of faith and intellectual commitment. That was to be the life of prayer, since ultimately, any expression of the truth in one's life was by the power of the Holy Spirit rather than the power of one's genius. Here again Angilbert borrowed most directly from the *De doctrina christiana*. His program comprised the witness of monks whose entire lifestyle was ordered around prayer through the *laus perennis*. The purity of that life was to let the Holy Spirit persuade "all the people of the faithful."

Angilbert did, however, choose one type of *signum* above all. His reading of the Book of Wisdom led him to define number as the essential structure of Creation, and therefore the essential worldly revelation of God. This he expressed not only in his *De doctrina christiana* poem, but also in his description of the monastery at Saint-Riquier. So that the faithful would venerate and truly believe in the Trinity, he said, he had been "zealous to establish three principal churches." Just as number symbolism had been the structural principle of his first poem on the conversion of the Saxons, so now it became the structural principle of his monastery.

That liturgy became a tool of persuasion against the Adoptionist heresy we have seen from the letters of Alcuin on the sacrament of baptism. To the monks of Gothia and Septimania Alcuin wrote defending the Carolingian and Roman practice of triple immersion against the Adoptionist practice of single immersion. Alcuin based his judgment on the catalytic spiritual effect of the immersion symbolism. This was not only a figurative mimesis of the burial and resurrection of Christ after three days and nights; it was an actual washing from the soul the deadly effects of the three degrees of sin. One person of the Trinity was invoked with each immersion. In Carolingian eyes, this was the heart of the Adoptionist error. Their sacramental symbolism could have no effect because it was wrongly performed. It was wrongly performed because their trinitarian belief was wrong.

Alcuin reaffirmed the importance of interior belief for the accomplishment of the sacrament in his letter to Arn of Salzburg on the evangelization of the Huns. Alcuin warned against the forced baptism of the Huns, citing the failure of such baptism among the Saxons, and asserting that without faith baptism profited nothing. Liturgical gesture, right faith, and moral status were thus inseparably joined in the Carolingian view.

This trinity of action, intellect, and emotional commitment was the basis of perhaps the most important of Angilbert's aesthetic sources, Augustine's *De Trinitate*. This treatise epitomized all of the claims made by the other sources that we have seen. The purpose of the *De Trinitate* was to prove that the Trinity was intrinsic in Creation, and therefore available to

human intuition. "Traces of the Trinity" in earthly signs led the mind naturally and reflectively to the Trinity itself as the ultimate source. Indeed, without those traces, humans could not come to the Trinity because it could not be known or knowable.

The most important trace of the Trinity was the human mind itself. Augustine defined the mind as threefold: reason or intellect, emotional response or love, and action or the fruition of the will. Knowing and loving were inseparable, since knowledge could only come through the act of attention, which was the expression of love. The act of attention also meant the desire to become like what one knew, and so the inner commitment led to action. This meant that one became assimilated to what one loved.

Since Christ was the ultimate source of knowledge about God for the Christian, Augustine defined the Incarnation as the turning point in one's assimilation to God. This was why Christ was the source of salvation. It was through him that one could achieve creative likeness to God himself. Christology, by extension, as the expression of one's knowledge of Christ, was critical to salvation.

In this we can see the very heart of Angilbert's program at Saint-Riquier. The *signa* that he created there were the embodiment of the trinitarian theology and the christology that he had negotiated for Charlemagne. Saint-Riquier was a revelation, a source of knowledge expressed in the most attractive and compelling way. It was the beginning of an entire moral and salvific process for those who saw it.

According to Angilbert's Augustinian understanding of the *signum,* the liturgical gestures of Saint-Riquier were physical acts that expressed the assimilation of the heart and mind of the believer to the Trinity. The unity of knowing, loving, and doing meant that to "confess, venerate, worship with the heart and firmly believe in the holy and inseparable Trinity" was to become Trinity-like. Gesture was regenerative, or rather, recreative. The liturgical symbolism of the stone and prayer of Saint-Riquier that "set forth the mystery" of the Trinity not only channeled the prayers of the faithful and the grace of God; it was a source of salvation for all who participated in its truth.

Let us now look at the stone and prayer of Saint-Riquier to consider at close range Angilbert's trinitarian program.

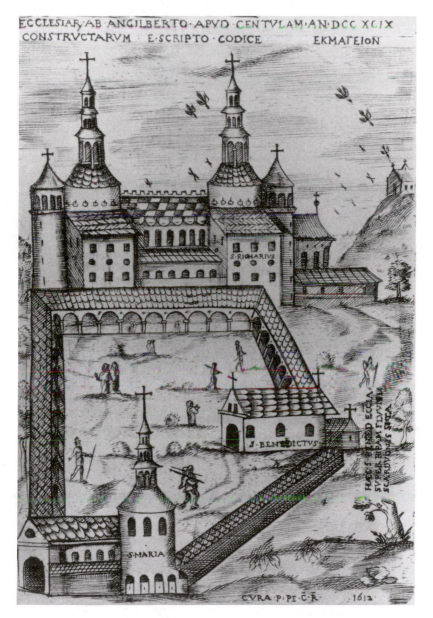

ECCLESIAR·AB·ANGILBERTO·APVD·CENTVLAM·AN·DCC·XCIX
CONSTRVCTARVM·E·SCRIPTO·CODICE EKMAΓEION

S·RICHARIVS

S·BENEDICTVS

HAEC·S·BENED·ECCLA·
SVPER·REI·M·FLVVIVM·
SCARDVONIS·SITA·

S·MARIA

CVRA·P·PE·C·R· 1612·

Figure 1. The Carolingian abbey of Saint-Riquier. Petau's Engraving of Hariulf's drawing, 1612.

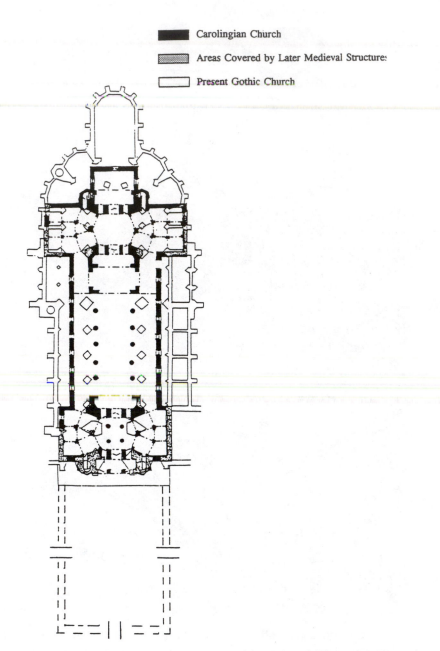

Figure 2. Plan of the basilica as reconstructed by Bernard. Plate after Honoré Bernard, "Saint-Riquier: une restitution nouvelle de la Basilique d'Angilbert," *Revue du Nord* 71 (1989): Figure 9. Adapted with permission of the author.

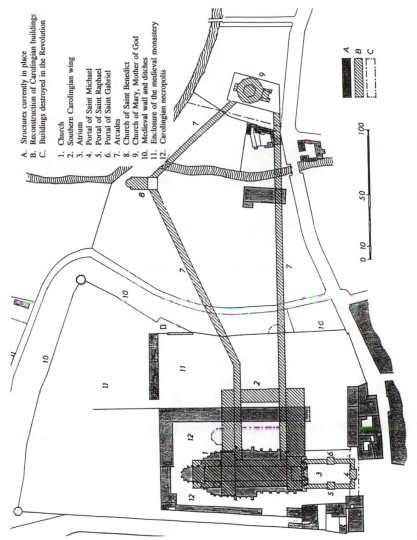

A. Structures currently in place
B. Reconstruction of Carolingian buildings
C. Buildings destroyed in the Revolution

1. Church
2. Southern Carolingian wing
3. Atrium
4. Portal of Saint Michael
5. Portal of Saint Raphael
6. Portal of Saint Gabriel
7. Arcades
8. Church of Saint Benedict
9. Church of Mary, Mother of God
10. Medieval wall and ditches
11. Enclosure of the medieval monastery
12. Carolingian necropolis

Figure 3. Aerial reconstruction of Angilbert's cloister by Bernard. Plate from Honoré Bernard, "L'abbaye de Saint-Riquier: évolution des bâtiments monastiques du IXe au XVIII siècle," *Sous la règle de Saint-Benoît* (Geneva: Librairie Droz, 1982), Figure 6. Reprinted with permission of the publisher.

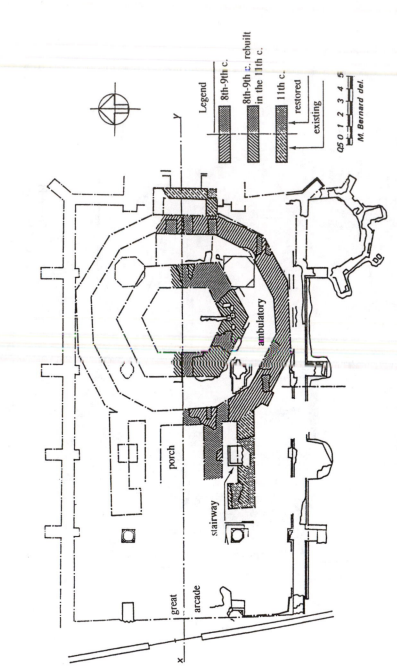

Figure 4. Plan of the Mary chapel as reconstructed by Bernard. Plate after Honoré Bernard, "D'Hariulphe à la lumière des récentes fouilles de Saint-Riquier," *Actes du quatre-vingt-quinzième congrès national des sociétés savantes, Section d'archéologie et d'histoire de l'art* (Paris: Bibliothèque Nationale, 1974), Figure 2. Used with permission of the author.

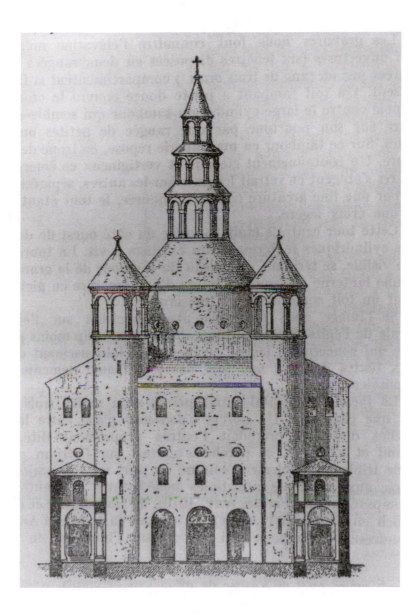

Figure 5. West end of the basilica as reconstructed by Effmann.

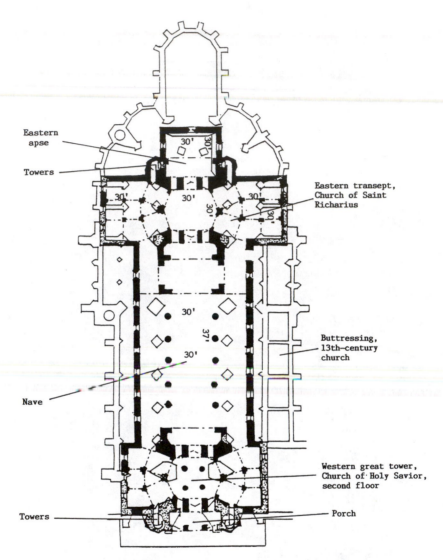

Figure 6. Floor plan of the basilica with modular dimensions. Plate after Honoré Bernard, "Saint-Riquier: une restitution nouvelle de la Basilique d'Angilbert," *Revue du Nord* 71 (1989): Figure 9. Adapted with permission of the author.

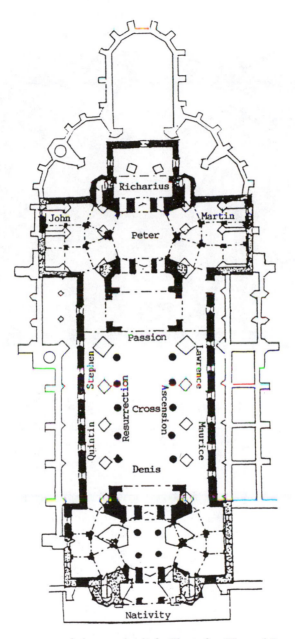

Figure 7. Arrangement of altars and reliefs. Plate after Honoré Bernard, "Saint-Riquier: une restitution nouvelle de la Basilique d'Angilbert," *Revue du Nord* 71 (1989): Figure 9: Adapted with permission of the author.

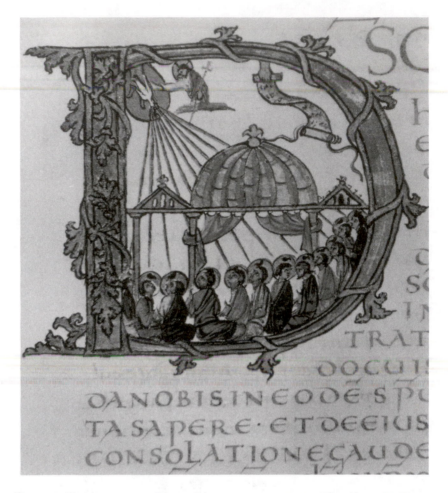

Figure 8. Pentecost scene, Drogo Sacramentary, circa 830. Plate from Wolfgang Braunfels, *Die Welt der Karolinger und ihre Kunst* (Munich: Georg D. W. Callwey, 1968), Plate 261. Reprinted with permission of the publisher.

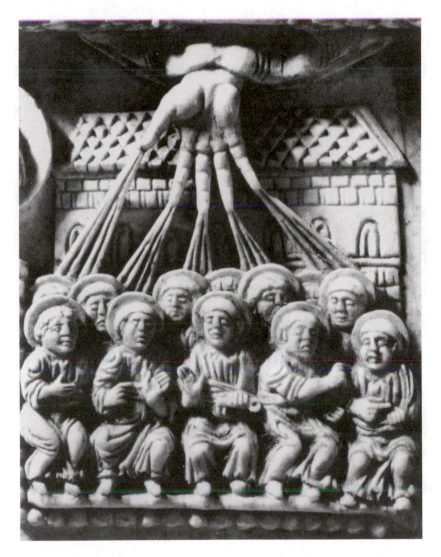

Figure 9. Pentecost scene, detail, ivory book cover, mid-ninth century. Narbonne, Cathedral of Saint-Just. Plate from Wolfgang Braunfels, *Die Welt der Karolinger und ihre Kunst* (Munich: Georg D. W. Callwey, 1968), Plate 200. Reprinted with permission of the publisher.

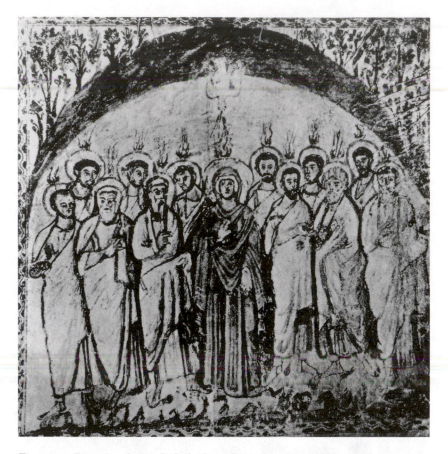

Figure 10. Pentecost Scene, Rabula Gospels, sixth century. Biblioteca Laurenziana, Florence, Photograph from Charles Diehl, *La peinture Byzantine* (Paris: G. Van Oest, 1933), Plate 71. Reprinted with permission.

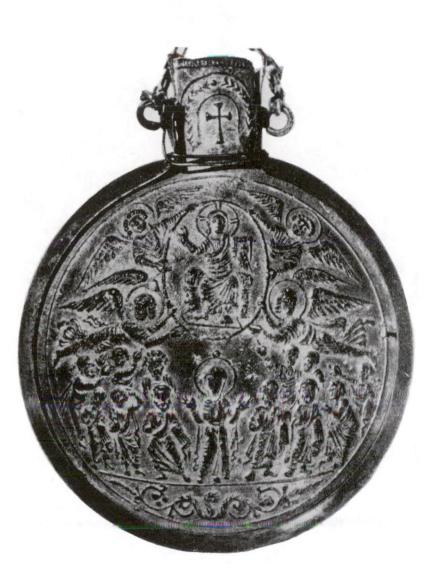

Figure 11. Pentecost scene with Ascension, Palestinian ampulla of Queen Theodolinda, circa 625. Treasure of the Collegia, Monza. Reprinted from Wolfgang Vollback, *Early Christian Art* (New York: Henry N. Abrams, n.d.), Figure 254. Reprinted with permission of the publisher.

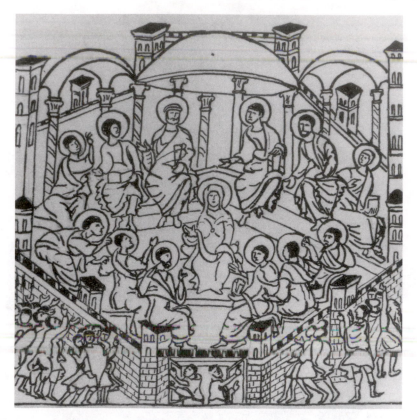

Figure 12. Pentecost scene, Bible of Charles the Bald, mid-ninth century. Rome, San Paolo fuori le Mura, line drawing by André Grabar, *L'Art de la fin de l'Antiquité et du Moyen-âge,* Volume 3 (Paris: Collège de France, 1968), Plate 115B. Reprinted with permission of the publisher.

5. *Datum Hoc Est Mirabile Signum*:
The Program of Saint-Riquier

Angilbert's program at Saint-Riquier was tightly structured around trinitarian imagery that in some cases was new to the West in the eighth century. Although Angilbert borrowed liberally from past, often disused tradition for his architecture and liturgy, he also did not hesitate to innovate in bold and striking ways. His sources were eclectic; his rationale cogent. His choices consistently and powerfully conveyed trinitarian *signa*.[1] With the theological and philosophical context of Angilbert's work in place, we are now in a position to examine his monastic program.

Let us first review the doctrinal issues and theological presuppositions that governed Angilbert's choices as a member of the group trying to uphold the *fides recta* as they knew it. Although their prosecution of these issues was based on misapprehension of the doctrinal positions emerging from Spain and Byzantium, Charlemagne and his intellectual circle believed that the correct faith was under attack. Their inability to perceive that Adoptionism and in large measure the image and *filioque* positions resulted from different starting points in theological reflection led them to assert that what was being taught was a perversion of the tradition of belief. The Carolingian perception, most clearly articulated by Alcuin was that it was only by adhering to the teachings of the Fathers as elaborated in the ecumenical councils of the fourth and fifth centuries that people of their own day could have full access to Jesus. It was this conviction that explained the Carolingian passion for the truth. More parochial theologies, then, became dangerous challenges to that universal and apostolic faith. Their passionate pursuit of the ecumenical tradition led to its establishment ever more squarely as the foundation on which subsequent christological and trinitarian reflection would take place.

From this perspective, the struggle with the Adoptionists centered on the true Sonship and primacy of Christ. Following Pope Hadrian's interpretation of the issues, the Carolingians saw a necessary distinction in

Adoptionism between the Word who was the true and eternal Son of God and the man Jesus who was the Son of God by adoption only. As opposed to the Adoptionist exegesis of the self-emptying of the Word into human form, the Carolingians elaborated their doctrine of the unity of the person of Christ based upon the Word's assumption (not adoption) of the human Jesus at the moment of incarnation. He was, as full God and full man, the true Son of God from the moment of his conception by the Holy Spirit in the womb of Mary. It was this mystery of personal unity that made Christ true redeemer of humankind in a mediatorial sense (as opposed to the familial, relational interpretation of Christ's gracious redemption understood by Adoptionism). The position of Mary as mother of God (and not merely mother of the man Jesus who became God) was a crucial corollary of this christological stance, particularly after the injection of Felix's term *nuncupativus* into the debate.

Against the Greeks and the Second Council of Nicaea the Carolingians sought to defend the Trinity. In the *Libri Carolini,* Charlemagne and his theologians claimed that the Greeks were worshiping false images by venerating icons because they did not know the true God who alone was worthy of worship. In particular, the Carolingians upheld the doctrine of the simultaneous procession of the Holy Spirit from the Father and the Son (*ex patre filioque*). This was a means of guaranteeing the proper relationship of coequality, coeternality, and consubstantiality between Father, Son, and Holy Spirit. Liturgy was of great importance within the Augustinian aesthetic framework of the *Libri* for the knowledge of God that it provided. It was especially revelatory because its very function was to set forth the *mysterium sanctae Trinitatis* for believers.

Here we must bear in mind two critically important and interrelated points. The first was the Augustinian triadic model of mind with which Angilbert at Saint-Riquier was working. The second was the pivotal role of Christ within that model. These doctrinal issues of trinitarian aesthetics and christology were crucial because within the tripartite understanding of mind as memory, understanding, and will, the model of knowledge was the source of the knower's love and action. Christ, as the epitome of faith and righteousness, was the ultimate source of knowledge about the Trinity. Therefore he was the source both of love for and of action on behalf of the Trinity. Augustine's trinity of mind made Christ not only the key to salvation, but also to the true fulfillment of human personality. Without the truth about Christ, there could be no salvation or fulfillment, since everything depended on and flowed from this initial spark of knowledge.

These, then, were the issues with which Angilbert was working when he said that he founded "three principal churches with the members pertaining to them so that all of the people of the faithful should confess, venerate, worship in the heart and truly believe in the holy and inseparable Trinity."[2] Like Theodulf at Germigny-des-Prés and Benedict at Aniane, Angilbert's project at Saint-Riquier was a cultural response to these doctrinal issues, a participation in the theological debate. Let us now consider the physical complex that he built.

The Physical Arrangement

Angilbert tells us that the core of his program, as it were the organizing structural principle, was three churches.[3] The original seventh-century monastery of Centula had contained one church dedicated to the Virgin Mary.[4] Angilbert replaced this with a large main basilica dedicated to Saint Richarius and the Holy Savior, a second smaller twelve-sided church dedicated to *Sancta Maria Dei Genitrix et Apostoli,* "Holy Mary Mother of God and the Apostles," and a third small private chapel dedicated to *Sanctus Benedictus Abbas et Reliquii Sancti Regularii Abbates,* "Saint Benedict and the Holy Regular Abbots."[5]

The churches were connected by arcades or arched and covered walkways (*tectae, arces*). These *tectae* gave the entire complex the shape of a triangle, with the basilica of the Holy Savior and Saint Richarius at the north or the apex, the Mary chapel at the bottom southwest corner, and the chapel of Saint Benedict at the southeast corner. A comparison of Figure 1, Hariulf's drawing, and Figure 3, Bernard's aerial view of the cloister based on his excavations of the site, reveals the extent to which Hariulf's version must be questioned. In Book 3.3 of the *Chronicon Centulense* Hariulf said, "Indeed the cloister of the monks has been made as a triangle: that is, from Saint Richarius to Saint Mary there is one arcade, likewise from Saint Benedict to Saint Richarius one arcade."[6] Hariulf portrayed the three churches and their basic orientation. But the cloister in his drawing was small, dense, irregularly shaped, and four-sided.

The excavations carried out by Honoré Bernard have revealed the actual relationship of the churches and the size of the cloister and have provided a truer schematic sense. Bernard excavated the site at various points. The most extensive work uncovered the entire foundation of the Mary church. (See Figure 4.)

Here Bernard discovered that the edifice portrayed by Hariulf gave little sense of the appearance of Angilbert's church. Hariulf's drawing presented a basilica with a clerestory, central nave, two side aisles, and an apsidal area at the east end which was a two-storey round tower. Bernard's excavations revealed instead a central form dodecagonal church (replacing the round eastern tower) with a small basilican entranceway in the west (replacing the basilica that in the drawing had appeared as the main body of the church). The dodecagonal main body of the church contained a thick outer wall, an ambulatory approximately 2.5 meters wide, and an inner wall or series of pillars and arches possibly meant to support an upper storey or a cupola. (Compare Figures 1 and 4.) Hariulf's drawing shows a three-tiered lantern capping the chapel. The inner diameter of the church was approximately 6.5 meters; the entire structure was inscribed in a circle 18 to 20 meters in diameter. The nave was approximately 8 meters long and 9 meters wide.

Bernard found no trace of the little chapel of Saint Benedict. Hariulf's drawing presented the Benedict chapel as a small, single-nave rectangular building with a rectangular apse at the east end. Like the Mary church, the building was oriented from east to west. In Bernard's reconstruction, the arcades approached the chapel at the front end of the building near the entrance. (See Figure 3.)

Bernard excavated the main basilica of the complex at key points. (See Figure 2.) Here he discovered that Hariulf's drawing greatly distorted the appearance of the church and particularly of the important and controversial western end. He uncovered both the northern and southern ends of the western transept, enabling him to determine both its size and its shape. He found that in both respects it was unlike the eastern transept. Hariulf had portrayed the western transept as the mirror image of the eastern.

Bernard also uncovered the foundation walls of the atrium of Angilbert, which he determined to be coterminous with the modern pavement in front of the thirteenth-century Gothic church. Of this Hariulf had given no hint whatsoever, leading architectural historians to debate the existence of an atrium at Saint-Riquier at all.[7] At the eastern end of the church Bernard excavated the southeastern corner and the northwestern corner of the transept arms, enabling him to determine their size and shape. He also excavated parts of the crypt. (See Figure 2.) Here he found, coterminous with the thirteenth-century Gothic radial chapels, a Carolingian lateral wall that marked the eastern end of Angilbert's church. Beyond that he found eleventh-century Romanesque material which had been added on. This

portion of the church appeared in Hariulf's drawing as a low appendage attached to the eastern apse. (See Figure 1.) Effmann had identified this as the crypt built in the eleventh century by Abbot Gervin. The original Carolingian crypt stood below the choir, as identified in Bernard's excavations.

Bernard also uncovered portions of a collateral structure attached to the southern length of the basilica. (See Figure 3.) This he believed was the remnant of the Carolingian monastic buildings. There was no trace of the buildings in Hariulf's drawing. However, the arcade that Bernard reconstructed between the churches does recall the cloister of Hariulf, although Bernard corrects the cloister's size and shape and provides a much clearer sense of the relationship of the three churches. Bernard uncovered no trace of the arcade, but his reconstruction posits a structure 260 meters in length between the main basilica and the Mary chapel, 85 meters in length between the Mary and Benedict chapels, and 220 meters in length between the Benedict chapel and the basilica. (See Figure 3.) The triangular shape of the complex that Hariulf cited appears much more clearly here than in Hariulf's own drawing; nevertheless, Bernard affirms the right-angle triangular form of which Hariulf's drawing hinted.

Let us now consider the evidence that Angilbert provided for his buildings. Of the Benedict chapel Angilbert said almost nothing. He mentioned it only to describe its altars, relics, and role in the monastic liturgy. The chapel contained three altars. Angilbert tells us that there were thirteen altars in the Mary chapel. One, in the center, was dedicated to Mary Mother of God (*Sancta Maria Dei Genetrix*), and was surmounted by a stone canopy. The Mary altar was in turn surrounded by twelve altars, one on each wall, each dedicated to one of the Apostles.

The most important of the churches was the basilica of the Holy Savior and Saint Richarius. The church was a standard basilica in plan. Despite its fame as one of the earliest westwork churches Bernard's excavations have shown that the western church of the Holy Savior was not a true westwork, that is a full western transept equal in size to that in the eastern end of the church. It consisted of *augmenta* of the monumental polygonal tower which was the centerpiece of this complex, and was somewhat smaller in size than the eastern transept.[8] The western end of the basilica consisted of an atrium, a porch with three portals, and the polygonal tower which was very similar in structure to the Mary church. (See Figure 2.) The worshiper entered through the atrium (*paradisus*), which had three portals.[9]

Each of these portals contained a chapel with an altar dedicated to one of the three Archangels.[10] Given the textual evidence, it seems that the

portal of the Archangel Michael was directly opposite the front of the church itself; we have no further information on the specific placement of the other portals.

The basilica itself was fronted by a porch flanked by two small lanterned towers (*turris, cocleae, ambulatorius*).[11] (Compare Effman's reconstruction of the west elevation, Figure 5, which posited a more monumental western face.) The façade had three portals.[12] Through them the worshiper entered the western church called *aecclesia sancti Salvatoris*.

The western complex at Saint-Riquier was a new and unique structure in western architecture, and we have seen the extent to which it has been the subject of much scholarly debate.[13] It was a two-storey polygonal tower with the chapel on the second floor. The worshipers entered through the two towers of the facade: *per cocleam meridianam ascendentes ad sanctum Salvatorem perveniat.*[14] The altar that it contained was one of the three main altars of the monastery (along with that of Saint Richarius and Mary Mother of God), and therefore was covered with a stone canopy.

The basilica contained three aisles: a large central nave and two lower side aisles. Hariulf's drawing indicates the use of a clerestory with round-headed windows. The eastern transept, larger than that of the west, was dedicated to Saint Richarius. The altar of the saint, also covered with a stone canopy, stood in the square apse beyond the transept in the east. Below it lay the crypt, which contained the relics of the three great patron saints of the area: Richarius himself, and Saints Frichor and Caidoc, the Irish disciples of Saint Columban who had first converted Richarius from paganism while evangelizing the territory.

The eastern front of the basilica seems to have mirrored the western. As two narrow towers flanked the vestibule in the west, so two flanked the apse in the east. In addition, both the eastern and western transepts were surmounted by a large tower with a three-tiered lantern.[15] Each end, then, was capped by three towers, the large and imposing central tower surrounded by the two small *cocleae*. We have no evidence of exterior sculptural decoration. Hariulf's drawing refers only to structural elements, windows punctuating the wall surface, which on the transept arms were arranged in three rows of three.[16]

The basilica seems to have been constructed on a modular pattern similar to that which Walter Horn discovered at Saint Gall, and Horn cited Saint-Riquier as the first Carolingian modular church.[17] According to Horn, modularity in Carolingian architecture meant that churches were organized spatially on the basis of square dimensions, and that the size of

the square transept crossing was the key element from which numerically all other proportions in the church were developed. In other words, the size of the square transept crossing established a module from which the proportions for the nave, the aisles, and the apse could be calculated. The square transept crossing was a Carolingian innovation.[18] The columns in the naves of these churches became the corners of superordinated modules.

We do not have exact dimensions for Angilbert's basilica.[19] The module of the transept crossing, according to the scale Bernard has provided, was ten meters by ten meters, or thirty by thirty Carolingian feet.[20] Therefore, at Saint-Riquier the basilica seems to have been constructed of modules based on the transept crossing. These proportions repeat the number three and its multiples. The eastern transept was made up of three modules of ten by ten meters, thirty by thirty Carolingian feet. The chapel of the western transept also seems to have been ten by ten meters, thirty by thirty Carolingian feet. If, as both Walter Horn and Irmgard Achter have suggested, we can assume a square grid pattern for the basilica, the nave would in theory consist of three modules of ten by ten meters, or thirty by thirty Carolingian feet. The total length of the nave would be thirty meters, or ninety Carolingian feet, long, and ten meters, or thirty Carolingian feet, wide. Bernard projected a nave of thirty-eight meters based upon the length of the nave and the placement of the supporting pillars in the current thirteenth-century church. This would yield a total length of 112 Carolingian feet, or three modules of thirty by thirty-seven Carolingian feet. Whether Angilbert intended to evoke the symbolic meaning of the number thirty-seven, which fit in, as we shall see, with his iconographical program, or whether Saint-Riquier as an early example of Carolingian modular architecture was not a completely consistent program is a matter of speculation. At any rate, these numbers, as multiples of three, had specific trinitarian symbolic significance, which we will examine below. Just as Angilbert had structured his *De conversione Saxonum* years before on the number three, so now he built threes into the very infrastructure of his basilica.[21]

The basilica contained four reliefs and eleven altars that were the focal points both of the liturgical celebrations and of the decoration of the church. We have little information on them individually and no archeological evidence, but taken together they reveal a great deal about the interior arrangement of the church and about Angilbert's theological program.

First let us consider the reliefs. (See Figure 7.) Angilbert described them by their subjects: the *Nativitas* (Nativity), the *Passio* (Passion), the

Resurrectio (Resurrection), and the *Ascensio* (Ascension).[22] Angilbert frequently described the Nativity as standing at the entrance of the church.[23] The Passion seems to have stood over the central nave at the entrance to the eastern transept.[24] The Resurrection and the Ascension are harder to locate, but the clearest view comes from Angilbert's description of the Office of the Dead.[25] He tells us that after Vespers (*horis Vespertinis*), Matins (*Nocturnos*), and Lauds (*Matutines*), the monks divided into two choirs, one processing to pray at the Resurrection, the other at the Ascension. Angilbert's text provides us with so much information that it is worth quoting at length.

> At all Vespers celebrated in the normal way, when everything has been completed at Saint Richarius, let the brothers proceed by singing psalms up to the holy Passion. When the prayer has been completed, let the choirs be divided into two, of which one proceeds to the holy Resurrection, the other to the holy Ascension. Then when the prayer has been done, let one choir come to (the altar of) Saint John, the other to Saint Martin. And then afterward (proceeding) through Saint Stephen and Saint Lawrence and the other altars by singing and praying, let them come together at the (altar of) the Holy Cross. . . . But when Vespers and Matins shall have been sung at the Holy Savior, then let one choir descend to the Holy Resurrection, the other to the Holy Ascension, and there, praying, let them just as above process singing to Saint John and Saint Martin; when the prayer has been completed, let them enter here and there through the arches of the middle of the church and let them pray at the Holy Passion. Thence let them proceed to Saint Richarius, where, when the prayers have been said, they shall divide themselves again just as before and shall come through Saint Stephen and Saint Lawrence, singing and praying, up to the Holy Cross.[26]

This is a key text that gives us insight into the placement of the reliefs. We may note several things. First, as these would have been two choirs of 150 monks each, they would have needed a fairly large space.[27] Since the side aisles were narrow, it is unlikely that they would have been the site of any ritual long in duration.

Then we must consider the purpose of the reliefs. Lehmann has claimed that in the West these subjects were unique to Saint-Riquier at this early period, and I have not found evidence of others.[28] The four representations were from the life of Christ, which bore significantly on the doctrinal proofs Angilbert was trying to make. As we have seen, the scriptural accounts of the Incarnation, Crucifixion, Resurrection, and Ascension were particularly important in the theological arguments forwarded by the Carolingians. We shall examine this further below, when we consider as a

whole the theological message of the complex.[29] But for now let us note a chapter of the *Admonitio generalis,* previously mentioned in the context of the theological controversies, which set out Charlemagne's royal and religious cultural program.[30] In Chapter 81 the king stated:

> In the same way must be preached how the Son of God became Incarnate by the Holy Spirit and from Mary ever virgin, for the salvation and restoration of humankind, suffered, was buried, and arose on the third day, and ascended into heaven; and how he will come again in divine majesty to judge all men according to their own merits; and how the impious will be sent into the eternal fire with the devil because of their sins and the just into eternal life with Christ and his holy angels.[31]

Here in Angilbert's reliefs were the subjects to be preached *per aecclesias* to all of the faithful. Significantly enough, the four subjects chosen were those by which Angilbert could argue the christological dogma of the God-man, the Nativity, Passion, Resurrection, and Ascension, rather than the Last Judgment also described here. We might expect, then, that the Resurrection and Ascension reliefs were located where all of the faithful could see them when they attended liturgies at the monasteries, that is, over the side arches of the nave before the Passion and toward the center of the church. (See Figure 7.)

From the same text we can posit the locations of the altars. We have three clues. First, we know that the altars of Saint John the Baptist and Saint Martin, of Stephen and Lawrence, and of Quentin and Maurice were paired in liturgies where the choirs divided in two. They were, therefore, on opposite sides of the church.[32] In the *De perfectione* Angilbert listed the altars in the following order: the Holy Savior and Saint Riquier (the two main altars that we know were at the West and East ends respectively), Saint Peter, John the Baptist, Stephen, Quintin, the Holy Cross, Denis, Maurice (which we would expect to stand near the portal of Saint Maurice), Lawrence (paired with its opposite Stephen), and Martin (paired with its opposite John the Baptist). Given the pairings, I would suggest that Angilbert listed the altars, starting with John, in a counter-clockwise order.

Second, the circuit described above, and especially the alternative circuit for liturgies celebrated in the chapel of the Holy Savior, suggests that the altars of John the Baptist and Martin were set apart from the others. The monks processed from the Ascension and Resurrection to these two altars while they prayed. They then came together at the Passion, where they

prayed, and processed to the altar of Saint Richarius to pray again. Only then did they separate into two choirs once again, and go to the altars of Stephen, Lawrence, and the others. The order of procession and the demands of space needed for 150 monks to chant at length imply that the altars of the Baptist and Saint Martin were located in the eastern transept arms, whereas the other altars of Stephen, Lawrence, Quintin, and Maurice, only briefly visited, were in the narrow side aisles.[32]

Third was the importance of the altar of the Holy Cross, where the two processing choirs repeatedly came together to pray and complete their circuits. I will argue that, given Angilbert's theological interest, it most likely stood at the center of the nave between the Resurrection and the Ascension.[33]

Thus I would suggest the arrangement of the altar shown in the accompanying sketch, based on an east-west axis (compare Figure 7).

Saint Richarius

John Peter Martin

Stephen Lawrence

Cross

Quintin Maurice

Denis

Holy Savior

Besides these liturgical and ornamental focal points, we know from Angilbert's inventory of the treasure of the church that the basilica was sumptuously decorated. Charlemagne, the royal family, and the royal household provided statues, furniture, and liturgical accoutrements of the most elegant sort.

> And when the altars of the aforementioned saints had been arranged for veneration and had been worthily ornamented, by our meagerness, with their relics . . . we began to consider with diligent care how we had even been able to decorate them, to the praise and glory of our Lord Jesus Christ and on behalf

of the veneration of all of the saints in whose honor they were consecrated, from the gifts of God and the largesse of my great lord Charles and of his most noble children and the rest of his good freemen, with works in gold, silver, and gems which they had collected for me; and how we had been able, where there were appropriate places, to set canopies above these altars as . . . we were zealous to do.[34]

The columns of the canopy over the altar of Saint Richarius were made of gold and silver. The basilica's two lecterns were of gold, silver, and marble. The treasury contained seventeen gold and silver crosses, two gold crowns, six silver lamps, two gold candelabra. There were two large gold chalices with their patens, a large carved silver chalice and paten, and twelve other silver chalices and patens. There were six statues of bronze and one of ivory. There were countless vestments of the finest fabrics, more than two hundred liturgical books, and *plurima ornamenta etiam insuper.*[35] There is no evidence of any permanent or large-scale architectural ornament in the basilica beyond the rich movable treasure detailed above and the four reliefs. Of the fresco or stucco decoration so characteristic of other Carolingian churches there is no trace in Angilbert's writings. Hariulf described substantial wealth. He wrote, however, at the end of the eleventh century, when the church had been despoiled and partially destroyed more than once.[36] Since Angilbert always described the treasure in detail when it was fabricated in a luxury material such as gold, silver, or marble, it is unlikely that he would not mention further luxury decoration, particularly of a large scale. Given Angilbert's evidence, we can say nothing more about the interior appearance of the basilica.

In the testimony of Angilbert's text, however, the true ornament of the church was the saints whose relics lay under its altars and in its niches. Put into gold and jeweled reliquaries *ad ornandas easdem sanctae Dei aecclesias* they inspired devotion to the Trinity: *magno desiderio nimioque amoris ardore sumus accensi.*

> These having been collected . . . honorably and fittingly in the name of the holy Trinity, we have with great diligence prepared a principal reliquary decorated with gold and gems, in which we have placed part of the above-mentioned relics, which we have been eager to place, with those for the veneration of the holy saints whose relics were seen to be collected in it under the crypt of the Holy Savior. Moreover, we have taken care to divide the relics of the other saints, which are noted above, into thirteen other smaller reliquaries decorated most handsomely with gold and silver and precious gems, which we merited to collect from the oft-mentioned venerable fathers with these same relics, Lord granting; and we have placed them on the beam that we have established on

the arch in front of the altar of Saint Richarius, so that in every corner in this holy place it will be fitting that the praise of God and the veneration of all of his saints always be adored, worshiped, and venerated.[37]

The list of saints was remarkable: Mary, the Apostles, the most heroic martyrs, the Popes, and above all, Christ himself. Angilbert's careful description of the worthy decoration of the relics recalls to mind those lines from the Prologue to the *Lex Salica*:

> And after the recognition of baptism
> The Franks adorned gold and precious jewels
> over the bodies of the holy martyrs, whom the
> Romans had burned with fire or maimed by the
> sword, or had thrown to the beasts to tear.[38]

At Saint-Riquier veneration and ornamentation of the relics of the saints was proof of true Frankish piety.[39]

In the eleven altars of the basilica, the arrangement of the relics under the altars varied, corresponding to theme or logical association. For example, under the altar of the Holy Savior lay relics of Jesus and the Holy Innocents. Under the altar of Peter lay his relics with those of Saint Paul, his fellow Apostle, and Saint Clement, one of the earliest Popes and martyrs. The altar of Saint Denis contained his relics as well as those of his disciples Rusticus and Eleutherius, whereas the altar of Saint Martin contained relics both of Martin and of other Gallican saints.

In the altars of the other churches, however, the arrangement was by number. In fact, it was by trinitarian number. The central altar of the Mary chapel contained her relics and those of nine great virgin martyrs. Each of the other twelve altars, which were dedicated to the Apostles, contained their relics and those of two other saints. They were arranged three by three. Similarly, the three altars of the chapel of Saint Benedict each contained the relics of three saints, three times three. Again we see Angilbert's concern with structuring everything in the physical space of the monastery around the number three.

Angilbert's Liturgical Order

It was not, however, only in the physical arrangement of the monastery that Angilbert wanted the perpetual worship of the Trinity to be carried out. It

occurred *in aedificiis marmoreis et in ceteris ornamentis, etiam in laudibus dei in doctrinis diversis et canticis spiritualibus.*[40] The liturgy too was integral.[41] He tells us that on account of the veneration of the holy Trinity (*quapropter ob veneratione sanctae Trinitatis*), he established three hundred monks in the monastery, a number that was to be kept constant.[42] One hundred boys also lived and worshiped at the monastery *in scolam.*

The daily liturgy consisted of the office, masses, and a procession with prayers between the three churches of the complex. For the office, which was the most important part of the liturgy, the monks and *scolae* divided into three equal choirs of one hundred monks and thirty-three *scolae* (the choir of the Holy Savior containing thirty-four boys). Angilbert stated that the numbers of the choirs were to be kept constant, probably for the sake of balance:

> Indeed, in any chorus it shall always be observed that an equal number of priests and deacons and the remaining holy orders be maintained. No less, let a division by equal measure of cantors and lectors be ordered, so that one choir not be overpowered by another.[43]

Each office took place at the basilica of the Holy Savior and Saint Richarius, where one choir stood at the altar of Saint Richarius, one at the altar of the Holy Savior, and one before the sculpture of the Passion. They sang the Psalms *in commune simul,* "together in common on behalf of Charlemagne and the stability of his kingdom," *pro salute gloriosi domini mei augusti Karoli proque regni eius stabilitate.*[44] After each office had been completed, a third part of each choir left the basilica to attend to their own needs and those of the monastery, whence they would return for the celebration of the next office *in commune simul.*[45] In the meantime, the other two choirs remained in the basilica to chant the Psalms. Thus Saint-Riquier was a *laus perennis* cloister.[46]

After the morning office (Lauds) and after Vespers in the evening, all the members of the choirs lined up *ordinabiliter* in front of the Passion. Ten cantors from the choirs remained there while the rest, singing, processed through the atrium, the Portal of Saint Gabriel, and the western part of the cloister to the Mary chapel. There they prayed the seasonal prayers. They then continued on to the Benedict chapel in the east and returned through the *tecta* to the Portal of Saint Maurice at the basilica, which Angilbert's text mentioned and which probably stood near the altar of Saint Maurice, where they again formed three choirs.[47]

Two solemn masses were celebrated by the entire community, one in

the morning and one at midday, on behalf of Pope Hadrian and of Charlemagne, his wife, and his children. In addition, at least thirty brothers celebrated thirty masses at the thirty altars of the churches.[48]

Thus the daily celebration of the office and the masses involved the entire three church complex and all 300 monks in a liturgical ritual that repeatedly called to mind trinitarian imagery: three choirs processing through a triangular arcade to three churches and thirty priests singing thirty masses at thirty altars. We might pause here to place these "trinitarian intercessions" within a broader context. We know that Charlemagne responded to the terrible crisis year of 792 (which saw not only the apostasy of Felix of Urgel, but also an assassination attempt againt Charlemagne by his son Pepin the Hunchback and other nobles, a severe food shortage, and preparations for a major military campaign) with a call for prayers and fasts by the clergy and the nobility. The structure of those prayers was telling: every bishop was to say three masses and three psalters (one for king, one for army, and one for famine), every priest to say three masses, and each cleric to say three psalters.[49] In addition, alms were assessed for financial help to those in need. Clearly, three-part intercession and trinitarian imaging in liturgy were of the profoundest consequence to the king, a special channel of supplication that invoked the greatest power of heaven for the material aid and comfort of a society beset on all sides. The trinitarian imaging of Saint-Riquier's daily liturgy was woven into a broad context of pragmatic need. It was an imaging Charlemagne understood well.

The special festal liturgies at Saint-Riquier took place in locations related specifically to the day. Most important were the Easter feasts, which centered liturgically on the Church of the Holy Savior. On Palm Sunday, the vigil offices were sung as usual in the basilica. But the monks sang the office of Tierce at the Mary chapel, where they then distributed palms and branches. The monks went out to the local people, who had gathered *in via monasterii,* and walked with them *una cum populo* to the atrium, entering through the portal of Saint Michael. The entire assembly stopped before the Nativity, where they said prayers, and then, entering through the central portal, they climbed the south tower to the Church of the Holy Savior where mass was sung in the presence of all.[50]

On Good Friday the monks and boys were divided into four choirs for the celebration of solemn prayers and the adoration of the Cross in the basilica. One choir of brothers stood before the altar of the Holy Cross. A second, of boys, stood in the east at the throne of Saint Richarius. Of the third we have no record; the fourth stood at the altar of the Holy Savior.

The ceremony of adoration involved three crosses. One cross stood at the altar of the Cross, to be adored by the choir of monks standing there, who sang *Ecce lignum crucis.* The second stood before the altar of Saint Quintin, to be adored by the common people (*populus vulgaris*). The third cross stood before the altar of Saint Maurice to be adored by the boys, who came in three choirs. At the end of the special liturgy, the usual three choirs sang the night office.

The liturgies for Holy Saturday were confined to the monks and boys alone. The office took place entirely in the Church of Saint Richarius. After Vespers had been completed, the choirs sang the litany of saints and prayers *ad fontes,* that is, at the baptismal fonts.[51] Then, while the *scola cantorum* went up to the church of the Holy Savior to sing the office, the other ministers prepared for the mass, which they too celebrated in the church of the Savior. This mass included three sets of litanies: those repeated seven times, those repeated five times, and those repeated three times. Finally, Compline and Matins were celebrated by the entire company of three choirs at the church of the Savior.[52]

On Easter itself, the monks celebrated a special procession, mass, and office.[53] The townspeople (*populus*) attended the mass at the church of the Holy Savior and participated in communion with the brothers.[54] The common worship of the entire community of believers was paramount here, as Angilbert repeatedly affirmed:

> But while the brothers and the rest of the clergy receive communion from that priest who shall have sung the mass on that day, let two other priests with two deacons and subdeacons give communion, one to the men, the other to the women in that same church, so that the clergy and the people, having received communion at the same time, can likewise hear the benediction or the completion of the mass. When this is finished, let them exit at the same time, praising God and blessing the Lord.[55]

Angilbert specified this despite the fact that there were others in the rest of the basilica who received communion only later.[56]

So went the Holy Week liturgy. We do not have the texts for the feast of Christmas, but from the references in the Paschal celebration, we know that the celebration must have been very similar to that of Easter. Thus, on the two greatest feasts of the liturgical year, the birth and the Passion and Resurrection of Christ, the ritual celebration brought together "all people of the faithful" for worship. On Palm Sunday they celebrated mass in the western transept, the church of the Holy Savior. On Good Friday they

celebrated the adoration of the Cross in the central nave of the basilica, between the reliefs of the Resurrection, the Ascension, and the Passion. On Easter, as at Christmas, they celebrated mass with communion *simul* in the church of the Holy Savior. The two great and central redemptive mysteries of Christ as God-man, the Incarnation and the Passion, were celebrated in a highly concentrated and symbolic ritual space.[57] That ritual space, dedicated to the Holy Savior, expressed concretely in stone the biblical and christological events being celebrated.

The Mary church was the liturgical setting of other feasts. As we have seen, anti-Adoptionist arguments, and especially those of Paulinus of Aquileia, placed a new importance on Mary in the development of their christological argument.[58] She was the Mother of God, *Theotokos,* in the traditional title of the Council of Ephesus, *Dei Genetrix* in Carolingian parlance. Her role was critical in the Incarnation, and therefore in the whole of salvation history. At the Annunciation, when the Holy Spirit "overshadowed" her, the Word became flesh in her womb. She was from that moment the true Mother of God, as well as the true mother of the human Jesus. The Carolingians had refuted what they saw to be the Adoptionist claim that Mary was the mother only of the man Jesus. Later, when the Word adopted the flesh, and Jesus himself became *Deus nuncupativus,* "God by appellation," Mary too became *Dei Genetrix nuncupativa,* "Mother of God by appellation." Both Jesus and Mary, then, as Carolingian theologians interpreted Adoptionism, received these titles as the mark of their new status. They were in no way integral to their persons. For Angilbert to name his Mary chapel *Sancta Maria Dei Genetrix et Apostoli* was in itself a significant doctrinal statement. He built his church in honor of the true Mother of God and surrounded her altar with those of the apostles who were the witnesses to the Incarnate Word.

The monks celebrated the offices at the Mary chapel on all of the feasts devoted to Mary, as we might expect. These included the Assumption, the Nativity, and the Purification of the Virgin.[59] On Holy Thursday, all of the offices were sung there. But most important was the celebration of the office and mass of Pentecost at the Mary church. This was the only day in the calendar of Saint-Riquier, as far as we know, that the mass took place here.

On this day, as on Holy Thursday, Angilbert specifically called the church by its full title: *Sancta Maria Dei Genetrix et Apostoli.* Every other mention of the church in the *Institutio* refers simply to *Sancta Maria.* This formal usage hints at the particular symbolic importance of the church. For

it was on two days of special revelation, Holy Thursday when the Eucharist was established and Pentecost when the Holy Spirit was manifested, that the Mary church was used. Both of those feasts celebrated particular revelations associated with the Carolingian anti-Adoptionist argument. Holy Thursday celebrated the Lord's Supper, the establishment of the sacrament of the Eucharist. This sacrament was the ongoing commemoration of the salvific sacrifice of Christ. The Crucifixion and Resurrection were the reasons for which the Word had become flesh, the purpose of the Incarnation. From the beginning of the Adoptionist problem, anti-Adoptionist arguments connected true belief in Christ with the sacrament of Baptism, the Eucharist and the salvation of the believer.[60] The Adoptionists, they said, by perverting the understanding of the true Sonship of the God-man Christ, also undermined the sacraments.[61] Therefore, there was a direct correspondence between christological doctrine and the understanding of the sacraments in the Carolingian position.

Pentecost was similarly related to Carolingian concerns. This was the celebration of the descent of the Holy Spirit upon the faithful believers in Christ, Mary, and the disciples. Pentecost, therefore, was the definitive revelation of the Trinity, Father, Son, and Holy Spirit. It must also have called up associations with the doctrine of the simultaneous procession involved in the *filioque* controversy because the Augustinian theological model failed to distinguish clearly between the internal relationship of the three persons of the Trinity and their external, historical relationship with the world. What was posited of one person implied the action of all three persons of the Trinity. The descent of the Holy Spirit therefore implied the Spirit's simultaneous procession at this moment *ex patre filioque*. This association buttressed christology as well, since we have seen that many of the scriptural texts used to prove the divinity of Jesus against the Adoptionists described Jesus's breathing forth of the Holy Spirit upon the disciples.[62]

Let us consider the liturgical and architectural iconography of the Mary church. On both Holy Thursday and Pentecost, what was essential in the biblical account was that the disciples were assembled together in the Upper Room. On Pentecost, they were with Mary.[63] Angilbert created an iconography akin to that which we have seen in the church of the Holy Savior: the liturgical space itself expressed the biblical event. Here were gathered the witnesses of the revelation. The architectural arrangement was particularly evocative on Pentecost, since the central altar of Mary was surrounded by those of the disciples. We may compare the text of Acts 1: 12–14 and 2: 1–4 which described the event from the time of the Ascension:

So from the Mount of Olives, as it is called, they went back to Jerusalem, a short distance away, no more than a sabbath walk; and when they had reached the city they went to the Upper Room where they were staying: there were Peter and John, James and Andrew, Philip and Thomas, Bartholomew and Matthew, James son of Alphaeus and Simon the Zealot, and Jude son of James. All these joined in continuous prayer, together with several women, including Mary the mother of Jesus, and with his brothers. . . .

When Pentecost day came round, they had all met in the room, when suddenly they heard what sounded like a powerful wind from heaven, the noise of which filled the entire house in which they were sitting; and something appeared to them that seemed like tongues of fire; these separated and came to rest on the head of each of them. They were all filled with the Holy Spirit and began to speak foreign languages as the Spirit gave them the gift of speech.[64]

If we compare the Mary church with slightly later ivory carvings and manuscript illuminations, Angilbert's program becomes clear. An early ninth-century illuminated initial from the Mass of Pentecost in the Drogo Sacramentary (Figure 8) presented the characteristic Carolingian iconography. The twelve disciples were seated in an architectural setting that suggested the Upper Room. Their haloes contained the tongues of fire that manifest the presence of the Spirit. They looked toward the sky, where they saw the Trinity revealed. Rays of fire emanated from the beak of the dove symbolizing the Spirit. Beside the Spirit sat the Son, on a cloud, identified by his halo, which contained a Cross, and the rod of his authority. His hand held the dove, a clear reference to the integral relationship between the Son and the Holy Spirit. The hand of the Father emerged from the heavens holding the unrolled scroll of the Law.

An ivory book cover dating from the mid-ninth century portrayed the scene, emphasizing the unity of the three persons (Figure 9). Here the disciples in the Upper Room were gathered around Peter, who held the keys of the Kingdom and raised his hand both in astonishment and blessing. (We may recall the growing cult of Peter in the Carolingian period.[65]) The divine hand from whose fingers poured the tongues of fire that visually manifested the Spirit, emerged from the heavens.

Comparison of these examples with early Byzantine representations of Pentecost yields one significant difference: in the Carolingian examples Mary was not present. The sixth-century Rabula Gospels (Figure 10) shows Mary surrounded by the disciples on a mountaintop. All were haloed; tongues of fire hovered above their heads. The Spirit-dove descended from heaven. An early Palestinian ampulla (Figure 11) combined the imagery of the Ascension and Pentecost in an iconography Grabar has

identified as a symbol of the Trinity.[66] Here Mary again stood in the center, surrounded by the disciples, on the mountaintop. She alone was haloed, and she stood in the *orans* position. The Spirit dove descended from above, as Jesus in the mandorla that symbolized his glorification, was borne to heaven by four angels.

The Carolingian failure to include Mary may have stemmed from strict adherence to the Biblical text. The presence of Mary at the Pentecost event was not specifically stated in Acts 2; it was, rather, implied from the preceding account of the Ascension. Angilbert's inclusion of Mary, therefore, underscored the importance of the Mother of God in his christological concerns and the doctrinal emphasis of his iconographical program. It was also one more example of Angilbert's innovative architectural usage. There was one later Carolingian parallel for his symbolism. The Bible of Charles the Bald, dating from the mid-ninth century, presented the Pentecost event in terms strikingly similar to that of Angilbert. (Compare Figures 12 and 4.) Mary was seated in the center of a polygonal Upper Room, the twelve apostles surrounding her on banks along the walls. There was no visible reference to the Trinity, no tongue of fire. Only the human narrative indicated what was happening: Mary and the disciples were astonished and reverent, and outside the crowds of people in the streets of Jerusalem pressed around the walls in amazement at the change in the disciples. The arrangement of the space and the characters, and the central presence of Mary, evoked Angilbert's Mary church.

These festal liturgies suggested a symbolism of place. But two other special liturgies evoked a symbolism of number. Both were liturgies of supplication.

The first was a liturgy of prayer and procession in times of trouble.[67] The *ordo* prescribed a highly formalized three-day ritual in which the monks in procession circumscribed the entire cloister. On the first day they went out of the monastery, through the public road out of the town of Centula itself and, returning through the western gate of the town, entered the monastery through the western arcade, after which they celebrated mass at the church of the Holy Savior. The second day, they went through the eastern gate of the town and the eastern arcade, returning through the Portal of Gabriel for mass at Saint Richarius. On the third day, they processed through the south gate of the town and returned through the houses of the artisans for mass at the Mary chapel. At every point they carried with them three crosses and three reliquaries, three vases with holy water and three thuribles.

The second of these was the liturgy for Rogations, the annual ritual of prayers, litanies, and processions for reconciliation with God that took place immediately before the feast of the Ascension. While ancient Gallican ritual prescribed a three-day penitential procession in which the entire local community of believers repented its sins and supplicated God's grace, Roman Rogations — the *litaniae maiores* — prescribed a one-day ritual.[68] Angilbert's order for Rogations continued the three-day tradition in an elaborate ritual that involved not only the monks and local populace of Centula, but also participants from seven neighboring towns.[69] Each town was to send a procession and a cross.

On the first day all convened in the atrium of the basilica, in front of the Nativity, where prayers began the ritual of processions organized in minute detail. First came those carrying three vases of holy water, then three censers with incense. Then followed seven crosses from the monastery, with the cross of the Holy Savior in the middle. The great reliquary (*capsa major*) with the relics of the Savior followed, with three priests carrying three reliquaries on the right and three likewise on the left. Then came seven deacons, seven subdeacons, seven acolytes, seven exorcists, seven lectors, and seven porters. Finally the rest of the monks processed in ranks of seven by seven.

The lay participants followed in the same ordering by sevens: the lay *scolae* with seven red standards, the noble men, the noble women, the seven crosses from the nearby towns, and boys and girls who chanted the Lord's prayer. Then came men and women from honorable local families, and finally the *mixtus populus* of the old and infirm, *ordine sicut ceteri septeni et septeni*.[70]

On this day they processed around the monastery chanting specified prayers. While the monks sang psalms, all of the others sang the three Creeds (Apostles', Constantinopolitan, and Athanasian), the Lord's Prayer, and the general litany. Then monks and *populus* sang together three litanies: the Gallican, the Italic, and the Roman. Finishing with prayers, the monks celebrated mass at the Holy Savior.

On the second day, following the same procedure, the procession went to two of the neighboring towns, and then celebrated mass at Saint Richarius. The third day they visited two other towns, and the monks returned for mass at Sancta Maria while the *populus* returned for mass at their own churches.

There were two striking innovations in this Rogations liturgy. First was the singing of the three Creeds by all of the laity. No such practice is

recorded in general Rogations ritual, which comprised the chanting of litanies of supplication, the reading of set passages from the Old and New Testaments, specific prayers, and the Constantinopolitan Creed. Angilbert's prescription of the Apostles', Constantinopolitan, and Athanasian Creeds and the Lord's Prayer echoed directly the frequent injunctions of Charlemagne's capitularies that the laity be able to recite these four *memoriter*.[71] The constant repetition of the formulae of the faith, and especially of the three Creeds, underscored Angilbert's (and Charlemagne's) concern that the monastery lead "the entire people of the faithful" to "confess, venerate, worship with the heart and firmly believe in the most holy and inseparable Trinity."

The second was the strict ordering of the procession in ranks of seven. Rogations processions were so ordered in Rome, where they represented the seven regions of the city.[72] But Angilbert's own intention was that the ranks of seven bear a trinitarian significance: "And we determined for this purpose to walk seven at a time, so that in our work we reveal thanks for the septiform grace of the Holy Spirit."[73]

The number seven was a highly charged *signum,* in which Angilbert understood the sevenfold gifts of the Holy Spirit as the seat of wisdom which led the believer to the vision of the Trinity. Through these gifts of wisdom, strength of character, and knowledge, the faithful Christian would understand and accept the true doctrine about the Father, Son, and Holy Spirit. Those sevenfold gifts were identified in a particular way with Christ. A quote from the *Libri Carolini* will illustrate the connection. On the subject of Christ as the cornerstone of the Church the *Libri* said,

> About him it is also said by the Father's voice through the prophet Zechariah: "Behold, I will lead my son, arising. . . . For this is the stone which I am placing before Joshua; on this single stone there are seven eyes." In these seven eyes the Spirit of the septiform grace who proceeds from the Father and the Son (*ex patre filioque*) is clearly revealed and is named through the Prophet Isaiah "the spirit of the Lord, the spirit of wisdom and understanding, the spirit of counsel and fortitude, the spirit of knowledge and piety, the spirit of the fear of God."[74]

Christ was presented as the seat of Wisdom and the bearer of the sevenfold gifts. It was this that made him the cornerstone of the Church, that is, the model of all of the faithful. He had the seven eyes that see God, because they were the gifts of the Holy Spirit *qui ex patre filioque procedit.* Wisdom led to the *visio Dei.*

As the symbol of Wisdom, seven was also the symbol of perfection

which explained the divine mysteries. Seven liberal arts taught the knowledge of the world. Wisdom built her house on seven pillars. The Creator rested on the seventh day. The world was to run through seven ages. We have already seen a similar division of time in the *De conversione Saxonum,* when Angilbert described the seventh age as the age of the Final Coming. The consummation was in the seventh age, *ab origine limes,* after Christ had redeemed and Charlemagne had converted pagans to the faith.[75] And Angilbert's poem was set in the year 777.

Thus seven was the number that connected heaven and earth. Alcuin described the connection in a discussion of the seven penitential psalms that prefaced his *Enchiridon*:

> And many other things are found scattered throughout the divine books that show the perfection of the sevenfold number. Whence also comes that saying of Solomon: "Wisdom has built a house for herself, she has quarried seven columns." . . . [This same number] explains all mysteries, this number which even in the beginning of creation was consecrated to the repose of the Creator himself; and now the order of the ages is established to run through that same number. And if seven is divided into two parts . . . that is into three and four, it comprises the wondrous secret of the world. For in three is signified the holy Trinity Creator of all that is; and in four is revealed the world of creatures, or the four poles of the earth.[76]

Just as Wisdom built her house on seven pillars, so through the seven gifts of the Holy Spirit did she lead the believer to the ultimate vision of Creation. For seven was the perfect number which comprised both heaven and earth, the ordering of Creation under the Creator Trinity.

The Symbolic Associations

These texts bring us to the heart of the number symbolism at Saint-Riquier.[77] The sevenfold ranks of Rogations processions announced the perfect wisdom of the sevenfold grace at the yearly point of penitential reconciliation between heaven and earth. So too the seven towers of the monastery complex—three large towers over the three main altars of the Holy Savior, Saint Richarius, and Mary, and four small towers at the beginning and end of the basilica—visually signified the Trinity and the four poles of the earth. (See Figure 1.)

Most important, here where the very structure of the buildings and liturgy was the number three, material Creation was visibly ordered under

the Creator Trinity. Angilbert put into visual terms the association between number, Wisdom, and the vision of the Trinity that he also made in his poetry, and especially in the *De doctrina christiana*. This was the teaching more eloquent than discursive theology, the persuasive symbolism of which Augustine had spoken in the *De doctrina christiana*. Angilbert's program made explicit the great truth implicit in Creation. And he thereby made available to the true believer the personal and collective regeneration that brought him to the final *visio Dei*. Alcuin illustrated the point in a letter to Charlemagne:

> After seven weeks the Holy Spirit was sent from heaven (at Pentecost) in fiery tongues over the 120 names of those believing; and we read about the seven gifts of the Holy Spirit in the prophet (Isaiah 11:2–3). And then most especially, while the white vestments are lifted from the baptized (seven days after baptism), they who in baptism receive the remission of all sins, are fit to receive the Holy Spirit through the imposition of hands (in confirmation) by the bishop; and for seven days they are accustomed to attend the holy sacrifices in the angelic garb of chastity and the lights of heavenly clarity.[78]

Seven signified Pentecost, the creation of the mission Church out of the 120, and the witnessing to the faith through the gifts of the Spirit. And seven signified the meaning of the Christian life in the confirmation that took place seven days after baptism for the faithful. This was the lived dimension of the *visio Dei* described before.

The full meaning of that vision at Saint-Riquier becomes clear only within the context of the *De Trinitate*. In the dominant three symbols of Saint-Riquier were Augustine's "traces of the Trinity." The threes in Angilbert's complex were everywhere. Three churches stood in a triangular cloister. Three main altars designated by three stone canopies were the sites of the main liturgies. The atrium contained three portals with three chapels and the three altars of the three Archangels. Worshipers entered the basilica through three doors. There were three aisles in the basilica and three lecterns. Three towers surmounted the basilica at the west end, and three at the east. Three-tiered lanterns capped the towers. Three modules of thirty by thirty-seven feet made up the nave, and three of thirty by thirty feet the eastern transept. One module of thirty by thirty feet made up the crypt. There were thirty altars in the complex. Three altars in the chapel of Saint Benedict each contained the relics of three saints. In the Mary chapel, the central altar contained the relics of three times three saints, and the Apostle altars each held the relics of three saints. Three hundred monks in three

choirs chanted the offices with three choirs of thirty-three boys. Thirty priests sang thirty masses at the thirty altars daily. Three crosses were adored on Good Friday. Three crosses were followed with three holy water vases and three thuribles during three-day processions in times of trouble. The three Creeds were sung at Rogations.

At every moment and in every corner were the innumerable traces by which the faithful believer could intuit the Trinity. Here indeed were the threes that designated *sancta Trinitas creatrix omnia quae sunt*. Here was the liturgy that set forth *metaforicos* the *mysterium sanctae Trinitatis* in the grace-filled terms of the *Libri Carolini*. Here too were physical traces that were vehicles for insight, mediating a mystery. Without this insight there could be neither recognition of nor participation in the divine truth. These were the partial clues which inspired the desire for knowledge and assimilation. We can illustrate the moral and salvific dimension of the symbol with a numerological text from Alcuin that explained the number three in the common understanding of the day:

> By three means Adam was tempted and overcome, those are by lust, by boastfulness, and by greed. In these three again Christ was tempted, and he conquered the conqueror of Adam. The whole world is divided into three parts, Europe, Africa, and India. In these regions in three ways God must be worshiped: by faith, by hope, and by charity. God taught Abraham three things, saying: "Go out from your land and your kin and from the house of your father."[79]

Here obedience to the precepts of God through the three Christian virtues led not only to the vision of the Trinity, but to the threefold glory of heaven: resurrection, life, and glory.

The bond between the true faith (or recognition of the Trinity) and righteousness (into Christ) was expressed in two aspects of life at Saint-Riquier. The first was the repetition of the number thirty. As the product of three times ten it represented righteousness through faith in the Trinity. Three symbolized the Trinity, and ten, the Ten Commandments. "There are ten precepts of the Law, which were given in two tablets through Moses and Aaron to the people of God," as Alcuin said.[80]

The second was the "perpetual" liturgy of the monastery. Liturgy comprised almost the entire life of the monks. Three things deserve mention in this context. First, we should recall the charter of Pepin to the abbey of Prüm. There the character of the monastic life was defined as prayer on behalf of the king and kingdom, and purity of life on the part of the monks

as the guarantor that prayers would be performed and heard. Saint-Riquier was the fullest expression of that monastic ideal.

Second, we should recall the text of the *Libri Carolini* on the meaning of the liturgy as the revelation of the *mysterium sanctae Trinitatis*. If Angilbert's purpose was to create an aesthetic complex that would inspire "the entire people of the faithful" to believe in and worship the Trinity *corde,* "in the heart," there was no better means of promulgating true doctrine and inspiring faith than liturgy. Third, in the Augustinian aesthetic theory and the emphasis on righteousness mentioned above, the ultimate and greatest expression of belief and love was perpetual prayer and praise of the Trinity. The liturgical lifestyle at Saint-Riquier was the epitome of the Christian life.

The great model for that life of faith, the linchpin between God and men as the great example of wisdom, was Christ himself, as we have seen in the *De Trinitate* and the Carolingian anti-Adoptionist arguments. *Datum hoc est mirabile signum,* as Paulinus of Aquileia said of Christ.[81] Christ was the ultimate means by which adequation or assimilation to God took place. Dogmatically (or intellectually, in the Augustinian schema) this adequation depended on the full union of true God and true man in Christ.

Angilbert expressed this truth *metaforicos* in the ritual space of the Church of the Holy Savior and the four narrative reliefs. The western transept at Saint-Riquier was a monumental innovation. Dedicated to the Holy Savior, and the place of celebration for the feasts of the Nativity and the Paschal mysteries, it stood in stone and prayer as the symbol of Christ himself. Incarnate as God-man on Christmas, and Redeemer in the Paschal triduum, this was the Christ of the Carolingian theologians against the Adoptionists.

The christological symbol was strengthened by the four reliefs. In the main body of the basilica and in full sight of all of the worshiping faithful, stood the four pillars of the Christian faith which the faithful were charged to believe. The dogmatic clues were highly concentrated. The worshipers stood between the Passion and the Holy Savior, with the altar of the Holy Cross in the center as the sign of Christ's redemptive role. The ultimate meaning of that redemption for the believer, and the proof of Christ's unique status as God-man were epitomized in the Resurrection and the Ascension. These were the revelatory stories of Christ's divine mission. And as Christ was "the first fruits of those that die," they were also hints of the life to come for the true believer.

The christological dogma of the true God and true man was repeated yet again in the vocable of the Mary chapel: *Sancta Maria Dei Genetrix et*

Apostoli. As we have seen, the title *Dei Genetrix* for Mary was a key issue in the Adoptionist struggle, since the Carolingians thought that the Adoptionists denied the title integrally to Mary, and said that she could be called "Mother of God" only as a God-granted honor. This was by virtue of Jesus's adoption as son of God, nothing more.

The Carolingians defended the traditional title *Dei Genetrix* as true and integral to Mary's role in God's plan of salvation. They supported with the scriptural text of the Annunciation the tenet that from the moment of his conception by the Holy Spirit, Christ was fully and wholly God and man in the womb of the Virgin. Thus to entitle the church *Dei Genetrix* was to forward the Carolingian christology.

The Mary church exposed a fuller trinitarian truth as well. As the site of the celebration of Pentecost this church symbolized the descent of the Holy Spirit, which was the final and ultimate manifestation of the Trinity. It was also the birth of the Christian Church. This was visually affirmed in the aesthetic program by the altar of Mary surrounded by the altars of the Apostles, a direct evocation of the Upper Room of Acts 2. (This was the same Upper Room used for the Holy Thursday institution of the Lord's Supper, a liturgy also celebrated at the Mary church.) The liturgical complexes of the Holy Savior and the Mother of God, and the nave reliefs in the basilica, directly and powerfully put across the true doctrine about Christ *in aedificiis marmoreis . . . etiam in doctrinis variis.*[82]

Let us return once more to the symbolic numbers of Saint-Riquier. The ultimate meaning of Angilbert's aesthetic program and the ultimate trinitarian revelation lay in the number three hundred, the number of monks in the abbey. Three hundred signified the great eschatological truth of the faith: one hundred, meaning the perfection of eternal life, times three, the Trinity. The definition came from the *Moralia* of Gregory the Great, a text that was in Angilbert's library.[83]

> By custom the fullness of perfection is understood in the centenary number. What, therefore, is designated in the number three hundred except the perfect cognition of the Trinity? Indeed, with these our Lord destroys the adversaries of the faith, with these he descends to the wars of preaching; they who can understand the divine truths, they who know about the Trinity, who is God, understand perfect truths. Indeed, it must be known that this number three hundred is contained in the letter Tau (T), which bears the appearance of the Cross. And if that which is distinguished on the Cross would be added over the transverse arm, this would no longer be the appearance of the Cross, but the Cross itself. . . . They who, following the Lord, so much more truly take up the Cross, how much more bravely do they also conquer themselves, and

are crucified for their neighbors by the compassion of charity. And certainly this is expressed in these three hundred that are contained in the Tau, that the sword of the enemies is overcome by the wood of the Cross.[84]

Three hundred symbolized the Cross and the Christian life. It symbolized the weapon that alone vanquished the heretic sword. And it symbolized the perfect understanding, recognition, and acknowledgment of the Trinity. Three hundred was the *visio Trinitatis,* the end and hope of the life lived in faith. This was the aim of the Augustinian program in the *De doctrina christiana.* It was the aesthetic end described in the *De Trinitate.* It was the "participation" in the object of knowledge that the *Libri Carolini* described. It was the goal of Angilbert's great *signum* for the people of the faithful.

So stood Angilbert's great program at Saint-Riquier. Established *quapropter ob veneratione sanctae Trinitatis,* it recounted in liturgy and sacred space the true and salvific faith, which Charlemagne, his theologians, and Angilbert himself were vitally concerned to forward. It expressed in terms more compelling than doctrinal teaching the essential and specific trinitarian and christological doctrines at stake in the 790s. Here were the truths about the God-man and the accomplishment of Christian redemption. Here were the threes, the triangular cloister, and the three churches that set forth the *mysterium sanctae Trinitatis.* The seven towers proclaimed the perfection of Wisdom, which led to the vision of God. And that greatest hope, the ultimate meaning of salvation, was revealed in the three hundred monks.

But how unique was Saint-Riquier? I have argued above that the consistency of his program and its monumentality were new elements in the 790s. Let us consider briefly the wider architectural context in which Angilbert was working.

Conclusions

Angilbert's program at Saint-Riquier was a powerful statement on the power of liturgy and one example of *herrscherliche Gottesdienst*. But how can we assess the uniqueness of Angilbert's creation? Chapter 2 presented the wide-ranging effort on behalf of the correct faith and the specific theological and theoretical arguments that were advanced. These arguments both consolidated a body of texts for theological education and argumentation, and advanced original positions, particularly by Paulinus and by Theodulf.

Angilbert's work, however, carried the promulgation of the faith into other intellectual and spiritual realms: liturgical realms and concrete, artistic realms of expression. Here we can find fruitful comparisons for his work. We have already seen the connection of Theodulf's church at Germigny-des-Près with the theological positions forwarded in the *Libri Carolini*.[1] Equally striking was the monastery of Benedict at Aniane, a monastery that has received less attention from scholars.

Peter Bloch, in one of the few studies to examine the character of the church at Aniane, has argued that the spirituality that undergirded both Germigny and this church was essentially that of the Old Testament. The emphasis on the Ark of the Covenant at Germigny and the persistent (in Bloch's view) evocation of the number seven and of Old Testament images at Aniane revealed a consistent Carolingian understanding of the Church as the new Temple of Solomon.[2] While the Old Testament interests of the Carolingian kings have long been known, and such links were certainly important for Theodulf both in the *Libri* and at Germigny, a fresh look at the evidence for Aniane will give us a new perspective on this thesis.[3] While Theodulf's spirituality at Germigny may very well have been multi-faceted — and the Old Testamental character of Visigothic spirituality, so clearly visible in the *Libri*, has been brought out by Freeman and by Dahlhaus-Berg — Theodulf's apse mosaic must be understood first within the context of the image and *filioque* controversies with Byzantium, as we have seen. The same is true of Aniane.

As has been noted in Chapter 1, scholars have traditionally focused

their attention on Benedict's later career under Louis the Pious, when he became Louis's monastic reformer and counsellor.[4] Less attention has been paid to Benedict's earlier career, however, both in his reforms at Aniane (before the foundation of Inde) and in his contributions to the anti-Adoptionist effort in Septimania.[5]

From the record of Benedict's disciple and biographer, Ardo Smaragdus, Benedict's earliest years were much like Angilbert's. Originally called Witiza, he seems to have been born around 750, of noble blood, the son of the count of Magdalonensis (Maguelonne), a Visigoth loyal to the Franks (*francorum genti fidelissimus . . . fortis et ingeniosus*) and therefore left in power under Frankish rule. Like Angilbert, he was brought as a youth to the court of Pepin where he received his training and remained to serve Charlemagne.[6] Here, however, his similarity to Angilbert ended. Drawn continually and secretly to the religious life, he cultivated great discipline and finally took up the habit. In 774 he entered the monastery of Saint-Seine near Dijon.[7] Here he lived a life of exemplary self-abnegation and mortification, ultimately proven by his election as abbot.[8] At this he left Saint-Seine with the monk Widmar and returned to his patrimony where he lived as a hermit on his family's land, and finally founded the monastery of Aniane (probably in 782), attracting holy men from the nearby territories.[9]

It was during the construction of the monastery that the "perverse dogma of Felix invaded" Septimania. Benedict took up the fight in Septimania under Charlemagne's instigation.[10] As we have seen, the thrust of Benedict's involvement was pragmatic rather than theoretical. As Heil has pointed out, it was above all due to the work of Benedict, his practical campaign against Adoptionism, and his monastic reform that orthodoxy and the Frankish Church triumphed in Septimania.[11] Despite his pragmatic focus, he did write two anti-Adoptionist treatises; although we have little information on the texts, it is probable that they were written in the late 790s, during the final campaign against Adoptionism after the condemnation of Felix at the Synod of Aachen. The first, today called the *Opuscula,* was an argument from Scripture on the coequality, coeternity, and consubstantiality of the Trinity. The second text, the *Disputatio adversus Felicianam impietatem,* presented the orthodox christological position through biblical authority.[12]

It was during the initial confrontation with Adoptionism in Septimania that Benedict was building his monastic foundation at Aniane. Ardo tells us that he began to construct the church, dedicated to the Savior, in 782 with the help of the nobility, and that when it was finished Charle-

magne granted an immunity.[13] The grant brought Benedict to court at the same time that the Synod of Regensburg was investigating Felix's theology.[14] We know too that by 786 there was so clear an Adoptionist problem in Septimania that Pope Hadrian condemned the teachings of Elipandus in a letter of the same year.[15] The immediate context within which Benedict was building his new monastery at Aniane was the pervasive Adoptionist challenge in the region.

Ardo's account of the church that Benedict built reveals a program with a number of similarities to Angilbert's, along with some notable differences. According to the disciple, there was already near the site a pre-existing church that the monks rededicated in honor of Mary the Mother of God.[16] Ardo went on to describe the churches of the cloister with great care, in a passage worth quoting in full.

> Indeed the venerable father Benedict, surpassing in pious consideration, determined to consecrate the aforesaid church not in the dedication of any saints whatsoever, but to use, as we have already said, the name of the sacred Trinity. So that, I say, it might be recognized[17] in clear daylight, he resolved that three altars be placed under the main altar, which is understood to be the principal one, so that in these the persons of the Trinity might be understood to be signified symbolically. And marvelous arrangement, that in three altars the undivided Trinity and in one high altar the Deity constant in essence might be shown. Indeed, that high altar is solid on the outside, but hollow on the inside; so that what Moses built in the desert earlier, containing the small dwelling place of God, was clearly prefiguring where the reliquaries are kept enclosed on ferial days, with the various relics of the Fathers. Let these words about the altars suffice. Let us continue on succinctly to the vessels of the church, by what order and number they are arranged. Indeed, all vessels which are kept in that church we know to be consecrated to the septenary number. There are, namely, a seven-branched candlestick made wondrously by the workman's art, from whose trunk proceed branches and small spheres and lilies, reeds and goblets in the manner of nut-trees made, namely, in the likeness of that which Beseleel put together with wondrous skill. Before the high altar hang seven lamps, magnificent and most beautiful, made with inestimable effort, which are said by those who are experienced in such matters and who long to see them, to have been cast in the manner of Solomon. Other silver lamps in the manner of crowns, just as great, hang in the choir, which receive small ladels all around on rings inserted in themselves; and by special custom on festal days, filled with oil, they are lit; and these having been lit, the entire church glitters both day and night. And finally, three altars are dedicated in that same basilica: namely, one in honor of Saint Michael the Archangel, another in veneration of the blessed Apostles Peter and Paul, the third in honor of the soul of the protomartyr Stephen. In the church, truly, of the Blessed Mary Mother of God, which was founded earlier, are seen to be kept the altars of Saint Martin and moreover

of Blessed Benedict. And that which stands founded in the cemetery, is distinguished as consecrated in honor of Saint John the Baptist, than whom no one born of women has risen up greater, as divine oracles attest. It pleases to consider with how much humility and reverence this place must be held in awe, which is known to have been protected by so many princes as these. Indeed the Lord Christ is Prince of all princes, King of kings and Lord of lords; truly his same blessed Mary Mother of God is believed to be Queen of all virgins; Michael is praised of all angels; Peter and Paul are the heads of the apostles; Stephen the protomartyr holds first place in the choir of witnesses; Martin truly shines forth as the jewel of protectors; Benedict is father of all monks. And in the seven altars, in the seven-branched candlestick and in seven lamps is understood the septifom grace of the Holy Spirit.[18]

Bloch has cited this passage as evidence that Benedict's spirituality was Old Testamental. Ardo's citation of Moses, of Solomon, and of the seven-branched candlestick and other utensils in groups of seven, is proof for him that the essential impulse behind Benedict's work was to recreate in new form the Temple of Solomon. Again, we must always be mindful of the multivalence of symbolism and of the syncretism and inclusiveness of a Carolingian spirituality that sought legitimacy in many kinds of authority. Nevertheless, Ardo's words in the above passage express a rather different impulse than this.

First, Ardo took pains to stress the fact that Benedict chose to consecrate his church "not in the dedication of any saints whatsoever, but of the sacred Trinity" (*non in alicuius sanctorum pretitulatione, set* (sic) *in deificae Trinitatis*). It was for that reason (*quod ut*) that he placed three small altars (*tres aras*) in the main altar (*in altare, quod potissimum ceteris videtur*), "so that in these the persons of the Trinity might seem to be signified symbolically" (*ut in his personalitas Trinitatis typice videatur significari*). Ardo likened this great altar to the Ark of the Covenant, which Moses built, only to say that the Ark was its prefiguration (*illud videlicet prefigurans, quod Moyses condidit in heremum*), in the sense that just as the Ark contained the small dwelling place of God (*hostiolum*), so this altar contains reliquaries with various relics of the Fathers (*quo privatis diebus inclusae tenentur capsae cum diversis reliquiis patrum*).

Ardo then went on to describe the holy vessels and utensils in the church, "consecrated in the septenary number" (*in septenario numero consecrata noscuntur*). When he cited Solomon, he did so by way of pointing out the beauty and majesty of the lamps (which he distinguished from the seven-branched candlestick): "Before the altar hang seven wondrous and most beautiful lamps, made with inestimable effort, which are said by those

who are experienced in such matters and who long to see them, to have been cast in the manner of Solomon" (*Ante altare etiam septem dependunt lampade mirae atque pulquerrimae, inaestimabili fusae labore, quae a peritis, qui eas visere exoptant, Salomonaico dicuntur conflatae*). Thus the Old Testament references are meant not so much to invoke an exact identity as to describe an appearance or a character. Ardo did, however, invoke an exact identity: adding up the total number of altars, the candlestick, and the lamps, he described the repetitious use of the number seven in the following terms: "Therefore, in the seven altars, the seven-branched candlestick, and the seven lamps is understood the septiform grace of the Holy Spirit" (*In septem itaque altaria, in septem candelabra et in septem lampades septiformis gratia Spiritus sancti intelligitur*).

Thus, on a much smaller scale, and based only on the interior decor and arrangement of the monastic church at Aniane, Benedict's work invoked the same symbolism as Angilbert's: three as the symbolic expression of the holy Trinity, seven as the expression of the seven gifts of the Holy Spirit. Aniane received its royal privileges in 792, at the height of the Adoptionist and image controversies, having been built by a man integrally involved in the fight against Adoptionism, in the very territory in which the threat was the greatest. Much work remains to be done on this issue. But the parallels with Saint-Riquier, and the context in which both monasteries were built, are striking.

Also striking, however, are the differences, which help us gain perspective on the character of Angilbert's program. Benedict's symbolism involved only the interior decor of his church; Angilbert's was contained in the entire monastic complex, including its shape, the organization of its liturgy, and its decor. While Aniane had a second church dedicated to Mary as Mother of God, which contained altars dedicated to great abbots (Benedict and Martin), Angilbert dedicated a third and separate church to the abbot fathers, dedicating the altars in the Church of Mary the Mother of God to the Apostles. As we have seen, this specific dedication combined with the physical arrangement of the altars, quite explicitly evoked Pentecost symbolism contained in Carolingian manuscript illuminations.

Nothing of this is found or alluded to in Ardo's account. Benedict's monastery did have a third small cemetery chapel, dedicated to John the Baptist, and although Ardo gives no specific information on whether this chapel was built under Benedict, the implication of the text is that it was.[19] Ardo says of this chapel only that divine oracles (variant text reading miracles) occurred (*divina attestarunt oracula*); the dedication may have

had some significance given the importance of the baptismal issue in the Adoptionist controversy. Ardo, however, alluded to no such integration into the larger program of the church.

Nor did Ardo provide any insight into the liturgical life of Aniane. We know of Benedict's liturgical interests only from the later testimony of his work at Inde and at the reform councils of Louis the Pious. Much has been written on what we might call the liturgification of the monastic life under the second Benedict, what Bishop referred to as liturgical accretions to the original Benedictine Rule. There were, however, two essential differences between the later liturgy of Benedict of Aniane and that of Angilbert at Saint-Riquier. The first is the physical extent — the sheer geography — of the ritual, a point Carol Heitz has noted.[20] As we have seen above, special processional liturgies for Easter and for Rogations encompassed the entire region in which Saint-Riquier stood, including a number of local small towns. One of the effects of the monastic legislation of Louis the Pious, inspired by Benedict of Aniane, was to reduce significantly the physical extent of these liturgies, limiting them to the confines of the monastic churches themselves.[21]

The second difference was precisely the role and significance of the laity within the liturgical life of the monastery. Just as the physical expansiveness of the liturgy was limited under the reform legislation, so too was the role of the laity circumscribed. The areas within monastic churches into which they laity could enter — even pilgrimage churches such as Steinbach — were severely reduced and circumscribed under the Aachen legislation. The monks were screened off from the laity, and the liturgy itself became a monastic function without further lay participation. The architecture of monastic churches following the reforms underscored this development, as Werner Jacobsen has pointed out; and it was precisely with the luxurious lay involvement of the monastic liturgy at Saint-Riquier that Jacobsen drew his contrasts.[22]

For Angilbert the role of the laity was essential. There are a number of references in Angilbert's *ordo* to lay participation in the liturgy, most notably on the great feasts of the Church. But for Angilbert that role was also expansive. As we have seen, particularly for the Paschal liturgy and for the celebration of Rogations, the laity, hierarchically organized, was fully integrated into the processional liturgy, "seven by seven." This participation fits squarely with Angilbert's intent. For just as his monastery had been built "so that all the people of the faithful should confess, venerate, worship with the heart and firmly believe in the most holy and undivided Trinity," so

Angilbert indicated that this was to be done, "not only in marble buildings and in other decorations . . . but also in the praises of God, in various teachings, and in spiritual songs."[23] Michael McCormick has pointed out the importance for Carolingian kings of the use of liturgy as a means of propagating an ideal; Janet Nelson has underscored the meaning of liturgy in creating a community and a common ideology, a set of social behaviors as much as a set of beliefs.[24] It is appropriate, then, that Angilbert's liturgy be so inclusive. For if Angilbert's expressed intent was to propagate the trinitarian and christological truth, the wide participation of the community surrounding Saint-Riquier was the means by which he could do it. Processional liturgy and lay involvement were certainly not unique to Saint-Riquier. But the extent and nature of that involvement were.

Similarly, Angilbert's choreography of liturgical and architectural elements brought together elements that were not used in the same way elsewhere, and organized them with a creativity and vision — and scale — which were unique both in Angilbert's day and afterwards. His stucco sculptures of the Nativity, Passion, Resurrection, and Ascension are not attested elsewhere. Heitz has noted that Angilbert appropriated elements of the Gallican liturgy (here as in Rogations) for this usage: the fraction of the host and its disposition on the patene.[25] But Angilbert's arrangement changed that of the Gallican liturgy in a way that led the believer progressively (and chronologically) from the Nativity through the Ascension, to the understanding of the faith, and gave what had been a Gallican liturgical gesture a new widely visual, monumental expression.[26] If Angilbert borrowed from Gallican liturgy, he also borrowed from explicit Carolingian royal concerns: the four pillars of the true faith, which every subject of Charlemagne should know and understand according to the prescriptions of the *Admonitio generalis* and its warnings against the recent teachings of *pseudodoctores,* were precisely the Nativity, the Passion, the Resurrection, and the Ascension.[27]

In this light, the consistency and monumentality of Saint-Riquier become clear. But there are comparisons with other important Carolingian churches that underscore Angilbert's boldness and innovation as well. Saint-Riquier was not the only church complex to use the vocable of the Holy Savior.[28] There were numerous examples of this usage in Carolingian churches, beginning at least with Fulda in the 750s and Paderborn in 777 (Hauck's great baptismal church).[29] The original vocable of Germigny-des-Prés was Holy Savior (dating from about 806). The great Palatine Chapel at Aachen was dedicated to the Holy Savior,[30] the episcopal church

at Reims also carried this title. But while all of these churches shared the same vocable, the sources indicate that it is unlikely that it meant the same thing or took the same particular emphasis in all of them. The interest in the Savior cult evident at Aachen, with its avowedly political content, is different from the baptismal concerns (even with their clear political overlay) of Paderborn, and different yet again from the theological focus at Saint-Riquier. While we can certainly discern a royal stratum of meaning and symbolism in all of these churches, we would be less than just to the sources if we failed to acknowledge the differences between them as well, or at least to acknowledge that *herrscherliche Gottesdienst* had precise meanings in specific circumstances. Within this context, the particular integration of the Church of the Savior, the westwork, into the greater liturgical and architectural structure at Saint-Riquier is unique in Carolingian religious life.

What of the importance of Saint-Riquier's developing westwork as a structure? While it is known that Lorsch had a westwork that was slightly earlier than that of Saint-Riquier, Angilbert's use of the westwork liturgically gave it an independence and status within the whole monastic complex for which there is no evidence at Lorsch. As Heitz has put it, at Saint-Riquier the Church of the Savior had an "autonomy within the complex that underscores its preeminence."[31] Saint-Riquier had a monumentality that came to be the model for subsequent Carolingian architecture, and subsequent use of westworks seems to have been modelled largely on Angilbert's work, as architectural historians have long said. Rheims's westwork contained baptismal fonts, which suggest the importance of the Paschal liturgy here as at Saint-Riquier; its westwork dates at the earliest from 816. Similarly, Fulda had a westwork, but it was not begun until after 802. The list of westworks is long. All, however, postdate Saint-Riquier with the exception of Lorsch.[32]

Saint-Riquier was also not the only monastery with three churches. We have already seen such a usage at Aniane. Saint-Bertin and Saint-Vaast had three sanctuaries. The seventh-century episcopal group at Thérouanne had three churches, two simple basilicas juxtaposed with what seems to have been a baptistery, all oriented frontally, side by side.[33] Metz, while an episcopal grouping of some considerable size as we shall see below, had what Chrodegang considered in the mid-eighth century to be three churches *inter domum,* or in the immediate canonical cloister, though they were built separately between the fifth and the seventh centuries. Corbie, possessing two churches at its foundation, eventually added a third sometime during the abbacy of Adalhard.[34] However, as at Corbie, most of the church or

monastic complexes containing three churches developed piecemeal; that is, a third church or chapel was added later. There seems to have been no necessary liturgical or architectural integration into the overall church complex as at Saint-Riquier.

Regarding such integration, Carol Heitz has drawn parallels, even filiation, between the Lenten stational liturgy of Metz and the processional liturgy of Saint-Riquier.[35] Chrodegang's establishment of a stational liturgy during Lent at Metz has been well known ever since Theodore Klauser's study of 1929.[36] The liturgy was extensive, involving stational masses at the seven churches of the episcopal group, the three *infra domum* mentioned above, and four other contiguous churches grouped around the *claustrum* of the cathedral. Traditionally, this stational liturgy has been interpreted as an importation from Rome, following Chrodegang's trip there in the 750s. His particular emphasis on the church of Saint Peter within this group, as the site of nine stational masses, has been understood as a mark of Chrodegang's veneration of Saint Peter and early Carolingian ties with the papacy.[37] Whether Chrodegang's usages at Metz were innovative, or whether they were merely reviving past disused custom as Heitz has posited, the differences with Saint-Riquier, despite any filiation, are striking. Chrodegang's interest was Roman, and he superimposed this orientation on a group of churches that were already substantially in place by the end of the seventh century. Angilbert created his program, with a different orientation according to his own words, within an architectural matrix of his own making, and with clear christological and trinitarian doctrinal intent, and a clearly expressed interpretation of the symbolism of the number seven. The triangular shape of his cloister alone underscored his concerns.

Saint-Riquier's complex was unique because it was conceived and developed as a whole both liturgically and architecturally, from scratch, as it were, to express a consistent symbolic vision. We can gain a similar insight into a coherent program only from Benedict of Aniane's very different and later monastic complex at Inde, contemporary with his reforms of the monastic life, in which there was also a coherence and consistency of vision, and a clear integration of architecture and liturgy built up from the beginning. But these are two striking instances of a rare phenomenon, and they perhaps account for at least some of the importance each of these programs has had in the eyes of scholars. The fact that we can see the consistency and the integration in Angilbert's vision, however, is precisely the challenge that calls us to look closely at the immediate circumstances of its creation and the wider concerns of the mind behind this program.

Here at Saint-Riquier the dominant concerns of politics and theology, most particularly the theological issues of the 790s, were expressed in aesthetic terms. As we have seen, they became a visual and sensory mimetic strategy that, according to Augustinian aesthetic theory, regenerated and recreated the individual believer and, consequently, human society. Saint-Riquier was thus of the greatest importance to Charlemagne and to the theologians who informed policy. It was at its root, through the creative vision of Angilbert, an expression of Carolingian culture in formation. It is, therefore, of the greatest importance to us. Saint-Riquier, understood within the context of the work of the man who created it, reveals the cultural nexus that was the interpenetration of faith, art, and politics in the Carolingian world.

Appendix A: The Original Text of the Athanasian Creed

The capitularies of Charlemagne indicate that the Athanasian Creed was an especially important tool for teaching the faith. A prolix text, the Creed repeatedly emphasizes the christological and trinitarian formulae so important to Carolingian belief. Thus, it clearly underscores the issues central to the doctrinal controversies of the 790s from the Carolingian perspective. The text of the Creed follows.[1]

(1) Quicunque vult salvus esse, ante omnia opus est ut teneat catholicam fidem: (2) quam nisi quis integram inviolatemque servaverit, absque dubio in aeternum peribit.

(3) Fides autem catholica haec est, ut unum Deum in trinitate et trinitatem in unitate veneremur, (4) neque confundentes personas neque substantiam separantes. (5) Alia est enim persona Patris, alia Filii, alia Spiritus sancti; (6) sed Patris et Filii et Spiritus sancti una est divinitas, aequalis gloria, coaeterna maiestas.

(7) Qualis Pater, talis Filius, talis et Spiritus sanctus. (8) Increatus Pater, increatus Filius, increatus Spiritus sanctus; (9) inmensus Pater, inmensus Filius, inmensus Spiritus sanctus; (11) et tamen non tres aeterni sed unus aeternus; (12) sicut non tres inmensi, sed unus increatus et unus inmensus. (13) Similiter omnipotens Pater, omnipotens Filius, omnipotens Spiritus sanctus; (14) et tamen non tres omnipotentes, sed unus omnipotens.

(15) Ita deus Pater, deus Filius, deus Spiritus sanctus; (16) et tamen non tres dii, sed unus est deus. (17) Ita dominus Pater, dominus Filius, dominus Spiritus sanctus; (18) et tamen non tres domini, sed unus est dominus. (19) Quia sicut singillatim unamquamque personam et deum et dominum confiteri christiana veritate compellimur, (20) ita tres deos aut dominos dicere catholica religione prohibemur.

(21) Pater a nullo est factus nec creatus nec genitus. (22) Filius a Patre solo est, non factus nec creatus sed genitus. (23) Spiritus sanctus a Patre et

Filio, non factus nec creatus nec genitus sed procedens. (24) Unus ergo Pater, non tres Patres; unus Filius, non tres Filii; unus Spiritus sanctus, non tres Spiritus sancti. (25) Et in hac trinitate nihil prius aut posterius, nihil maius aut minus, (26) sed totae tres personae coaeternae sibi sunt et coaequales. (27) Ita ut per omnia, sicut iam supra dictum est, et trinitas in unitate et unitas in trinitate veneranda sit. (28) Qui vult ergo salvus esse, ita de trinitate sentiat.

(29) Sed necessarium est ad aeternum salutem ut incarnationem quoque domini nostri Iesu Christi fideliter credat. (30) Est ergo fides recta ut credamus et confiteamur quia dominus noster Iesus Christus Dei filius et deus pariter et homo est.

(31) Deus est ex substantia Patris ante saecula genitus, et homo est ex substantia matris in saeculo natus; (32) perfectus deus, perfectus homo ex anima rationabili et humana carne subsistens; (33) aequalis Patri secundum divinitatem, minor Patri secundum humanitatem.

(34) Qui licet deus sit et homo, non duo tamen sed unus est Christus. (35) Unus autem non conversione divinitatis in care, sed adsumptione humanitatis in deo; (36) unus omnino non confusione substantiae, sed unitate personae. (37) Nam sicut anima rationabilis et caro unus est homo, ita deus et homo unus est Christus.

(38) Qui passus est pro salute nostra, descendit ad inferna, surrexit a mortuis, (39) ascendit ad caelos, sedit ad dexteram Patris, inde venturus iudicare vivos et mortuos: (40) ad cuius adventum omnes homines resurgere habent cum corporibus suis et reddituri sunt de factis propriis rationem; (41) et qui bona egerunt ibunt in vitam aeternam, qui mala in ignem aeternum.

(42) Haec est fides catholica: quam nisi quis fideliter firmiterque crediderit, salvus esse non poterit.

Appendix B: *Regula fidei metrico promulgata stili Mucrone*

Paulinus of Aquileia seems to have written this poem at the time of the Synod of Friuli in 796. A virtual Creed in verse, it addresses the challenges raised in the struggle with Adoptionism.

> Te, pater omnipotens, mundum qui luce gubernas,
> et te, nate dei, caeli qui sidera torques,
> teque, sacer flamen, rerum moderator et auctor,
> aeternum trinumque deum veneranter et unum
> 5 confiteor labiis pleno sed pectore credo.
> In te credo patrem, cum quo deus unica proles
> regnat, et omnipotens cum quo deus aureus ignis.
> Non tres ergo deos, absit, sed sanctius unum
> corde deum credo, labiis non cesso fateri,
> 10 qui semper summus, perfectus semper et altus,
> solus et ipse potens, trinus persistis et unus.
> Personas numero distinguo denique trino,
> naturam nullo patior dividere pacto.
> In deitate quidem simplex essentia constat,
> 15 in trinitate manet sed subsistentia triplex.
> Non hunc esse patrem subolem quam credo tonantem,
> sed hoc esse patrem summum quod germen adoro.
> Et non qui genitor genitusque est, spiritus hic est,
> sed hoc quod genitor genitusque est spiritus hoc est.
> 20 Virgine de sacra, sancto de flamine natum
> credo dei genitum, lingua decanto fideli,
> tempore sub certo tempus qui condidit omne,
> lucida rorigeri caeli qui temperat astra,
> qui pontum terramque, polum, qui maxima mundi
> 25 clymata quadrifidi, montes collesque creavit,
> aetheris atque humi cludit qui limina pugno,
> articulis trinis vastis cum finibus orbem
> praelibrat et latum palmo metitur Olympum,
> saecula praecedit, fecit quia saecula cuncta.
> 30 Hunc pater omnipotens tinctum Iordanis in unda,
> protinus ex alto sanctus cum spiritus albae

caelitus in specie discendit namque columbae,
baptista sibimet magno famulante Iohanne,
dilectum propriumque, pium dulcemque tonantem
35 esse cuum genitum sancto discrevit ab ore.
Splendida florigeram nubes cum cingeret alpem,
esset et hic summa secreti montis in arce
discipulis altithroni caelorum gloria Iesus,
40 ut solis radius facies plus pulchra refulget,
candor ut alba nivis vestis radiabat, et ecce
intonuit vox alta dei de nube serena,
aera per vacuum, teneras transfusa per auras.
Talia mellifluis depromit gaudia dictis:
45 "Hic meus est" inquit "dilectus filius unus,
hunc audite." Datum hoc est mirabile signum,
quod deus atque homo Christus sit verus et altus.
Filius ille dei sancta de virgine natus
arguitur hinc: forte Petrus hac voce docetur
50 non homines aequare deo, dominoque clyentos.
Haec est vera fides, frangit quae colla celydri,
haec mundum vincit, peccati crimina tollit,
hac Petrus in clavi caelorum limini pandit,
aurea ruriculas reserans ad regna phalanges
55 mittit, et his nivaea depromit gaudia vitae.
Agniculos albo teneros cum vellere natos
lactea per centum suspensos ubera matrum
ad campos, Iordane, tuos cinctasque rosetis
gramineas segetes propter myrteta virentes,
60 lilia mixta rosis, florentia pascua Petrus
carpere mille movit ruminanti fauce bidentes.
Illic picta rubent croceo de flore virecta,
candidulo rident pulchre de germine cincta,
frigore quae numquam radio nec solis arescunt,
65 marcescunt numquam gelidis infecta pruinis.
Nec pluuiis perfusa quidem madefacta tabescunt
sed semper, paradise, tuos redolentia flagrant
messis aromaticae permixto chrismate odores.
Virgultum foliis gemmato robore produnt,
70 quod numquam foliis viduatum turpe vilescit,
punica mixta simul foliis sed poma retentat,
quae semper liquidos sudant de cortice sucos,
transfundunt dulces mandentis in ore sapores.
Ad fontem, salientis aquae qui viva fluenta
75 influit et rores uno de gurgite fusos
divisos spargit pariles per quattuor amnes,
albentes perducit oves, hinc pocula cogit
sumere, quo numquam spumanti fauce balantes
alterius fontis sitientes flumina poscant.

80 Percelli pravi fautores dogmatis omnes
 censeo falsiloquos geminato anathemate Pauli,
 doctoris mundi, Galatas quo forte rebelles
 terruit. Aut etiam croceo succinctus amictu
 angelus altivagas quisquis iaculatus in auras
85 grandisono referens aliter sermone profatur,
 quam Gabrihel regis praedixit nuntius alti,
 quam docuit Petrus, Pauli quam scribit arundo,
 quattuor et proceres parili quam voce fatentur,
 huius erit biplici feriendus fulminis ictu.
90 Principium, caput omne mali, nefas omne, Cerintus
 ultricibus fomis flammis infertur obustus.
 Infelix Ebyon huic non dispar in omni
 impietate iacet socius sub vulnere poenae.
 Arrius in foveam, fodiit quam perfidus ipse,
95 corruit, aeterna damnatus nocte tabescit.
 Eunomius laequeo sese suspendit in alto,
 per medium crepuit, picei petit ima profundi.
 Perfidiae iaculo propria se perculit ulna
 Nestorius demens, Stigias descendit ad umbras.
100 Canceris ut pestis Macedonia dogmata serpent,
 pro quibus ambusta Macedonius ardet in olla.
 Eutices infelix, ex omni parte nefandus,
 trita venena bibit, sibimet quae miscuit ipse.
 Pestifer ille Manis, totum quem possidet error,
105 sulphoreae fumos conflat sine fine gehennae.
 Haud secus horrisono spurcoque Sabellius ore
 blasphemus ignivoma Cociti gemet ustus ab unda.
 Hos etenim conctosque simul qui numinis alti
 obsistunt sacris confuso pectore iussis,
110 qui regem Sabaoth fallaci fauce lacessunt
 et dominum Christum natum de virgine sacra,
 flamine de sancto, regemque hominemque deumque
 corde negant pravo labiis spumantibus acti,
 inpugnare student, casso sudore latrantes,
115 de gremio avelli, sancto de corpore matris
 ecclesiae abscidi cultro decerno fidei,
 quam Petrus Paulusqsue docent, quam cocinit orbis,
 quamque satis prisci clare cecinere prophetae.
 Catholicos sanctosque viros patresque beatos
120 trecentos octoque decem conctosque perennis
 iudicis aequisonae cultores nempe fidei
 amplector placidis strictim feliciter ulnis.
 Nullus ab his terror, nullus me perfidus ultor
 sanguivomo abscidi mucrone secante valebit,
125 quorum nulla meo poterit de pectore famam
 auferre oblivio pactoque abolerier ullo.

Non iam sub tabulis dura de rupe recisis
scalpelli rimis sulcatis cuspide sculpam,
nec pingam nigris calamo de ororbus hausto,
130 sed potius scribam cordis sub pixide lento
instillante poli rutilo de culmine fonte
infuso stilo, post me monumenta relinquo
venturis descripta, libens non parco referre
carmine succincto lata sed mentis hauena,
135 praecepto findente duas dulcedinis undas
amplectens, dominus sancto quas protulit ore.
Primam libo deo, collegae reddo secundam
pectore de puro caritatis victus amore.
 In iubilo vultuque alacri sub mente iovunda
140 semper et almisonas sincero famine grates,
summe tibi, genitor, referam, deus alta potestas,
et tibi, nate dei, lati spes unica mundi,
spiritus alme, tibi, metuende, tremenda maiestas,
fons caritatis, amor dulcis super omnia mella,
145 lux et origo boni, casti spirator amoris,
qui quo vadis et unde venis nesciris, et orbem
terrarum reples et ubivis perpete spiras.
Auditur vox ecce tua, clamore silenti
cordis in aure sonat, nullo quatiente fragore.
150 Sit patri, genitoque deo sit gloria summo,
spiritui per cuncta deo sit saecula sancto.

Te vero, mi o karissime frater, obsecro devotionis affectu,
quicumque hos dignatus fueris versiculos lectitare, cum aut per
incuriam brevem pro longa aut longam pro brevi aut communem pro
naturali aut naturalem pro communi syllaba aut pedem pro pede
5 aut scema pro scemate aut tropoum pro tropo aut indiscretas
membrorum cesuras incauta disidiae manu resectas aut inconsideratum
colae defossum punctum aut comatum inaequales incisiones aut
inconditos eufonae melos aut si quid huiuscemodi reperiri potest
in his inspexeris exaratum, et videris ob id forte meretriculam
10 indignari Carmentem manumque ad ferulam mittere: non te eiusdem
modi formido perturbet sed adcinge sicut vir lumbos tuos et ad vices
meae parvitatis in faciem eius viriliter resiste. Inpavido utique
vulpiculae illi dicito ore, quoniam nihili eto pendens flammantes
repidosque indignationum eius furores, tamquam in lutum redactam
15 superbiae eius cervicem curvabo. Et ut veritus sum dicere, et
licet pudebit me referre non tamen celabo, quasi liciscae
multumque post carecta latrantis memoria illius mei tangit animi
modos. Tu autem studio veritatis inpulsus, extincto nihilo minus
usque ad cinus omni poenitus invidiae fomite, supple nimirum
20 ea quae desunt calamo caritatis. Superflua quidem dulcedinis reseca
falce, tortuosa namque dilectionis rectius aequare normula stude.

Cave praeterea ne forte fluxim per incuriam, extensa linea violento
directo obductu, a sui rectitudinis statu incurvari deformata formula
conpellantur. Considerare summopere stude, ne quando cum sarmentis
25 pampineas etiam amputasse te gemmulas peintearis. Non tibi, obsecro,
vilescant vernales folliculi necdum erumpentes in flores, qui clusas
celant botrionum gemmatas suo in tempore producendas uuas. Sed
neque triticeas summitates spicarum indigne feras, quae armatos
acutis, quibus pungant, lento conamine culmos fluctuare videntur
30 aristis. Memento cuius suavitatis sapor celatur in spica, cuiusve
edulia dulcedinis grana flava reservantur in teca. Non enim haec
ad humanas edentium traiciuntur fauces, nisi et uua prius calcibus
vel dentibus et spicae aut plaustri strictae rota aut flagellis conterantur
 percussae.

Notes

Introduction

1. *De perfectione Centulensis ecclesiae libellus* 1 (*MGH SS* 15, p. 174): Quia igitur omnis plebs fidelium sanctissimam atque inseparabilem trinitatem confiteri, venerari et mente colere firmiterque credere debet, secundum huius fidei rationem in omnipotentis Dei nomine tres aecclesias principales cum menbris (sic) ad se pertinentibus in hoc sancto loco, Domino cooperante, et praedicto domino meo augusto iuvante, fundare studuimus.

2. *MGH SS* 15 p. 178: sicut in aedificiis marmoreis et in ceteris ornamentis . . . ita etiam in laudibus Dei, in doctrinis diversis et canticis spiritualibus.

3. Since the time of Ernst Kantorowicz (Chapter 1, n. 9) Carolingianists have been especially interested in the role of liturgy for the Carolingians, and much recent scholarship has illuminated this issue. See Janet Nelson, *Politics and Ritual in Early Medieval Europe* (London: Hambledon Press, 1986), a collection of her most important articles on Carolingian ritual. Cf. the comparative studies in P. H. Sawyer and I. N. Wood, *Early Medieval Kingship* (Leeds: University of Leeds Press, 1977). Also seminal are the studies of Michael McCormick. See *Eternal Victory: Triumphal Rulership in Late Antiquity, Byzantium, and the Early Medieval West* (Cambridge: Cambridge University Press, 1986), and "The Liturgy of War in the Early Middle Ages: Crisis, Litanies, and the Carolingian Monarchy," *Viator* 15 (1984): 1–23. See also Thomas Head, *Hagiography and the Cult of the Saints: The Diocese of Orléans* (Cambridge: Cambridge University Press, 1990). Also pertinent in this context is the interesting article by Karl Hauck on baptism as *herrscherliche Gottesdienst* and the origins of the baptismal church at Paderborn. See below, Chapter 3, note 15. Cf. Josef Fleckenstein, *Die Hofkapelle der deutschen Könige. Schriften der Monumenta Germaniae Historica* 16, Volume 1 (Stuttgart: Anton Hiersemann, 1959), and on the ecclesiological vision of society, Walter Ullmann, *The Carolingian Renaissance and the Idea of Kingship* (London: Methuen, 1969).

4. For a discussion of the sources see Chapter 1, pp. 12–20.

5. See note 3.

6. See Gary B. Blumenshine, *Liber contra haeresim Felicis,* cited below in Chapter 2, note 11.

7. A new edition of the *Libri Carolini* is being prepared by Ann Freeman. On the recent bibliography on Theodulf, see below, Chapter 2, note 12.

8. See below, Chapter 2, note 11. Dag Norberg has also produced a recent edition of Paulinus's poetry. See *L'oeuvre poétique de Paulin d'Aquilée* (Stockholm: Almqvist and Wiksell, 1979).

9. See *Poetry of the Carolingian Renaissance* (Norman: University of Oklahoma Press, 1985), and *Poets and Emperors: Frankish Politics and Carolingian Poetry* (Oxford: Clarendon Press, 1987).

10. *Die Hofkapelle der deutschen Könige,* pp. 105–107.

Chapter 1

1. There has also been a fourth group, the earliest students of Saint-Riquier, who were nineteenth-century local French historians anxious to preserve the documentary history of pre-Revolutionary France and to glorify their local areas. With the exception of Durand, whose work will be discussed below in Chapter 5, this group has had little influence in wider scholarship on Saint-Riquier. See Antoine-Pierre-Marie Gilbert, *Déscription historique de l'église de l'ancienne abbaye royale de Saint-Riquier* (Amiens: Caron-Viet, 1836); Jules Hénocque, *Histoire de l'abbaye et de la ville de Saint-Riquier, les saints, les abbés, le monastère et l'église, la ville, et la commune,* 3 volumes (Amiens: A. Douillet, 1880–1888); "Notice sur Saint-Angilbert, abbé de Saint-Riquier: mariage de Saint-Angilbert avec la princesse Berthe," *Bulletin de la Société des Antiquaires de Picardie* 9, 2 (1866): 250–269; and "Observations de M. l'abbé Carlet, curé de Manicamps," *Bulletin de la Société des Antiquaires de Picardie* 11, 3 (1873): 333–351. This type of interpretation has continued recently with the publication of two small volumes published by the abbey itself: *Saint-Riquier I: Études concernant l'abbaye depuis le huitième siècle jusqu'à la Révolution* (Saint-Riquier: Abbaye de Saint-Riquier, 1962); and *Saint-Riquier II: Chronique de Pierre le Prestre, abbé de Saint-Riquier, et commentaires* (Saint-Riquier: Abbaye de Saint-Riquier, 1977), an edition and commentary on the fifteenth-century chronicle by Honoré Bernard.

2. See below, pp. 3–5 and note 15 for a detailed discussion of Hubert's thesis.

3. For a complete discussion of the extant evidence see below, pp. 12–20.

4. Wilhelm Effmann, *Centula-Saint-Riquier* (Münster-in-Westfälen: Aschendorff, 1912). For a discussion of the sources, and most especially the important drawing attributed to Hariulf, see also Hugo Graf, *Opus francigenum* (Stuttgart: K. Wittwer, 1878), p. 104; Heinrich Holtzinger, *Über den Ursprung und die bedeutung der Doppelchöre* (Leipzig: Seemann, 1891), pp. 7 ff.; Georg Dehio and Gustav von Bezold, *Die kirchliche Baukunst des Abendlandes,* Volume 2 (Stuttgart: Alfred Kroner, 1892), p. 175; Camille Enlart, *Manuel d'archéologie française,* Volume 1 (Paris: Alphonse Picard, 1902), p. 156; and George Durand, *La Picardie historique et monumentale,* Volume 4, part 2: *Saint-Riquier* (Amiens: Yvert et Tellier, 1907–11), 189.

5. On Bernard's excavations and publications, see note 49. Effmann's primary method was to draw upon the later evidence of the monastery of Corvey to illuminate and flesh out Angilbert's text. In the view of Saint-Riquier's excavator, this resulted in too excessive a reliance on Corvey and distorted the reconstruction of Saint-Riquier. See "Saint-Riquier: une restitution nouvelle de la basilique d'Angilbert," *Revue du Nord* 71 (1989): 307–361.

6. Krautheimer in 1941 called for a new method of study for architectural history. the study of iconographical content or the symbolic interpretation of buildings, which he saw as "perhaps the most important problem of medieval architectural theory." The paper was initially read at the meeting of the College Art Association in January, 1941 and was later published in the *Journal of the Warburg and Courtauld Institutes* 5 (1942): 1–33. It has been reprinted with a number of Krautheimer's most important works in *Studies in Early Christian, Medieval, and Renaissance Art* (New York: New York University Press, 1969), pp. 115–150. Krautheimer was not the only architectural historian to see the need for such symbolic interpretation; at the same time, independently, André Grabar and Günter Bandmann were preparing similar works. But Krautheimer first clearly enunciated the problem. See Grabar's *Martyrium* (Paris: Collège de France, 1946), and Bandmann's *Mittelalterliche Architektur als Bedeutungsträger* (Berlin: G. Mann, 1951).

7. Effmann, *Centula*, p. 149. Cf. Effmann's *Die karolingisch-ottonischen Bauten zu Werden*, Volume 1 (Strasbourg: Heitz, 1899), pp. 176–83, and Herwin Schäfer, "The Origin of the Two-Tower Façade in Romanesque Architecture," *Art Bulletin* 27 (1945): 105.

8. See Alois Fuchs, who first broached this interpretation in 1929 in *Die karolingischen Westwerke und andere Fragen der karolingischen Baukunst* (Paderborn: Bonifacius-drukerei), and then developed it much more fully in "Entstehung und Zweckbestimmung der Westwerke," *Westfälische Zeitschrift* 100 (1950): 227–291; Wolfgang Lotz, "Zum Problem der karolingischen Westwerke," *Kunstchronik* 5 (1952): 65–71; Adolf Schmidt, *Westwerke und Doppelchöre: Höfische und liturgische Einflüsse auf die Kirchenbauten des frühen Mittelalters* (Doctoral Dissertation, Göttingen, 1950), pp. 195–197; and Edmund Stengl, "Über Ursprung, Zweck und Bedeutung der karolingischen Westwerke," *Festschrift Adolf Hofmeister* (Halle: M. Niemeyer, 1955), pp. 285–311.

9. Ernst Kantorowicz, *Laudes Regiae: A Study in Liturgical Acclamations and Medieval Ruler Worship* (Berkeley: University of California Press, 1946). Lotz explicitly acknowledged his debt to Kantorowicz. Percy Ernst Schramm, *Herrschaftszeichen und Staatssymbolik: Beiträge zur ihrer Geschichte vom dritten bis zum sechszehnten Jahrhundert, Monumenta Germaniae Historica Schriften* 13, parts 1–3 (Stuttgart: Hiersemann, 1954–56).

10. "Santa Maria Rotunda," in *Studies*, pp. 203–256. The article was originally published in 1942.

11. As we shall see below, other interpretations can also draw on the image of Mary leading the faithful to Christ. This study clearly put into place the principles which Krautheimer elaborated in 1941. Ironically, at this same time, Kenneth Conant was studying Saint-Riquier's churches from a strictly technical point of view as examples of "fusion churches" amalgamating many previously existing architectural tendencies into a coherent whole. Though Conant's work was influential and analyzed all of the churches in Angilbert's complex, it in no way incorporated the methodological insights of Krautheimer. See *A Brief Commentary on Early Medieval Church Architecture* (Baltimore: Johns Hopkins University Press, 1942), especially p. 22. Conant's thesis remained essentially unchanged in his later *Carolingian and Romanesque Architecture, 800–1200* (Baltimore: Penguin Books, 1959), pp. 11–14.

12. "Saint-Riquier et le monachisme en Gaule à l'époque carolingienne," *Il monachesimo nell'alto medioevo e la formazione della civiltà occidentale: Settimane di studio del Centro italiano di studi sull'alto medioevo*, Volume 4 (Spoleto: Sede del Centro, 1957), pp. 293–309. Cf. *The Carolingian Renaissance* (New York: George Braziller, 1970), pp. 1–4.

13. See *Histoire de la propriété ecclésiastique en France*, 2 volumes (Lille: R. Giard, 1910). This pattern was elaborated by Albert Hauck, *Kirchengeschichte Deutschlands*, 5 volumes, reprinted edition (Berlin: Akademie Verlag, 1958).

14. *Propriété ecclésiastique*, 2, pp. 197 ff. In many respects this interpretation turned upon the question of Angilbert's clerical status, which is by no means unambiguous. Whether Angilbert was a cleric cannot be definitively determined, and it is a concern which reveals more about nineteenth-century canonical and political concerns than about Carolingian monasticism.

15. The classic statement of this view is Dom Ursmer Berlière's *L'ordre monastique des origines au XIIe siècle* (Maredsous: Abbaye de Maredsous, 1912), especially pp. 51–52, 112–115.

16. The work of the second Benedict was to purify the Rule by weeding out other practices and making Benedictinism the sole norm. See, for example, Stephanus Hilpisch, *Geschichte des benediktinischen Mönchtums in ihren Grundzügen* (Frieburg: Herder, 1929), pp. 72, 110–123. Dom J. Winandy would later repeat this assessment in stronger terms when he said, "There were hardly any Benedictines in the eighth century. The entire work of Benedict of Aniane consisted in bringing back the monasteries to the traditional observances, taking for a foundation the Rule of Saint Benedict." "L'oeuvre monastique de saint Benoît d'Aniane," *Mélanges bénédictins publiés à l'occasion du XIVe centenaire de la mort de saint Benoît* (Saint Wandrille: Editions de Fontenelle, 1947), pp. 235–258, quotation from p. 249.

17. For a complete summary of the research on the *Regula Magistri*, see Bernd Jaspert, *Die Regula Benedicti-Regula Magistri Kontroverse* (Hildesheim: Verlag Gustenberg, 1977).

18. This can be seen, for example, in S. G. Luff's study examining early Gallican rules and observances cloister by cloister. See "A Survey of Primitive Monasticism in Central Gaul," *Downside Review* 70 (1952): 180–203.

19. The project was put under the direction of Kassius Hallinger. *Corpus consuetudinum monasticarum*, 10 volumes (Siegburg: Francis Schmitt, 1963–1980), hereafter *CCM*. For Angilbert's *ordo* see Volume 1: *Initia consuetudinis benedictinae* (1963), pp. 283–303. The documents in the early volumes of the *CCM* had been published previously, largely by Dom Bruno Albers in *Consuetudines monasticae*, Volumes 2–5 (Monte Cassino: Abbazia di Montecassino, 1905–1912). Cf. Ursmer Berlière, "Les coûtumiers monastiques des VIIIe et IXe siècles," *Revue Bénédictine* 25 (1908): 95–107. The *CCM*, however, provided a critical apparatus previously unparalleled. Hallinger's work had grown out of earlier studies of tenth-century monastic reform which led him to investigate further the wide variety of earlier customs. See *Gorze-Kluny*, 2 volumes (Rome: Herder, 1950). This led him to question even the most fundamental presuppositions of the traditional view. In a 1957 article he examined the precise meaning of the term *Regula* or "Rule" in the writings of Gregory the Great (supposedly the great disseminator of Benedic-

tinism) and found that Gregory meant by this *not* Benedict's Rule, but *any* regulated religious life. He was promoting God's Rule, not Benedict's. See "Papst Gregor der Grosse und der heilige Benedikt," *Studia Anselmiana* 42 (1957): 213–319.

20. This has been the work of Josef Semmler. Besides the editions and critical commentary in Volume 1 of the *CCM*, see "Karl der Grosse und das fränkische Mönchtum," in Wolfgang Braunfels, editor, *Karl der Grosse, Lebenswerk und Nachleben*, Volume 2: *Das geistige Leben* (Düsseldorf: Schwann, 1965), pp. 255–289; "Zur Überlieferung der monastischen Gesetzgebung Ludwig des Frommen," *Deutsches Archiv* 16 (1960): 309–388; "Die Beschlüsse des Aachener Konzils im Jahre 816," *Zeitschrift für Kirchengeschichte* 74 (1963): 15–82; "Episcopi Potestas," in Borst, pp. 379 ff.; "Pepin III und die fränkischen Klöster," *Francia* 3 (1975): 88–146; "Mission und Pfarrorganisation in den rheinischen, mosel- und maasländischen Bistümern (5.–10. Jahrhundert)," *Settimane* 28 (1982), Volume 2, pp. 813–888; "*Iussit ... princeps renovare ... praecepta:* Zur verfassungsrechtlichen Einordnung der Höchstifte und Abteien in die karolingische Reichskirche," in Joachim F. Angerer and Josef Lenzenweger, editors, *Consuetudines monasticae: Festschrift für Kassius Hallinger* (Rome: Pontificio Ateneo San Anselmo, 1982), pp. 96–124; "Zehntgebot und Pfarrtermination in karolingischer Zeit," in H. Mordek, editor, *Aus Kirche und Reich: Studien zu Theologie, Politik und Recht im Mittelalter. Festschrift für Friedrich Kempf* (Sigmaringen: J. Thorbecke, 1983), pp. 33–44; and "Benedictus II — Una Regula — Una Consuetudo," *Benedictine Culture 750–1050*, Medievalia Lovaniensia, Series 1, Volume 11 (Louvain: Louvain University Press, 1983), pp. 1–49. See also a number of studies examining the impact of Benedict under Louis the Pious from a variety of perspectives in Peter Godman and Roger Collins, editors, *Charlemagne's Heir: New Perspectives on the Reign of Louis the Pious* (Oxford: Clarendon Press, 1990), as well as Eric John "'Secularium Prioratus' and the Rule of Saint Benedict," *Revue Bénédictine* 75 (1965): 212–239.

21. "Angilbert's Ritual Order for Saint-Riquier," in *Liturgica Historica* (Oxford: Clarendon Press, 1918), pp. 321–329. Cf. *Downside Review* 14 (1895): 84–98. It should be noted that while Ferdinand Lot had also published the *ordo* in his edition of Hariulf's *Chronicle,* as Appendix 6, the text got lost in the midst of the broader history.

22. "On the Origin of the Prymer," *Liturgica Historica*, pp. 211–237.

23. Dom Philibert Schmitz, "Livres d'heures et usages bénédictins," *Revue littéraire et monumentale* 13 (1927–28): 301–321; "Benoît d'Aniane," *Dictionnaire d'histoire et de géographie ecclésiastique*, Volume 8 (Paris: Letouzey et Ané, 1935), p. 184; and *Histoire de l'ordre de Saint Benoît* (Maredsous: Abbaye de Maredsous, 1949), pp. 220 ff. Cf. Dom Cuthbert Butler, *Benedictine Monachism* (Cambridge: Speculum Historiale, 1919), pp. 295 ff., who acknowledged his indebtedness to Bishop.

24. "Die gallikanischen 'Laus Perennis'-Kloster und ihr 'Ordo Officii'," *Revue Bénédictine* 69 (1959): 33–48, and on Saint-Riquier particularly, pp. 44 ff.

25. See, for example, the work of Friedrich Prinz, particularly *Frühes Mönchtum im Frankenreich: Kultur, und Gesellschaft in Gallien, den Rheinlanden und Bayern im Beispiel der monastischen Entwicklung* (Vienna: R. Oldenbourg, 1965); Arno Borst, editor, *Mönchtum, Episkopat, und Adel zur Gründungszeit des Klosters Rei-*

chenau (Sigmaringen: J. Thorbecke, 1974); Karl Schmid, editor, *Die Klostergemein-schaft von Fulda im frühen Mittelalter,* 3 volumes (Munich: Wilhelm Fink, 1978), and for Schmid's applications to another important monastery, "Zur historischen Be-stimmung des ältesten Eintrags im St. Galler Verbrüderungsbuch," *Alemannisches Jahrbuch* 1973/75 (1976): 500–532; cf. Schmid's "Zeugnisse der Memorialüber-lieferung aus der Zeit Ludwigs des Frommen," in Peter Godman and Roger Collins, *Charlemagne's Heir: New Perspectives on the Reign of Louis the Pious* (Oxford: Claren-don Press, 1990), pp. 509–522. See also Otto Gerhard Oexle, *Forschungen zu monastischen und geistlichen Gemeinschaften im westfränkischen Bereich* (Munich: Wil-helm Fink, 1978).

26. See note 20 above.

27. *The Plan of Saint Gall,* 3 volumes (Berkeley: University of California Press, 1979).

28. Horn and Born 1, p. 25.

29. Horn and Born 1, pp. 121–123, 212.

30. Horn and Born 1, p. 212.

31. Horn and Born 1, p. 221.

32. Horn and Born 1, pp. 123–124.

33. See Dom Patrice Cousin, "Les origines du monastère de Corbie," Dom Jean Laporte, "Grimo, abbé de Corbie," and Gerard Mathon, "Pascase Radbert et l'évolution de l'humanisme carolingien," in *Corbie, abbaye royale* (Lille: Facultés Catholiques, 1963), Chapters 2, 3, and 7.

34. *Corbie in the Carolingian Renaissance* (Sigmaringen: Jan Thorbecke, 1990), p. 11.

35. Ganz, p. 12.

36. Ganz, pp. 121–122; cf. Mathon, pp. 148–152.

37. See Chapter 2, note 12. Cf. the connections made between the Evangelist miniature of Bern Codex 348, a Fleury Evangelary from the time of Theodulf, and the mosaic at Germigny, Otto Homburger, "Eine unveröffentlichte Evangelien-Handschrift aus der Zeit Karls des Grossen," *Zeitschrift für schweizerische Archeologie und Kunstgeschichte* 5 (1943): 149–165.

38. The church was rebuilt in 1869 by Lisch, an architect. Subsequent excava-tions enabled Jean Hubert to posit an alternative plan in 1930, which is still substantially accepted by scholars. See "L'église de Germigny-des-Prés," *Congrès Archéologiques de France* 93 (1930): 534–538; cf. *L'art pré-roman* (Paris: n.pub., 1938), pp. 76, 114, 141–142. See also A. Khatchatrian, "Notes sur l'architecture de Germigny-des-Prés," *Cahiers Archéologiques* 7 (1954): 161–169; May Vieillard-Troiekouroff, "L'architecture en France du temps de Charlemagne," in *Karl der Grosse,* Volume 3: *Karolingische Kunst,* p. 356.

39. See, for example, H. Del Medico, "La mosaïque de l'apside orientale à Germigny-des-Prés," *Monuments Piot* 39 (1943): 81–102, who saw this as an expres-sion of Byzantine or Ravennate sources; André Grabar, who saw the iconography and sources of the mosaic as Hellenistic, mediated through the Ommayad art of Theodulf's Spain, "Les mosaïques de Germigny-des-Prés," *Cahiers archéologiques* 7 (1954): 171 ff.; and, for the essentially Carolingian interests, Otto Homburger, "Evangelien-Handschrift," pp. 149–165, followed by Ann Freeman, "Theodulf of

Orléans and the *Libri Carolini*, pp. 663–705, and May Vieillard-Troiekouroff, "Tables de canons et stucs carolingiens," *Stucchi e mosaici alto medioevali, Atti dell'ottavo congresso di studi sull'arte dell'alto medioevo* (Milan, 1962), pp. 154–178.

40. Cf. Freeman, "Theodulf of Orléans and the *Libri Carolini*," p. 699, as cited in Chapter 2, note 12.

41. This is the insight of Freeman, "Theodulf of Orléans and the *Libri Carolini*, p. 699. She goes on to say that the mosaic avoids representations of the divine persons which might "evoke superstitious veneration from the untutored, and replaces them with a motif critical to the argument of the *Libri*."

42. For this term in particular, see Freeman and Vieillard-Troiekouroff, cited above. On the comparison and common themes of Theodulf's written texts, including his biblical exegesis, his writings on baptism and the *Libri Carolini*, see Dahlhaus-Berg, *Nova Antiquitas,* as cited in Chapter 2, note 12.

43. See Dahlhaus-Berg, *Nova Antiquitas,* Chapter 4.

44. See *Recherches sur les rapports entre architecture et liturgie à l'époque carolingienne* (Paris: S.E.V.P.E.N., 1963); "Le groupe cathédral de Metz au temps de saint Chrodegang," *Actes du colloque de saint Chrodegang* (Metz: n.pub., 1967), pp. 123–132; "Architecture et liturgie processionnelle à l'époque préromane," *Revue de l'art* 24 (1974): 30–47; *Architecture et liturgie à l'époque carolingienne* (Paris: Alphonse Picard, 1980); "De Chrodegang à Cluny II: cadre de vie, organisation monastique, splendeur liturgique," *Sous la règle de saint Benoît. Structures monastiques et sociétés en France du Moyen-âge à l'époque moderne* (Geneva: Librairie Droz, 1982), pp. 491–497.

45. See *La chronique de l'abbaye de Saint-Riquier,* Ferdinand Lot, editor, *Collection de textes pour servir à l'étude et l'enseignement de l'histoire,* Volume 17 (Paris: Alphonse Picard, 1894), called the *Chronicon Centulense* by Hariulf. According to Lot, Hariulf's autograph manuscript was for some time in the library of Paul Petau, from which one copy was made by André Duchesne in about 1615. In Lot's view, Duchesne collated the passages by Angilbert from Vatican 235 with those corresponding to Hariulf's autograph manuscript in his own copy. Two copies were made from Duchesne's version, including Amiens MS 531 and Dom Luc d'Achéry's first edition of the *Spicilegium* (1661). Mabillon copied Books 2 and 4 from the *Spicilegium* edition for his *Vita Angilberti. See AASS, OSB,* saec. 4, Volume 1, pp. 91 ff. The second edition of d'Achéry's *Spicilegium* took the *Chronicon* from the Petau autograph manuscript. See *Chronicon* 2.viii–x (Lot, pp. 57–70), and "Nouvelles recherches sur la Chronique de l'abbaye de Saint-Riquier par Hariulphe," *Bibliothèque de l'École des Chartes* 72 (1911): 245–258.

The two parts of the *Libellus* have been published separately in modern editions. The best and most recent edition of the *Institutio* is that of Hallinger, Wegener and Frank, *CCM* 1, 283–303, which presents the two texts of Vatican 235 and Hariulf side by side. Bishop's edition of the *Institutio,* published in 1918, has been discussed above (see note 21). George Waitz published an edition of Angilbert's *De perfectione* in *MGH SS* 15, 173–179. Lot published Hariulf's version of both texts in his edition of the *Chronicon Centulense,* pp. 57–76. For this study I have examined Vatican Codex 235, which is often fragmentary, and have relied for secondary editions upon the texts of the *CCM* and Waitz. The twelfth-century *vita* of Angilbert

by the abbot Anscher is untrustworthy, as it adds details that reflect the mentality of the twelfth century and are not supported by the early evidence. See *MGH SS* 15, 180, and Mabillon's edition along with Anscher's *Miraculi sancti Angilberti* in *AASS Februarii* 3, pp. 88–98, 101–102.

46. The art historians who have studied Saint-Riquier have attributed the drawing to Hariulf himself, although there is no direct record of that other than the fact that the drawing was contained in the autograph manuscript of the *Chronicon Centulense*. See, for example, Effmann, p. 5; Durand, p. 140; Hubert in *Il Monachesimo*, p. 296; and, most recently, Heitz, *Recherches*, p. 23.

The drawing perished with the manuscript in the 1719 fire at Saint-Riquier. Paul Petau had already made an engraved copy of the drawing directly, according to Lot, from what seems to have been the autograph manuscript, which was in his possession in the early seventeenth century. Duchesne, who copied the autograph manuscript in about 1615, also copied the drawing. Duchesne's version was in turn reproduced in Amiens MS 531 and the first edition of *Spicilegium* in 1661. Mabillon's version came from the *Spicilegium* in 1677. Cf. Lot, "Nouvelles recherches," pp. 245–258. While Petau's version of the drawing was rather sketchy and schematic, it was very likely closer to the original than was Mabillon's. In cases where the version of Mabillon differs from Petau, I follow Petau.

47. See Conant's pp. 11–14 and Plate 2A.

48. "Die Anordnung der Altare in der karolingischen Klosterkirche zu Centula," *Karl der Grosse*, Volume 3: *Karolingische Kunst*, pp. 373–383.

49. See "Les fouilles de l'eglise de Notre-Dame a Saint-Riquier," *Bulletin Archéologique du Comité des Travaux Historiques et Scientifiques* n.s., 1 and 2 (1965–1966): 25–47 and 219–235; "Premières fouilles de Saint-Riquier," in *Karl der Grosse* 3, pp. 369–373; "Un site prestigieux du monde carolingien: Saint-Riquier," *Cahiers Archéologiques de Picardie* 5 (1978): 241–254; "L'abbaye de Saint-Riquier: évolution des bâtiments monastiques du IXe au XVIIIe siècle," in *Sous la règle de Saint-Benoît*, pp. 499–526; and "Saint-Riquier: une restitution nouvelle de la basilique d'Angilbert," *Revue du Nord* 71 (1989): 307–361.

50. "The Pre-Romanesque Church of Saint-Riquier: The Documentary Evidence," *Journal of the British Archeological Association* 130 (1977): 21–51. Two years earlier Theodore Evergates had suggested in a much more limited way that Hariulf had manipulated his ninth-century sources. See "Historiography and Sociology in Early Feudal Society: The Case of Hariulf and the *Milites* of Saint-Riquier," *Viator* 6 (1975): 35–49.

51. Hariulf, p. 324; Parsons, p. 24.

52. Parsons, pp. 36–37.

53. See below, Chapter 3, pp. 71–72.

54. Patrick Geary, *Furta Sacra: Thefts of Relics in the Central Middle Ages*, second edition (Princeton, NJ: Princeton University Press, 1990); Leo Mikoletsky, "Art und Sinn der Heiligung im frühen Mittelalter," *Mitteilungen des Instituts für österreichische Geschichtsforschung* 57 (1949): 83–122.

55. Both interpreted Hariulf's comment that he had copied out the text *non sine labore* to mean that the text was already fragmentary and difficult to read. Parsons interprets it rather to mean that Hariulf was frustrated with the tedious lists contained in the text. See Hariulf, pp. xxiii–xxiv; Bishop, p. 322; Parsons, p. 29.

56. I am indebted to Professor Jean Vezin for the perspective that such textual relationships are rarely casual.

57. Parsons, p. 33 ff.

58. Ganz, p. 67.

59. Parsons, pp. 34–38.

60. Huc usque de certis sanctorum reliquiis, de quibus a sanctis patribus, qui eas nobis largiti sunt, nomina certa recepimus, separatim martyres vel confessores descripsimus. Deinceps autem distincte aliorum sanctorum nomina sive martyrum, vel confessorum, quia non invenimus, minime scripsimus. Hariulf, p. 66.

61. Professor Lemaître kindly provided this insight in conversation about this text.

62. All these texts are found in *MGH, SS* XV, pp. 238–264 (Einhard), 286–288 (Alexander and Justin), 328–341 (Rudolf), 374–376 (Chrysanthus and Daria), and 472–473 (Januarius and Fortunata).

63. *Institutio* 8 (*CCM*, pp. 295–296).

Chapter 2

1. This phrase is taken from Paulinus of Aquileia's *Regula fidei metrico* 121 (Norberg, p. 94). The context was a discussion of the establishment of theological orthodoxy at the Council of Nicaea in 325, in which the three hundred eighteen fathers of the Church judged and embraced the true faith. By extension, Paulinus was paralleling the Carolingian defenders of the faith with the fathers as cultivators of truth.

2. Much has been written on the court circle of Charlemagne, and it is a topic which has been given considerable new clarity by recent publications on the intellectual life of the court. The *locus classicus* is the work of Josef Fleckenstein, *Hofkapelle* 1, and "Karl der Grosse und sein Hof," in Wolfgang Braunfels, ed., *Karl der Grosse,* Volume 2: *Das geistige Leben* (Düsseldorf: L. Schwann, 1965), pp. 24–50. See also Donald Bullough, *The Age of Charlemagne* (New York: Putnam, 1965), Chapter 4; "Alcuin and the Kingdom of Heaven," in Uta-Renate Blumenthal, ed., *Carolingian Essays* (Washington, DC: Catholic University of America Press, 1983), pp. 1–69, reprinted with revisions in *Carolingian Renewal* (Manchester: Manchester University Press, 1990), pages 161–240, and "*Albuinus deliciosus Karoli Regis:* Alcuin of York and the Shaping of the Early Carolingian Court," in Lutz Fenske, Werner Rosner and Thomas Zotz, editors, *Institutionen, Kultur und Gesellschaft im Mittelalter: Festschrift für Josef Fleckenstein* (Sigmaringen: Jan Thorbecke, 1984), pp. 73–92; see also "*Aula Renovata:* The Carolingian Court before Aachen," in *Carolingian Renewal,* pp. 123–160. Rosamond McKitterick has examined the court in a variety of contexts: *The Frankish Church and the Carolingian Reforms, 789–895* (London: Royal Historical Society, 1977) on religious reform, administration in *The Frankish Kingdoms Under the Carolingians, 751–987* (New York: Longmans, 1983), and on cultural influence *The Carolingians and the Written Word* (Cambridge: Cambridge University Press, 1989). Most recently Peter Godman's studies of Carolingian poetry have helped to bring to light the common cultural activities of intellectuals seeking royal patronage in propagating an image of Charlemagne's power in panegyric poetry.

See *Carolingian Renaissance*, and especially *Poets and Emperors*, cited above in the Introduction, note 9.

3. See below, Chapter 3, for a detailed discussion of Angilbert at court.

4. *MGH Epp* 4, numbers 147–148; see below, Chapter 3.

5. See J. M. Wallace-Hadrill, *The Frankish Church* (Oxford: Clarendon Press, 1983), p. 217, and Bullough, *Charlemagne*, p. 102.

6. *MGH Capitularia* 1, pp. 52–62. Cf. Ullmann, *Carolingian Renaissance*, especially Chapter 3.

7. *Admonitio generalis*, Prologue (*MGH, Capitularia* 1, p. 54).

8. *MGH LL* 1, *Capitularia* 1, p. 61. This passage is worth quoting at length, as we will see these subjects again at Saint-Riquier: Primo omnium praedicandum est omnibus generaliter, ut credant Patrem et Filium et Spiritum sanctum unum esse Deum omnipotentem, aeternum, invisibilem, qui creavit caelum et terram, mare et omnia quae in eis sunt, et unam esse deitatem, substantiam, et maiestatem in tribus personis Patris et Filii et Spiritus sancti.

Item praedicandum est quomodo Dei Filius incarnatus est de Spiritu sancto et ex Maria semper virgine pro salute et reparatione humani generis, passus, sepultus, et tertia die resurrexit, et ascendit in celis; et quomodo iterum venturus sit in maiestate divina iudicare omnes homines secundum merita propria; et quomodo impii propter scelera sua cum diabulo in ignem aeternum mittentur, et iusti cum Christi et sanctis angelis suis in vitam aeternam. See below, Chapter 5, pp. 118–119. Cf. the same capitulary, number 32, p. 56.

9. This is, most likely, because the issues arose in different places, Spain and Byzantium respectively, and had different foci. Adoptionism was a christological matter; images and the *filioque* as defined by the Greeks and the Carolingians were essentially trinitarian questions. Even the most recent considerations of the issues, while recognizing that they occurred at the same time, have not considered the relationship of the theological concerns. See Jaroslav Pelikan, *The Christian Tradition*, Volume 2, *The Spirit of Eastern Christendom* (Chicago: University of Chicago Press, 1977), pp. 183 ff., and Volume 3, *The Growth of Medieval Theology (600–1300)* (Chicago: University of Chicago Press, 1978), pp. 52–58; Ann Freeman, "Carolingian Orthodoxy and the Fate of the *Libri Carolini*," *Viator* 16 (1985): 65–108; and Celia Chazelle, "Matter, Spirit, and Image in the *Libri Carolini*," *Recherches Augustiniennes* 21 (1986): 163–184.

10. The reference to "rebel Galatians" in the title of this section comes from Paulinus, *Regula fidei metrico* 82 (Norberg, p. 93). The reference is to Galatians 1: 8–9, in which Paul excoriates the faithlessness of the Galatians. Paulinus placed it within a series of references proving the true sonship of Jesus, along with the Baptism and the Annunciation. Therefore, by implication, he directed it against the Adoptionists. See below, p. 33, and Appendix B.

11. What follows is reconstructed from the following sources. On the theology and chronology of Adoptionism: Beatus and Etherius *Adversus Elipandum libri II*, Bengt Löfstedt, editor, *CCCM* 59 (Turnhout: Brepols, 1984); Elipandus *Epistula in Migetium* (*CSM* 1, pp. 67–78), *Epistula ad Alchuinum* (*CSM* 1, pp. 96–109), *Epistula ad Felicem* (*CSM* 1, pp. 109–111), *Epistula ad Fidelem* (*CSM* 1, pp. 80–81), *Symbolum fidei* (*CSM* 1, pp. 78–80), and *Epistola ad Carolum Magnum* (*MGH*

Epistolae 4, number 182); Alcuin *Adversus Felicem libri VII* (*PL* 101, 127–230), *Liber contra haeresim Felicis,* Gary B. Blumenshine, editor, *Studi e Testi* 285 (Vatican City: Biblioteca Apostolica Vaticana, 1980), *Adversus Elipandum libri IV* (*PL* 101, 243–300), and *Epistolae* 23, 137, 139, 148, 149, 166, 200 ff. (*MGH Epistolae* 4); and Paulinus of Aquileia *Contra Felicem libri III,* Dag Norberg, editor, *CCCM* 95 (Turnhout: Brepols, 1990) and the doctrinal statement from the Synod of Friuli of 796 (*MGH LL* 3, *CC* 2, pp. 180–189). Cf. Agobard *Liber adversus Felicem Urgellitanum* (*PL* 104, 29–70). On the conciliar response to Adoptionism see *Annales regni Francorum, Revised Version* 792 (*MGH Scriptores* I, p. 179) for the Council of Regensburg. (I am citing this source, usually known as *Annales qui dicuntur Einhardi,* as *Annales regni Francorum, Revised Version* according to the suggestion of F.-L. Ganshof, "L'historiographie dans la monarchie franque sous les Mérovingiens et les Carolingiens," *La storiografia nell'altomedioevo, Settimane* 17 (1970), Volume 2, p. 677.) Indispensible is Wilhelm Heil's closely argued chronology in *Alkuinstudien,* Volume 1 (Düsseldorf: Schwann, 1970), and "Der Adoptianismus, Alkuin und Spanien," in *Karl der Grosse* Volume 2: *Das geistige Leben,* pp. 95 ff. Also essential for untangling both the issues and the historiography is Knut Schäferdiek, "Der adoptianische Streit im Rahmen der spanischen Kirchengeschichte I and II," *Zeitschrift für Kirchengeschichte* 80 (1969): 291–311 and 81 (1970): 1–16, which discusses Adoptionism from its earliest appearance against the heresy of Migetius through the final recantation of Felix of Urgel. See also Jesus Solano, S.J., "El Concilio de Calcedonia y la Controversia Adopcianista del siglo VIII en España," in Aloys Grillmayer and Heinrich Bacht, *Das Konzil von Chalkedon,* Volume 2: *Entscheidung um Chalkedon* (Würzburg: n.pub., 1952), pp. 841–871; and Ramon Abadal y Vinyals, *La batalla del adopcionismo en la desintegración de la iglesia visigoda* (Barcelona: n.pub., 1949), which argues that Adoptionism was a nationalist movement against encroaching Frankish domination over the Visigothic Church. For the work of John Cavadini, see note 13. The sources for the events surrounding the *Libri Carolini* and the *filioque* will be discussed in the following note.

12. See *MGH LL* 3, *CC* 2, *Supplementum.* The *Libri* has been a controversial text. The traditional order and dating of events was established by Wolfram von den Steinen, "Entstehungsgeschichte der *Libri Carolini,*" *Quellen und Forschungen aus italienischen Archiven und Bibliotheken* 21 (1929–30): 1–93. I follow here the convincing arguments of Ann Freeman on Theodulf's authorship of the text, and most recently on a revised chronology and fate for the text. See "Theodulf of Orléans and the *Libri Carolini,*" *Speculum* 32 (1957): 663–705; "Further Studies in the *Libri Carolini* II," *Speculum* 40 (1965): 203–289; "Further Studies in the *Libri Carolini* III," *Speculum* 46 (1971): 597–611; and "Carolingian Orthodoxy and the Fate of the *Libri Carolini,*" *Viator* 16 (1985): 65–108. Cf. Paul Meyvaert, "The Authorship of the *Libri Carolini:* Observations Prompted by a Recent Book," *Revue Bénédictine* 89 (1979): 29–57, and Donald Bullough, "Alcuin and the Kingdom of Heaven," in Blumenthal, editor, *Carolingian Essays,* pp. 31–39. Bullough emphasizes his conviction that Alcuin had an influence on the writing of the text in the revised version of this article in *Carolingian Renewal,* pp. 182–186. On the traditional theory that Alcuin was the author, see Jaffé, the editor of Alcuin's works, in the *Monumenta Alcuiniana;* Dümmler, who edited the *Libri* for the same collection; and more

recently Luitpold Wallach in *Alcuin and Charlemagne, Studies in Carolingian History and Literature* (Ithaca, NY: Cornell University Press, 1959), Chapter 9, and *Diplomatic Studies in Latin and Greek Documents from the Carolingian Age* (Ithaca, NY: Cornell University Press, 1977), parts 2 and 3. For an important interpretation of the text within the larger context of Theodulf's thought, see Elisabeth Dahlhaus-Berg, *Nova Antiquitas et Antiqua Novitas: typologische Exegese und isidorianisches Geschichtsbild bei Theodulf von Orléans* (Cologne/Vienna: Böhlau, 1975), Chapter 4.

13. See Schäferdiek I, pp. 293 ff., and p. 304 on Felix. Cf. Hadrian *Codex Carolinus Epistola* 95 (*MGH Epp* 3, p. 637), and compare *Epistola* 96 and 97; Elipandus *Epistola in Migetium* (*CSM* 1, pp. 67–78). I am especially indebted to John Cavadini for allowing me to see his manuscript on Adoptionism, *The Last Christology of the West* (Philadelphia: University of Pennsylvania Press, 1993), before its publication.

14. This was also the starting point for the christologies of the great Western fathers Hilary, Augustine, and Leo. See Cavadini, *Last Christology,* p. 33, note 73; Pelikan, *Christian Tradition,* I, pp. 256–259.

15. *Epistola episcoporum Hispaniae ad episcopos Franciae.* (*MGH LL* 3, CC 2, 118). I have used the translation of Cavadini, pp. 33–34.

16. See Cavadini, p. 35.

17. *Codex Carolinus* 95; *Epistola Hadriani papae ad episcopos Hispaniae directa* (*MGH, LL* 3, CC 2, p. 122–130). Cf. Cavadini, pp. 73–77.

18. *Epistola Hadriani papae,* p. 126.

19. *Sancta synodus septima generalis Nicaena secunda Anastasio Bibliothecario interprete* (PL 129, 195).

20. See Book 51, 74 (*CCSL* 44A, pp. 79–80, 213).

21. *Libri Carolini* 3.26 (*MGH LL* 3, CC 2, pp. 160 ff.), cf. Chazelle, "Matter, Spirit, and Image," pp. 174–175.

22. *Libri Carolini* 2.27–2.30, 3.24 (*MGH LL* 3, CC 2, pp. 87 ff., 153 ff.). On Angilbert's use of the *Libri,* see below, Chapter 4, pp. 86–92.

23. For the term "simultaneous procession" see Pelikan 2, pp. 183–198.

24. The starting point of Western trinitarian speculation was the unity of the Trinity; that of the East the diversity of the Trinity. Augustine's assertion of the simultaneous procession in the *De Trinitate,* a determinative treatise for Latin theology, and the persistence in the West of Arianism and its challenge to the oneness of the Trinity made the *filioque* clause a fundamental issue. See especially *De Trinitate* 4.20.29 and 15.17–18; Pelikan 1, Chapter 4; and J. N. D. Kelly, *Early Christian Creeds,* third edition (London: Longmans, 1972), pp. 231 ff., and *Early Christian Doctrines* (London: A. and C. Black, 1968), Chapter 9. The doctrine had a long usage: Hilary of Poitiers first clearly stated the principle (*De Trinitate* 2.29, 8.19 ff., and 12.55–57), though it was also suggested in the theology of Tertullian. See also Marius Victorinus (*Hymn* 1.23, and *Adversus Arium Liber I* (PL 8 1146). For a complete history of the simultaneous procession doctrine see H. B. Swete, *History of the Doctrine of the Procession of the Holy Spirit* (Cambridge: Deighton, Bell and Co., 1876), which though old is a masterful account. The specific use of the term *filioque* in the Nicene Creed came from two sources: the Athanasian Creed and the Visigothic liturgy, both developing the usage explicitly in an anti-Arian context.

The first appearance of the interpolated creed was in 589 when at the Third Council of Toledo King Reccared abjured Arianism and promulgated the catholic faith by royal decree (Mansi Volume 9, 981, 985, 993). As the Athanasian Creed was the primary catechetical tool of the seventh and eighth centuries, the *filioque* became widespread throughout the West by the late seventh century. See J. N. D. Kelly, *The Athanasian Creed* (New York: Harper and Row, 1964).

25. Cf. Dahlhaus-Berg, pp. 197–201, who discusses Theodulf's argument for a true Christian universalism under the political authority of Charlemagne, replacing Byzantine/Roman world dominion with a biblical grounding for the Franks as the new Chosen People.

26. *Libri Carolini* 3. Praefatio.

27. Avitus of Vienne and Cassiodorus in the sixth century both taught the *filioque* as the universal faith of the Church; Fulgentius of Ruspe believed that the doctrine had apostolic sanction. The simultaneous procession had papal support as well, having been taught by the two theologian popes, Leo the Great in the fifth century and Gregory the Great in the sixth. When the Visigoth Reccared converted in 589 and promulgated the Nicene Creed as his own, the theologians at the Third Council of Toledo operated under the assumption that the *filioque* was part of the original Nicene Creed. The conviction that this was the universal and unalterable expression of the faith was thus long-standing and of fine pedigree in the West.

28. As Pelikan has said, Felix made "sonship a predicate of the *nature* rather than of the *person* of Christ." See *The Christian Tradition* 3, p. 57.

29. Apud Paulinus *Contra Felicem libri III* 1.8, 10–11, 23, 32–33; 3. 26 (Norberg, pp. 13–17, 28–29, 37–40, 115). Cf. Alcuin *Adversus Felicem Urgellitanum episcopum libri VII* 2.11 (*PL* 101, 155).

30. For the synod see *Annales Regni Francorum, Revised Version,* 792 (*MGH SS* 1, p. 179), and Alcuin *Adversus Elipandum libri IV* 1.16 (*PL* 101, 235). Wolff posits the participation of Benedict of Aniane, since both Paulinus and Benedict had been granted substantial immunities for their religious foundations during the same year, 792, at their personal requests, which very likely meant their requests in person before the king. Benedict's foundation and his work of coordination and reform lay in the heart of the March territory, and as a representative of Frankish interests he spearheaded Carolingian religious policy. He became the leader of the anti-Adoptionist campaign throughout the region. Alcuin was not present, as he was away in England most likely for the whole period between 790 and 792. See Philippe Wolff, "L'Aquitaine et ses marges" in *Karl der Grosse,* Volume 1: *Persönlichkeit und Geschichte,* pp. 296 ff., and the later letters of Alcuin (*MGH Epp* 4, numbers 200 ff., as well as his work with Leidrad of Lyons from 798 onward. For the immunities, see Johann Böhmer, *Die Regesten des Kaiserreichs unter den Karolingern,* Volume 1 (Innsbruck: Wagner Verlag, 1889), pp. 317–318. Alcuin seems to have been aware of the Adoptionist problem, as a letter of 798 had spoken of *tempora periculosa, ut apostoli praedixerunt, quia multi pseudodoctores surgent, novas introducentes sectas* (*MGH Epp* 4, number 74). Cf. Bullough, "Kingdom of Heaven," p. 39, note 90.

31. This difficult conjunction of events has been pieced together by Freeman, "Carolingian Orthodoxy," passim.

32. *MGH Epistolae* 5, number 2, pages 7 ff., 53.

33. The papal prohibition of the *filioque* interpolation remained until the twelfth century, even though the usage in the Western Church was normative from the seventh century onward.

34. See especially Freeman, "Carolingian Orthodoxy," pp. 89 ff.

35. Cf. Cavadini, p. 81.

36. *Epistola Hadriani I papae ad episcopos Hispaniae directa* (*MGH LL* 3, *CC* 2, p. 128: Super quem putatis Spiritum sanctum in specie columbae descendisse, super Deum an super hominem, an propter unam personam Christi super Dei hominisque filium? Spiritus namque sanctus, cum sit inseparabiliter amborum, patris videlicet et filii, et ex patre filioque essentialiter procedat, quo pacto credi potest super Deum descendisse, a quo numquam recesserat et a quo ineffabiliter semper procedit? Dei enim filius secundum id, quod Deus est, sanctum Spiritum cum patre numquam a se recedente inenarrabili modo mittit et secundum id, quod homo est, super se venientem suscepit.

37. *MGH LL* 3, *CC* 2, pp. 130–142. Albert Werminghoff mentions a letter of Pope Hadrian, no longer extant, written sometime before the council, which refused Adoptionism according to Scriptural testimony much as the *Libellus* did. It is likely that the Italian bishops used this letter as the basis for their work. See *MGH LL* 2, *Concilia aevi Karolini* 1, p. 122.

38. Paulinus himself wrote a compendium of these textual proofs in his poetic Creed, the *Regula fidei metrico promulgata stili mucrone*. See below, pp. 36–40 and Appendix B.

39. *Libellus sacrosyllabus* (*MGH LL* 3, *CC* 2, p. 140).

40. *MGH LL* III, *CC* II, pp. 142–157. See also Wallach, *Alcuin and Charlemagne*, Part II. Wallach cites many examples of the anti-rationalism of Alcuin's argument, which stressed the mystery of the union of God and human in Christ. See especially pp. 148 ff.

41. *Epistola Episcoporum Franciae* (*MGH LL* 3, *CC* 2, p. 145): Et si Hildefonsus vester in orationibus suis Christum adoptivum nominavit, noster vero Gregorius, pontifex Romanae sedis et clarissimus toto orbe doctor, in suis orationibus semper eum unigenitum nominare non dubitavit.

42. Cf. John J. Contreni, "Carolingian Biblical Studies," in Blumenthal, ed., *Carolingian Essays*, especially pp. 74–83.

43. *Epistola Hadriani I papae ad episcopos Hispaniae directa* (*MGH Leges* 3, *Concilia* 2, pp. 122–130).

44. *Epistola Hadriani papae,* p. 123.

45. For the following chronology, I use Heil, *Alkuinstudien* I; see also Heil's "Der Adoptianismus, Alkuin und Spanien," pp. 95 ff.

46. *PL* 101, 66–82. The date is uncertain, but the reference to a council in the opening section probably refers to Frankfurt. Cf. Karl Joseph Hefele, *Histoire des conciles d'après les documents originaux,* second edition, (Paris: Letouzey et Ané, 1907–1952), 3.2.1127. This work has traditionally been ascribed to Alcuin.

47. *De processione* 1 and 3 (*PL* 101, especially cc. 80–81).

48. *De processione,* as in note 47.

49. See Gary B. Blumenshine, "Alcuin's *Liber contra haeresim Felicis* and the Frankish Kingdom," *Frühmittelalterliche Studien* 17 (1983): 222–223. Blumenshine

argues that the work was a conscious statement of political theology, in which the sources quoted and the identification of Charlemagne with David and Solomon were an overt assertion of Frankish royal and orthodox religious control over Septimania. Blumenshine, however, claims too much for his evidence. Quotations that he cites, for example, from Popes Leo and Gregory the Great—standard patristic authorities of great prestige—illustrate rather the peculiar relationship between Rome and the Frankish kings. I agree with Donald Bullough, who says that the work is notable for its theological development but should not claim more than an argument from authority, Alcuin's tried and true strategy, as its aim. See "Kingdom of Heaven," p. 51.

50. *MGH Leges* 3, *Concilia* 2, p. 180.

51. *MGH Leges* 3, *Concilia* 2, pp. 180–182.

52. *MGH LL* 3, *CC* 2, p. 184: The emphases are mine. Quam bene ergo Dominus alta et ineffabili sapientia, ut ostenderet personaliter mysterium Trinitatis, "in nomine," inquit, "Patris, et Filii, et Spiritus Sancti," et ut demonstraret inseparabilem essentialiter individuae Deitatis unitatem, praemisit "in nomine." Non enim ait in nominibus, quasi in multis, sed in nomine, quia trinus et unus est Deus. Non enim naturam, sed personam discrevit. Quam feliciter quidem et Apostoli in nomine Jesu, id est Salvatoris, totam sanctam et ineffabilem docuerunt intellegere Trinitatem.

53. See Capelle, "L'Origine antiadoptianiste de notre text du Symbole de la messe," *Recherches de Théologie Ancienne et Médiévale* 1 (1929): 15–16.

54. Both Alcuin and Paulinus seem to have undertaken a virtual campaign with Charlemagne to have the Creed included formally and permanently in the liturgy of the Mass as a main defense against Adoptionism. By 798 Paulinus's version of the Creed was being sung regularly at the Masses of the Palatine Chapel. Walafrid Strabo, writing around 840, added that the Creed was sung in the Mass *latius et crebrius post deiectionem Felicis haeretici*, indicating that it was because of Adoptionism that the Creed became a permanent liturgical fixture constantly in the view of the laity. *PL* 114, 947. Cf. Capelle, "Introduction du Symbole à la messe," p. 1012.

55. Dag Norberg, *L'oeuvre poétique*, p. 26.

56. The lengthy Latin text can be found in its entirety in Appendix B. Here I will examine characteristic sections.

57. On this see Cavadini, pp. 83 ff.

58. *MGH Epp* 4, number 166.

59. *MGH Epp* IV, number 166: Dominus itaque noster Iesus Christus solus sic potuit nasci, ut secunda regeneratione non indiguisset; ideo in baptismo Iohannis certa dispensationis miseratione baptizari voluit, quia in Iohannis baptismo non fuit regeneratio, sed quaedam precursoria significatio baptismi Christi. In quo solo baptismo per Spiritum sanctum vera est remissio peccatorum credentibus, ut in eo spiritu renascamur, in quo ille natus est ex virgine Maria. 'In aqua enim voluit baptizari a Ionanne, non ut eius ulla dilueretur iniquitas, sed ut magna illius commendaretur humilitas. Ita quippe nihil in eo baptismum, quod ablueret, sicut mors nihil, quod puniret, invenit, ut diabolus veritate iustitiae vinceretur, non violentia potestatis opprimeretur. Utrumque enim, et baptismum et mors, non miseranda necessitate, sed miserante potius voluntate susceptum est.'

60. *MGH Epp* 4, number 137: Tertia quoque nobis de Hispania—quae olim tyrannorum nutrix fuit, nunc vero scismaticorum—contra universalem sanctae ecclesiae consuetudinem, de baptismo quaestio delata est. Adfirmant enim quidam sub invocatione sanctae Trinitatis unam esse mersionem agendam. Videtur enim apostolus huic observationi esse contrarius in eo loco, ubi ait: "Consepulti enim estis Christo per baptismum." Scimus enim Christum . . . tres dies et tres noctes in sepulchro esse. . . . Possunt tres noctes tres mersiones et tres dies tres elevationes designare. . . . Nobis vero . . . videtur, ut, sicut interior homo in fide sanctae Trinitatis ad imaginem sui abluendus est; ut, quod invisibiliter spiritus operatur in anima, hoc visibiliter sacerdos imitetur in aqua.

61. On the orthodoxy and character of the Visigothic and Adoptionist practice of baptism, see T. C. Akeley, *Christian Initiation in Spain, c. 300–1100* (London: Darton, Longman and Todd, 1967), especially pp. 64, 69, 131–133.

62. Apud Paulinus *Contra Felicem Urgellitanum episcopum libri III* 1.15.

63. *MGH Epistolae* 4, number 148, dated 798: Si nihil aliud inveniatur contra fidem catholicam, hoc solum sufficit sibi ad perditionem sui. Cf. Letters 139 to Paulinus; 146 to Arn; 148, 149, 171 and 172 to Charlemagne; 160 to Theodulf; and 166 to Elipandus. See also the argument of Cavadini, pp. 89 ff.

64. *MGH Epistolae* 4, number 149; cf. Letter 160 and Bullough, pp. 49–54. Alcuin had sent a treatise on the catholic faith to Theodulf and promised to send him a copy of his recent *libellus* to Septimania. We do not have the responses of Theodulf and Richbod. Paulinus and Pope Leo will be discussed below.

65. Alcuin *Adversus Elipandum* 1.16 (*PL* 101, 23). Cf. *MGH Epp* 4, numbers 193, 194, and 199. There is much confusion over the dating of the council. Werminghoff dated it June, 800, an opinion supported by Dümmler who edited the corresponding letters for the *MGH*. See *LL* 3, *Concilia Aevi Carolini*, p. 222, and the letters cited above. Hefele, however, set the date in 798 (3.2.1098, note 1), following the chronology of J. Nicolai, *Annalen des historischen Vereins für den Niederrhein* (Cologne: no pub., 1859), pp. 78–121. I here follow the opinion of Heil, *Alkuinstudien,* in favor of 799. Theodulf's involvement is posited by Heil, according to the bishop's undated poem lauding the monks of Benedict at Aniane, where he stayed while working as *missus*. See *MGH PL* 1, pp. 520–522, and Heil, "Adoptianismus," pp. 106–107.

66. *PL* 101, 126–230.

67. *Adversus Felicem* 1.1 (*PL* 101, 129): Stultitia magna est hominem in sua solius confidere sententia, et sanctorum Patrum vel totius Ecclesiae catholicos spernere sensus. Nonne haec omnibus haereticis causa fuit perditionis, quod suae magis voluerunt amatores esse sententiae, quam veritatis? . . . Et mirum est cur non timeant tales doctores nova inferre, et incognita antiquis temporibus, dum egregius doctor gentium omnes novitates vocum, et inventas noviter sectas omnino firmiter prohibeat a quoquam catholico recipi.

68. Cavadini, pp. 103–106.

69. For Alcuin, see *PL* 101, 119–230. For Paulinus see Norberg, editor, *CCCM* 95; cf. *PL* 99, 343–468.

70. *Contra Felicem* 1.12–19 (Norberg, pp. 17–26).

71. Philippians 2:6–11. See *Contra Felicem* 1.12–38, 2.6–18 (Norberg, pp. 17–

47, 55–69). Cf. Alcuin *Adversus Felicem libri VII* 3.2, 4.9 (*PL* 101, 163, 182), and *Adversus Elipandum libri IV* 4.8 (*PL* 101, 291–292).

72. Cf. Cavadini, p. 94, who points out the irony that this avowedly anti-Nestorian formulation was actually more divisive of the person of Christ than that of the Adoptionists. The distinction between the man and the God stressed in these treatises was very different from the continuum of the self-emptying Word made man of the Adoptionists.

73. *Contra Felicem* 1.37 (Norberg, p. 44): Et quia inseparabilia sunt semper opera Trinitatis, sicut in utero virginis tota Trinitas operata est hominem Christum, ita cum de sepulcro tota Trinitas a mortuis non abnuitur suscitasse. . . . Sed non est alter Filius qui suscitavit, et alter suscitatus: quamquam sit aliud et aliud, hoc est divinum et humanum; unus tamen est Filius, suscitans et suscitatus.

74. Capelle, "L'introduction du Symbole à la messe," pp. 1019–1020; Cf. his "L'origine antiadoptianiste," pp. 15–16.

75. Paulinus of Aquileia again provides the focus, *de culmine fonte,* in his *Regula fidei metrico* 131 (Norberg, p. 95). The context was a discussion of the establishment of the true faith at Nicaea, in which the sources of belief were drawn "from the deepest well," *de culmine fonte.* By extension, Paulinus was paralleling Carolingian defense of the faith *de culmine fonte.* See Appendix B.

76. The central importance of Scripture as the authoritative source of divine revelation as well as of interpretation of current events and mores is well known, though surprisingly little has been written on the use of the Bible in the Carolingian period. See Beryl Smalley's classic *The Study of the Bible in the Middle Ages* (Oxford: Basil Blackwell, 1952), for a general analysis of Medieval biblical usage, though she has little to say about the Carolingians. On the Carolingians specifically, see John Contreni, "Carolingian Biblical Studies," in Blumenthal, editor, *Carolingian Essays,* pp. 71–98. Cf. Dahlhaus-Berg for Theodulf's exegetical method and its significance for the rest of Theodulf's work.

77. The English texts are quoted from the Jerusalem Bible. For this usage, compare Paulinus of Aquileia *Regula fidei metrico,* 2.20–29; *Libellus sacrosyllabus* (*MGH LL* 3, *CC* 2, p. 133), *Contra Felicem Urgellitanum episcopum libri III* 2.1, 13, and 15 (Norberg, pp. 48, 63–65); and Alcuin *Adversus Felicem Urgellitanum episcopum libri VII* 2.2 (*PL* 101, 147–148).

78. Paulinus of Aquileia *Libellus sacrosyllabus* (*MGH LL* 3, *CC* 2, p. 137): Cum ergo venit plenitudo temporis, misit Deus Filium suum factum ex muliere, factum sub lege, ut eos qui sub lege erant, redimeret, ut adoptionem filiorum reciperemus per ipsum. Cf. *Regula fidei metrico* 2.110–118 (Norberg, p. 94), where the text is placed squarely within the context of the true faith, from which any deviation is heresy according to Galatians 1: 8–9: "Let me warn you that if anyone preaches a version of the Good News different from the one we have already preached to you, whether it be ourselves or an angel from heaven, he is to be condemned." See also Alcuin *Liber contra haeresim Felicis* 15 (Blumenshine, p. 62); *Adversus Felicem Urgellitanum episcopum libri VII* 1.13–16, 2.1–12, 19, 4.10–12 (*PL* 101, 139–143, 145–156, 160–161, 183–187); *Adversus Elipandum libri IV* 3.4–5, 3.10, 4.4–5 (*PL* 101, 273–274, 277, 286–290).

79. Cf. Paulinus of Aquileia *Libellus sacrosyllabus* (*MGH LL* 3, *CC* 2, p. 134),

Regula fidei metrico 30–46 (Norberg, p. 92), and *Contra Felicem libri III* 1.35, 2.18, 30, and 3.1–3 (Norberg, pp. 42, 68, 82, 85–87). Alcuin's *Liber contra haeresim Felicis* was entirely a patristic exposition on the meaning of this text: "what (the Fathers) understood by this paternal witness." See especially 3–4 (Blumenshine, pp. 56 ff.). See also *Adversus Felicem Urgellitanum episcopum libri VII* 1.12, 2.15–17 (*PL* 101, 138, 157–159); and *Adversus Elipandum Libri IV* 1.20, 3.2–3 (*PL* 101, 256, 271–272).

80. Given the prominence of the issue of baptismal practice in Alcuin's thinking about Adoptionism, it is somewhat surprising to find no such reference in his late anti-Adoptionist writings. This may be due to the context of theological debate, unlike the practical concerns of his letters to Oduin and to the monks of Septimania. On the other hand, it is also important to bear in mind that the anti-Adoptionist treatment of Christ's baptism was to see it as distinguishing Christ from mere humans, unlike the Adoptionist view.

81. See especially Paulinus *Contra Felicem libri III* 2.7–8; cf. the confession of Martha, 2.12 (Norberg, pp. 57–58, 62).

82. *Epistola Hadriani I papae ad episcopos Hispaniae directa* (*MGH LL* 3, CC 2, p. 127). For Paulinus and Alcuin, see the following note.

83. Paulinus often treats the texts of the Crucifixion and the Resurrection together. See *Contra Felicem libri III* 1.28, 29, 37; 2.4, 9 (Norberg, pp. 33, 44, 52, 59–60). Cf. Alcuin *Contra Felicem Urgellitanum episcopum libri VII* 2. 13, 3.10 (*PL* 101, 156, 168).

84. See *Epistola Hadriani I papae ad episcopos Hispaniae directa* (*MGH LL* 3, CC 2, p. 123). See also Paulinus *Contra Felicem libri III,* texts as cited in the previous note.

85. This was an especially important text for Paulinus. *Contra Felicem libri III* 1.38, 2.23, 25, 26 (Norberg, pp. 45–46, 74, 77–78). Cf. *Epistola Hadriani I papae ad episcopos Hispaniae directa* (*MGH LL* 3, CC 2, p. 123); although the ascension described in this text was different from the great Ascension described in Acts I, Hadrian used this text indiscriminately.

86. Paulinus of Aquileia *Contra Felicem libri III* 1.37 (Norberg, pp. 42–43).

87. *De perfectione* 1, 3 (*MGH SS* 15, p. 174–176).

Chapter 3

1. *MGH SS* 15, p. 179.

2. See for example *MGH, Epp* 4, numbers 9, 11, 75, 92–95, 97, 125, 147, 151, 152, 162, 164, 165, 172, 175, 220, 221, 237, and 306. The letters and Nithard's *Historia* Book 4 (Philippe Lauer, ed. and trans., Paris: H. Champion, 1926), pp. 139–141, as contemporary sources are the most reliable for details about Angilbert's life. The letters provide a basic chronology and references to the most important events of Angilbert's life. Nithard gives us rudimentary information about Angilbert's relationship with Charlemagne's daughter Bertha and the two children from that union. Our information about Angilbert's work at the monastery of Saint-Riquier comes from his own description of the monastery and its reconstruction, to be discussed below, and from Book 2 of the late eleventh-century *Chronicon Centulense.*

3. *MGH, Epp* 4, 92.

4. *MGH Epp* 5, number 2, p. 7: Praeterea directum a vestra clementissima praecelsa regali potentia suscepimus fidelem familiarem vestrum videlicet Engilbertum abbatem et ministrum capellae, qui pene ab ipsis infantiae rudimentis in palatio vestro enutritus est, et in omnibus consiliis vestris receptus.

5. Nithard *Histoire des fils de Louis le Pieux* 4.5 (Lauer, pp. 139–141). Corblet took the text as an interpolation. Hauck, *Kirchengeschichte Deutschlands* 2, p. 180, note 2, accepted it as authentic; there is no compelling reason not to accept its authenticity. Corblet's squeamishness with Angilbert's marriage and children comes from his nineteenth-century cleric's concerns. For Richard see *Vita Hludovici* 6, 55–56 (*MGH SS* 2, pp. 610, 641–642). Cf. Alan Cabaniss, *Son of Charlemagne* (Syracuse University Press, 1961), p. 139, note 44. For Madelgaud, see Johann Friedrich Böhmer, *Regesten* 1, p. 155, number 374. Hauck identified Angilbert's family as Neustrian because Nithard lived in the realm of Charles the Bald. However, as Nithard was the son of Angilbert and himself abbot of Saint-Riquier, which was in Charles the Bald's territory, there is no reason to assume that Angilbert was Neustrian by birth. *Kirchengeschichte Deutschlands* 2, p. 180, note 1. Cf. Fleckenstein, *Hofkapelle* 1, p. 88 for Angilbert's high birth.

6. Cf. McKitterick, *Frankish Kingdoms,* p. 73, note 16. There are striking parallels between Angilbert's early history and the early life of Benedict of Aniane who, Ardo says, also received his early training at the courts of both Pepin and Charlemagne, and whose subsequent noble service to Charlemagne Ardo also notes. See *Vita Benedicti abbatis Anianensis et Indensis* (*MGH SS* 15, pars 1, pp. 198 ff.). Hariulf says that when Angilbert witnessed the will of Charlemagne he was already *senio lassescente,* "growing weary with the feebleness of old age." For the date 740 for Angilbert's birth, see Abbé J. Corblet, *Hagiographie du diocèse d'Amiens* 1 (Paris: Dumoulin, 1868), pp. 104–105. For the 750s see Hénocque, *Histoire* 3.1, p. 113. Cf. P. Richard, who assigned the same date in his article "Angilbert," *DHGE* 3, col. 120. I have assigned a somewhat later date, in the later 750s. Angilbert must have been younger than Charlemagne to earn the nickname *puer.* I have taken the papal statement *enutritus in palatio vestro* at face value, to mean that Angilbert was still a youth being educated when Charlemagne became king in 768. He became abbot, then, in his early thirties, and Hariulf's statement that Angilbert was enfeebled with age in 811 would hardly be improbable in the ninth century for a man in his mid-fifties. Cf. Pierre Riché, *La vie quotidienne dans l'empire carolingien* (Paris: Hachette, 1973), p. 63.

7. Pierre Riché, *Education and Culture in the Barbarian West,* John J. Contreni, translator (Columbia: University of South Carolina Press, 1976), pp. 236, 439; compare the terms *a pueritia, robustior aetas, in pubentibus annis.* It is worth noting the similarities between Angilbert's early years and those of Benedict of Aniane. See Ardo *Vita Benedictis abbatis Anianensis et Indensis* (*MGH SS* 15, pp. 198–220, especially pp. 200–204.

8. Cf. Pierre Riché, "Le renouveau de la culture à la cour de Pepin," *Francia* 2 (1974): 59–70.

9. The influence of Ovid and Virgil came from Angilbert's early education and not from his later contact with Alcuin, as Angilbert's earliest extant poem, the *De 'conversione Saxonum,* including Ovidian and Virgilian figures, dates from 777,

before the arrival of the Anglo-Saxon master in Francia. For Angilbert's authorship, and for the influence of Aldhelm on this poem, see below.

10. For the name "Homer" see *MGH, Epp* 4, numbers 25, 92, 97, 162, 164, 172, 175, 220, 221, and 237. Despite the honorable judgment of Angilbert's friends, modern scholars have been divided on the artistic merit of his poems. Cf. Max Manitius, *Geschichte der lateinischen Literatur des Mittelalters,* Volume 1 (Munich: C. H. Beck, 1911), pp. 543–547; F. J. E. Raby, *A History of Secular Latin Poetry in the Middle Ages* 1, second edition (Oxford: Clarendon Press, 1967), pp. 201–202. The claim that Angilbert knew Greek is groundless; the letter of Alcuin quoting Greek words and phrases uses what would have been common knowledge and implies no further knowledge of the language. See *MGH Epp* 4, number 162.

11. See below, pp. 72–74, and note 48.

12. *MGH PL* 1, pp. 380–381.

13. See, for example, Max Manitius, "Das Epos 'Karolus Magnus et Leo papa,'" in *Neues Archiv der Gesellschaft für altere deutsche Geschichtskunde* 8 (1883): 9–45, and *Geschichte der lateinischen Literatur des Mittelalters,* Volume 1 (Munich: C. H. Beck, 1911), pp. 543 ff., for a comprehensive discussion of Angilbert's writings and style; Ludwig Traube, *Karolingische Dichtungen, Schriften zur germanischen Philologie* (Berlin: Weidmann, 1888), pp. 51 ff.; Nino Schivoletto, "Angilberto abate di S. Riquier e l'humanitas' carolingia," *Giornale italiano di filologia* 5 (1952): 289–313; H. Schneider, *Heldendichtung-Geistlichendichtung-Ritterdichtung,* revised edition (Heidelberg: C. Winter, 1943), pp. 64 ff.; Otto Schuhmann, "Angilbert," in Wolfgang Stammler, editor, *Die deutsche Literatur des Mittelalters. Verfasserlexikon,* Volume 1 (Berlin: De Gruyter, 1933). cc. 80–85; and Alfred Ebenbauer, *Carmen historicum: Untersuchungen zur historischen Dichtung im karolingischen Europa* (Vienna: Wilhelm Braumüller, 1978), pp. 7 ff.

14. See, for example, Dieter Schaller, "Angilbert," in Wolfgang Stammler and Karl Langosch, editors, *Die deutsche Literatur des Mittelalters. Verfasserlexikon* 1 (Berlin: De Gruyter, 1978), cc. 358–363; and in Volume 2 of the same work, published in 1980, see Franz Josef Worstbrock, "De conversione Saxonum," cc. 11–13. See also Schaller's "Vortrags- und Zirkulardichtung am Hof Karls des Grossen," *Mittellateinisches Jahrbuch* 6 (1970): 14–36. Karl Strecker had already rejected Angilbert's authorship: "Studien zu den karolingischen Dichtern," *Neues Archiv der Gesellschaft für altere deutsche Geschichtskunde* 44 (1922): 209–251. Also valuable is the assessment of Peter Godman, *Poets and Emperors,* pp. 41 ff.

15. "Karolingische Taufpfalzen im Spiegel hofnaher Dichtung," *Nachrichten der Akademie der Wissenschaften in Göttingen I: Philologisch-historische Klasse* (1985): 1–97.

16. Fleckenstein, "Karl der Grosse und sein Hof," pp. 36 ff.; cf. Hauck, p. 5.

17. On the poetry of Aldhelm, and a new English translation of the *De Virginitate,* see Michael Lapidge and James L. Rosier, editors and translators, *Aldhelm: The Poetic Works* (Cambridge: D. S. Brewer, 1985), pp. 97–167. For the Latin see the edition of Rudolf Ehwald, *MGH AA* 15, pp. 327–471. On Ehwald's manuscript sources, especially the Saint-Riquier codex, see p. 331.

18. Hariulf 3.3 (Lot, p. 93).

19. Ehwald, *MGH AA* 15, p. 331.

20. See Carmen 3 (*MGH PL* 1, pp. 363–364). For a striking, and perhaps surprising resonance employing Bede in phraseology and meter similar to the *De conversione Saxonum* in the York poem of Alcuin see Bullough, "Alcuin and the Kingdom of Heaven," revised version in *Carolingian Renewal,* p. 162.

21. Cf. Hauck, pp. 18 ff.

22. See "Der Dichter des 'Carmen de conversione Saxonum,'" in Günter Bernt, Fidel Rädle and Gabriel Silagi, editors, *Tradition und Wertung: Festschrift für Franz Brunhölzl zum 65. Geburtstag* (Sigmaringen: Jan Thorbecke, 1989), pp. 27–45.

23. Although Schaller does not specify the poems of Theodulf that contain such imagery, Aldhelm's influence can be seen in, for example, poems 29, 32, 50, and 58 in *MGH PL* 1, pp. 517, 522–524, 550–551, 554.

24. The Anglo-Saxons saw the rim of the North Sea as one continuous Saxon land and culture, the "Saxon littoral," whose unity was broken only by the paganism of the old tribes. To be their brothers' keepers, as it were, and reestablish the family tie by ministering to the faith was a desire common to both groups, in their view. As Saint Boniface stated in a letter to the Anglo-Saxons, "Take pity upon them (the Old Saxons); for they themselves are saying: 'We are of one blood and one bone with you.'" *MGH Epp* 3, number 46: Miseremini illorum, quia et ipsi solent dicere: 'De uno sanguine et de uno osse sumus.' I have taken this translation from *The Letters of Saint Boniface,* ed. and trans. Austin P. Evans, Records of Civilization: Sources and Studies 31 (New York: Columbia University Press, 1940), p. 75. For a thorough and interesting discussion of the evidence on the Saxon littoral, see Michel Rouche, "Les Saxons et les origines de Quentovic," *Revue du Nord* (October–December 1977): 457–478.

25. See Wilhelm Levison, *England and the Continent in the Eighth Century* (Oxford: Clarendon Press, 1946); K. Hauck, "Taufpfalzen," for the importance of Paderborn as the *urbs karoli* and the image of Constantinian greatness, as well as the significance of the Saxon baptism as *herrscherliche Gottesdienst;* Hans Dietrich Kahl, "Karl der Grosse und die Sachsen. Stufen und Motive einer historischen 'Eskalation,'" in Herbert Ludat and Rainer Christoph Schwinges, editors, *Politik, Gesellschaft, Geschichtsschreibung: Giessener Festgabe für Frantisek Graus. Beihefte zum Archiv für Kulturgeschichte* 18 (Cologne/Vienna: Egon Boshof, 1982), pp. 49–130.

26. *Annales Laurissenses et Einhardi* 772–775 (*MGH SS* 1, pp. 150–155). Cf. Louis Halphen, *Charlemagne et l'empire carolingien* (Paris: Albin Michel, 1968), pp. 63–70.

27. *RFA,* 776 here translated by Bernhard Walter Scholz, *Carolingian Chronicles* (Ann Arbor: University of Michigan Press, 1970), pp. 53–54. For a lucid and detailed discussion of these annals, including date, author, and character, see McKitterick, *Frankish Kingdoms,* pp. 4–5, and Ganshof, pp. 631–685.

28. *MGH, Epp* 3, *Codex Carolinus* 50: Quo audito, vehementi exultationis laetitia noster in Domino ovans relevatus est animus, et protinus, extensis palmis ad aethera, regi regum et domino dominantium optimas laudes retulimus, enixius deprecantes ineffabilem eius divinam clementiam, ut et corporis sospitatem et anime salutem vobis tribuat et multipliciter de hostibus victorias tribuat omnesque barbaras nationes vestris substernat vestigiis . . . ab illo die, quo ab hac Roma urbe in

illis partibus profecti estis, cotidiae momentaneis etiam atque sedulis horis omnes nostri sacerdotes seu etiam religiosi Dei famuli, monachi, per universa nostra monasteria simulque et reliquus populus tam per titulos 'krieleyson' extensis vocibus pro vobis Deo nostro adclamandum non cessant flexisque genibus eumdem misericordissimum dominum Deum nostrum exorantes, ut et veniam delictorum vobis et maximam prosperitatis laetitiam et copiosas victorias vobis multipliciter e caelo concedat.

Cf. a similar letter, *Codex Carolinus* 76, written in 785 after the submission of the formidable Saxon chief Widukind to baptism, in which Hadrian praised Charlemagne for his holy and inspired victory and proclaimed that there were to be three days of litanies in Rome and throughout the West. The letters of Alcuin criticizing the forced conversion of the Saxons and the failure of Christianity to penetrate among the people date from the mid-790s and refer to conditions then that apparently were not anticipated earlier.

29. Cf. Chapter 5, pp. 136–137.

30. See, for example, *MGH Epp* 3, *Codex Carolinus* numbers 2, 3, 6, 8, 10, 11, 17, 24, 32, 33, 39, 43, 45.

31. Hauck's 1985 edition is the best; see "Taufpfalzen," pp. 62–65. I have maintained Dümmler's title, as it seems most appropriate to the sense of the poem.

32. The version above, following Hauck, has seventy-five lines, as did Dümmler's. Hauck states, however, that the organization of the lines actually works out to seventy-seven (a symbolic number important to Angilbert). See "Taufpfalzen," p. 66.

33. See Richard Landes, "Lest the Millennium be Fulfilled: Apocalyptic Expectations and the Pattern of Western Chronography, 100–800 C.E.," in Werner Verbrecke, Daniel Verhelst, and Andries Welkenhuysen, editors, *The Use and Abuse of Eschatology in the Middle Ages* (Louvain: Louvain University Press, 1988), pp. 135–211; see especially pp. 179–191. Cf. Elizabeth Sears, *The Ages of Man* (Princeton, NJ: Princeton University Press, 1986), Chapter 3. For a discussion of the Carolingian theory of the six ages as related to their theory of the moralism of the arts, and for the sources of that theory, see Edgar De Bruyne, *Etudes d'esthétique médiévale,* Volume 1 (Bruges: n. pub., 1946), pp. 209 ff.

34. Compare in the Frankish tradition the warrior imagery throughout Gregory of Tours's *Historia Francorum* and in the Anglo-Saxon tradition Beowulf's warrior character and death, and the *Dream of the Rood's* description of Christ's death and resurrection as his coming into his treasure horde in heaven.

35. See above, Introduction, note 3.

36. For the numerical symbolism understood by the Carolingians see below, Chapter 5.

37. *MGH Epp* 4, number 11. See Bernhard von Simson, *Jahrbücher des fränkischen Reichs unter Karl dem Grossen* 2 (Leipzig: Duncker and Humbolt, 1884), p. 435, note 6 for a discussion of the authentic form of the salutation containing the title *primicerius.* There has been some debate over whether Angilbert actually held this position in Pavia. The early students of Saint-Riquier, such as Durand and Hénocque, took this letter at face value. Eduard Hlawitschka has challenged it, charging that Angilbert served only as *missus* to Italy (actually, to the Pope), several

times in the 780s and 790s. See *Franken, Alemannen, Bayern und Burgunder in Oberitalien (774–962)* (Freiburg im Breisgau: Eberhard Albert Verlag, 1960), pp. 27 ff. Wattenbach-Levison accepted the title, *Deutschlands Geschichtsquellen im Mittelalter* 1, p. 237. Monod thought that this letter referred to Angilbert's work in the 790s at Charlemagne's royal chapel; cf. the title *ministrum capellae* with which Pope Hadrian referred to him in a letter to Charlemagne in 792. I believe that both titles are accurate: both refer to the same kind of religious functions exercised both at the court of Pepin and that of Charlemagne. Alcuin's letter clearly refers to Angilbert as *primicerius Italiae;* the papal letter was written to Charlemagne in the early 790s regarding Angilbert's work as *missus* with Felix and the *reprehensia.* Given his closeness to the king, his family background, and his prominence at court since his youngest days, these duties and honors are not unlikely. Cf. Fleckenstein, *Hofkapelle* 1, p. 67.

38. Charles Du Cange, *Glossarium mediae et infimae latinitatis* (Niort: L. Favre, 1883–1886), Vol. 2, p. 118, c. 4 and Vol. 6, p. 498, c. 1. Cf. Fleckenstein, *Hofkapelle* 1, pp. 11–12.

39. See *Hofkapelle* 1, p. 67. Fleckenstein notes the borrowing of this term precisely through Angilbert from the papal chancery whose head was also known as *primicerius.*

40. See Geary, pp. 40 ff.

41. *MGH, Epp* 4, number 75.

42. See note 3. *Ministrum capellae* may refer here to Angilbert's former role at Pepin's court, since in 791 Angilbert was back in Francia, probably at the royal court; or it may refer to some dignity held now at Charlemagne's court as one of the clerics responsible for safeguarding the relics and attending to the chapel of the king. For *manualem . . . auricularium,* see *MGH, Epp* 4, number 93.

43. *MGH, Epp* 4, number 27.

44. *MGH, Epp* 4, number 97: Te abeunte temptavi saepius ad portum stabilitatis venire. Sed rector rerum et dispensator animarum necdum concessit posse quod olim fecit velle. Adhuc ex radice cordis nascentes cogitationum ramusculos ventus temptationum flagellat, ut consolationis flores et refectionis fructus nutriri nequiverunt. . . . Sed ut iterum ad seriem rugosa fronte revertar, te vero unanimem deposcens amicum, te custodem animi obsecrans, ut consilium salutis animarum nostrarum cum suffragiis sanctorum apostolorum a Deo depreceris. Nam nos ambos, ut recognosco, quaedam necessitatis catena constringit et libero cursu voluntatis castra intrare non permittit.

45. John Boswell, *Christianity, Social Tolerance, and Homosexuality* (Chicago: University of Chicago Press, 1980), pp. 188–191.

46. Cf. Heinrich Fichtenau, *The Carolingian Empire: The Age of Charlemagne,* trans. Peter Munz (New York: Harper Torchbooks, 1964), p. 97. It is Fichtenau who brings out the shift in the later letters of Alcuin, and first interpreted the term "chain of necessity" as a common sin.

47. For the most recent edition of the poem, see Godman, *Renaissance.* Cf. *MGH, PL* 1, pp. 360–363, and Nithard, *Historia* 4.5 (Lauer, pp. 135–141).

48. Clerical celibacy was a longstanding obligation in the Western Church, though one much ignored. Charlemagne's *Admonitio generalis,* promulgated in 789,

forbade any cleric to have a woman in his house (except a housekeeper). See *MGH LL* 1, *Capit* 1, p. 55, number 4. However, two sources written during the reign of Louis the Pious, Einhard's *Vita Caroli Magni* 25 (*MGH, SS* 1, p. 456) and the *Vita Hludovici* 2.25.1 speak of the scandals of life at the court of Charlemagne and the reaction of Louis the Pious in clearing the palace of all offenders. The latter says that the "blemish" of Louis's sisters' behavior was the only disgrace of the court of Charlemagne, and that Louis, sensitive to the impropriety of their affairs, banished them from court. Hence Angilbert's marriage, even if he was in orders (e.g., as a deacon, as was Alcuin), is not unlikely. The character of the *Friedelehe* was informal, and the fact that the woman remained within her own kin group sheds light on Einhard's famous comment that Charlemagne so loved his daughters that he would not allow them to marry, preferring to keep them always with him (*Vita Caroli Magni* 19).

Angilbert's relationship with Bertha has always been problematic for later historians. See Hariulf 2.3; today only the chapter heading is extant). See also A. P. M. Gilbert, *Déscription historique*, pp. 147–148; Hénocque, "Mariage de saint Angilbert avec la princesse Berthe, réponse à Monsieur Dufour," *Bulletin de la Société des antiquaires de Picardie* 9, 2 (1866): 258–259, 263–268; *Histoire* 3.3 pp. 95 ff., and "Obsérvations de M. l'abbé Carlet, curé de Manicamps," *Bulletin de la Société des antiquaires de Picardie* 11, 3 (1873): 335–351. The most thoughtful resolution of the problem is that of Suzanne Fonay Wemple whose discussion of *Friedelehe* and early medieval women suggests an answer for Angilbert and Bertha. See *Women in Frankish Society: Marriage and the Cloister, 500–900* (Philadelphia: University of Pennsylvania Press, 1981), pp. 12–15, 35.

49. *MGH, Epp* 4, number 9. Anscher's claim that Angilbert was appointed Count of Ponthieu of France-Maritime is without corroboration in the earlier sources. Any such reference in Hariulf was probably an interpolation by Anscher.

50. Cf. McKitterick, *Frankish Kingdoms*, p. 37. Widmar, like Angilbert later, was the ambassador of Pepin to Pope Paul I between 761 and 766. In 763 he was a signatory to the acts of the Council of Attigny, and therefore Saint-Riquier participated in the prayer confraternity established by Chrodegang of Metz. See *MGH LL* 3, *CC* 2, part 1, pp. 72–73.

51. *MGH Epp* 4, number 93.

52. *MGH Epp* 4, number 172: "scriptam esse eandem (sic) controversiam in eadem civitate audivi. Idem Petrus fuit, qui in palatio vestro gramaticam docens claruit. Forsan Omerus vester aliquid exinde audivit a magistro praedicto."

53. See above, Chapter 2, and the response of Hadrian, *MGH Epp* 5, number 2. Cf. Freeman, "Carolingian Orthodoxy," pp. 81 ff.; *Annales regni Francorum. Revised Version* 792 (*MGH SS* 1, p. 178).

54. See pp. xv–xvi, and Chapter 5. Cf. Angilbert *De perfectione* 1 (*MGH SS* 15, p. 174).

55. *MGH, Epp* 4, numbers 92, 93, and 94.

56. *RFA* 796 (Cf. Scholz, p. 75). For Angilbert's poem, see *MGH PL* 1, pp. 358–360.

57. This is the edition of Traube. For his dating and attribution of this poem to Angilbert of Saint-Riquier, see *O Roma Nobilis: Abhandlungen der königlichen-bayerisch Akademie der Wissenschaft* (1891): 322–331.

58. Augustine did quote it in the *De civitate Dei*, and the *De Trinitate*. But Augustine used only the words "numero, mensura ac pondere," and did not elaborate on the numerical order of Creation.

59. The text is quoted from the Jerusalem Bible.

60. See pp. 12–20 for a discussion of the sources.

61. *Institutio* (*CCM*, p. 291).

62. See Chapter 5 for a detailed description of the monastery.

63. *De perfectione* 1: Quia igitur omnis plebs fidelium sanctissimam atque inseparabilem Trinitatem confiteri, venerari et mente colere firmiterque credere debet, secundum huius fidei rationem in omnipotentis Dei nomine tres aecclesias principales cum menbris ad se pertinentibus in hoc sancto loco, Domino cooperante, et praedicto domino meo augusto iuvante, fundare studuimus.

64. *MGH LL* 3, *CC* 2, p. 158.

Chapter 4

1. See Introduction, note 1 for the Latin text.

2. See Chapter 3, pp. 54–71.

3. *Libri Carolini* Praefatio (*MGH LL* 3, *CC* 2, *Supplementum*, p. 2):

Quae incessanter per partes trinae orationis mysterium sanctae Trinitatis exponit, dum et verba sua auribus divinae maiestatis percipienda, id est psallendi melodiam, quam sine intermissione exhibet, deprecatur et clamorem intelligendum, id est cordis affectum, qui non auribus carnalibus, sed ineffabilibus divinae maiestatis auditibus mirabiliter excipitur, devota mente exorat et orationis suae vocem intendam exposcit, ut scilicet declaret hanc esse orationem perfectam, quam mentis affectus ardentis inflammat. Et quamquam metaforicos mutatis verbis sensus nostros inmisceat, divinam tamen naturam credit non partibus membrorum discernenda discernere, sed una virtute cuncta peragere, qui ea, quae a nobis videntur, audit et, quae cogitavimus sive cogitaturi sumus, intro inspicit nec quicquam eius ineffabili lumini potest abscondi. Auribus etenim verba percipere, clamorem intellegere, voci orationis intendere quamquam iterate sub varietate verborum per id locutionis genus, quod a rhetoribus metabole dicitur, proferantur, trina tamen repetitio unum idemque significat. Quae etenim in invocatione regis et Dei sive Domini, dum dicit: "Rex meus et Deus meus, quoniam ad te orabo, Domine," tres personas et unam substantiam in divinitate se credere et fateri demonstrat, cum trium nominum invocationi non pluralia, sed singularia verba interserit.

It was only somewhat later, under the liturgical reforms of Benedict of Aniane, that the *trina oratio* took on a very specific meaning as the series of gradual Psalms (Psalms 119–133). The threefold prayer implied in the *Libri* has a much different symbolic meaning, as we know from the context of this quote. On the *trina oratio* see Schmitz, "L'influence de saint Benoît dans l'histoire de l'ordre de saint Benoît," in *Il monachesimo nell'alto medioevo e la formazione della civiltà occidentale: Settimane di studio del Centro italiano di studi sull'alto medioevo 4*, pp. 401–415.

4. See Psalm 5. Cf. Psalms 44 and 145.

5. Cf. Angilbert *Institutio* 9, 11 (*CCM,* pp. 296–297, 300), texts that describe the sensual quality of the liturgy down to the *turibula,* or thuribles.

6. For prayer without ceasing as *laus perennis* at Saint-Riquier, see below, Chapter 5, p. 123.

7. *Libri Carolini* 1.7 (*MGH LL* 3, *CC* 2, *Supplementum* 1024): Omnia vero quia vivunt et non sapiunt, paulo amplius participant similitudini. . . . Quod enim participat sapientiae, et vivit, et est. Cf. *De diversis quaestionibus liber unus* 51.2 (*CCSL* 44/a, pp. 79–80). Cf. Chazelle, "Matter, Spirit, and Image," pp. 170–171.

8. See below, Chapter 5, pp. 117–119. On this character of religious art, see *Libri Carolini* Praefatio, 2.13 (*MGH LL* 2, *CC* 2, *Supplementum* 3 ff.). Cf. Chazelle, "Matter, Spirit, and Image," p. 165.

9. *De perfectione* 3 (*MGH SS* 15, p. 178):

His et aliis (quae) prout donante Domino valuimus, eleganter dispositis atque ex diversis predictis reliquiis supradictorum sanctorum ornatis aecclesiis, diligenti mentis affectu tractare cepimus, qualiter Domino donante pervenire valuissemus, ut, sicut in aedificiis marmoreis et in ceteris ornamentis oculis honeste clarescunt humanis, ita etiam in laudibus Dei, in doctrinis diversis et canticis spiritualibus honestius, in augmento fidei roborante, nostris et futuris temporibus, Deo auxiliante, cotidie ad salutem proficiendo crescerent sempiternam.

10. Angilbert's program will be discussed in detail below in Chapter 5. For a comparison with other contemporary buildings, see the Conclusion.

11. *MGH Diplomatum Karolinorum* 1, number 18.

Igitur dum notum est omnibus tam propinquis quam externis nationibus nos et coniuge nostra Bertradane in amore sancti Salvatoris nec non et sanctae dei genetricis Mariae atque beatorum principum apostolorum Petri et Pauli vel sancti Johannis Baptistae seu et martirum sancti Stephani, Diunisii, et Mauricii atque confessorum sancti Martini, Vedasti atque Germani monasterium in re proprietatis nostrae aedificare . . . in ipsius vero monasterii ecclesia de scandaliis domini nostri Iesu Christi nec non ipsius genetricis Mariae ceterorumque sanctorum, quorum supra fecimus mentionem, visi fuimus recondere reliquias atque ibidem monachos constituemus, qui sub sanctae conversationis norma vel secundum praecedentium patrum doctrinam debeant omnino exercere, quatenus ut, qui monachi solitarii nuncupantur, de perfecta quiete valeant duce domino per tempora exultare et sub sancta regula viventes beatorum patrum vitam sectantes pro statu ecclesiae atque longevitate regni nostri necnon et uxoris vel filiis nostris populoque exorare. Providendum est tamen. . . . sacerdotes atque monachi, qui ibidem servientes aderunt, possint deo omnipotenti die noctuque laudes referre.

While this charter was not directly contemporary with Saint-Riquier, it expresses more clearly than any other the meaning of the monastic life of prayer for

Carolingian kings in a monastery intimately and continuously associated with the dynasty.

12. The "people of the faithful" of the town of Saint-Riquier and its surrounding territory were often involved in the liturgical celebrations. Cf. pp. 124–131.

13. *Institutio* 1. Praefatio (*CCM* 1, pp. 292–293):

Quinimmo omnes unanimes sacrificium laudis domino omnipotenti pro salute gloriosi domini mei Augusti Karoli proque regni eius stabilitate. Atque continua devotione iugiter exhibeant. . . . Illud etiam observari praecipua devotione mandamus, ut nulla dies praetereat absque sacrarum missarum decantatione . . . quae mane et meridie sollemnissime celebrantur, in quibus quotidie memoria sanctissimi papae Adriani et gloriosi domini mei Augusti Karoli, coniugis et prolis eius teneatur; qualiter iuxta verbum apostoli, "pro regibus et omnibus qui in sublimitate sunt" constituti salvatori deo nostro obsecrationum vel orationum gratias iugiter persolvamus.

14. "Liturgy of War," pp. 2–5. Cf. Heitz, *Recherches,* pp. 145 ff.

15. See pp. 76–81, 83–84.

16. The bibliography on Augustine and symbolism is, of course, enormous. My intention here has been to undertake a fresh reading of Augustine's text. Among the most important studies are the following: Karel Svoboda, *L'esthétique de saint Augustin et ses sources* (Paris/Brno: Vydava Filosoficka Fakulta, 1933), in many ways the *locus classicus* of these studies; Robert J. O'Connell, *Art and the Christian Intelligence in Saint Augustine* (Oxford: Basil Blackwell, 1978); Joseph Arthur, *L'art dans saint Augustin,* 2 Volumes (Montréal: n.pub., 1944); Emmanuel Chapman, *Saint Augustine's Philosophy of Beauty* (New York/London: Sheed and Ward, 1939); Josef-Matthias Tscholl's series of articles, "Augustins Interesse für das körperliche Schöne," *Augustiniana* 14 (1964): 72–104, "Vom Wesen der körperlichen Schönheit zu Gott," *Augustiniana* 15 (1965): 32–53, "Augustins Aufmerksamkeit am Makrokosmos," *Augustiniana* 15 (1965): 389–413, "Augustins Beachtung der geistigen Schönheit," *Augustiniana* 16 (1966): 11–53, and "Dreifaltigkeit und dreifache Vollendung des Schönen nach Augustinus," *Augustiniana* 16 (1966): 330–370; Cornelius P. Mayer, *Die Zeichen in der geistigen Entwicklung und in der Theologie des jungen Augustinus* (Würzburg: Augustinus Verlag, 1969), as well as his "*Res per signa,*" *Revue des études augustiniennes* 20 (1974): 100–112, and "Signifikations-Hermeneutik im Dienste der Daseinauslegung," *Augustiniana* 24 (1974): 21–74; R. A. Markus, "Saint Augustine and Signs," in his *Augustine: A Collection of Critical Essays* (Garden City, NY: Anchor Books, 1972), pp. 61–85; Olivier du Roy, *L'intelligence de la foi en la trinité selon saint Augustin* (Paris: Études Augustiniennes, 1966); P. M. Löhrer, *Der Glaubensbegriff des heiligen Augustinus* (Einsiedeln: n. pub., 1955); A. Holl, *Die Welt der Zeichen bei Augustinus* (Vienna: Herder, 1963); more generally, Katherine Gilbert and Helmut Kuhn, *A History of Esthetics,* revised edition (London: Thames and Hudson, 1956). Fundamental on the development and context of Augustine's thought in general is Peter Brown's *Augustine of Hippo* (Berkeley: University of California Press, 1967); also essential is H.-I. Marrou, *Saint Augustin et la fin de la culture antique* (Paris: E. de Boccard, 1938).

17. *De doctrina christiana,* Joseph Martin, editor, *CCSL* 32 (Turnhout: Brepols, 1962), 1.1.1: Duae sunt res, quibus nititur omnis tractatio scripturarum, modus inueniendi, quae intellegenda sunt, et modus proferendi, quae intellecta sunt.

I have relied throughout this discussion on the English translation of John J. Gavigan, O.S.A., Fathers of the Church Series, *Writings of Saint Augustine,* Volume 4 (Washington, DC: Catholic University of America Press, 1947), which is reliable. This quote comes from p. 27.

18. *De doctrina christiana* 1.2.2 (Martin, p. 37): Omnis doctrina vel rerum est vel signorum, sed res per signa discuntur. (Gavigan, p. 28).

19. *De doctrina christiana* 1.5.5 (Martin, p. 9): Res igitur, quibus fruendum est, pater et filius et spiritus sanctus, eademque trinitas (Gavigan, p. 30).

20. *De doctrina christiana* 2.1.1 (Martin, p. 32): Signum est enim res praeter speciem, quam ingerit sensibus, aliud aliquid ex se faciens in cogitationem venire (Gavigan, p. 61).

21. *De doctrina christiana* 2.1.2; 2.1.4 (Martin, pp. 32–34 and Gavigan, pp. 61–64).

22. *De doctrina christiana* 2.10.15 (Martin, p. 41 and Gavigan, p. 72).

23. Cf. Revelation 4: 7, Deuteronomy 25: 4, 1 Corinthians 9: 9, and 1 Timothy 5: 18.

24. *De doctrina christiana* 2.7.9–10 (Martin, pp. 36–37 and Gavigan, pp. 66–68).

25. *De doctrina christiana* 2.7.10–11 (Martin, pp. 37–38 and Gavigan, pp. 68–69).

26. *De doctrina christiana* 2.7.11 (Martin, p. 38 and Gavigan, pp. 68–69). Cf. 1 Corinthians 13:12.

27. *De doctrina christiana* 2.7.11 (Martin, p. 38): "Initium" enim sapientiae timor domini. Ab illo enim ad ipsam per hos gradus tenditur et venitur (Gavigan, p. 69).

28. *De doctrina christiana* 2.6.7–8 (Martin, pp. 35–36 and Gavigan, pp. 65–66).

29. *De doctrina christiana* 4.15.32 (Martin, p. 138): pietate magis orationum quam oratorum facultate (Gavigan, p. 198).

30. De *doctrina christiana* 4.28.61 (Martin, p. 164 and Gavigan, pp. 231–232).

31. See above, pp. 90–91.

32. Cf. *De doctrina christiana* 2.16.25, 2.38.56–57. (Martin, pp. 50–51, 71–72 and Gavigan, pp. 83–85, 109–110).

33. See Chapter 3, pp. 79–80.

34. See above, Chapter 2, pp. 40–41.

35. *MGH Epp* 4, number 137:

Tertia quoque nobis de Hispania—quae olim tyrannorum nutrix fuit, nunc vero scismaticorum—contra universalem sanctae ecclesiae consuetudinem, de baptismo quaestio delata est. Adfirmant enim quidam sub invocatione sanctae Trinitatis unam esse mersionem agendam. Videtur enim apostolus huic observationi esse contrarius in eo loco, ubi ait: "Consepulti enim estis Christo per

baptismum." Scimus enim Christum . . . tres dies et tres noctes in sepulchro esse. . . . Possunt tres noctes tres mersiones et tres dies tres elevationes designare . . . Nobis vero . . . videtur, ut, sicut interior homo in fide sanctae Trinitatis ad imaginem sui abluendus est; ut, quod invisibiliter spiritus operatur in anima, hoc visibiliter sacerdos imitetur in aqua.

36. *MGH Epp* 4, number 137:

Nobis vero iuxta parvitatem ingenioli nostri videtur, ut, sicut interior homo in fide sanctae Trinitatis ad imaginem sui conditoris reformandus est, ita exterior trina mersione abluendus est; ut, quod invisibiliter spiritus operatur in anima, hoc visibiliter sacerdos imitetur in aqua. Nam originale peccatum tribus modis actum est: delectatione consensu et opere. Itaque, quia omne peccatum aut delectatione aut consensu aut operatione efficitur, ideo triplici generi peccatorum trina videtur ablutio convenire.

37. Even a study as recent as that of André Vauchez, *La spiritualité du Moyen-âge occidental, VIIIe–XIIe siècles* (Paris: Presses Universitaires de France, 1975), pp. 18 ff., tended to treat Carolingian spirituality as formalistic, with either little understanding of or attention to intention or internal conviction or transformation. Gerald Ellard's *Master Alcuin, Liturgist: A Partner of Our Piety* (Chicago: Loyola University Press, 1956), pp. 73 ff., discusses this text and its extended citations of Roman authorities as a clear indication of Alcuin's concern to follow the Roman Church in all things. In fact, Alcuin cites biblical authorities as fully and makes no argument of his own about Roman liturgical practice. Alcuin is very careful, on the other hand, to develop his theory on the symbolic importance of this liturgical usage. He never says that Adoptionist single immersion is wrong because it differs from Rome. He says that it is wrong because it does not accomplish its desired internal effect.

38. *MGH Epp* 4, number 113:

Absque fide quid proficit baptisma? . . . Idcirco misera Saxonum gens toties baptismi perdidit sacramentum, quia numquam habuit in corde fidei fundamentum. . . . Quod enim visibiliter sacerdos per baptismum operatur in corpore per aquam, hoc Spiritus sanctus invisibiliter operatur in anima per fidem. Tria sunt in baptismatis sacramento visibilia, et tria invisibilia. Visibilia sunt sacerdos corpus et aqua. Invisibilia vero spiritus anima et fides. Illa tria visibilia nihil proficiunt foris, si haec tria invisibilia non intus operantur. . . . "Cooperatores enim Dei sumus."

39. On the library, see Hariulf, *Chronicon*, 3.3; cf. McKitterick, *The Carolingians and the Written Word* (Cambridge: Cambridge University Press, 1989), pp. 175–178; and E. Dekkers, "La bibliothèque de Saint-Riquier au moyen âge," *Bulletin de la Société des Antiquaires de Picardie* 46 (1955–56): 157–197.

For a complete discussion of each of these manuscripts, see E. A. Lowe, *Codices Latini Antiquiores* Volumes 1–10 (Oxford: Clarendon Press, 1934–1965). Cambrai

300 is found in Volume 6, p. 12, number 739; Vaticanus Pal. Lat. 202 in Volume 1, p. 25, number 83; Paris Lat. 9538 in Volume 5, p. 21, number 588; and Monte Cassino 19 in Volume 3, p. 31, number 373 (Cf. number 372 for the companion manuscript of the Ambrose texts). Laon 130 and Paris Nouv. Acq. Lat. 1445 are discussed in the *CCSL* edition of the *De Trinitate*, Volume 50, W. J. Mountain, editor (Turnhout: Brepols, 1968), pp. lxx–lxxviii.

40. The second half of the treatise seems to have been as important for the Carolingians as the first. Benedict of Aniane sometime between 800 and 802 wrote the *Munimenta verae fidei*, the first portion of which was a direct restatement of this aesthetic portion of the *De Trinitate*. Cf. the edition of Jean Leclercq in *Studia Anselmiana* 20 (1948): 27–66.

41. Karl Morrison has recently discussed Augustine's theory as a mimetic strategy that assimilated humans to God through "advancement by correction." See *Mimetic Tradition,* pp. 59 ff.

42. *De Trinitate* 6.19, 8.10, and 9.3–4.

43. *De Trinitate* 10.10.13–14; 11.2.5; 11.3.6; 11.4.7; and 12.7.10.

44. *De Trinitate* 8.6.9.

45. *De Trinitate* 15.23.43.

46. Cf. Morrison, *Mimetic Tradition,* p. 60.

47. *De Trinitate* 15.21.41.

48. *De Trinitate* 9.7.12.

49. *De Trinitate* 11.11.18. Cf. Morrison, *Mimetic Tradition,* p. 59.

50. *De Trinitate* 4.9 (Mountain, p. 178 and McKenna, p. 146).

51. *De Trinitate* 8.7.10 (Mountain, pp. 284–285 and McKenna, p. 260).

52. *De Trinitate* 10.1.1. Cf. 10.1.3 and 10.2.4.

53. *De Trinitate* 10.1.1–2. (Mountain, pp. 311–315 McKenna, pp. 291–292).

Chapter 5

1. The title of this chapter is taken from the *Regula fidei metrico* of Paulinus of Aquileia, line 46. The context is a listing of scriptural texts that prove the true Sonship of Jesus: *Datum hoc est mirabile signum, quod deus atque homo Christus sit verus et altus.* The text quoted was the story of the Transfiguration, Matthew 17: 5, one of the arguments used in Paulinus's own anti-Adoptionist writings.

2. See above, p. xv. Modern art historians, while they have been assiduous in their formalistic reconstructions of the abbey complex, have all but ignored this statement of intent by Angilbert in their assessments of the symbolic meaning of his program. Even the most recent studies have paid only lip service to this insight.

3. *De perfectione* 1 (*MGH SS* 15, p. 174, 11.26–29): Quia igitur omnis plebs fidelium sanctissimam atque inseparabilem Trinitatem confiteri, venerari et mente colere firmiterque credere debet, secundum huius fidei rationem in omnipotentis Dei nomine tres aecclesias principales cum menbris ad se pertinentibus in hoc sancto loco . . . fundare studuimus.

4. Hariulf *Chronicon Centulense* 1.15 (Lot, pp. 24–26).

5. *De perfectione* 1 (*MGH SS* 15, p. 174).

6. Cf. Lot, p. 56: Claustrum vero monachorum triangulum factum est, videlicet a sancto Richario usque ad sanctam Mariam tectus unus; itemque a sancto Benedicto usque ad sanctum Richarium tectus unus.

7. See note 9.

8. Bernard, "Une restitution nouvelle," passim.

9. There has been considerable controversy over whether the basilica had an atrium. Hans Reinhardt denied that there was an atrium on two grounds: the seventeenth-century drawing did not show one, and Angilbert never expressly used the term in his writings. See "L'église carolingienne de Saint-Riquier," *Mélanges offerts à René Crozet*, Volume I (Poitier: Société d'Études Médiévales, 1966), pp. 81–92. Reinhardt felt that the archangel chapels were located high in the tribunes over the doors of the western transept. His opinion would appear to have some backing from Alois Fuchs's earlier study, *Die karolingischen Westwerke* pp. 16, 31. Fuchs traced the origin of the western transept to the idea of having a chapel over the entrance at the western end of the church. Usually these chapels were dedicated to Saint Michael as the guardian of the gate.

Although Angilbert did not use the term *atrium,* he did use the term *paradisus* when referring to the portal area. Cf. *Institutio* 6 (*CCM,* p. 294). This term was synonymous with *atrium,* as Du Cange has documented. See *Glossarium* 6, p. 156. Du Cange cited Angilbert's use of the term in the *Institutio* among other examples. Cf. *McGraw-Hill Dictionary of Art,* Volume 4 (New York: McGraw-Hill, 1969), p. 297. Furthermore, Angilbert stated that the altars of Michael and Gabriel were each consecrated on separate occasions from those of the basilica, and he was quite concerned to count them separately from the other altars, referring to each chapel as a separate "church": *In ecclesiis sancti Salvatoris sanctique Richarii altaria fabricata xi. . . . In ecclesiis vero sanctorum Gabrielis, Mychaelis et Raphaelis altaria iii.* See *De perfectione* 3 (*MGH SS* 15, p. 177).

Most scholars have thought that Saint-Riquier had an atrium, and the reconstructions of Durand (p. 184), Effmann (pp. 20–21), and Conant (p. 11 and Figure IIA) all included it. Cf. Helen Dickinson Baldwin, *The Carolingian Abbey Church of Saint-Riquier,* a master's thesis submitted to Vanderbilt University, 1970, p. 62, note 1. Bernard's excavations have confirmed the existence of the atrium.

10. It was the existence of these chapels and altars, mentioned by Angilbert (see the preceding note), which led Durand, Bernard, and Conant to suggest that the portals were arranged one on each side of the atrium. Another Carolingian arrangement, following Roman custom, seems to have been to place the three portals side by side on the façade of the atrium. This was the arrangement, for example, of the great gate at Lorsch. Because of the textual evidence of Angilbert regarding the chapels and altars of the atrium, I have followed Durand, Bernard, and Conant in assigning the portals to each wall. (See Figure 2.) The cult of the Archangels, Michael, Gabriel, and Raphael, flourished during Charlemagne's reign, promoted in particular by the Synod of Aachen in 789. See *Admonitio generalis* 16 (*MGH LL* 2, *Capitularia* 1, p. 55).

11. Angilbert used the terms *turris, cocleae,* and *ambulatorius* interchangeably. We know that *ambulatorius* referred to the tower rather than to an ambulatory in the church because he spoke of *pueri ascendentes et descendentes.*

12. Angilbert spoke of the *ostium medianum. Institutio* 6 (*CCM,* p. 294).

13. Walter Horn has cited the existence of a number of aisled double apse churches in the pre-Carolingian West, with an apse in the west as well as in the east, a style possibly originating in North Africa. Of their liturgical significance Horn said, "The counterapse became a leitmotiv of Carolingian architecture, providing a convenient sanctuary for the founding saint of the monastery who had in many instances become more important in the ritual than its patron saint, as in the eighteenth-century church of Saint Maurice d'Agaune and Fulda or helped to establish a close liturgical tie with Rome by instituting at the western end of the church a sanctuary that could be interpreted as an imitation of the liturgical position of the altar of Old Saint Peter's in Rome, as in the church of the Plan of Saint Gall." The first reason has interesting implications for Saint-Riquier, where the cult of the Savior became all important and the saints in general were described as "God's ornament." See below, p. 121. For the Horn reference, see "On the Selective Use of Sacred numbers," p. 365, cited below in note 16.

14. *Institutio* 6 (*CCM,* p. 294).

15. Cf. Virginia Jansen, "Round or Square?" The Axial Towers of the Abbey Church of Saint-Riquier," *Gesta* 21, 2 (1982): pp. 83–90, and Bernard, "Une restitution nouvelle," passim.

16. Effman's evaluation of the west end posits the same window arrangement for the vestibule. Although there is no direct evidence from Hariulf, the arrangement seems likely given the symmetry both with the transepts and with the three main portals of the west facade. (Compare Figures 5 and 1.)

17. For a summary of the findings of Horn and Born, see "On the Selective Use of Sacred Numbers and the Creation in Carolingian Architecture of a New Aesthetic Based on Modular Concepts," *Viator* 6 (1975): 351–390. For a full explanation of the definition and aesthetic of modularity, see the accompanying articles (which form, appropriately, a triad), on Carolingian modular aesthetics in literature and in music: Charles W. Jones, "Carolingian Aesthetics: Why Modular Verse?" pp. 309–340, and Richard L. Crocker, "The Early Frankish Sequence: A New Musical Form," pp. 341–350.

18. Cf. Horn, "On the Selective Use of Sacred Numbers," p. 370.

19. Bernard's excavations of the basilica have been partial. He has excavated the ends of the westwork, the crypt and the eastern apsidal area. From the measurements gathered here, he has projected other measurements for the church. (See Figures 2 and 6.)

20. The Carolingian foot as computed by Walter Horn was 33.37 centimeters. I have reached these dimensions for Saint-Riquier by using the dimensions recorded in meters by Bernard, multiplying by 100 to obtain the measurement in Carolingian feet. Prior to Bernard's excavations, Irmgard Achter attempted to reconstruct the floorplan of Saint-Riquier on a square-dimensioned modular pattern. See "Zur Rekonstruktion der karolingischen Klosterkirche Centula," *Zeitschrift für Kunstgeschichte* 19 (1956): 133–154. No such work has been attempted since the excavations.

21. Cf. Chapter 3, p. 70; cf. Chapter 4, p. 85.

22. The only information about the material from which the reliefs were made comes from Ancher's eleventh-century *Vita Angilberti.* Anscher described the scenes

as *tabulae mirifico opere ex gipso figuratae et auro musivo aliisque pretiosis coloribus pulcherrime compositae sunt.* Thus they seem to have been of stucco and polychrome, with gold mosaic probably as the background. Cf. Lot, p. 127; Conant, *Carolingian and Romanesque Architecture,* pp. 11–13. Much Carolingian interior decor was of stucco work. Compare the churches of Germigny-des-Prés, built by Theodulf of Orléans in the late eighth century, and San Benedetto at Malles, built in the early ninth century. The famous church of Santa Maria in Valle in Cividale, Paulinus of Aquileia's territory, still contains stucco figure sculptures on *trabes* above the door, which date from the late eighth century. According to Donald Bullough, most extant Carolingian stucco work is to be found in northern Italy and the Alps. See *The Age of Charlemagne,* pp. 133, 155, and Plate 7.

23. *Institutio* 6 (*CCM,* p. 294), 9 (pp. 296, 299), 11 (p. 300), and 14 (p. 301).

24. *Institutio* 1 (*CCM,* pp. 292–293), and 17 (pp. 302–303).

25. *Institutio* 16, 17 (*CCM,* pp. 301–303). Edmund Bishop describes this as the first evidence of the Office of the Dead. See "Spanish Symptoms," *Liturgica Historica,* p. 190.

26. *Institutio* 17 (*CCM,* p. 302):

Omnibus horis uespertinis more solito celebratis quando ad sanctum Richarium expleuerint omnia, pergant fratres psallendo usque ad sanctam Passionem. Ubi oratione facta in duos diuidantur choros, quorum unus pergat ad sanctam Ascensionem. Deinde oratione peracta veniat unus chorus ad sanctum Iohannem, alter ad sanctum Martinum. Et post exinde per sanctum Stephanum et sanctum Laurentium ceteraque altaria psallendo et orando coniungant se ad sanctam Crucem. . . .

Cum enim Uesperos et Matutinos ad sanctum Saluatorem cantauerint, tunc descendat unus chorus ad sanctam Resurrectionem, alter ad sanctam Ascensionem, ibique orantes uadant similiter ut supra canendo usque ad sanctum Iohannem et sanctum Martinum; ubi oratione facta ingrediantur hinc et inde per arcus mediae aecclesiae et ornet ad sanctam Passionem. Inde ad sanctum Richarium peruneniant, ubi oratione finita diuidant se iterum sicut ante fierant, et ueniant per sanctum Stephanum et sanctum Laurentium psallendo et orando usque ad sanctam Crucem.

27. For the numbers of monks in the choirs, see below, p. 123 and note 42. This would seem to eliminate Lehmann's suggestion that the two sculptures stood over the arches (*bogen*) of the aisles, since archeological evidence reveals that the small size of the side aisles would have made prolonged chanting cumbersome at best.

28. While there were similar representations in fresco at the church of San Clemente in Rome, they date from the late ninth century (c. 885), and therefore postdate Angilbert's sculptures. Several remarkable series of fresco cycles of the life of Christ are extant which date from the mid-ninth century at Malles, Mustair, and Auxerre. Cf. Jean Hubert, *Carolingian Renaissance,* pp. 5–11, and André Grabar, *Early Medieval Painting from the Fourth to the Eleventh Century,* trans. Stuart Gilbert (New York: Skira, 1957), passim.

29. See p. 135.
30. See Chapter 2, p. 23.
31. *MGH LL* 2, *Capit* 1, pp. 66:

Item praedicandum est, quomodo Dei filius incarnatus est de spiritu sancto et ex Maria semper virgine pro salute et reparatione humani generis, passus, sepultus, et tertia die resurrexit, et ascendit in celis; et quomodo iterum venturus sit in maiestate divina iudicare omnes homines secundum merita propria; et quomodo impii propter scelera sua cum diabulo in ignem aeternum mittentur, et iusti cum Christo et a sanctis angelis suis in vitam aeternam. We may note Angilbert's specific choice of the four key events that were prescribed in the *Admonitio generalis.*

32. Cf. *Institutio* (*CCM*, pp. 294–295).
33. Cf. Edgar Lehmann, "Die Anordnung der Altare in Klosterkirche zu Centula," in Braunfels, editor, *Karl der Grosse* Volume 3: *Karolingische Kunst,* pp. 374–383. Cf. Bernard, "Premières fouilles," pp. 342–350 in the same volume. Bernard has rejected Lehmann's view, stating that it was based too heavily on Effmann's reconstruction. In Bernard's opinion, the altars were clustered closer to the eastern apse, rather than spread throughout the length of the basilica. I continue to hold Lehmann's view, however. The size of the monastic company and the liturgical functions to be performed at the altars would make it unwieldy at best, impossible at worst, for the altars to have been positioned so close together.
34. *De perfectione* 3 (*MGH SS* 15, pp. 177):

Cumque prescriptorum liter, ut sanctorum venerationi altaria atque de eorum reliquiis venerabilis supra legitur, a nostra parvitate essent ornata, diligenti cura tractare cepimus, qualiter ea ad laudem et gloriam domini nostri Ihesu Christi, ob venerationem sanctorum omnium in quorum honore sunt consecrata, de donis Dei et largitate magni domini mei Caroli eiusque nobilissimae prolis vel reliquorum bonorum liberorum michi ab illis collatis opere fabrili in auro, argento et gemmis ornare etiam, et ubi loca convenientia existerent, desuper ciboria ponere potuissemus, sicut, prout eodem Domino cooperante valuimus, facere studuimus.

35. *De perfectione* 3 (*MGH SS* 15, p. 177):

Id sunt: in aecclesia sancti Salvatoris et sancti Richarii altaria fabricata 11 et ciboria duo, lectoria auro, argento et marmoribus parata duo. In ecclesia sanctae Dei genitricis Mariae et sanctorum apostolorum altaria fabricata 13, ciborium 1 et lectorium optime paratum 1. In aecclesia sancti Benedicti altaria parata 3. In ecclesiis vero sanctorum angelorum Gabrielis, Mychaelis et Raphaelis altaria 3. Quae fiunt simul altaria 30, ciboria 3 et lectoria 3. Nam de aliis vasis et suppellectilibus habentur cruces auro argentoque paratae 17; coronae aureae 2; lampades argentee 6, cuprinae auro argentoque decoratae

12; poma aurea 3; calices aurei magni cum patenis 2. Item calix unus magnus aureus cum imaginibus simul cum patena sua. Alii calices argentei 12 cum suis patenis. Offertoria argentea 10. Ad caput sancti Richarii tabula auro et argento parata 1, ostia maiora auro et argento parata 2, alia minora 2, alia ostiola similiter parata 2. Balteus aureus 1. Altramentarium optimum argenteum auro paratum 1; cultellus auro et margaritis paratus 1. Codex eburneus auro, argento et gemmis optime paratus. Ponga auro parata 1. Incensaria argentea auro parata 4. Hanappi argentei superaurati 13. Conca argentea maior cum imaginibus argenteis 1. Bocularis argenteus 1. Urcei argentei cum aquamanilibus suis 2. Canna argentea 1, eburnea 1. Situle argenteae 2. Suiones argentei duo. Clavis aurea 1. Schilla argentea 1. Corone argenteae cum luminibus 13. Columnae coram altare sancti Richarii auro et argento paratae 6. Trabes minores cum arcubus suis argento paratae 3. Cloccaria auro parata 3. Cloccae opeimae 15, cum earum circulis 15. Scillae 3. Imagines aeneae 6, eburnea 1. Candelabra auro parata 2. Ostia auro parata 7. Insuper donavimus ibi pallia opeima 78; cappas 200; dalmaticas sericas 24; albas Romanas cum amictis suis auro paratas 6; albas lineas 260; stolas auro paratas 5; fanones de pallio aureo paratos 10; cussinos de pallio 5; saga de pallio 5; casulas de pallio 30, de purpura 10, de storace 6, de pisce 1, de platta 15, de cendato 5.

De Libris. Evangelium auro scriptum cum tabulis argenteis, auro et lapidibus preciosis mirifice paratum 1. Aliud evangelium plenarium 1. De aliis libris volumina 200.

Insuper etiam plurima ornamenta in fabricaturis et in diversis utilitatibus, in plumbo, vitro, marmore, seu cetera instrumenta quae longum fuit numerare prolixiusque scribere.

The claim of 78 pallia for a monastery seems extraordinary. The evangelary mentioned as the first of the books is probably Abbeville Codex 5, a gift from Charlemagne.

36. Hariulf himself described the burning of the church during the third quarter of the ninth century by the "barbarian invader" Guaramund: Denique ecclesiam splendidissimam beati Richarii quae pro sui magnitudine vel firmitate dejice non poterat, admoto igne succenderunt, sublatis prius omnibus, quae discendentibus fratribus ex supellectili remanserant ecclesiae. *Chronicon Centulense* 3.20 (Lot, pp. 142–143).

37. *De perfectione* 2 (*MGH SS* 15, p. 176):

His ita sicut paulo superius scriptum est honorifice decenterque reconditis in nomine sanctae Trinitatis, cum multa diligentia preparavimus capsam maiorem auro et gemmis ornatam, in qua posuimus partem supra scriptarum reliquiarum, quam cum ipsis ob venerationem illorum sanctorum quorum reliquie in ea recondi videbantur subtus criptam sancti Salvatoris ponere studuimus. Nam ceterorum sanctorum reliquias que supra leguntur conscriptae per alias 13 capsas minores auro argentoque vel gemmis preciosis honestis sine paratas, quas a sepe dictis venerabilibus patribus cum eisdem reliquiis, donante Domino, adipisci meruimus, dividere atque super trabem, quam in

arcu coram altare beati Richarii statuimus, ponere curavimus, qualiter in omnibus locis sicut dignum est laus Dei et veneratio omnium sanctorum eius in hoc sancto loco semper adoretur, colatur atque veneretur.

38. *MGH LL* 1, Volume 4, part 1.

39. We have seen Parsons's caveat about this text in Chapter 1. However, Angilbert's concern in this text is not the origin of the relics, but their arrangement. The text takes great pains to explain the threefold character of the groupings of the relics under the thirteen altars of this church.

40. *MGH SS* 15, p. 178.

41. This insight has been developed most fully by Carol Heitz, who has argued that we must understand Carolingian architectural innovations through the liturgical functions they were to house. Heitz's study, especially of Saint-Riquier, led him to identify the churches and holy sites of Jerusalem as the formal and iconographic source of Carolingian architecture. See the Select Bibliography at the end of this work.

42. This information, and that which follows on the daily processional liturgy, comes only from the Hariulf version of the *Institutio;* it does not appear in the Vatican manuscript. Like Parsons, Theodore Evergates has challenged the authenticity of this section of the *Chronicon,* on the same grounds of the manipulation of sources for eleventh-century ends. See "Historiography and Sociology in Early Feudal Society: The Case of Hariulf and the *Milites* of Saint-Riquier," *Viator* 6 (1975): 35–49. Hariulf's *Chronicon* needs detailed paleographical analysis. Nevertheless, several points should be made.

Evergates has assumed the greater authority of the Vatican 235 text. But an examination of this manuscript casts Hariulf's text in a different light. Vatican 235 is fragmentary and sometimes erratic, with several interruptions in the text. Elements have been left out, some because they were lost, some selectively. Unrelated texts have been inserted illogically and often arbitrarily; the same texts that appear in Hariulf's version, on the other hand, are consistent. The problems with Vatican 235 have been detailed by Lot, p. xxiii–xxv. They indicate that paleographically Vatican 235 must be treated with some caution.

Second, the internal evidence from Hariulf's text makes reference to the "royal liturgy," prayers and masses and *laudes* for Charlemagne, his family and realm, and for the Pope, which we have seen above and which are certainly attested in other documents contemporary with Angilbert. Cf. Kantorowicz, *Laudes Regiae,* Chapters 2 and 3; Heitz, *Recherches,* pp. 145 ff.; and McCormick, "Liturgy of War," pp. 1 ff. The prominence that these prayers and masses receive in the daily liturgy at Saint-Riquier mirror their importance in the "ritual apparatus of sovereignty" for the Carolingians.

Finally, the processional liturgy Hariulf's text described was a liturgical form found widely in the Carolingian period. It makes sense in the broad context of Latin liturgical practice. It does not simply "exalt the grandeur" of Saint-Riquier for eleventh-century monks, as Evergates has claimed. Additionally, although much work needs to be done in this area, we must also place Saint-Riquier within the context of other monastic populations. Although Saint-Riquier was undoubtedly

large for its time, it does not seem to have been unique in its claims. Adalhard's
Corbie supposedly had 300 monks; Irminon's Saint Germain-des-Prés had 212, and
Aniane under Saint Benedict had 300 monks. Even if Angilbert's claim of 300 monks
was nothing more than an ideal, since in his symbolic system 300 and 100 had great
significance, that ideal in itself is instructive for us in determining the nature of
Saint-Riquier's program. Cf. Dom Ursmer Berlière, "Le nombre des moines dans les
anciens monastères," *Revue Bénédictine* 41 (1929): 19 ff., a study that lists the
available population figures for monasteries at various times, but is based on
secondary sources, and Hilpisch, p. 26.

43. *Institutio* 1 (*CCM*, p. 292): In uno quoque etiam choro id iugiter obser-
vetur, ut sacerdotum ac levitarum reliquorumque sacrorum ordinum aequalis nu-
merum teneatur. Cantorum nihilominus et lectorum aequali mensura divisio or-
dinetur, qualiter chorus a choro invicem non gravetur.

44. *Institutio* 1 (*CCM*, p. 292). Cf. McCormick, "Liturgy of War," pp. 3 ff.

45. *Institutio* 1 (*CCM*, p. 292): Ea autem ratione ipsi chori tres in divinis
laudibus personabunt, ut omnes horas canonicas in commune simul omnes decan-
tent; quibus decenter expletis uniuscuiusque chori pars tertia ecclesiam exeat, et
corporeis necessitatibus vel aliis utilitatibus ad tempus inserviat, certo temporis
spatio interveniente ad divinae laudis munia celebranda denuo redeuntes.

46. Cf. Gindele, "Laus-Perennis-Kloster."

47. *Institutio* 1 (*CCM*, pp. 292–293):

Matutinali etenim seu vespertinali officio consummato mox omnes chori
ordinabiliter se ante Passionem congregent decem tantum psalmistis uni-
cuique choro remanentibus, et sic per portam sancti Gabrielis ac per salam
domni abbatis ambulando per occidentalem claustri regionem cantando ve-
niant ad sanctam Mariam, ubi oratione pro temporis ratione deposita, re-
meando veniant ad sanctum Benedictum in orientali parte claustri situm; inde
per gradus arcuum intrent ad sanctum Mauricium, sicque intrantes sancti
Richarii basilicam restituantur suis choris.

48. *Institutio* 1 (*CCM*, p. 293):

Illud etiam observari praecipua devotione mandamus, ut nulla dies praetereat
absque sacrarum missarum decantatione, videlicet ut, si non plus, vel triginta a
fratribus diversorum chororum per diversa altaria missae quotidie agantur
exceptis illis duabus de conventu, quae mane et meridie sollemnissime cele-
brantur, in quibus quotidie memoria sanctissimi papae Adriani et gloriosi
domini mei augusti Karoli, coniugis et prolis eius teneatur; qualiter iuxta
verbum apostoli, pro regibus et omnibus qui in sublimitate sunt constituti,
salvatori deo nostro obsecrationum vel orationum gratias iugiter persolvamus.

49. *Capitulare episcoporum* 21 (*MGH LL* 3, *CC* 1, pp. 108–109); Cf. McCor-
mick, "Liturgy of War," pp. 9–10.

50. Given the size of the Holy Savior chapel, it seems probable that the monks
stood in the chapel itself, while the people remained below in the nave, where they

could hear the mass being sung. This text and the references to the normal antiphonal singing of the offices imply a balcony for the upper chapel that would enable those in other parts of the church to hear the liturgy. *Institutio* 6 (*CCM,* p. 294):

> Dominica Palmarum omne uespertinum et nocturnum officium in ecclesia sancti Saluatoris et Sancti Richarii celebretur. Post capitulum uero procedentes ueniant ad sanctam Mariam, ubi Tertia cantata et ramis ac palmis acceptis per uiam monasterii una cum populo accedentes ad portam beati archangeli Michaelis paradisum ingrediantur et coram sancta Natiuitate oratione facta per ostium medianum et per cocleam meridianam ascendentes ad sanctum Saluatorem peruemiant, ubi honore condigno ab illis missa celebretur.

51. Angilbert carefully prescribed a litany comprised of *centum triginta quinque nomina sanctorum excepto ordine angelorum, patriarcharum et prophetarum.* See *Institutio* 8 (*CCM,* p. 295). Except for this text, there is no evidence of the baptismal fonts or their placement in the basilica. The inclusion of fonts indicates the use of this church as a parish church, since the Vigil Mass of Holy Saturday was the traditional time of baptizing new Christians.

52. *Institutio* 8 (*CCM,* p. 295):

> In Sancto etenim Sabbato omne officium, quod fieri debet antequam perveniatur ad fontes, ad sanctum Richarium impleatur. Hoc autem facto descendant ad fontes laetaniam ad faciendam, illam tamen, in qua continentur centum triginta quinque nomina sanctorum excepto ordine angelorum, patriarcharum et prophetarum atque deprecationes diuersas, quae quarta in scripto nostro, in quo reliquae continentur, habetur. Haec enim semel tantum dicatur. Ibique omnia, quae ad hanc conueniunt rationem peracta, scola cantorum ascendat ad sanctum Saluatorem officium suum ad perficiendum. Ceteri vero ministri ad ea, quae tunc expediunt, agenda reuertantur in secretarium, unde iterum preparati procedant ad sanctum Saluatorem ibique missam condigne perficiant. Ad quam missam illa letania fiat primum septenaria, quae in eodem scripto prima habetur. Deinde quinaria, quae secunda ibi continetur. Nouissime autem ternaria, quae illic tertia constare uidetur. Eadem uero nocte Nocturni et Matutini eo ordine, ut supra scriptum est, per tres choros in sancto Saluatore peragantur.

53. Angilbert prescribes in his Easter description only that all take place *ut in Natiuitate Domini omnia peragantur.* The texts for Christmas are no longer extant. *Institutio* 8 (*CCM,* p. 295).

54. Evidently it was rare that anyone receive communion, as Angilbert makes special mention of his decision to allow it on Easter and Christmas. *Institutio* 8 (*CCM,* p. 296): Ordinaui enim, ut in die sanctissimo Paschae et in Natiuitate Domini fratres et ceteri omnes, qui in aecclesia sancti Saluatoris ad missam audiendam steterint in eadem aecclesia communionem percipiant. Cf. the critique of Parsons on this text and that of note 50, as discussed in Chapter 1, pp. 13–20.

55. *Institutio* 8 (*CCM,* p. 296):

Dum uero fratres uel reliqui clerici ab illo sacerdote, qui ipsa die missam cantauerit, communicantur, sint duo sacerdotes alii cum duobus diaconibus atque subdiaconibus, quorum unus viros, alter in eadem aecclesia communicet mulieres, ut clerus et populus simul communicati benedictionem siue completionem missae pariter possint audire. Qua finita laudantes deum et benedicentes dominum simul egrediantur.

56. *Institutio* 8 (*CCM*, p. 296):

Hoc autem facto remaneant iam dicti sacerdotes duo, ex quibus unus ad unum ostium, alter ad alterum, pueros ex ambulatoriis descendentes communicent. Et cum haec omnia adimpleta fuerint, descendat unus ex una parte, alter ex altera, cum eorum ministris, et sic ad extremum stantes gradum communicent illos, qui ad cetera supra nominata loca communicare non occurrerint.

57. Similarly, the mass of the feast of the Ascension took place in the church of the Holy Savior. *Institutio* 10 (*CCM*, p. 300).

58. See Chapter 2, pp. 30, 43, 48.

59. *Institutio* 13, 14 (*CCM*, p. 301).

60. See Beatus of Liebana and Etherius of Osma *Epistola ad Elipandum* 1.77–81 (Löfstedt, pp. 59–60).

61. Cf. Chapter 2, pp. 40–41.

62. Cf. Chapter 2, p. 48.

63. For the Holy Thursday and Pentecost liturgies, see *Institutio* 7 and 12 (*CCM*, pp. 294, 301).

64. The text is quoted from the Jerusalem Bible.

65. See Thomas F. X. Noble, *The Republic of Saint Peter: The Birth of the Papal State, 680–825* (Philadelphia: University of Pennsylvania Press, 1984).

66. *Christian Iconography: A Study of Its Origins* (Princeton, NJ: Princeton University Press, 1968), p. 200 and Plate 275.

67. *Institutio* 11 (*CCM*, p. 300):

Qualiter Pro Tribulatione Cruces Sequi Debeant. In tempore autem illo, cum pro qualibet tribulatione cruces sequendae, ieiunia obseruanda et dei omnipotentis misericordia maxime est deprecanda, primo die per medium paradysi et per portam beati archangeli Mychaelis exeant, et inde per uiam publicam usque ad ianuam, per quam ingreditur in Baldiniacum campum. Inde recto itinere aquam transeant per pontem iuxta murum, et inde per ianuam occidentalem, quae habetur in platea, et per arcus similiter occidentales reuertantur per Portam beati Mychaelis usque ad gloriosam Natiuitatem. Ubi oratione peracta et crucibus vel ceteris, quae portauerant, in sancto Richario remissis ascendant ad sanctum Saluatorem ad missam audiendam. Secundo die per supra dictam portam beati Michaelis exeant, et inde per arcus orientales et per ianuam orientalem, quae habetur in platea, ingrediantur broilum. Unde recto itinere introeant per posterulam orientalem in ortum fratrum, et sic per curticulam domni abbatis et per salam uel portam monasterii necnon et per

portam beati Gabriehelis perueniant ad sanctam Natiuitatem. Ubi oratione finita ueniant ad sanctum Richarium ad missam perficiendam. Tertio namque die de prefata aecclesia promouentes ipsam uiam teneant, quam pridie tenuerant, quousque supra dictum ortum egrediantur. De quo egressi per campum Centulensem et per broilum fontem girando recto itinere exeant per ianuam iuxta portam meridianam. De quo loco per uiam publicam coram supra dictis mansionibus fabrorum ad portam, quae eis coniungitur, accedant ad sanctam Mariam ad celebrandam missam. Nam his diebus tres cruces et tres capsae minores, tria vasa cum aqua benedicta et tria turibula tantum portentur, nisi aliter a priore uel a fratribus consideretur.

68. For the origins of the Gallican Rogations triduum see *Liber historiae Francorum* 16 (*MGH SSRM* 2, pp. 266–267). Cf. *DACL* 14, part 2, cc. 2459–2461, and 9, part 2, cc. 1550–1553.

69. *Institutio* 9 (*CCM*, p. 296):

Ad sollemnes litanias faciendas conueniant cruces et processiones uicinarum aecclesiarum ad sanctum Richarium: De Durcapto una, de Drusciaco una, de Bersaccas una, de Uillaris una, de Monte angelorum una, de Monte martyrum una, de Angilbertiuilla una.

70. *Institutio* 9 (*CCM* pp. 296–297):

Qui eo ordine exeant, ut primum tres situle cum aqua benedicta per portam eiusdem beati archangeli Mychaelis precedant; deinde thuribula tria cum thymiamate. Tunc cruces septem sequantur, ex quibus sit media crux sancti Saluatoris, quas sequatur capsa maior ipsius sancti Saluatoris. Ad cuius dextram partem uadant sacerdotes tres cum aliis capsis minoribus tribus, ad leuam similiter. Post quos sequantur diaconi septem, subdiaconi septem, accoliti septem, exorcistae septem, lectores septem et ostiarii septem. Deinde relique monachi septeni et septeni per loca conuenientia ambulent. . . . Tunc sequatur scola laicorum puerorum cum flammulis septem. Quos statim subsequantur nobiles uiri septeni et septeni a preposito uel decano electi. Feminae uero nobiliores similiter obseruent. Tunc iterum procedant septem iam dictae forinsicae cruces; ipsas sequantur pueri et puellae, quae canere sciunt orationem dominicam et fidem, uel cetera, quae eis auxiliante domini insinuare precepimus. Hos statim subsequantur honorabiliores uiri uel femine ex familiis, quae in eo loco fuerint constitutae. Deinde mixtus populus, infirmorum uidelicet ac senum, pedestri ordine sicut ceteri septeni et septeni.

71. See *MGH Capitularia* 1; cf. p. 103 number 30; p. 110 numbers 9 and 13.

72. This has led Jean Hubert to assert that the Rogations liturgy, and indeed the entire *ordo* of Saint-Riquier, was imitative of Rome. See above, Chapter 1, pp. 4–5.

73. *Institutio* 9 (*CCM*, p. 297):

Et ideo eos septenos ambulare decernimus, ut in nostro opere gratiam sep-
tiformem sancti Spiritus demonstremus. Heitz has also discovered a septiform
arrangement in the processional liturgy for the feast of Saint Maurice, one
much more subtle that what we have just seen. I quote: "Tandis que quatre
mouvements font progresser les moines d'un pôle liturgique à l'autre: de Saint-
Sauveur (à l'Ouest) à Saint-Riquier (à l'Est), trois mouvements marquent le
reflux jusqu'à l'autel Saint-Maurice. Leur addition donne le nombre sept.
L'ordre 'septiforme' transparaît également dans la répartition: quatre mouve-
ments sont accomplis ensemble: les étapes menant à la Passion, à Saint-
Riquier, puis, lors du retour, à Saint-Croix et à Saint-Maurice."

See "Liturgie processionnelle," pp. 35–36.
 74. Libri *Carolini* 1.10 (*MGH LL* 3, *CC* 2, p. 29):

De quo (Christus lapis angularis) et per prophetam Zachariam paterna voce
dicitur: "Ecce ego adducam filium meum orientem, quia lapis, quem dedi
coram Iesu, septem in eo oculi sunt." In quibus septem oculis septiformis
gratiae Spiritus, qui a Patre Filioque procedit, evidenter ostenditur et per
Esaiam prophetam "spiritus Domini, spiritus sapientiae et intellectus, spiritus
consilii et fortitudinis, spiritus scientiae et pietatis, spiritus timoris Domini"
nominatur.

 75. See Chapter 3, pp. 57, 66–68.
 76. Alcuin *Enchiridion* (*PL* 100, 571–572):

Sed primum omnium numerorum eruendas rationes ratum putavi, id est cur
etiam psalmi poenitentiae septenario numero consecrati essent . . . Et multa
alia sparsim in divinis reperiuntur libris, quae septenarii numeri perfectionem
ostendunt. Unde est et illud Salomonis: "Sapientia aedificavit sibi domum,
excidit columnas septem," quae longiorem poscunt sermonem; si tamen est
nostri temporis quis idoneus, universa ejusdem numeri explanare mysteria:
qui etiam in principio creaturarum ipsius Creatoris requie consecratus est, et
nunc ordo saeculorum per eumdem numerum decurrere constat; qui etiam si
in duo dividitur membra majoris portionis habitudinis suae, id est in tria et
quatuor, mirabile universatitis habet arcanum. Nam in tribus sancta Trinitatis
creatrix omnium quae sunt, designatur; et in quatuor scilicet, universitas
demonstratur creaturarum; seu ob quatuor mundi plagas.

 77. On number symbolism and its difficulties of interpretation, see Heinz
Mayer and Rudolf Suntrup, "Zum Lexikon der Zahlenbedeutungen im Mittelalter.
Einführung in die Methode und Probeartikel: Die Zahl 7," *Frühmittelalterliche
Studien* 11 (1977): 1–73. Cf. Wolfgang Haubrichs, *Ordo als Form. Strukturstudien
zur Zahlenkomposition bei Otfrid von Weissenburg und in karolingischer Literatur.*
Hermaea 27 (Tübingen: n. pub., 1969).
 78. Epistola 143, *De Septuagesima* (*MGH Epp* 4, p. 226):

Unde et post septem hebdomadas Spiritus sanctus missus est de coelo in igneis linguis super centum viginti nomina credentium; et septem dona sancti Spiritus legimus in propheta. Et tunc maxime, dum alba tolluntur a baptizatis vestimenta, per manus impositionem a pontifice Spiritum sanctum accipere conveniens est, qui in baptismo omnium receperunt remissionem peccatorum; et per septem dies in angelico castitatis habitu et luminibus coelestis claritatis sanctis assistere sacrificiis solent.

Alcuin made a similar point in the preface of the *Adversus Felicem libri VII*, when he described the significance of having written seven books in this text: Hos quinque panes et duos pisciculos simul septenario numero consecratos, de apostolicae fidei per prolatos vestrae sanctae auctoritati direxi, domine me Davide, ut Dei Christi multiplicati, per vos esurienti populo et in desertis locis habitanti ad satietatem catholice ministrentur. *PL* 101, 128.

79. Alcuin Epistola 81 (*MGH Epp* 4, p. 124):

Tribus modis Adam temptatus est et superatus, id est gula, iactantia et avaritia. In his tribus iterum Christus temptatus est, et vicit victorem Adae.

Totus orbis in tres dividitur partes, Europam, Africam et Indiam, in quibus partibus tribus modis colendus est Deus: fide, spe et caritate.

Tria praecepit Deus Abrahae dicens: "Egredere de terra tua et cognatione tua et de domo patris tui." Tria promittuntur nobis: resurrectio, vita et gloria.

80. Epistola 81 (*MGH Epp* 4, p. 123): Decima praecepta sunt legis, quae data sunt in duabus tabulis per Moysen et Aaron populo Dei.

81. *Regula fidei metrica* 46 (Norberg, p. 92.)

82. See above, Introduction, note 2.

83. A number of manuscripts of the *Moralia* are candidates for Saint-Riquier's collection, all from the eighth or early ninth centuries, including Autun Bibliothèque Municipale MS 21/Paris Bibliothèque Nationale NAL 1628 (probably written at Lyons under Leidrad); Besançon Bibliothèque Municipale MS 184 (probably from eastern France); Chartres Bibliothèque Municipale MS 40; Douai Bibliothèque Municipale MS 281.2 and 342; Laon Bibliothèque Municipale MS 50; and Paris Bibliothèque Nationale MSS Latins 10399, 2206 (less likely, since it seems to have been in Lyons by the early ninth century), and MSS NAL 2061 and 2243/2388 (also paired with London Additional MSS 11878 and 41567J). Three candidates, all from Corbie, seem especially likely: Montpellier Bibliothèque Universitaire MS 69 (possibly written at a neighboring center) and Paris Bibliothèque Nationale MSS Latin 12226 and NAL 2061. See Lowe, *Codices Latini Antiquiores*, Volumes 5 and 6. Cf. Hariulf 3.3 (Lot, p 90).

84. *Moralia in Job* 3.25 (*PL* 76, 565–566):

Solet in centenario numero plenitudo perfectionis intelligi. Quid ergo per ter ductum centenarium numerum designatur, nisi perfecta cognitio Trinitatis? Cum his quippe Dominus noster adversarios fidei destruit, cum his ad prae-

dicationis bella descendit, qui possunt divina cognoscere, qui sciunt de Trinitate, quae Deus est, perfecta sentire. Notandum vero est quia iste trecentorum numerus in tau littera continetur, quae crucis speciem tenet. Cui si super transversam lineam id quod in cruce eminet adderetur, non jam crucis species, sed ipsa crux esset. . . . Qui sequentes Dominum tanto verius crucem tollunt, quanto acrius et se edomant, et erga proximos suos charitatis compassione cruciantur.

Conclusions

1. See Chapter 1, p. 11.

2. See "Das Apsismosaik von Germigny-des-Prés: Karl der Grosse und der Alte Bund," *Karl der Grosse* 3, pp. 234 ff.; "Siebenarmige Leuchter in christlichen Kirchen," *Wallraf-Richartz Jahrbuch* 23 (1961): 55–190.

3. On the Carolingians and the Old Testament see J. M. Wallace-Hadrill, *Early Germanic Kingship in England and on the Continent* (Oxford: Clarendon Press, 1971).

4. Indeed, Thomas Noble has argued that Benedict provided the organizing model and ideology of empire for Louis, so often noted for his monkishness, in the Benedictine monastic community promulgated through the many reform councils held during Louis's reign. See "The Monastic Ideal as a Model for Empire: The Case of Louis the Pious," *Revue Bénédictine* 86 (1976): 235–250.

5. The sources for Benedict's early life include Ardo's *Vita Benedicti abbatis Anianensis et Indensis* (*MGH SS* 15, part 1, pp. 199–220), Benedict's own anti-Adoptionist writings, the *Opuscula* (*PL* 103 1381–1399), and the *Disputatio adversus Felicianam impietatem* (*PL* 103 1399–1411); also several letters of Alcuin (*MGH Epp* 4, numbers 137, 200–208). See especially Heil, "Adoptianismus," pp. 133 ff., Wolff, pp. 274 ff. and 297–301, and Abadal, pp. 29–36.

6. Hic pueriles gerentem annos prefatum filium suum in aula gloriosi Pipini regis reginae tradidit inter scolares nutriendum; qui mentis indole gerens aetatem, diligebatur a commotionibus; erat quippe velox et ad omnia utilis. . . . Post cuius excessum cum regni gubernacula Karolus gloriosissimus rex potiretur, ei adaesit serviturus. Ardo *Vita* 1 (*MGH SS* 15, part 1, p. 201). Cf. Wolff, pp. 274 ff.

7. "Eo namque anno, quo Italia gloriosi Karoli regis ditione subiecta est" is the information given by Ardo. Waitz, the editor of the text, dated this at 773; the revised date of the expedition is 774. See Abel and Simson, *Jahrbücher* 1, pp. 439–441; Wolff, p. 274.

8. Ardo *Vita* 2 and 3 (*MGH SS* 15, part 1, p. 202):

Sepe etiam pervigili in oratione pernoctans, nudis plantis in pavimento glaciali rigore perfusus persistens, in divinis nempe meditationibus ita se totum contulit, ut quam plures continuaret dies sacris psalmodiis deditus, silentii legem non interrumpens. . . . Cotidie lacrimis, cotidie gemitu ob gehennae metum alebatur. . . . Pallebant ora idiuniis, et macie exausta carne, pellis ossibus inherebat hac in modum pallearia bovum rugata pendebat.

9. Ardo *Vita* 3 (*MGH SS* 15, part 1, p. 203); Wolff, p. 275.

10. "Adoptianismus," p. 133; Ardo *Vita* 8 (*MGH SS* 15, part 1, p. 204).

11. "Die fränkische Kirche überstand diese Phase und konnte den Adoptianismus überwinden. Dass dieser Erfolg erreicht wurde, war aber vor allen anderen das Verdienst Benedikts von Aniane, seines Einsatzes gegen die Häresie und auch bereits eine Frucht seines Reformwerks." Heil, "Adoptianismus," p. 133.

12. Here again we can cite Heil, in commenting on these anti-Adoptionist texts. While they said nothing new, he said, "Man möchte sagen, er war der 'Praktiker' dieser Ketzerbekämpfung. Das praktische, tägliche Handeln und Überzeugen mit den zu Gebote stehenden Mitteln — im Falle des Felix auch dem der Internierung — waren das Gebot dieser Geistlichen im Süden." "Adoptianismus," p. 134.

13. Ardo stresses that it was *eodem tempire. Vita* 8 (*MGH SS* 15, part 1, p. 204).

14. See above, Chapter 2, p. 30.

15. He drew a close parallel between Elipandus's teachings and Nestorianism. See *Codex Carolinus* 95 (*MGH Epp* 3, p. 637).

16. Ardo *Vita* 3 and 17 (*MGH SS* 15, part 1, pp. 203, 205).

17. It should be noted that the word Ardo as used here, *agnoscatur,* connotes a subjective perception, recognition, or grasping, as opposed to the objective understanding or recognition connoted in the word *cognoscere.*

18. Ardo *Vita Benedicti* 17 (*MGH SS* 15, part 1, p. 206):

Siquidem venerabilis pater Benedictus pia consideratione preventus, non in alicuius sanctorum pretitulatione, set in deficae Trinitatis, uti iam diximus, nomine prefatam aecclesiam consecrare disposuit. Quod ut, dico, luce clarius agnoscatur, in altare, quod potissimum ceteris videtur, tres aras censuit subponi, ut in his personalitas Trinitatis typice videatur significari. Et mira dispositio, ut in tribus aris individua Trinitas et in uno altare essentialiter firma demonstretur Deitas. Altare vero illud forinsecus est solidum, ab intus autem cavum; illud videlicet prefigurans, quod Moyses condidit in heremum, retrorsum habens hostiolum, quo privatis diebus inclusae tenentur capsae cum diversis reliquiis patrum. Haec de altaria dicta sufficiant. Ad instrumentum domus, quo ordine vel numero sit compositum, succincte pergamus. Cuncta siquidem utensilia, quae in eadem domo habentur, in septenario numero consecrata noscuntur. Septem scilicet candelabra fabrili arte mirabiliter producta, de quorum stipite procedunt astilia spherulaeque ac lilia, calami ac sciphi in nucis modum, ad instar videlicet illius facta quod Beseleel miro conposuit studio. Ante altare etiam septem dependunt lampade mirae atque pulquerrimae, inaestimabili fusae labore, quae a peritis, qui eas visere exoptant, Salomonaico dicuntur conflatae. Aliae tantundem in choro dependunt lampadae argenteae in modum coronae, quae in se insertis circulis cyatos recipiunt per girum; morisque est precipuis in festivitatibus oleo repleto accendi; quibus accensis, veluti in die ita in nocte tota refulget aecclesia. Tria denique altaria in eadem sunt dicata basilica, unum videlicet in honore sancti Michaelis archangeli, aliud in veneratione beatorum apostolorum Petri et

Pauli, tercium in honore almi prothomartiris Stephani. In aecclesia vero beatae Dei genitricis Mariae, quae primitus est fundata, sancti Martini necnon et beati Benedicti haberi videntur altaria. Illa vero quae in cimiterio fundata consistit in honore sancti Iohannis babtistae consecrata dinoscitur, quo inter natos mulierum maiorem neminem surrexisse, divina attestarunt oracula. Considerare libet, quanta umilitate ac reverentia hisdem metuendus sit locus, qui tot principibus videtur esse munitus. Siquidem dominus Christus princeps est omnium principum, rex regum et dominus dominantium, beata vero eiusdem Dei genitrix Maria cunctarum virginum creditur esse regina; Michael cunctis prefertur angelorum; Petrus et Paulus capita sunt apostolorum; Stephanus protomartir principatum tenet in choro testium, Martinus vero gemma refulget presulum; Benedictus cunctorum est pater monachorum. In septem itaque altaria, in septem candelabra et in septem lampades septimformis gratia Spiritus sancti intelligitur.

19. Ardo *Vita* (*MGH SS* 15, part 1, p. 206).

20. See "Architecture et liturgie processionnelle à l'époque préromane," *Revue de l'Art* 24 (1974): 30–47, especially p. 37; cf. Werner Jacobsen, "Allgemeine Tendenzen im Kirchenbau unter Ludwig dem Frommen," in Godman and Collins, *Charlemagne's Heir,* pp. 648–649.

21. Heitz and Jacobsen as cited in note 20.

22. See the sensitive assessments of Jacobsen, especially pp. 648–649.

23. See the Introduction, p. xv, and note 2.

24. See the Introduction, note 3.

25. Heit, "Liturgie processionnelle," p. 35 and Figure 14.

26. According to Heitz (Figure 14), following Duchesne, the arrangement of the fraction of the host was as follows:

	Corporatio	
Mors	Nativitas	Resurrectio
	Circumcisio	
	Apparitio	
	Passio	

27. See Chapter 2, p. 23 and note 8.

28. See A. Ostendorf, "Das Salvator-Patrozinium," *Westfälische Zeitschrift* 100 (1950): 357–376. Cf. Heitz, *L'architecture religieuse,* passim, especially pp. 59–60, 74, 111; and generally on the development of the Christ cult and Carolingian royalty, Kantorowicz, *Laudes Regiae.* Heitz associated the decline of the vocable and the declining use of the Westwork in church architecture with the weakening of Carolingian royal power. The decline was visible, in his opinion, already in the Plan of Saint-Gall.

29. See Chapter 3, p. 55.

30. Heitz sees this as most clearly connected with the *Laudes. L'architecture religieuse,* p. 74.

31. *L'architecture religieuse,* p. 61.

32. See the analysis in Heitz, *L'architecture religieuse,* pp. 43, 60 ff., 92, 100, 101–102, 111, 119–120.

33. This group was excavated by Honoré Bernard. For this and what follows on Metz, see Heitz, *L'architecture religieuse,* pp. 19–21.

34. Our only reference is that Paschasius Radbertus was buried there at mid-century. Cf. Heitz, *L'architecture religieuse.* p. 49.

35. See most particularly "Liturgie processionnelle," pp. 34–35. Heitz draws a line of liturgical filiation from Chrodegang's Metz to Angilbert's Saint-Riquier to the Plan of Saint Gall.

36. Theodore Klauser and R. S. Bour, "Un document du IXe siècle, notes sur l'ancienne liturgie de Metz et sur les églises antérieures à l'an mil," *Annuaire de la Société d'Histoire et d'Archéologie de la Lorraine* 38 (1929): 497–643. For a comparative list of the stational offices at Rome, Metz, and Saint-Riquier see Carol Heitz, "Le groupe cathédrale de Metz au temps de saint Chrodegang." *Actes du Colloque de Saint Chrodegang* (Metz: n. pub., 1967), pp. 123–132. Cf. "Liturgie processionnelle," p. 34.

37. See in particular Heitz, *L'architecture religieuse,* p. 20.

Appendix A

1. The text and its English translation are given in Kelly, *The Athanasian Creed,* pp. 17–20. Cf. Chapter 2, pp. 35–36.

Select Bibliography

PRIMARY SOURCES

Alcuin. *Adversus Elipandum libri IV. PL* 101, cc. 243–300.
——. *Adversus Felicem Urgellitanum episcopum libri VII. PL* 101, cc. 127–230.
——. *De fide sanctae et individuae Trinitatis. PL* 101, cc. 13–58.
——. *De processione Spiritus sancti. PL* 101, cc. 64–82.
——. *Enchiridion. PL* 100, cc. 569–620.
——. *Epistola episcoporum Franciae. MGH LL* 3, *CC* 2, pp. 142–157.
——. *Liber contra haeresim Felicis.* Gary B. Blumenshine, editor. *Studi e Testi* 285. Vatican City: Biblioteca Apostolica Vaticana, 1980.
——. *Versus ad Samuhelem Sennensis civitatis episcopus de clade Lindisfarnensis monasterii. MGH PL* 1, pp. 228–235.
Aldhelm. *De virginitate. MGH AA* 15, pp. 327–471.
——. *The Poetic Works.* Michael Lapidge and James. L. Rosier, editors and translators. Cambridge: D. S. Brewer, 1985.
Anastasius Bibliothecarius. *Sancta synodus septima generalis Nicaena secunda. PL* 129, cc. 195–512.
Angilbert, *De conversione Saxonum. MGH PL* 1, pp. 380–381.
——. *De conversione Saxonum.* Karl Hauck, editor. "Karolingische Taufpfalzen im Spiegel hofnaher Dichtung." *Nachrichten der Akademie der Wissenschaften in Göttingen I. Philologisch-historische Klasse* (1985): 62–65.
——. *De doctrina christiana.* Ludwig Traube, editor. *O Roma nobilis. Abhändlungen der königlichen-bayerisch Akademie der Wissenschaft* (1891): 322–331.
——. *De perfectione Centulensis ecclesiae libellus. MGH SS* 15, 1 pp. 173–181.
——. "To Charlemagne and his Entourage." In Peter Godman, editor. *Poetry of the Carolingian Renaissance.* London: Duckworth, 1985, pp. 112–118.
——. *Institutio de diversitate officiorum. CCM* 1, pp. 283–303.
Agobard. *Liber adversus Felicem Urgellitanum. PL* 104, cc. 29–70.
Annales laurissensis. MGH SS 1, pp. 134–174.
Annales regni Francorum. Revised Version. MGH SS 1, pp. 135–218.
Ardo Smaragdus. *Vita Benedicti abbatis Anianensis et Indensis. MGH SS* 15, 1, pp. 199–220.
Augustine. *De doctrina christiana.* Joseph Martin, editor. *CCSL* 32. Turnhout: Brepols, 1962.
——. *De doctrina christiana.* John Gavigan, O.S.A., editor and translator. Fathers of the Church Series: Writings of Saint Augustine, Volume 4. Washington DC: Catholic University of America Press, 1947.
——. *De Trinitate.* W. J. Mountain, editor. *CCSL* 50. Turnhout: Brepols, 1968.

———. *De Trinitate*. Andrew McKenna, editor and translator. Fathers of the Church Series: Writings of Saint Augustine, Volume 45. Washington DC: Catholic University of America Press, 1963.

———. *De diversis quaestionibus liber unus*. Almut Mutzenbecher, editor. *CCSL* 44/a. Turnhout: Brepols, 1975.

Beatus and Etherius. *Adversus Elipandum libri II*. Bengt Löfstedt, editor. *CCCM* 59. Turnhout: Brepols, 1984.

Capitulare Francofurtense. *MGH LL* 3, *CC* 2, pp. 165–171.

Conciliorum Oecumenicorum Decreta. Centro di Documentazione. Istituto per le Scienze Religiose. Freiburg: Herder, 1962.

De Pippini regis victoria Avarica. *MGH PL* 1, pp. 116–117.

Einhard. *Vita Karoli Magni*. *MGH SS* 2, pp. 426–463.

Elipandus. *Epistula ad Alchuinum*. *CSM* 1, pp. 96–109.

———. *Epistola ad Carolum Magnum*. *MGH Epistolae* 4, number 182.

———. *Epistula ad Felicem*. *CSM* 1, pp. 109–111.

———. *Epistula ad Fidelem*. *CSM* 1, pp. 80–81.

———. *Epistula in Migetium*. *CSM* 1, pp. 67–78.

———. *Symbolum Fidei*. *CSM* 1, pp. 78–80.

Epistola episcoporum Hispaniae ad Karolum Magnum. *MGH LL* 3, *CC* 2, pp. 120–121.

Epistola episcoporum Hispaniae ad episcopos Franciae. *MGH LL* 3, *CC* 2, pp. 111–119.

Epistola Karoli Magni ad Elipandum et episcopos Hispaniae. *MGH LL* 3, *CC* 2, pages 157–164.

The Fourth Book of the Chronicle of Fredegar. John Michael Wallace-Hadrill, editor. London: Thomas Nelson, 1960.

Gregory of Tours. *History of the Franks*. Lewis Thorpe, editor and translator. Baltimore: Penguin Books, 1974.

Hadrian. *Epistola ad episcopos Hispaniae directa*. *MGH LL* 3, *CC* 2, pp. 122–130.

Hariulf. *Le Chronique de l'abbaye de Saint-Riquier*. Ferdinand Lot, editor. Collection de textes pour servir à l'étude et l'enseignement de l'Histoire, Volume 17. Paris: Alphonse Picard, 1894.

Hilary of Poitiers. *De Trinitate*. Peter Smulders, editor. *CCSL* 62 and 62/a. Turnhout: Brepols, 1979–1980.

Isidore of Seville. *Etymologiae*. *PL* 82, cc. 9–728.

Jesse of Amiens. *Epistola de baptismo*. *PL* 105, cc. 794.

Lex Salica. *MGH LL* 1, *Leg. Nat. Germ.* 4, 2.

Libri Carolini. *MGH LL* 3, *CC* 2, Supplementum.

Marius Victorinus. *Adversus Arium liber I*. *PL* 8, cc. 1039–1040.

———. *Hymn*. *PL* 8, c. 1146.

Missa in dies Pentecostes. *Missale mixtum secundum sancti Isidori*. *PL* 95, cc. 613–621.

Nithard. *Histoire des fils de Louis le Pieux*. Philippe Lauer, editor and translator. Paris: H. Champion, 1926.

Paulinus of Aquileia. *Contra Felicem libri III*. Dag Norberg, editor. *CCCM* 95. Turnhout: Brepols, 1990.

———. *Libellus sacrosyllabus*. *MGH LL* 3, *CC* 2, part 1, pp. 130–142.

———. *Regula fidei metrico promulgata stili Mucrone*. Dag Norberg, editor. *L'oeuvre poétique de Paulin d'Aquilée*. Stockholm: Almqvist and Wiksell, 1979.

Royal Frankish Annals. Carolingian Chronicles. Bernhard Walter Scholz, editor and translator. Ann Arbor: University of Michigan Press, 1970, pp. 37–125.

Sacrorum conciliorum nova et amplissima collectio. Giovanni Domenico Mansi, editor. Florence: A. Zatta, 1759–1927.

Theodulf of Orléans. *De Ordine baptismi ad Magnum Senonensem liber.* PL 105, c. 226.

——. *De Spiritu Sancto.* PL 105, cc. 239–276.

Vita Hludovici. MGH SS 2, pp. 604–648.

SECONDARY SOURCES

Abadal y Vinyals, Ramon. *La batalla del adopcionismo en la desintegración de la iglesia visigoda.* Barcelona: n. pub., 1949.

Akeley, T. C. *Christian Initiation in Spain, c. 300–1100.* London: Darton, Longman and Todd, 1967.

Amann, Emile. *L'époque carolingienne.* Volume 6 of *Histoire de l'église depuis les origines jusqu'à nos jours.* Augustin Fliche and Victor Martin, general editors. Paris: Bloud and Gay, 1947.

Arthur, Joseph. *L'art dans saint Augustin.* 2 Volumes. Montréal: n. pub., 1944.

Baldwin, Helen Dickinson. *The Carolingian Abbey Church of Saint-Riquier.* M.A. thesis, Vanderbilt University, 1970.

Bandmann, Günter. *Mittelalterliche Architektur als Bedeutungsträger.* Berlin: G. Mann, 1951.

Berlière, Ursmer. "Le nombre des moines dans les anciens monastères." *Revue Bénédictine* 41 (1929): 231–261; 42 (1930): 19–42.

——. "Les coûtumiers monastiques des VIIIe et IXe siècles." *Revue Bénédictine* 25 (1908): 95–107.

——. *L'ordre monastique des origines au XIIe siècle.* 1st edition. Maredsous: Abbaye de Maredsous, 1912.

Bernard, Honoré. "D'Hariulf à Effmann, à la lumière des récentes fouilles de Saint-Riquier." *Bulletin Archéologique du Comité des Travaux Historiques et Scientifiques* n.s. 1–2 (1965–1966): 219–235.

——. "Les fouilles de l'église de Notre-Dame à Saint-Riquier." *Bulletin Archéologique du Comité des Travaux Historiques et Scientifiques* n.s. 1–2 (1965–1966): 25–47.

——. "Premières fouilles de Saint-Riquier." In Wolfgang Braunfels, editor, *Karl der Grosse, Lebenswerk und Nachleben,* volume 3: *Karolingische Kunst.* Düsseldorf: Schwann, 1965, pp. 369–373.

——. "Saint-Riquier, les fouilles de la Tour du Sauveur." *Bulletin de la Société Nationale des Antiquaires de France* (1988): 66–71.

——. "Saint-Riquier: une restitution nouvelle de la basilique d'Angilbert." *Revue du Nord* 71 (1989): 307–361.

——. "Un site prestigieux du monde carolingien." *Cahiers Archéologiques de Picardie* 5 (1978): 241–254.

Bischoff, Bernhard. *Die südostdeutschen Schriebschule und Bibliotheken in der Karolingerzeit.* Wiesbaden: D. Harrassowitz, 1960–80.

Bishop, Edmund. *Liturgica Historica*. Oxford: Clarendon Press, 1918.

Bloch, Peter. "Das Apsismosaik von Germigny-des-Prés: Karl der Grosse und der Alte Bund." In Wolfgang Braunfels, editor, *Karl der Grosse, Lebenswerk und Nachleben*. Volume 3: *Karolingische Kunst*. Düsseldorf: Schwann, 1965, pp. 234–261.

———. "Siebenarmige Leuchter in christlichen Kirchen." *Wallraf-Richartz-Jahrbuch* 23 (1961): 55–190.

Blumenshine, Gary B. "Alcuin's *Liber contra haeresim Felicis* and the Frankish Kingdom." *Frühmittelalterliche Studien* 17 (1983): 222–233.

Böhmer, Johann Friedrich. *Die Regesten des Kaiserreichs unter den Karolingern, 751–918*. Innsbruck: Wagner Verlag, 1889.

Boswell, John. *Christianity, Social Tolerance, and Homosexuality*. Chicago: University of Chicago Press, 1980.

Bouyer, Louis, Jean Leclercq, and F. Vandenbroucke. *Histoire de la spiritualité chrétienne*. 3 volumes. Paris: Aubier, 1961–1966.

Braunfels, Wolfgang. *Die Welt der Karolinger und ihre Kunst*. Munich: Georg D. W. Callwey, 1968.

Brown, Peter. *Augustine of Hippo*. Berkeley: University of California Press, 1967.

———. *The World of Late Antiquity*. London: Harcourt-Brace-Jovanovich, 1971.

Bullough, Donald. "*Albuinus deliciosus Karoli Regis:* Alcuin of York and the Shaping of the Early Carolingian Court." In Lutz Fenske, Werner Rosner, and Thomas Zotz, editors, *Institutionen, Kultur und Gesellschaft im Mittelalter: Festschrift für Josef Fleckenstein*. Sigmaringen: Jan Thorbecke, 1984, pp. 73–92.

———. "Alcuin and the Kingdom of Heaven." In Uta-Renate Blumenthal, *Carolingian Essays*. Washington, DC: Catholic University of America Press, 1983, pp. 1–69. Reprinted with revisions in Donald Bullough. *Carolingian Renewal*. Manchester: Manchester University Press, 1991, pp. 161–240.

———. *The Age of Charlemagne*. New York: Putnam Press, 1965.

———. "*Aula Renovata:* The Carolingian Court Before Aachen." In Donald Bullough, *Carolingian Renewal*. Manchester: Manchester University Press, 1991, pp. 123–160.

Capelle, Bernard. "L'introduction du Symbole à la messe." *Mélanges Joseph de Ghellinck, S.J.* 2 volumes. Gembloux: J. Duculot, 1951, pp. 1010–1025.

———. "L'origine antiadoptianiste de notre texte du Symbole de la messe." *Recherches de Théologie Ancienne et Médiévale* 1 (1929): 7–20.

Cavadini, John C. *The Last Christology of the West: Adoptionism in Spain and Gaul, 785–820*. Philadelphia: University of Pennsylvania Press, 1993.

Chapman, Emmanuel. *Saint Augustine's Philosophy of Beauty*. New York/London: Sheed and Ward, 1939.

Chazelle, Celia. "Matter, Spirit, and Image in the *Libri Carolini*." *Recherches Augustiniennes* 21 (1986): 163–184.

Conant, Kenneth John. *A Brief Commentary on Early Medieval Church Architecture*. Baltimore: Johns Hopkins University Press, 1942.

———. *Carolingian and Romanesque Architecture, 800–1200*. Baltimore: Penguin Books, 1959.

Contreni, John. "Carolingian Biblical Studies." In Uta-Renate Blumenthal, editor,

Carolingian Essays. Washington, DC: Catholic University of America Press, 1983, pp. 71–98.

Corblet, J. *Hagiographie du diocèse d'Amiens.* Paris: Dumoulin, 1868.

Crocker, Richard L. "The Early Frankish Sequence: A New Musical Form." *Viator* 6 (1975): 341–350.

Dahlhaus-Berg, Elisabeth. *Nova Antiquitas et Antiqua Novitas: typologische Exegese und isidorianisches Geschichtsbild bei Theodulf von Orléans.* Cologne/Vienna: Böhlau, 1975.

De Bruyne, Edgar. *Étude de l'esthétique médiévale.* 3 volumes. Bruges: n. pub., 1946.

Dehio, Georg and Gustav von Bezold. *Die kirchliche Baukunst des Abendlandes.* Stuttgart: Alfred Kroner, 1892.

Dekkers, E. "La bibliothèque de Saint-Riquier au Moyen-âge." *Bulletin de la Société des Antiquaires de Picardie* 46 (1955–56): 157–97.

Del Medico, H. "La mosaïque de l'apside orientale à Germigny-des-Prés." *Monuments Piot* 39 (1943): 81–102.

Du Cange, Charles du Fresne. *Glossarium mediae et infimae latinitatis.* 10 volumes. Niort: L. Favre, 1883–1887.

Duckett, Eleanor. *Alcuin, Friend of Charlemagne: His World and His Work.* New York: Macmillan, 1951.

Dumeige, Gervais. *Nicée II.* Volume 4 of *Histoire des conciles oecuméniques.* Gervais Dumeige, general editor. Paris: Éditions de l'Orante, 1963–1964.

Durand, Georges. *La Picardie historique et monumentale.* Amiens: Yvert et Tellier, 1898.

Du Roy, Olivier. *L'intelligence de la foi en la trinité selon saint Augustin.* Paris: Études Augustiniennes, 1966.

Ebenbauer, Alfred. *Carmen historicum: Untersuchungen zur historischen Dichtung im karolingischen Europa.* Vienna: Wilhelm Braumuller, 1978.

Effmann, Wilhelm. *Centula-Saint-Riquier.* Münster-in-Westfälen: Verlag Aschendorff, 1912.

———. *Die karolingisch-ottonischen Bauten zu Werden.* Strasbourg: Heitz, 1899.

Ellard, Gerald. *Master Alcuin, Liturgist: A Partner of Our Piety.* Chicago: Loyola University Press, 1956.

———. *Ordination Anointings in the Western Church Before 1000 A.D.* Cambridge: Medieval Academy of America, 1933.

Enlart, Camille. *Manuel d'archéologie française.* 3 volumes. Paris: Alphonse Picard, 1902.

Erler, Adalbert and Ekkehard Kaufmann, editors. *Handwörterbuch zur deutschen Rechtsgeschichte.* Berlin: Erich Schmidt Verlag, 1971.

Evergates, Theodore. "Historiography and Sociology in Early Feudal Society: The Case of Hariulf and the *Milites* of Saint-Riquier." *Viator* 6 (1975): 35–49.

Felten, Franz. *Äbte und Laienäbte im Frankenreich.* Stuttgart: Anton Hiersemann, 1980.

Ferrari, Guy. *Early Roman Monasteries.* Vatican City: Pontificio Istituto di Archeologia Cristiana, 1957.

Fichtenau, Heinrich. *The Carolingian Empire.* Peter Munz, translator. New York: Harper Torchbook, 1964.

Fleckenstein, Josef. *Die Hofkapelle der deutschen Könige. MGH, Schriften* 16, Volume
 1. Stuttgart: Anton Hiersemann, 1959.
——. "Karl der Grosse und sein Hof." In Wolfgang Braunfels, editor. *Karl der
 Grosse, Lebenswerk und Nachleben.* Volume 1: *Persönlichkeit und Geschichte.* Düs-
 seldorf: Schwann, 1965, pp. 24–50.
Freeman, Ann. "Carolingian Orthodoxy and the Fate of the *Libri Carolini." Viator*
 16 (1985): 65–108.
——. "Further Studies in the *Libri Carolini II." Speculum* 40 (1965): 203–289.
——. "Further Studies in the *Libri Carolini III." Speculum* 46 (1971): 597–611.
——. "Theodulf of Orléans and the *Libri Carolini." Speculum* 32 (1957): 663–705.
Fried, Johannes. "Ludwig der Fromme, das Papsttum und die frankische Kirche." In
 Peter Godman and Roger Collins, editors, *Charlemagne's Heir: New Perspectives
 on the Reign of Louis the Pious.* Oxford: Clarendon Press, 1990, pp. 231–273.
Fuchs, Alois. *Die karolingischen Westwerke und andere Fragen der karolingischen
 Baukunst.* Paderborn: Bonifacius-druckerei, 1929.
——. "Entstehung und Zweckbestimmung der Westwerke." *Westfälische Zeitschrift*
 100 (1950): 227–291.
Ganshof, François-Louis. "L'historiographie dans la monarchie franque sous les
 Mérovingiens et les Carolingiens." *La storiografía nell'altomedioevo. Settimane di
 studio del Centro italiano di studi sull'alto medioevo* 17, volume 2 (1970), pp. 631–
 685.
Ganz, David. *Corbie in the Carolingian Renaissance.* Sigmaringen: Jan Thorbecke,
 1990.
Geary, Patrick. *Furta Sacra: Thefts of Relics in the Central Middle Ages.* Second
 edition. Princeton, NJ: Princeton University Press, 1990.
Gilbert, Antoine-Pierre-Marie. *Déscription historique de l'église de l'ancien abbaye royale
 de Saint-Riquier.* Amiens: Caron-Vitet, 1836.
Gilbert, Katherine and Helmut Kuhn. *A History of Esthetics.* Revised edition. Lon-
 don: Thames and Hudson, 1956.
Gindele, Carl. "Die gallikanischen 'Laus-Perennis'-Kloster und ihr 'Ordo Officii'."
 Revue Bénédictine 69 (1959): 33–48.
Giry, Arthur. *Manuel de diplomatique.* Paris: Hachette, 1894.
Godman, Peter. *Poetry of the Carolingian Renaissance.* Norman: University of Okla-
 homa Press, 1985.
——. *Poets and Emperors: Frankish Politics and Carolingian Poetry.* Oxford: Claren-
 don Press, 1987.
Grabar, André. *Byzantium from the Death of Theodosius to the Rise of Islam.* Stuart
 Gilbert and James Emmons, translators, London: Thames and Hudson, 1967.
——. *Christian Iconography, A Study of Its Origins.* Terry Grabar, translator. Prince-
 ton, NJ: Princeton University Press, 1968.
——. *Early Medieval Painting from the Fourth to the Eleventh Century.* Stuart Gilbert,
 translator, New York: Skira, 1957.
——. *L'art de la fin de l'antiquité et du Moyen-âge.* 3 volumes. Paris: Collège de
 France, 1968.
——. *Martyrium. Recherches sur la culte des reliques et l'art chrétien antique.* 2 vol-
 umes. Paris: Collège de France, 1943–1946.

————. "Les mosaïques de Germigny-des-Prés." *Cahiers archéologiques* 7 (1954): 171–183.

Graf, Hugo. *Opus francigenum*. Stuttgart: K. Wittwer, 1878.

Grossmann, D. "Zum Stand der Westwerkforschung." *Wallraf-Richartz Jahrbuch* 19 (1957): 253–264.

Hallinger, Kassius. *Gorze-Kluny*. 2 Volumes. Rome: Herder, 1950.

————. "Papst Gregor der Grosse und der Heilige Benedikt." *Studia Anselmiana* 42 (1957): 231–319.

Halphen, Louis. *Charlemagne et l'empire carolingien*. Paris: Albin Michel, 1947.

Haubrichs, Wolfgang. *Ordo als Form. Strukturstudien zur Zahlenkomposition bei Otfrid von Weissenburg und in karolingischer Literatur. Hermaea* 27. Tübingen: n. pub., 1969.

Hauck, Albert. *Kirchengeschichte Deutschlands*. 5 Volumes. Reprint edition. Berlin: Akademie Verlag, 1958.

Hauck, Karl. "Karolingische Taufpfalzen im Spiegel hofnaher Dichtung." *Nachrichten der Akademie der Wissenschaften in Göttingen I. Philologisch-historische Klasse* (1985): 1–97.

Haugh, Richard. *Photius and the Carolingians*. Belmont, MA: Norland, 1975.

Head, Thomas. *Hagiography and the Cult of the Saints: The Diocese of Orléans, 800–1200*. Cambridge: Cambridge University Press, 1990.

Hefele, Karl Joseph. *Histoire des conciles d'après les documents originaux*. 2nd edition. Paris: Letouzey et Ané, 1907–1952.

Heil, Wilhelm. *Alkuinstudien*. 2 volumes. Düsseldorf: Schwann, 1970.

————. "Der Adoptianismus, Alkuin und Spanien." In Wolfgang Braunfels, editor, *Karl der Grosse, Lebenswerk und Nachleben*. Volume 3: *Das geistige Leben*. Dusseldorf: Schwann, 1965, pp. 95–155.

Heitz, Carol. "Architecture et liturgie processionnelle à l'époque préromane." *Revue de l'art* 24 (1974): 30–47.

————. *L'architecture religieuse carolingienne: Les formes et leurs fonctions*. Paris: Alphonse Picard, 1980.

————. "Le groupe cathédrale de Metz au temps de saint Chrodegang." In J. Schneider, editor, *Actes du colloque de saint Chrodegang*. Metz: n. pub., 1967, pp. 123–132.

————. *Recherches sur les rapports entre architecture et liturgie à l'époque carolingienne*. Paris: S.E.V.P.E.N., 1963.

————. "De Chrodegang à Cluny II: cadre de vie, organisation monastique, splendeur liturgique." In *Sous la règle de saint Benoît: Structures monastiques et sociétés en France du Moyen Âge à l'époque moderne*. Geneva: Librairie Droz, 1982, pp. 491–497.

Hénocque, Jules. *Histoire de l'Abbaye et de la ville de Saint-Riquier, les saints, les abbés, le monastère et l'église, la ville, et la commune*. 3 volumes. *Mémoires de la Société des antiquaires de Picardie, documents inédits concernant la province*, Volumes 9–11. Amiens: A. Douillet, 1880–1888.

————. "Notice sur saint Angilbert, abbé de Saint-Riquier: mariage de saint Angilbert avec la Princesse Berthe." *Bulletin de la Société des Antiquaires de Picardie* 9, 2 (1866): 250–269.

——. "Observations de M. l'abbé Carlet, curé de Manicamps." *Bulletin de la Société des Antiquaires de Picardie* 11, 3 (1873): 335–351.

Hilpisch, Stephanus. *Geschichte des benediktinischen Mönchtums in ihren Grundzügen.* Freiburg-im-Breisgau: Herder: 1929.

Hlawitschka, Eduard. *Franken, Alemannen, Bayern und Burgunder in Oberitalien (774–962).* Freiburg-im-Breisgau: Eberhard Albert Verlag, 1960.

Holl, A. *Die Welt der Zeichen bei Augustinus.* Vienna: Herder, 1963.

Holtzinger, Heinrich. *Über den Ursprung und die Bedeutung der Doppelchöre.* Leipzig: E. A. Seemann, 1891.

Homburger, Otto. "Eine unveröffentlichte Evangelien-Handschrift aus der Zeit Karls des Grossen." *Zeitschrift für schweizerische Archeologie und Kunstgeschichte* 5 (1943): 149–165.

Horn, Walter and Ernest Born. *The Plan of Saint Gall.* Berkeley: University of California Press, 1979.

——. "On the Selective Use of Sacred Numbers and the Creation in Carolingian Architecture of a New Aesthetic Based on Modular Concepts." *Viator* 6 (1975): 351–390.

Hubert, Jean. *The Carolingian Renaissance.* New York: George Braziller, 1970.

——. *L'art pre-roman.* Paris: Éditions d'art et d'histoire, 1938.

——. "L'église de Germigny-des-Prés." *Congrès Archéologiques de France* 93 (1930): 534–538.

——. "Saint-Riquier et le monachisme en Gaul à l'époque carolingienne." *Il monachesimo nell'alto medioevo e la formazione della civiltà occidentale. Settimane di studio del centro italiano di studi sull'alto medioevo* 4. Spoleto: Sede del Centro, 1957, pp. 293–309.

Jacobsen, Werner. "Allgemeine Tendenzen im Kirchenbau unter Ludwig dem Frommen." In Peter Godman and Roger Collins, editors, *Charlemagne's Heir: New Perspectives on the Reign of Louis the Pious.* Oxford: Clarendon Press, 1990, pp. 641–654.

Jansen, Virginia. "Round or Square? The Axial Towers of the Abbey Church of Saint-Riquier." *Gesta* 21, 2 (1982): 83–90.

Jaspert, Bernd. *Die Regula Benedicti-Regula Magistri Kontroverse.* Hildesheim: Verlag Gustenberg, 1977.

John, Eric. "'Secularium Prioratus' and the Rule of Saint Benedict." *Revue Bénédictine* 75 (1965): 212–239.

Jones, Charles W. "Carolingian Aesthetics: Why Modular Verse?" *Viator* 6 (1975): 309–340.

Jungmann, Josef Andreas. *Missarum Sollemnia.* 3 Volumes. Vienna: Herder, 1948.

——. *The Early Liturgy to the Time of Gregory the Great.* Francis A. Brunner, translator, Notre Dame, IN: University of Notre Dame Press, 1959.

Kahl, Hans Dietrich. "Karl der Grosse und die Sachsen. Stufen und Motive einer historischen 'Eskalation'." In Herbert Ludat and Rainer Christoph Schwinges, editors, *Politik, Gesellschaft, Geschichtsschreibung: Giessner Festgabe für Frantisek Graus.* Beihefte zum Archiv für Kulturgeschichte 18. Cologne/Vienna: Egon Boshof, 1982, pp. 49–130.

Kantorowicz, Ernst. *Laudes Regiae: A Study in Liturgical Acclamation and Medieval Ruler Worship.* Berkeley: University of California Press, 1946.

Kelly, John Norman Davidson. *The Athanasian Creed.* New York: Harper and Row, 1964.

——. *Early Christian Creeds.* London: Longmans, 1972.

——. *Early Christian Doctrines.* London: A. and C. Black, 1968.

Kern, Fritz. *Kingship and Law in the Middle Ages.* S. B. Chrimes, translator, Oxford: Blackwell, 1968.

Khatchatrian, A. "Notes sur l'architecture de Germigny-des-Prés." *Cahiers archéologiques* 7 (1954): 161–170.

Klauser, Theodore and R. S. Bour. "Un document du IXe siècle, notes sur l'ancienne liturgie de Metz et sur les églises antérieures à l'an mil." *Annuaire de la Société d'Histoire et d'Archéologie de la Lorraine* 38 (1929): 497–643.

Kleinclausz, Arthur. *L'empire carolingien, ses origines et ses transformations.* Paris: Hachette, 1902.

Krautheimer, Richard. *Studies in Early Christian, Medieval, and Renaissance Art.* Alfred Frazer et al., translators, New York: New York University Press, 1969.

Landes, Richard. "Lest the Millennium be Fulfilled: Apocalyptic Expectations and the Pattern of Western Chronography, 100–800 C.E." In Werner Verbrecke, Daniel Verhelst, and Andries Welkenhuysen, editors, *The Use and Abuse of Eschatology in the Middle Ages.* Louvain: Louvain University Press, 1988, pp. 135–211.

Lehmann, Edgar. "Die Anordnung der Altäre in Klosterkirche zu Centula." In Wolfgang Braunfels, editor, *Karl der Grosse, Lebenswerk und Nachleben.* Volume 3: *Karolingische Kunst.* Düsseldorf: Schwann, 1965, pp. 374–383.

Lesne, Emile. *Histoire de la propriété ecclésiastique en France.* 6 Volumes. Lille: H. Champion, 1910–1943.

Levison, Wilhelm. *England and the Continent in the Eighth Century.* Oxford: Clarendon Press, 1946.

Löhrer, P. M. *Der Glaubensbegriff des heiligen Augustinus.* Einsiedeln: n. pub., 1955.

Lot, Ferdinand. "Nouvelles recherches sur le texte de la Chronique de l'abbaye de Saint-Riquier par Hariulf." *Bibliothèque de l'École des Chartes* 72 (1911): 245–258.

Lotz, Wolfgang. "Zum Problem der Westwerke." *Kunstchronik* 5 (1952): 65–71.

Bowe, E. A. *Codices Latini Antiquiores.* 10 Volumes. Oxford: Clarendon Press, 1934–1965.

Luff, S. G. "A Survey of Primitive Monasticism in Central Gaul." *Downside Review* 70 (1952): 180–203.

Manitius, Max. "Das Epos 'Karolus Magnus et Leo Papa'." *Neues Archiv der Gesellschaft für ältere deutsche Geschichtskunde* 8 (1883): 9–45.

——. *Geschichte der lateinischen Literatur des Mittelalters.* 3 volumes. Munich: C. H. Beck, 1911–1935.

Markus, Robert A. *Augustine: A Collection of Critical Essays.* Garden City, NY: Anchor Books, 1972.

Marrou, H.-I. *Saint Augustin et la fin de la culture antique.* Paris: E. de Boccard, 1938.

Mayer, Cornelius P. *Die Zeichen in der geistigen Entwicklung und in der Theologie des jungen Augustinus*. Würzburg: Augustinus Verlag, 1969.

——. "*Res per signa*." *Revue des Études Augustiniennes* 20 (1974): 100–112.

——. "Signifikations-Hermeneutik im Dienste der Daseinauslegung." *Augustiniana* 24 (1974): 21–74.

Mayer, Heinz and Rudolf Suntrup. "Zum Lexikon der Zahlenbedeutungen im Mittelalter. Einführung in die Methode und Probeartikel: Die Zahl 7." *Frühmittelalterliche Studien* 11 (1977): 1–73.

McCormick, Michael. *Eternal Victory: Triumphal Rulership in Late Antiquity, Byzantium, and the Early Medieval West*. Cambridge: Cambridge University Press, 1986.

——. "The Liturgy of War in the Early Middle Ages: Crisis, Litanies, and the Carolingian Monarchy." *Viator* 15 (1984): 1–23.

McKitterick, Rosamond. *The Carolingians and the Written Word*. Cambridge: Cambridge University Press, 1989.

——. *The Frankish Church and the Carolingian Reforms, 789–895*. London: Royal Historical Society, 1977.

——. *The Frankish Kingdoms Under the Carolingians*. New York: Longmans, 1983.

——. "Town and Monastery in the Carolingian Period." *Studies in Church History* 16 (1979): pp. 93–102.

Meyendorff, John. *Byzantine Theology: Historical Trends and Doctrinal Themes*. New York: Fordham University Press, 1974.

——. *Christ in Eastern Christian Thought*. Washington, DC: Corpus Books, 1969.

Meyvaert, Paul. "The Authorship of the *Libri Carolini*: Observations Prompted by a Recent Book." *Revue Bénédictine* 89 (1979): 29–57.

Mikoletsky, Leo. "Sinn und Art der Heiligung im frühen Mittelalter." *Mitteilungen des Instituts für österreichische Geschichtsforschung* 57 (1949): 83–122.

Mohlberg, Cunibert. *Missale Gothicum*. Augsburg: Benno Filser, 1929.

Molas, Clemente. "A proposito del 'ordo diurnus' de san Benito de Aniano." *Studia Monastica* 2 (1960): 205–221.

Montalembert, Charles. *Les moines d'Occident depuis saint Benoît jusqu'à saint Bernard*. 6 volumes. Paris: J. LeCoffre, 1860–1877.

Morrison, Karl Frederick. *The Mimetic Tradition of Reform in the West*. Princeton, NJ: Princeton University Press, 1982.

——. *The Two Kingdoms: Ecclesiology in Carolingian Political Thought*. Princeton, NJ: Princeton University Press, 1964.

——. *Tradition and Authority in the Western Church, 300–1140*. Princeton, NJ: Princeton University Press, 1969.

Musset, Lucien. *The Germanic Invasions*. Edward James and James Columba, translators. London: Elek, 1975.

Nelson, Janet. *Politics and Ritual in Early Medieval Europe*. London: Hambledon Press, 1986.

Netzer, H. *L'introduction de la messe romaine en France sous les Carolingiens*. Paris: Alphonse Picard, 1910.

Noble, Thomas F. X. "Louis the Pious and the Frontiers of the Frankish Realm." In Peter Godman and Roger Collins, editors, *Charlemagne's Heir: New Perspec-*

tives on the Reign of Louis the Pious. Oxford: Clarendon Press, 1990, pp. 333–
347.

——. "The Monastic Ideal as a Model for Empire: The Case of Louis the Pious."
Revue Bénédictine 86 (1976): 235–250.

——. *The Republic of Saint Peter: The Birth of the Papal State, 680–825.* Philadelphia:
University of Pennsylvania Press, 1984.

O'Connell, Robert J. *Art and the Christian Intelligence in Saint Augustine.* Oxford:
Basil Blackwell, 1978.

Ostendorf, A. "Das Salvator-Patrozinium." *Westfälische Zeitschrift* 100 (1950): 357–
376.

Ostrogorsky, George. *History of the Byzantine State.* Joan Hussey, translator. Revised
edition. New Brunswick, NJ: Rutgers University Press, 1969.

Panofsky, Erwin. *Gothic Architecture and Scholasticism. Wimmer Lecture II, 1948.*
Latrobe, PA: Archabbey Press, 1951.

——. *Renaissance and Renascences in Western Art.* Stockholm: Almquist and Wik-
sell, 1960.

Parsons, D. "The Pre-Romanesque Church of Saint-Riquier: The Documentary
Evidence." *Journal of the British Archeological Association* 130 (1977): 21–51.

Paxton, Frederick. *Christianizing Death.* Ithaca, NY: Cornell University Press, 1990.

Pelikan, Jaroslav. *The Christian Tradition.* 5 volumes. Chicago: University of Chi-
cago Press, 1971–1989.

Prinz, Friedrich. *Frühes Mönchtum im Frankenreich: Kultur und Gesellschaft in Gal-
lien, den Rheinlanden und Bayern am Beispiel der monastischen Entwicklung (4. bis
8. Jahrhundert).* Vienna: R. Oldenbourg, 1965.

Raby, F. J. E. *A History of Secular Latin Poetry in the Middle Ages.* 2 volumes. Second
edition. Oxford: Clarendon Press, 1967.

Réau, Louis. *Iconographie de l'art chrétien.* 3 volumes. Paris: Presses universitaires de
France, 1955–1959.

Reinhardt, Hans. "L'église carolingienne de Saint-Riquier." *Mélanges offerts à René
Crozet.* 2 volumes. Poitiers: Société d'Études Médiévales, 1966, pp. 81–92.

Richard, P. "Angilbert." *DHGE* 3. Paris: Letouzey et Ané, 1924, cc. 120–123.

Riché, Pierre. *Education and Culture in the Barbarian West.* John Contreni, transla-
tor. Columbia: University of South Carolina Press, 1976.

——. "Le renouveau de la culture à la cour de Pepin." *Francia* 2 (1974): 59–70.

——. *La vie quotidienne dans l'empire carolingien.* Paris: Hachette, 1973.

Rouche, Michel. "Les Saxons et les origines de Quentovic." *Revue du Nord*
(October–December 1977): 457–478.

Saint-Riquier I: Études concernant l'abbaye depuis le huitième siècle jusqu'à la Révolution.
Saint-Riquier: Abbaye de Saint-Riquier, 1962.

Saint-Riquier II: Chronique de Pierre le Prestre, abbé de Saint-Riquier, et commentaires.
Honoré Bernard, editor, Saint-Riquier: Abbaye de Saint-Riquier, 1971.

Sawyer, P. H. and I. N. Wood, editors. *Early Medieval Kingship.* Leeds: University of
Leeds Press, 1977.

Schäfer, Herwin. "The Origin of the Two-tower Façade in Romanesque Architec-
ture." *Art Bulletin* 27 (1945): 105.

Schäferdiek, Knut. "Der adoptianische Streit im Rahmen der spanischen Kirchen-

geschichte I and II." *Zeitschrift für Kirchengeschichte* 80 (1969): 291–311, and 81 (1970): 1–16.

Schaller, Dieter. "Angilbert." In Wolfgang Stammler and Karl Langosch, editors, *Die deutsche Literatur des Mittelalters. Verfasserlexikon*. Volume I. Berlin: De Gruyter, 1978, pages 358–363.

———. "Der Dichter des 'Carmen de conversione Saxonum.'" In Günter Bernt, Fidel Rädle, and Gabriel Silagi, editors, *Tradition und Wertung: Festschrift für Franz Brunholzl zum 65. Geburtstag*. Sigmaringen: Jan Thorbecke, 1989, pp. 27–45.

———. "Vortrags- und Zirkulardichtung am Hof Karls des Grossen." *Mittellateinisches Jahrbuch* 6 (1970): 14–36.

Schivoletto, Nino. "Angilberto abate di S. Riquier e l'humanitas' carolingia." *Giornale italiano di filogia* 5 (1952): 289–313.

Schmid, Karl. "Zeugnisse der Memorialüberlieferung aus der Zeit Ludwigs des Frommen." In Peter Godman and Roger Collins, editors, *Charlemagne's Heir: New Perspectives on the Reign of Louis the Pious*. Oxford: Clarendon Press, 1990, pp. 509–522.

Schmidt, Adolf. *Westwerke und Doppelchöre. Höfische und liturgische Einflüsse auf die Kirchenbauten des frühen Mittelalters*. Doctoral dissertation, Göttingen, 1950.

Schmidt-Wiegand, Ruth. "Die kritische Ausgabe der Lex Salica-noch immer ein Problem?" *Zeitschrift der Savigny-Stiftung für Rechtsgeschichte, Germanistische Abteilung* 76 (1959): 301–319.

Schmitz, Philibert. "Benoît d'Aniane." *DHGE* 8. Paris: Letouzey et Ané, 1935, cc. 177–188.

———. *Histoire de l'ordre de saint Benoît*. Maredsous: Abbaye de Maredsous, 1949.

———. "L'influence de saint Benoît d'Aniane dans l'histoire de l'ordre de saint Benoît." *Il monachesimo nell'alto medioevo e la formazione della civiltà occidentale. Settimane di studio del centro italiano di studi sull'alto medioevo* 4 (1957): 401–415.

———. "Livres d'heures et usages bénédictins." *Revue Littéraire et Monumentale* 13 (1927–1928): 301–321.

Schneider, Hermann. *Heldendichtung-Geistlichendichtung-Ritterdichtung*. Revised edition. Heidelberg: C. Winter, 1943.

Schramm, Percy Ernst et al. *Herrschaftszeichen und Staatssymbolik: Beiträge zur ihrer Geschichte vom dritten bis zum sechszehnten Jahrhundert. MGH, Schriften* 13. Stuttgart: A. Hiersemann, 1954–1978.

Schuhmann, Otto. "Angilbert." In Wolfgang Stammler, editor, *Die deutsche Literatur des Mittelalters. Verfasserlexikon*. Volume 1 (Berlin: De Gruyter, 1933), cc. 80–85.

Sears, Elizabeth. *The Ages of Man*. Princeton, NJ: Princeton University Press, 1986.

Semmler, Joseph. "Benedictus II—Una Regula—Una Consuetudo." *Benedictine Culture 750–1050*. Medievalia Lovaniensia, Series 1, Volume 11. Louvain: Louvain University Press, 1983, pp. 1–49.

———. "Die Beschlüsse des Aachener Konzils im Jahre 816." *Zeitschrift für Kirchengeschichte* 74 (1963): 15–82.

———. "Episcopi Potestas." In Arno Borst, editor, *Mönchtum, Episkopat und Adel zur Gründungszeit des Klosters Reichenau*. Sigmaringen: Jan Thorbecke, 1974, pp. 305–395.

———. "*Iussit . . . princeps renovare . . . praecepta*: Zur verfassungsrechtlichen

Einordnung der Höchstifte und Abteien in die karolingische Reichskirche." In Joachim F. Angerer and Josef Lenzenweger, editors, *Consuetudines monasticae: Festschrift für Kassius Hallinger.* Rome: Pontificio Ateneo San Anselmo, 1982, pp. 96–124.

——. "Karl der Grosse und das fränkische Mönchtum." In Wolfgang Braunfels, editor, *Karl der Grosse, Lebenswerk und Nachleben.* Volume 2: *Das geistige Leben.* Düsseldorf: Schwann, 1965, pp. 255–289.

——. "Mission und Pfarrorganisation in den rheinischen, mosel- und maasländischen Bistümern (5.–10. Jahrhundert)." *Settimane di studio del Centro italiano di studi sull alto medioevo* 28, 2. Spoleto: Sede del Centro, 1982, pp. 813–888.

——. "Pepin III und die fränkischen Klöster." *Francia* 3 (1975): 88–146.

——. "Zehntgebor und Pfarrtermination in karolingischer Zeit." In H. Mordek, editor, *Aus Kirche und Reich: Studien zu Theologie, Politik und Recht im Mittelalter. Festschrift für Friedrich Kempf.* Sigmaringen: Jan Thorbecke, 1983, pp. 33–44.

——. "Zur Überlieferung der monastischen Gesetzgebung Ludwig des Frommen." *Deutsches Archiv* 16 (1960): 309–388.

Sherrard, Philip. *The Greek East and the Latin West.* London: Oxford University Press, 1959.

Smalley, Beryl. *The Study of the Bible in the Middle Ages.* Second edition. Oxford: Basil Blackwell, 1952.

Solano, Jesus. "El concilio de Calcedonia y la controversia adopcionista del siglo VIII en España." In Aloys Grillmeier, S. J. and Heinrich Bacht, S. J., editors, *Das Konzil von Chalkedon.* Volume 2. Würzburg: Echter-Verlag, 1953, pp. 841–871.

Stengl, Edmund. "Über Ursprung, Zweck und Bedeutung der karolingischen Westwerke." *Festschrift Adolf Hofmeister.* Halle: M. Niemeyer, 1955, pp. 285–311.

Strecker, Karl. "Studien zu den karolingischen Dichtern." *Neues Archiv der Gesellschaft für altere deutsche Geschichtskunde* 44 (1922): 209–251.

Svoboda, Karel. *L'esthétique de saint Augustin et ses sources.* Paris/Brno: Vydava Filosoficka Fakulta, 1933.

Swete, H. B. *History of the Doctrine of the Procession of the Holy Spirit.* Cambridge: Deighton, Bell and Company, 1876.

Thompson, E. A. *Romans and Barbarians.* Madison: University of Wisconsin Press, 1982.

Traube, Ludwig. *Karolingische Dichtungen, Schriften zur germanischen Philologie.* Berlin: Weidmann, 1888.

Tscholl, Josef-Matthias. "Augustins Aufmerksamkeit am Makrokosmos." *Augustiniana* 15 (1965): 389–413.

——. "Augustins Beachtung der geistigen Schönheit." *Augustiniana* 16 (1966): 11–53.

——. "Augustins Interesse für das körperliche Schöne." *Augustiniana* 14 (1964): 72–104.

——. "Dreifaltigkeit und dreifache Vollendung des Schönen nach Augustinus." *Augustiniana* 16 (1966): 330–370.

——. "Vom Wesen der körperlichen Schönheit zu Gott." *Augustiniana* 15 (1965): 32–53.

Uhde-Stahl, B. "Ein unveröffentlichter Plan des mittelalterlichen Klosters Aniane." *Zeitschrift für Kunstgeschichte* 43 (1980): 1–10.

Ullmann, Walter. *The Carolingian Renaissance and the Idea of Kingship*. London: Methuen, 1969.

Vauchez, André. *La spiritualité du Moyen âge occidental, VIIIe–XIIe siècle*. Paris: Presses Universitaires de France, 1975.

Vieillard-Troiekouroff, May. "L'architecture en France du temps de Charlemagne." In Wolfgang Braunfels, editor, *Karl der Grosse, Lebenswerk und Nachleben*. Volume 3: *Karolingische Kunst*. Düsseldorf: Schwann, 1965, pp. 336–368.

———. "Tables de canons et stucs carolingiens." *Stucchi e mosaici altomedioevali: Atti dell'ottavo congresso di studi sull'arte dell'alto medioevo*. Milan: n. pub., 1962, pp. 154–178.

Vogel, Cyril. "Les échanges liturgiques entre Rome et les pays francs jusqu'à l'époque de Charlemagne." *Le chiese nei regni dell'Europa occidentale e i loro rapporti con Roma fino all'800. Settimane di studio del Centro italiano di studi sull'alto medioevo* 7. Spoleto: Sede del Centro, 1960, pp. 225–246.

Von den Steinen, Wolfram. "Entstehungsgeschichte der *Libri Carolini*." *Quellen und Forschungen aus Italienischen Archiven und Bibliotheken* 21 (1929–1930): 1–93.

Von Simson, Bernhard. *Jahrbücher des fränkischen Reichs unter Karl dem Grossen*. Leipzig: Duncker and Humbolt, 1883–1888.

Wallace-Hadrill, John Michael. *Early Germanic Kingship in England and on the Continent*. Oxford: Clarendon Press, 1971.

———. *Early Medieval History*. New York: Barnes and Noble, 1976.

———. *The Barbarian West*. New York: Hutchinson's University Library, 1957.

———. *The Frankish Church*. Oxford: Clarendon Press, 1983.

Wallach, Luitpold. *Alcuin and Charlemagne: Studies in Carolingian History and Literature*. Ithaca, NY: Cornell University Press, 1959.

———. *Diplomatic Studies in Latin and Greek Documents from the Carolingian Age*. Ithaca, NY: Cornell University Press, 11977.

Wand, J. W. C. *A History of the Early Church to 500 A.D.* Fourth edition. London: Methuen, 1963.

Wemple, Suzanne Fonay. *Women in Frankish Society: Marriage and the Cloister, 500–900*. Philadelphia: University of Pennsylvania Press, 1981.

Winandy, J. "L'oeuvre monastique de saint Benoît d'Aniane." *Mélanges bénédictins publiés à l'occasion du XIVe centenaire de la mort de saint Benoît*. Saint Wandrille: Éditions de Fontenelle, 1947, pp. 235–258.

Wolff, Philippe. "L'Aquitaine et ses marges." In Wolfgang Braunfels, editor, *Karl der Grosse: Lebenswerk und Nachleben*. Volume 1: *Persönlichkeit und Geschichte*. Düsseldorf: Schwann, 1965, pp. 269–306.

Worstbrock, Franz Josef. "*De Conversione Saxonum*." In Wolfgang Stammler and Karl Langosch, editors, *Die deutsche Literatur des Mittelalters. Verfasserlexikon* 2. (Berlin: De Gruyter, 1980), cc. 11–13.

Zettler, Alfons. "Der St. Galler Klosterplan: Überlegungen zu seiner Herkunft und Entstehung." In Peter Godman and Roger Collins, editors, *Charlemagne's Heir: New Perspectives on the Reign of Louis the Pious*. Oxford: Clarendon Press, 1990, pp. 655–687.

Index

University of Pennsylvania Press
MIDDLE AGES SERIES
Edward Peters, General Editor

F. R. P. Akehurst, trans. *The* Coutumes de Beauvaisis *of Philippe de Beaumanoir.* 1992

Peter L. Allen. *The Art of Love: Amatory Fiction from Ovid to the* Romance of the Rose. 1992

David Anderson. *Before the Knight's Tale: Imitation of Classical Epic in Boccaccio's* Teseida. 1988

Benjamin Arnold. *Count and Bishop in Medieval Germany: A Study of Regional Power, 1100–1350.* 1991

Mark C. Bartusis. *The Late Byzantine Army: Arms and Society, 1204–1453.* 1992

Thomas N. Bisson, ed. *Cultures of Power: Lordship, Status, and Process in Twelfth-Century Europe.* 1995

Uta-Renate Blumenthal. *The Investiture Controversy: Church and Monarchy from the Ninth to the Twelfth Century.* 1988

Daniel Bornstein, trans. *Dino Compagni's* Chronicle *of Florence.* 1986

Maureen Boulton. *The Song in the Story: Lyric Insertions in French Narrative Fiction, 1200–1400.* 1993

Betsy Bowden. *Chaucer Aloud: The Varieties of Textual Interpretation.* 1987

Charles R. Bowlus. *Franks, Moravians, and Magyars: The Struggle for the Middle Danube, 788–907.* 1994

James William Brodman. *Ransoming Captives in Crusader Spain: The Order of Merced on the Christian-Islamic Frontier.* 1986

Kevin Brownlee and Sylvia Huot, eds. *Rethinking the* Romance of the Rose: *Text, Image, Reception.* 1992

Matilda Tomaryn Bruckner. *Shaping Romance: Interpretation, Truth, and Closure in Twelfth-Century French Fictions.* 1993

Otto Brunner (Howard Kaminsky and James Van Horn Melton, eds. and trans.). *Land and Lordship: Structures of Governance in Medieval Austria.* 1992

Robert I. Burns, S. J., ed. *Emperor of Culture: Alfonso X the Learned of Castile and His Thirteenth-Century Renaissance.* 1990

David Burr. *Olivi and Franciscan Poverty: The Origins of the* Usus Pauper *Controversy.* 1989

David Burr. *Olivi's Peaceable Kingdom: A Reading of the Apocalypse Commentary.* 1993

Thomas Cable. *The English Alliterative Tradition.* 1991

Anthony K. Cassell and Victoria Kirkham, eds. and trans. *Diana's Hunt/Caccia di Diana: Boccaccio's First Fiction.* 1991

John C. Cavadini. *The Last Christology of the West: Adoptionism in Spain and Gaul, 785–820.* 1993

Brigitte Cazelles. *The Lady as Saint: A Collection of French Hagiographic Romances of the Thirteenth Century.* 1991

Karen Cherewatuk and Ulrike Wiethaus, eds. *Dear Sister: Medieval Women and the Epistolary Genre.* 1993

Anne L. Clark. *Elisabeth of Schönau: A Twelfth-Century Visionary.* 1992

Willene B. Clark and Meradith T. McMunn, eds. *Beasts and Birds of the Middle Ages: The Bestiary and Its Legacy.* 1989

Richard C. Dales. *The Scientific Achievement of the Middle Ages.* 1973

Charles T. Davis. *Dante's Italy and Other Essays.* 1984

William J. Dohar. *The Black Death and Pastoral Leadership: The Diocese of Hereford in the Fourteenth Century.* 1994

Katherine Fischer Drew, trans. *The Burgundian Code.* 1972

Katherine Fischer Drew, trans. *The Laws of the Salian Franks.* 1991

Katherine Fischer Drew, trans. *The Lombard Laws.* 1973

Nancy Edwards. *The Archaeology of Early Medieval Ireland.* 1990

Margaret J. Ehrhart. *The Judgment of the Trojan Prince Paris in Medieval Literature.* 1987.

Richard K. Emmerson and Ronald B. Herzman. *The Apocalyptic Imagination in Medieval Literature.* 1992

Theodore Evergates. *Feudal Society in Medieval France: Documents from the County of Champagne.* 1993

Felipe Fernández-Armesto. *Before Columbus: Exploration and Colonization from the Mediterranean to the Atlantic, 1229–1492.* 1987

Jerold C. Frakes. *Brides and Doom: Gender, Property, and Power in Medieval Women's Epic.* 1994

R. D. Fulk. *A History of Old English Meter.* 1992

Patrick J. Geary. *Aristocracy in Provence: The Rhône Basin at the Dawn of the Carolingian Age.* 1985

Peter Heath. *Allegory and Philosophy in Avicenna (Ibn Sînâ), with a Translation of the Book of the Prophet Muhammad's Ascent to Heaven.* 1992

J. N. Hillgarth, ed. *Christianity and Paganism, 350–750: The Conversion of Western Europe.* 1986

Richard C. Hoffmann. *Land, Liberties, and Lordship in a Late Medieval Countryside: Agrarian Structures and Change in the Duchy of Wrocław.* 1990

Robert Hollander. *Boccaccio's Last Fiction: Il Corbaccio.* 1988

Edward B. Irving, Jr. *Rereading* Beowulf. 1989

Richard A. Jackson, ed. Ordines Coronationis Franciae: *Texts and Ordines for the Coronation of Frankish and French Kings and Queens in the Middle Ages, Vol. 1.* 1994

C. Stephen Jaeger. *The Envy of Angels: Cathedral Schools and Social Ideals in Medieval Europe, 950–1200.* 1994

C. Stephen Jaeger. *The Origins of Courtliness: Civilizing Trends and the Formation of Courtly Ideals, 939–1210.* 1985

Donald J. Kagay, trans. *The Usatges of Barcelona: The Fundamental Law of Catalonia.* 1994

Richard Kay. *Dante's Christian Astrology.* 1994

Ellen E. Kittell. *From Ad Hoc to Routine: A Case Study in Medieval Bureaucracy.* 1991

Alan C. Kors and Edward Peters, eds. *Witchcraft in Europe, 1100–1700: A Documentary History.* 1972

Barbara M. Kreutz. *Before the Normans: Southern Italy in the Ninth and Tenth Centuries.* 1992

Michael P. Kuczynski. *Prophetic Song: The Pslams as Moral Discourse in Late Medieval England.* 1995

E. Ann Matter. *The Voice of My Beloved: The Song of Songs in Western Medieval Christianity.* 1990

A. J. Minnis. *Medieval Theory of Authorship.* 1988

Lawrence Nees. *A Tainted Mantle: Hercules and the Classical Tradition at the Carolingian Court.* 1991

Lynn H. Nelson, trans. *The Chronicle of San Juan de la Peña: A Fourteenth-Century Official History of the Crown of Aragon.* 1991

Barbara Newman. *From Virile Woman to WomanChrist: Studies in Medieval Religion and Literature.* 1995

Joseph F. O'Callaghan. *The Learned King: The Reign of Alfonso X of Castile.* 1993

Odo of Tournai (Irven M. Resnick, trans.). *Two Theological Treatises:* On Original Sin *and* A Disputation with the Jew, Leo, Concerning the Advent of Christ, the Son of God. 1994

David M. Olster. *Roman Defeat, Christian Response, and the Literary Construction of the Jew.* 1994

William D. Paden, ed. *The Voice of the Trobairitz: Perspectives on the Women Troubadours.* 1989

Edward Peters. *The Magician, the Witch, and the Law.* 1982

Edward Peters, ed. *Christian Society and the Crusades, 1198–1229: Sources in Translation, including* The Capture of Damietta *by Oliver of Paderborn.* 1971

Edward Peters, ed. *The First Crusade: The* Chronicle of Fulcher of Chartres *and Other Source Materials.* 1971

Edward Peters, ed. *Heresy and Authority in Medieval Europe.* 1980

James M. Powell. *Albertanus of Brescia: The Pursuit of Happiness in the Early Thirteenth Century.* 1992

James M. Powell. *Anatomy of a Crusade, 1213–1221.* 1986

Susan A. Rabe. *Faith, Art, and Politics at Saint-Riquier: The Symbolic Vision of Angilbert.* 1994

Jean Renart (Patricia Terry and Nancy Vine Durling, trans.). *The Romance of the Rose or Guillaume de Dole.* 1993

Michael Resler, trans. Erec *by Hartmann von Aue.* 1987

Pierre Riché (Michael Idomir Allen, trans.). *The Carolingians: A Family Who Forged Europe.* 1993

Pierre Riché (Jo Ann McNamara, trans.). *Daily Life in the World of Charlemagne.* 1978

Jonathan Riley-Smith. *The First Crusade and the Idea of Crusading.* 1986

Joel T. Rosenthal. *Patriarchy and Families of Privilege in Fifteenth-Century England.* 1991

Teofilo F. Ruiz. *Crisis and Continuity: Land and Town in Late Medieval Castile*. 1994

Pamela Sheingorn, ed. and trans. *The Book of Sainte Foy*. 1995

Robin Chapman Stacey. *The Road to Judgment: From Custom to Court in Medieval Ireland and Wales*. 1994

Sarah Stanbury. *Seeing the* Gawain-Poet: *Description and the Act of Perception*. 1992

Robert D. Stevick. *The Earliest Irish and English Bookarts: Visual and Poetic Forms Before A.D. 1000*. 1994

Thomas C. Stillinger. *The Song of Troilus: Lyric Authority in the Medieval Book*. 1992

Susan Mosher Stuard. *A State of Deference: Ragusa/Dubrovnik in the Medieval Centuries*. 1992

Susan Mosher Stuard, ed. *Women in Medieval History and Historiography*. 1987

Susan Mosher Stuard, ed. *Women in Medieval Society*. 1976

Jonathan Sumption. *The Hundred Years War: Trial by Battle*. 1992

Ronald E. Surtz. *The Guitar of God: Gender, Power, and Authority in the Visionary World of Mother Juana de la Cruz (1481–1534)*. 1990

William H. TeBrake. *A Plague of Insurrection: Popular Politics and Peasant Revolt in Flanders, 1323–1328*. 1993

Patricia Terry, trans. *Poems of the Elder Edda*. 1990

Hugh M. Thomas. *Vassals, Heiresses, Crusaders, and Thugs: The Gentry of Angevin Yorkshire, 1154–1216*. 1993

Mary F. Wack. *Lovesickness in the Middle Ages: The* Viaticum *and Its Commentaries*. 1990

Benedicta Ward. *Miracles and the Medieval Mind: Theory, Record, and Event, 1000–1215*. 1982

Suzanne Fonay Wemple. *Women in Frankish Society: Marriage and the Cloister, 500–900*. 1981

Jan M. Ziolkowski. *Talking Animals: Medieval Latin Beast Poetry, 750–1150*. 1993

This book has been set in Lintron Galliard. Galliard was designed for Mergenthaler in 1978 by Matthew Carter. Galliard retains many of the features of a sixteenth-century typeface cut by Robert Granjon but has some modifications that give it a more contemporary look.

Printed on acid-free paper.